Our Separate Ways

OUR SEPARATE WAYS

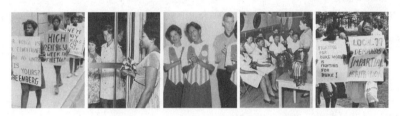

Women and the Black Freedom Movement

in Durham, North Carolina CHRISTINA GREENE

The University of North Carolina Press | Chapel Hill and London

© 2005 The University of North Carolina Press
All rights reserved
Manufactured in the United States of America

Designed by Barbara E. Williams
Set in Quadraat and Scala type by BW&A Books, Inc.

The paper in this book meets the guidelines for permanence and
durability of the Committee on Production Guidelines for Book
Longevity of the Council on Library Resources.

Parts of this book have been reprinted with permission in revised form from
the following works: Christina Greene, "'In the Best Interest of the Total Com-
munity'?: Women-in-Action and the Politics of Race and Class in a Southern
Community, 1968–1972," Frontiers 16, no. 2/3 (1996): 190–217, University of
Nebraska Press, and "'. . . The New Negro Ain't Scared No More!': Black
Women's Activism in North Carolina and the Meaning of Brown," in From the
Grass-Roots to the Supreme Court: Brown v. Board of Education and American Democracy,
edited by Peter Lau (Durham: Duke University Press, 2004).

Library of Congress Cataloging-in-Publication Data
Greene, Christina, 1951–
 Our separate ways : women and the Black freedom movement in Durham,
North Carolina / Christina Greene.
 p. cm.
 Includes bibliographical references and index.
 ISBN 978-0-8078-2938-7 (cloth : alk. paper)—
 ISBN 978-0-8078-5600-0 (pbk.: alk. paper)
 1. Durham (N.C.)—Race relations. 2. African Americans—Civil rights—North
Carolina—Durham—History—20th century. 3. Civil rights movements—
North Carolina—Durham—History—20th century. 4. African American
women—North Carolina—Durham—Political activity—History—20th century.
5. Women, White—North Carolina—Durham—Political activity—History—
20th century. I. Title
 F264.D9G74 2005
 323.1196'0730756563—dc22 2004024382

cloth 09 08 07 06 05 5 4 3 2 1
paper 09 08 5 4 3 2

For Joan

and

For my father

Contents

Illustrations

Acknowledgments

I now understand why authors claim that books are never solitary, individual endeavors. This book is no exception. I have spent more than a decade researching and writing, revising and editing this manuscript in nearly a dozen cities and states. Along the way, I have been helped by countless individuals and institutions.

My first debt is to the women and men who grace these pages. I am especially thankful to all those who generously shared their lives and stories with me. I hope I have captured even a small bit of their courage, dignity, perseverance, and commitment. Many of the individuals who participated in Durham's black freedom struggle do not appear here—an unfortunate but unavoidable feature of a study of grassroots activism that, by its very nature, involved scores of people too numerous to name. Though they are anonymous, their contributions are no less valuable.

My parents, Patricia Greene and the late James Greene, gave me early lessons in social justice. As a young girl, I had little interest in their fair-housing battles in New Jersey; and only shortly before he died did I learn that my father had joined freedom rides in the 1960s, helping to desegregate restaurants in Maryland. But the seeds they planted bore fruit in the evolution of my own political and intellectual commitments, and I am forever grateful to them both. My father, the first in his family to attend college, went on to receive a Ph.D.; he helped provide a home where ideas were important and professors were people with foibles and flaws just like everyone else. My mother also was the first in her family to earn a college degree, taking advantage of the free-tuition policy at Hunter College. She too dreamed of pursuing graduate work, but family and financial constraints as well as social conventions that frowned on married women and mothers pursuing doctoral degrees in the 1950s kept those dreams from becoming a reality. When I received my doctorate, she was so proud that she asked if she could frame a copy of my diploma. It still hangs on her bedroom wall. I shall always cherish my late maternal grandmother, Veronica Gibbons, a daughter of immigrants, whose stories of survival and resistance during the Depression and World

War II inspired my own efforts to document the history of women's efforts on behalf of their families and communities. My siblings, Jimmy, Claudia, Cathy, Susan, and Stephen, each in his and her own way, always believed in my abilities. My nieces and nephews have enriched my life immeasurably: Damien and Jenny, my sweethearts always, kept their promise and allowed me to finish the final editing process when they came for a summer visit; Brian and Steven don't know how remarkable they are, but I do; Victoria and Tara inherited their mother Evangeline's beauty, grace, and intelligence, and they light up my life. Allie Figueroa Greene, who became the daughter I never had, announced at age seven that her heroines were Rosa Parks and Wonder Woman, giving me hope that perhaps I too had planted some seeds.

Over the years, I have had the good fortune to amass an amazing group of friends and colleagues who supported me and pushed me to think more carefully about the interplay of race, gender, and class dynamics. I was privileged to attend City College of New York, where I received a tuition-free college education and was introduced to women's studies and the notion of class struggle, all within the context of New York City's fractious multiracial politics. There I met the late Joan Kelly, whom I loved and admired and who set me on a life-changing quest to uncover the history of women. At Sarah Lawrence College Women's History Graduate Program, which Joan Kelly and Gerda Lerner founded, I discovered under Gerda's brilliant and demanding tutelage the centrality of race in American history. While I was working toward my master's degree in women's history, Jane Gould saw promise in me despite my lousy office skills and hired me at Barnard College Women's Center, where I fought to unionize clerical workers and learned about bringing feminist scholarship to wider audiences. At the women's center at Jersey City State College I discovered how working-class and low-income women of all races could merge campus and community concerns; the late Pat Kernodle's heroic and unbending determination to secure an education against enormous odds, including a debilitating and ultimately fatal illness, touched my life profoundly, and I will never forget her. At Sarah Lawrence, I also met one of my most cherished friends—Bonnie Johnson. Bonnie brings extraordinary gifts to her life-long battle against all oppression, and our late-night talks helped me think more clearly about black women's history and activism. Lisa Watson, my oldest and dearest friend, has stood by me through thick and thin, and she is more precious to me than she perhaps knows. Whether at CARASA meetings or Berkshire Conferences, "study group" dinners or birthday bashes "up the lake," Bonnie and Lisa remind me always of the power of women's friendships.

At Duke University I was blessed with the most wonderful group of faculty and fellow students anyone could imagine. I first came to Duke in the mid-1980s, not as a student, but as the project director for the Duke-UNC Center for Research on Women, thanks to Elizabeth Minnich, who convinced me to make another life-altering decision. At the Center I worked closely with Bill Chafe, an extraordinary human being. Before meeting and working with Bill, I couldn't quite believe that this white guy had started the center, served as its academic director, and retained the friendship and respect of feminist scholars of all races, not only at Duke and the University of North Carolina, but across the country. While still at the Center, I returned to graduate school and Bill agreed to be my adviser, reading more chapter drafts than I'm sure he cares to remember, first for the dissertation and then for this book. Bill and Lorna Chafe, along with their now adult children, Jenny and Chris, opened their home and hearts to me and my family, and they are all dear friends. After leaving North Carolina, "Chez Chafe" in Chapel Hill became our home away from home, enabling me to complete the additional research for this book. Bill's ability to maneuver these multiple roles and relationships is a testament to his enormous generosity of spirit, intellectual rigor, and capacity to live egalitarian social relationships in the midst of fighting for a world where these are the norm rather than the exception. Over lunch one day and several years before she came to Duke, Nancy Hewitt, along with Steve Lawson, helped me find the dissertation topic that became this book. Nancy has been a good friend over the years, always ready with sage advice and support. My dissertation committee—Bill Chafe, Nancy Hewitt, Ray Gavins, Barry Gaspar, and Jacquelyn Dowd Hall (who gave me one of the best compliments I've ever received when she bestowed on me the title of "honorary southerner")—helped steer me on the course that turned a dissertation into a book. Larry Goodwyn, Claudia Koonz, Syd Nathans, Kristen Neuschel, Bill Reddy, Anne Firor Scott, and Peter Wood taught me to think more broadly about history and historical problems. Faculty members Cynthia Herrup (at Duke) and Judith Bennett (at UNC) opened their home to the Duke and UNC Feminist Women's History Group, which became a kind of contemporary salon where intellectual bonds between women students and faculty could be forged and nurtured; it is also the forum where I first presented my research for this book. I can't conceive of a better group of graduate students: Herman Bennett, Nick Biddle, Leslie Brown, Mary Ellen Curtin, Kirsten Fischer, Jennifer Morgan, and Tim Tyson were a model of interracial solidarity, political commitment, and intellectual excitement. They made graduate school one of the richest and most rewarding experiences of my life, and they remain my clos-

est friends still. Martha Jane Brazy, Rod Clare, Jackie Bindman Campbell, Ann Farnsworth-Olvear, Lisa Hazirjian, Janet Irons, Marjoleine Kars, Gretchen Lemke-Santangelo, Chuck McKinney, Kara Miles-Turner, Celia Naylor-Ojurongbe, and Annie Valk also became buddies and allies.

My twelve years in Durham remain among the best of my life—the crew on Pennsylvania Avenue is unsurpassed. I will always be grateful to David Cecelski for inviting me to join him at the Institute for Southern Studies in Durham, where I worked with Eric Bates, Laura Benedict, Cynthia Brown, Christina Davis-McCoy, Meredith Emmett, Bob Hall, Mary Lee Kerr, Jim Lee, Isaiah Madison, Temma Okun, Len Stanley, Dimi Stephen, and Sharon Ugochukwu and learned first-hand about the on-going southern movement for racial and economic justice.

At the University of South Florida, where I began to turn my dissertation into a book, I had the good fortune of landing among another group of wonderful colleagues who soon became friends: Giovanna Benadusi and Fraser Ottanelli (with whom I shared parenting tips and who are still my comrades in arms), Carolyn DePalma, Laura Edwards, Carolyn Eichner, Kennan Ferguson, Susan Fernandez, Kirsten Fischer, Alejandro de la Fuente, John McKeirnan Gonzalez, Gurleen Grewal, Bob and Joelle Ingalls, Rebecca Johns, Steve Johnson, Shreeram Krishnaswami, Phil Levy, Bill and Suzanne Murray, Ella Schmidt, Ward Stavig, and Kelly Tipps, all made Florida far more than just a tropical paradise. Participants in the Department of History's Faculty and Graduate Seminar provided insightful comments about portions of chapter 3. Ray Arsenault and Gary Mormino also took an interest in my work and helped along the way. My graduate students Michele Alishahi, Caitlin Crowell, Gordon Mantler, Lee Irby, Pam Iorio (who became mayor of Tampa), Carl Parke, and Jason Vickers made me remember why I wanted to be a historian and teacher. I am also grateful for having found Rev. Warren Clark, Julian Cunningham, and the wonderfully eclectic congregation at First United Church of Tampa, a rare interracial, open and affirming faith community committed to the ongoing struggle for peace and justice.

I have presented earlier versions of many of the chapters from this book at professional conferences and received thoughtful comments and suggestions from a host of people including Eileen Boris, Albert Broussard, Connie Curry, Davison Douglas, Adam Fairclough, Gerald Gill, Michael Honey, Michael Klarman, Bob Korstad, Peter Lau, Chana Kai Lee, Annelise Orleck, Charles Payne, Jacqueline Rouse, Stephanie Shaw, and Pat Sullivan. I am especially grateful to Charles Payne, who has commented on several papers and provided insightful critiques and encouragement. Although they may not

know it, Darlene Clark Hine and Millicent Brown asked probing questions that spurred me to think more critically about my material. Rhonda Williams took time away from her own book to offer extensive comments on chapter 4. Conversations over the years with Leslie Brown, Laurie Green, Kathy Nasstrom, and Rhonda Williams sharpened my thinking about black women's activism. Ned Kennington, my former next-door neighbor and slayer of dragons both real and imagined, helped bring me up to date on Durham politics as I was rewriting the epilogue. Any errors or misinterpretations, of course, are mine alone.

As I completed the final manuscript, my colleagues in the Afro-American Studies Department at the University of Wisconsin—Sandy Adell, Jim Danky, Frieda High, Stanlie James, Robert Livingston, Nellie McKay, Richard Ralston, Michael Thornton, Tim Tyson, Bill Van Deburg, and Craig Werner—provided the kind of collegial atmosphere that every scholar envisions. Robin Brooks was a diligent research assistant, and I am grateful for all she did. The graduate students at UW—John Adams, Maria Bibbs, Mat Blanton, Robin Brooks, Tessa Desmond, Jerome Dotson, Tanisha Ford, Dave Gilbert, Michelle Gordon, Kori Graves, Brenna Greer, Helen Hoguet, Charles Hughes, Sherry Johnson, David La Croix, Rhea Lathan, Holly McGee, Story Matkin-Rawn, Lydia Melvin, Crystal Moten, Eric Pritchard, Kate Slattery, Tyina Steptoe, Zoe Van Orsdol, and Shannen Williams—remind me continuously about the importance of the work we all do. Two colleagues in particular, Tim Tyson and Craig Werner, gave invaluable assistance. Not only are they the founding members of Madison's infamous Harmony Bar Writers Collective, which I was invited to join, but both read multiple chapter drafts and offered their expert literary skills as well as their broad knowledge of African American history and culture. Craig Werner is without question the most generous and skilled editorial critic I have ever come across; he read the entire manuscript twice, and words cannot express my gratitude. And Tim Tyson is always ready to prop up a beleaguered writer with his legendary chicken and ribs and a splash of bourbon (or a mean gin and tonic) . . . what more can I say!

Jean Boydston, Jeannie Comstock, Suzanne Desan, Nan Enstad, Anne Enke, Barbara Forrest, Steve Kantrowitz, Gerda Lerner, Trina Messer, and especially Perri Morgan provided a warm welcome to the freezing Midwest and made the transition from Florida to Wisconsin and the completion of this book a whole lot easier and more fun.

Every researcher depends on the professionalism and generosity of archivists, and I have run across some of the best. At each of the archives listed

in the bibliography, the staff offered invaluable help. I am most grateful to those who granted me access to unprocessed materials: Bill Erwin, Linda McCurdy, and Janie Morris at the Special Collections Library at Duke University; John White at the Southern Historical Collection at the University of North Carolina at Chapel Hill; and especially Doris Terry Williams at the Hayti Heritage Center at North Carolina Central University, who allowed me unrestricted access to the original tape recordings of the Black Solidarity Committee meetings and to the unprocessed Floyd McKissick Papers. Bill Boyarsky, Lynn Richardson at the Durham County Library, Janie Morris and Eleanor Mills at Duke, Keith Longiotti at the North Carolina Collection Photographic Archives, and Steve Massengill at the North Carolina State Archives were especially helpful in securing photographs.

I was fortunate to receive an AAUW fellowship when I was writing my dissertation. A two-year internship at the Special Collections Library at Duke provided much-needed financial support at a crucial point during the dissertation. Steve Lawson and Bill Link offered me a full-time instructor position at the University of North Carolina at Greensboro, enabling me to finish the dissertation. Summer research grants from the National Endowment for the Humanities, the University of South Florida, and the University of Wisconsin allowed me to conduct additional archival research and oral histories and to complete the final editing process for the book. A small travel grant from the Institute of Black Life at the University of South Florida provided additional support.

The University of North Carolina Press boasts a superb cast of characters. Kate Torrey, David Perry, and especially my editor, Chuck Grench, gave steady support and encouragement. Several anonymous readers offered helpful suggestions. At crucial points, David Perry and Chuck Grench in particular refused to stop believing in this book, and I will always be grateful to them both. Ruth Homrighaus provided excellent copyediting assistance, while Paula Wald and Amanda McMillan steered the book through production.

First, last, and forever are "my boys"—Jim Conway and our son, Dylan. Both have lived with this project for more years than is reasonable to ask of any family. Dylan has spent his entire life wondering how one person could possibly spend so much time writing one book and is sure it must be well over a thousand pages by now. Their love and support—including Jim's cheerful willingness to take on more than half of the household and childcare tasks—have kept me grounded and ever mindful of what is most important.

Abbreviations

AAUW	American Association of University Women
AFL	American Federation of Labor
AME	African Methodist Episcopal
BSC	Black Solidarity Committee for Community Improvement
CAN	Congregations, Associations, and Neighborhoods
CIO	Congress of Industrial Organizations
CNC	Committee for North Carolina (state chapter of the SCHW)
CORE	Congress of Racial Equality
CWJ	Concerned Women for Justice
DCNA	Durham Committee on Negro Affairs
DIC	Durham Interim Committee
EPO	Experiment in Parallel Organization
ERAP	Economic Research and Action Project
FCD	Foundation for Community Development
HUAC	House Un-American Activities Committee
KKK	Ku Klux Klan
LDEF	Legal Defense and Education Fund (of the NAACP)
LWV	League of Women Voters
NAACP	National Association for the Advancement of Colored People
NCC	North Carolina College for Negroes (North Carolina College at Durham from 1947 to 1969; currently North Carolina Central University)
NCF	North Carolina Fund
OBT	Operation Breakthrough
OEO	Office of Economic Opportunity
PTA	Parent-Teacher Association
SCHW	Southern Conference for Human Welfare
SCLC	Southern Christian Leadership Conference
SDS-ERAP	Students for a Democratic Society–Economic Research and Action Project
SNCC	Student Non-Violent Coordinating Committee

SSOC	Southern Student Organizing Committee
TWIU	Tobacco Workers International Union
TWUA	Textile Workers Union of America
UDI	United Durham Incorporated
UNC-CH	University of North Carolina at Chapel Hill
UOCI	United Organizations for Community Improvement
WIA	Women-in-Action for the Prevention of Violence and Its Causes
WILPF	Women's International League for Peace and Freedom
YWCA or Y	Young Women's Christian Association

Introduction

In 1931, Julia Lucas left her birthplace in Warren County, a rural, predominantly black area of North Carolina, and made her way fifty miles south to Durham. In less than a century, the "Bull City" had grown from a railroad depot established in 1854 to become the tobacco center of the world. The sharp, sweet smell of flue-cured tobacco wafted from the gigantic red brick warehouses downtown; people liked to joke that it smelled like money. The manufacturing success of the Piedmont's brightleaf tobacco industry soon brought textiles to the city, and between 1890 and 1930 scores of black and white women, often outnumbering men, flooded to Durham's factories and mills. Tobacco money fueled the establishment of a white professional class as well, and in 1925 the prominent Duke tobacco family transformed Trinity College, affiliated with the Methodist Church, into Duke University. In a sense, Julia Lucas had moved from an old South to a new one.[1]

But Durham was not just a New South industrial city with a university. When Julia Lucas arrived, she discovered a small black business elite centered around the North Carolina Mutual Life Insurance Company, the largest black-owned financial institution in the country. The Mutual's success had drawn praise from both Booker T. Washington and W. E. B Du Bois, legendary (though opposed) black leaders. In the 1920s, a leading sociologist named Durham the "capital of the black middle class."[2]

When she arrived, Julia Lucas quickly embraced some of the leading institutions of the "black capital." She enrolled at North Carolina College for Negroes (NCC), the first publicly funded black liberal arts college in the South.[3] She also joined White Rock Baptist Church, the largest and most prestigious black church in town, which once again was looking for a new minister. Bypassing Adam Clayton Powell Jr., the flamboyant young minister from Harlem—the elder churchwomen thought his "cream-colored trousers and flashy jacket" were a bit too "sporty"—White Rock selected the lettered son of another prestigious minister, Rev. Miles Mark Fisher, who remained for over thirty years. The young minister had been influenced by Ida B. Wells's settlement movement in Chicago, and he knew that Durham's small black

business elite and professional class had done little to diminish the poverty that most blacks endured. In a style both erudite and soothing, Fisher exhorted his flock to embrace a social gospel ministry somewhat at odds with their comfortable social position. Before long, tobacco workers were praising the Lord alongside wealthy executives, and the church was sponsoring a wide range of community programs and services.[4]

Julia Lucas no doubt felt at home with Fisher's mix of old-time religion, social gospel, and advanced degrees, for she also straddled two worlds. Durham's black tobacco workers, day laborers, and maids frequented the barbershop and pool hall she opened with her husband just before World War II. "Every dime I made, I made it off of those people," she said of Durham's African American working class. Lucas also joined the ranks of organized black women, participating in a wide range of civic and voluntary associations from the Parent-Teacher Association (PTA) to the National Association for the Advancement of Colored People (NAACP) and the Volkamenia Literary Society. The literary club, which boasted a female majority, functioned as a kind of salon where members gathered to discuss current issues. The group also sponsored a newspaper reading circle that taught literacy skills with an eye toward increasing black voter registration.[5] During the 1940s, Lucas occasionally ventured across the racial divide for annual prayer services with white women's groups. Nearly fifty years later, Julia Lucas still remembered the white women who had worshipped beside her but found it impossible to greet her on the street. "We had our little . . . World Day of Prayer. And we always had black and white women," she recalled. "But then we would go our separate ways."[6]

In Edgemont, where poor whites fared little better than the masses of Durham blacks, World War II pushed nineteen-year-old Bascie Hicks into one of the city's several textile mills. There, Bascie met her future husband and joined the Textile Workers Union of America (TWUA), a Congress of Industrial Organizations (CIO) union. One day, a black man, out of work, out of luck, and with a family to feed, stopped by the mill. The "boss man told the man he could not hire him because he was black," Hicks recalled. Reared in the Jim Crow South and well-versed in the ways of the racial caste system, she kept quiet, but the injustice gnawed at her. "I wonder now why I didn't say anything," she mused years later.[7] Both Bascie Hicks and Julia Lucas would have another chance to reach across the chasm that divided white and black as they and their descendants acted on the possibility of creating a different kind of Durham.

In 1965, Julia Lucas's daughter, Charsie Hedgepath, and a brilliant young

community organizer, Howard Fuller, knocked on Ann Atwater's door. Atwater was a single mother of two, behind on the rent in a house "that was leanin' toward the street . . . with broken boards . . . [and leaks in] the bathroom." When the water ran, "it would shoot up. . . . My kids called it Niagara Falls," Atwater remarked. Something about Hedgepath and Fuller's suggestion that collective action could help solve her problems struck a chord. Within a few years, Atwater became one of the most respected community organizers in black Durham and a veritable expert on public housing regulations. Charsie Hedgepath continued to organize neighborhood councils through Durham's antipoverty agency, Operation Breakthrough (OBT), and low-income black women soon formed their own neighborhood federation, United Organizations for Community Improvement (UOCI), which mounted a protracted campaign against the city's white power brokers. During a demonstration outside a slumlord's home, one picket had the audacity to direct a message to the man's wife: "My Children Sleep With Rats, Mrs. Greenberg," the picket sign announced to the neighbors.[8]

By the late 1960s, Charsie Hedgepath found herself the secretary of the Black Solidarity Committee (BSC), a cross-class Black Power community alliance that launched a seven-month boycott of white downtown merchants. During the boycott, Hedgepath's mother, Julia Lucas, and Blue Greenberg, wife of the notorious white slumlord, worked together in a new biracial women's organization, Women-in-Action for the Prevention of Violence and Its Causes (WIA). WIA had been established in 1968 by Elna Spaulding, wife of the retired president of the North Carolina Mutual Life Insurance Company. Lucas tried to move the largely middle-class, biracial WIA membership beyond its class-based politics of respectability, while a white woman urged the members to form dialogue groups with "the Mrs. Atwaters" or else risk becoming "just another group of visiting ladies."[9]

Bascie Hicks also played her part in the racial politics of the mid- to late 1960s. Drawing on several earlier efforts to organize poor whites, Bascie, her husband, Doug, and their daughter, Theresa, helped form a new organization called ACT, which organizers hoped might lay the foundation for a biracial movement of the poor. "Someday, I don't know when, the colored and white will stand together," Hicks insisted. Her prediction soon bore fruit, if only in small ways. In 1968, when a local black woman appealed to Hicks to join the Edgemont health clinic, a community-controlled endeavor, Hicks agreed to serve on its board. Her symbolic action reassured local whites, and the clinic became one of the most successful cooperative efforts among low-income blacks and whites in Durham.[10]

As might be expected, these moves toward freedom were not made without conflict. Ann Atwater may have been one of the most respected community organizers in town, but her patience had limits. After C. P. Ellis, a local Klansman and Edgemont resident, spewed forth racial epithets at a 1968 city council meeting, Atwater lunged at him with her knife in hand, hoping to silence him forever. Fortunately for both Atwater and her target, Atwater's friends physically restrained her. A few years later, however, Ann Atwater and C. P. Ellis formed an unlikely alliance. The knife-wielding black mother and the iconoclastic Klansman agreed to head up a local committee designed to ease school desegregation. Before long, Ellis left the Klan, and the ex-Klansman and the black community organizer became good friends. "I begin to see, here we are, two people from the far ends of the fence, havin' identical problems, except her being black and me bein' white," C. P. said. Weeping as he spoke, Ellis explained his transformation: "From that moment on, I tell ya, that gal and I worked together good. . . . I begin to love the girl, really," he admitted.[11]

Such are the vagaries and mysteries of race in America. As these stories suggest, southerners well understood that the color line that defined their worlds was less a rigid demarcation than a fluid, permeable marker. Following World War II, some believed the color line might finally be eradicated. The war heightened black expectations for redress of age-old grievances and fueled the expansion of black women's organizations as well as women's membership in the local NAACP. From formal groups like the Housewives League to informal networks forged in churches, beauty parlors, and drink houses, black women used their new organizational base to press for freedom.

The interracial women's fellowship that beckoned Julia Lucas underlined the limitations as well as the possibilities of the postwar years. "The world into which you and I were born is no more," writer Lillian Smith warned an interracial audience in Durham five years after the war ended. The white Georgian visionary called for a presidential proclamation immediately ending segregation, though she knew it would be akin to "the dropping of the atom bomb."[12] Most white southerners clung to segregation, and the timorous few who dissented did so hesitantly. But black women grew increasingly frustrated with their cautious white sisters. By the 1950s, they began to insist on full inclusion in groups like the Young Women's Christian Association (YWCA, or Y), the American Association of University Women (AAUW), the League of Women Voters (LWV), and the Women's International League for Peace and Freedom (WILPF). During the repressive years of the Cold War, when an incipient progressive, interracial movement collapsed and white su-

premacist violence surged forward, mainstream women's organizations in the region were sorely tested. Within such groups, black and white women, often timidly and haltingly, tried to keep alive a vision of racial equality. But in the face of only limited progress, black women more often worked in concert with black men than with white women, and Louis Austin, Floyd McKissick, and Howard Fuller, among others, were indispensable to Durham's African American freedom struggle.

When direct action erupted in the 1960s, black women's organizational bases helped to sustain the movement. Drawing on community organizing efforts initiated during the local NAACP school desegregation lawsuits of the late 1950s, women organizers mobilized their networks to demand an end to segregated public facilities and to push for expanded job opportunities. After the mid-1960s, as the freedom movement focused more intently on poverty, low-income black women utilized their numbers and their organizing skills to shape the direction of black protest. At times, black and white women reached across the racial divide to forge fragile interracial alliances, even during the height of the Black Power movement. Indeed, some African American women embraced black nationalism and racial integration simultaneously, sometimes within the same organization.

The story of Durham's black freedom movement is not unlike that of countless towns and cities, especially in the Upper South. Many of the broader themes in this story resonate with the history of the struggles that swept the region in the years after World War II. Too often, however, the women who participated in those struggles have remained invisible, elusive, or unappreciated despite the oft-quoted observation of a civil rights activist nearly twenty-five years ago: "It's no secret that young people and women led organizationally."[13] As one scholar confirmed in a recent history of the black freedom movement, "Women took civil rights workers into their homes of course, but women also canvassed more than men, showed up more frequently at mass meetings and demonstrations and more frequently attempted to register to vote."[14] Yet a curious anomaly has prevailed. Despite the lip service given to women's importance, their participation has received little scholarly attention until very recently. It is not simply that women's contributions have been inadequately examined.[15] More importantly, analysis of women's activism suggests new ways of understanding protest, leadership, and racial politics. The inclusion of women, especially African American women, in this history demands an entire rethinking of a movement that changed forever a region and a nation. *Our Separate Ways* is one attempt to provide that perspective, to tell that story.

If You Want Anything Done, Get the Women and the Children

Fighting Jim Crow in the 1940s and 1950s

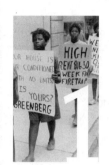

Ersalene Williams must have jumped at the chance to earn a few dollars that summer day in July of 1952. Simply living in Durham, the capital of the black middle class, did not put money in the pockets of an unemployed African American woman. Little of the post–World War II prosperity that swept the nation had found its way to the inhabitants of the unpaved streets and dilapidated houses that made up most of black Durham. So when Thomas Wilbert Clark, a white resident, asked Mrs. Williams if she could help his wife with some household chores, she readily agreed.[1]

When Mrs. Williams arrived at the Clark home, however, Clark's wife was nowhere in sight. Without warning, Thomas Clark pounced on the unsuspecting Williams. When she rebuffed his "pawing," he offered her money for what the press called "immoral purposes." The horrified Williams kicked and screamed as Clark dragged her into the bedroom, tossed her on the bed, and "got on top of her." During a "frantic struggle," Mrs. Williams managed to free herself and escape. Thomas Clark soon appeared at her door to apologize. He had been drinking, he explained. Couldn't they just forget the whole thing? When Williams refused, Clark returned with two white detectives, perhaps hoping to intimidate her; but the ploy backfired, and Ersalene Williams swore out a warrant for Clark's arrest.[2] White male privilege was not so easily curtailed, however. "Later on in the day, two other white men came to my home and offered me money to compromise," Williams reported. "They stated that I would gain nothing because [Clark] would probably [not get more] than 30 days."[3]

The assault on Ersalene Williams typified the sexualized racial violence that had plagued African American women for centuries. Slavery had maintained its grip by abrogating black women's control of their own bodies while simultaneously denying black men both the ability to protect black

women and any other claims to conventional notions of masculinity. The end of slavery had not eradicated these arrangements, and black women too often were forced to rely upon their own efforts for protection and redress of grievances.[4] Tellingly, Durham's traditional black male leadership—perhaps out of class snobbery, but undoubtedly wary of the volatile mixture of race, sex, and violence in the case—remained silent in the wake of the attack on Ersalene Williams. The *Carolina Times*, Durham's black weekly, denounced black men's "lethargy" and "excuses" while praising a small local group of African American women, the Sojourners for Truth and Justice, for rallying behind the unemployed Ersalene Williams.[5] Headed by a Duke Hospital worker and the wife of a local tobacco worker, the left-leaning Sojourners for Truth pointed to a renewed organizational impulse among black women that had emerged during World War II and its aftermath.[6]

It was not the first time that the *Carolina Times*'s fiery editor, Louis Austin, had castigated Durham's black male elite for its timidity. Nor was it the first time that black men recognized women's collective abilities. "If you want anything done, get the women and the children," a local NAACP official had declared two years earlier.[7] Sojourners for Truth itself may have yielded little sway among Bull City power brokers, yet its public support for Ersalene Williams symbolized both the legacy of African American women's community work and the growing importance of black women's organizations in Durham's burgeoning African American freedom movement. Usually invisible to the white public and too often unappreciated within the black community, African American women's wartime activity laid the foundation for the freedom struggle of the 1960s, in which female activists frequently outnumbered men.[8]

World War II and Black Women's Organized Activity

Indeed, during World War II, Durham witnessed an upsurge in black women's organized activity, a response to both the hardships and the opportunities created by the war. Throughout the 1940s and 1950s, African American women increasingly added both their voices and their numbers to the growing demand for black freedom. The experiences of the war, both at home and abroad—and especially the racially motivated murder of a black soldier on a Durham bus in 1944—exacerbated class and ideological divisions among Durham's black leaders. Much of the conflict centered in the local NAACP. The question became which brand of leadership would ascend in the postwar years, the old accommodationist brand exemplified by the traditional black business elite or the new militancy spurred by the exigencies of

war. Although the battle between the old guard and the militants usually did not involve African American women directly, it provided space for women's organizations to join the new black insurgency.[9]

Class and political divisions among Durham's black residents were hardly a new phenomenon, despite the fact that class lines among African Americans were always somewhat permeable.[10] Durham's reputation as a center for the black bourgeoisie reflected the remarkable success of the North Carolina Mutual Life Insurance Company, the largest black financial institution in the world, and the host of African American businesses that grew up around the Mutual. Within the constraints of Jim Crow, Durham's black business elite frequently negotiated behind the scenes with white power brokers on behalf of the larger black community.[11] Embedded in this arrangement was an element of social control; white largesse was offered in exchange for racial peace and quiescence among the black masses.[12]

While significant numbers of African Americans had never been comfortable with this arrangement of quasi-paternalism, World War II both aggravated differences of opinion about race strategy and enhanced black women's organizational base. The war strengthened existing women's groups and spurred the creation of new organizations, though this expansion drew on a historic tradition of black women's community work.[13] "Organized activity" included not only formal organizations but more informal settings—family and community gatherings and even leisure activities—in which women established social and political networks. Black women's group activity throughout the 1940s and 1950s, whether benevolent, social, or overtly political, strengthened personal bonds and provided critical space for the development of a collective identity.[14] As the freedom movement swelled, women's networks furnished a crucial organizational base for mobilizing mass protests.[15]

Black women's organized activity was also class based. Although class lines were somewhat fluid in Durham's black community, the middle class had a more formal style of organizing, especially through voluntary associations. Middle-class women formed the Harriet Tubman branch of the Young Women's Christian Association, a local chapter of the National Council of Negro Women, the LINKS Incorporated, and a branch of the National Housewives League, along with church groups, sororities, literary societies, social clubs, and mothers' clubs.[16]

Notwithstanding these middle-class organizational bastions, an exclusively female organizational base may have been even more pronounced in working-class neighborhoods, where both men and women frequently per-

The North Carolina Mutual Life Insurance Company, established in 1899, was the largest black-owned financial institution in the nation, and it helped give Durham its reputation as the "capital of the black middle class." This was the home office building from 1921 to 1966. (*Courtesy North Carolina State Archives*)

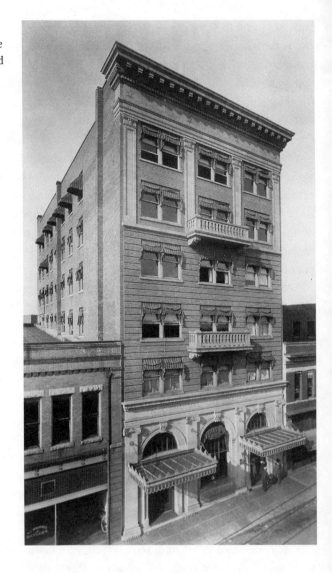

ceived community work as "women's work." For example, black women to-bacco workers in Durham often lived in the same neighborhoods and at-tended the same churches, where they formed a majority of their congrega-tions and led usher boards, missionary circles, and Sunday schools. These networks established a basis for female solidarity and a form of black "sister-hood" within Durham's African American communities.[17] Although women tobacco workers were active in union locals in Durham—even holding lead-ership positions in the early years—they remained ambivalent about the To-bacco Workers International Union (TWIU), an American Federation of La-

bor (AFL) union.[18] Unlike nearby Winston-Salem's less hierarchical CIO tobacco union, where black women were a dominant force, the Durham TWIU remained male dominated and male centered. White male union officials in the national TWIU office were especially patronizing toward black women.[19] But the most decisive factor in black women's ambivalence toward the union was the men's failure to address their concerns. Black women refused to back a 1939 tobacco workers' strike after black male tobacco workers chose to form an alliance with white male workers and then failed to include black women's grievances in the strike demands. The women's complaints were echoed repeatedly by the *Carolina Times*, which accused African American labor leaders of complacency and ineptitude in behalf of their members. Black working-class women were equally dismissive of the "pious attitudes" of middle-class black women at the Tubman Y who tried unsuccessfully to develop programs for women tobacco workers in the 1940s.[20] Despite these difficulties, working-class women organized in neighborhood and church groups and strengthened community bonds at social gathering places including beauty parlors, corner grocery stores, and even drink houses and "piccolo" joints.[21] Such networks in turn formed an important foundation for black community and church support of civil rights protest.

By the 1950s, a wide array of women's organizations in Durham had begun to take organizational memberships in the NAACP. When direct action protest broke out in 1960, the local NAACP had a majority female membership and large numbers of working-class members. In Durham, the NAACP, notably its youth and college chapters, galvanized the new direct action movement.[22] Two decades of women's community activism had laid the foundation. The origins of the 1960s direct action movement, therefore, can be found not simply in the more visible public demonstrations of black discontent or in the activities of black men in labor unions, churches, and the military but also among African American women in neighborhoods, community organizations, and NAACP branches throughout the South during the 1940s and 1950s.[23]

Camp Butner and the Double-V Campaign

The federal government's decision to construct Camp Butner, a 40,000-acre military training facility twelve miles north of Durham, had a dramatic impact on the Bull City.[24] When Butner opened in August 1942 with a population of 35,000—including about 7,500 African Americans—it was like a city within a city. Thousands of young soldiers and their families streamed into the area, intensifying the housing crunch but also providing a boost to the

local economy. Bus routes were set up to transport soldiers between Butner and Durham, and on any given day close to 4,000 soldiers could be found strolling the streets of the city.[25] Durham's black Hayti section, with its entertainment outlets—movie theaters, pool halls, juke joints—and its businesses, attracted many a GI, black and white alike, looking for a good time.[26]

At its height, Hayti (pronounced "hay-tie")—named after the black Caribbean republic, Haiti—boasted over one hundred independent black businesses, schools, restaurants, hotels, and theaters. Many of Durham's African American lawyers, doctors, politicians, and athletes lived or worked in Hayti. As a local historian described the area, "[moonshine liquor], chitterling dinners, high class prostitutes, and crap games rounded out the menu of attractions that extended a warm welcome to plain and not-so-plain folk alike."[27] Hayti also supported a thriving musical tradition and was the center of the Piedmont blues—a genre that differentiated itself from the "sultry music of the Mississippi Delta" by its "enthusiastic foottapping . . . [and] ragtime energy accentuated by the rhythmic rapping of a washboard and punctuated by the whoops and calls of the harmonica."[28] Many of the nation's top blues, jazz, and big band performers were drawn to Hayti, including the "'hottest' women's jazz band of the 1940s," the first all-female, multiracial (but predominantly black) band, the International Sweethearts of Rhythm.[29] One black resident recalled: "The place was jumping because there were clubs and joints of all descriptions everywhere. It turned into a Vegas strip almost. . . . The soldiers made business better in every category, licensed or unlicensed. If you get a bunch of guys that will only be here for a little while, they'll pay double for everything they get, only they want it right now . . . whatever it was from booze to women. The MPs had to patrol all the time, cause it was hairy."[30]

Middle-class black women frequently recoiled at the spectacle of wartime Hayti, championing more wholesome recreation for black servicemen. The Harriet Tubman YWCA took the lead in recruiting volunteers for the black USO and carefully screened local young women to entertain black GIs. There were practical needs to be met as well, and black women eagerly stepped up to the tasks at hand. They set up guesthouses for the families of black soldiers and launched salvage drives for scrap metal. Local teachers such as Mrs. Bessie McLaurin volunteered to teach literacy classes for black soldiers, while another Durham woman directed a Colored Travelers Aid Society in the black section of the local train station. A local Alpha Kappa Alpha sorority sponsored a soldiers' aid project, doing minor sewing repairs, and the Daughters of Dorcas made curtains for the club room at Camp Butner.[31]

As they attended to the needs of African American soldiers and their families, black women in Durham struggled to balance their own family and work pressures. Before the war, over 40 percent of black and white Durham women were employed—among the highest rates in the country. World War II drew even greater numbers of Durham women into the workforce, creating a child care crisis, especially for black women, whose labor force participation always exceeded that of white women.[32] By the end of 1942, the North Carolina Board of Charities and Public Welfare was pointing to the problem of "delinquent Negro girls[, which was] accentuated by the war emergency," and to the lack of "day nurseries and play centers for Negro children . . . because so many Negro mothers work[ed] . . . and [were] away from home for long hours." Meanwhile, black women acted independently to secure federal funds for three child care centers in Durham, although federal assistance fell far short of meeting the need.[33]

Black women eagerly joined in the patriotic fervor on the home front. "Negro Women's Organizations Giving One-Hundred Percent Cooperation in Rationing" boasted one headline in the *Carolina Times*. Mothers' clubs promoted "victory gardens," and the Volkamenia Literary Society frequently devoted meetings to wartime issues such as the "necessity and value" of rationing. Even Durham's DeShazor Beauty School adapted advertisements to reflect the new spirit of national allegiance: "Victory is America's Goal. Keeping our women in the defense program well groomed will help to keep up their morale."[34]

Appeals to black women's patriotism were part of the Double-V campaign, which was premised on the notion that black loyalty entailed the right to basic freedoms. African American women were frequently pictured in the patriotic "V for Victory" formation, but the victory symbol in this context stood for twofold victory: victory abroad against fascism and victory on the home front against racism. One black women's group, the We Will Help Club, adopted the motto "We Aim to Buy Our Share of Freedom," projecting a double message that linked war support to racial equity.[35]

Black women also established a number of lasting organizations in Durham during the 1940s, including the Durham chapters of the National Council of Negro Women, the National Housewives League, and the Jack and Jill Club, all of which soon joined the growing demand for black freedom.[36] The Durham branch of the National Housewives League, made up of women business owners and the wives of small business owners, encouraged black families to patronize black businesses. It also informed women "about bargaining practices of the places at which they deal and the respective estab-

lishments' stand on employing Negroes." Although its members avoided terms like "boycott," the women promoted both black businesses and anti-discrimination policies by appealing to racial solidarity.[37] In 1944, the Durham league waged a selective buying campaign. Under the slogan "Boosting Negro Business and Spending Your Money Where You Can Work with Dignity and Pride," league members canvassed door to door, encouraging Durham blacks to patronize African American businesses and avoid white establishments that practiced racial discrimination.[38]

Black frustration with the old-style accommodationism seemed to spring up everywhere. In an August 1942 column, "*Carolina Times* Readers Speak," several prominent beauticians endorsed legal action to equalize the schools, a clear rupture with the black elite's preference for negotiation over lawsuits.[39] In 1943, African American teachers in Durham pressed for equal pay and framed their demands within the context of the war: equalizing teachers' salaries would boost black morale and patriotism while undermining the "subversive propaganda of our enemies of war," they argued.[40] Initially, the black North Carolina Teachers Association had refused to back the NAACP teachers' salary equalization campaign, partly because teachers feared reprisals if their association with the civil rights organization became known; their refusal was also influenced by the conservative head of the teachers' association, James Shepard. Shepard, who simultaneously served as president of Durham's North Carolina College for Negroes, eschewed legal strategies and "outside" influences such as the NAACP, preferring negotiations between powerful whites and the traditional black leadership.[41]

African American women lent their energies to a wide variety of racial justice efforts. Recognizing the importance of black electoral strength, they joined forces with men to increase the black vote. But even in work with men, women's efforts frequently stood out. In 1942, two young women in the Durham Negro Youth Federation led a door-to-door voter registration drive in the working-class neighborhoods of Walltown and Hickstown on behalf of a black candidate for county commissioner.[42] After the war, the female leadership of the Durham Pearsontown Community Club joined in the statewide NAACP voter registration drive by utilizing its "personal contacts to get as many people as possible to register" and by organizing transportation to get local blacks to the polls. By 1949, Durham blacks could claim a bloc vote, and four years later Rencher Harris became the first African American elected to the Durham City Council. In the mid-1950s, the city was heralded as a model for black registration across the state. By 1960, 68 percent of Durham blacks were registered to vote, a remarkable achievement by any measure.[43]

Other mixed-sex organizations, such as black neighborhood councils in Walltown and the East End, afforded women valuable experience that could be transformed into civil rights activity. The Walltown Community Council formed in 1937 and two years later boasted an all-female leadership. One resident penned a poem, "Walltown Points the Way," that captured the neighborhood's determination to "organize, [a]nd go out and fight for our rights." Walltown even claimed its own "Bronze Mayor," Frizelle Daye, whose wife, Callie Daye, was a beautician and an active community member in her own right. She wrote a column for the *Carolina Times* during the 1940s called "Walltown Notes," headed the local branch of the Housewives League in the late 1940s and the 1950s, and was active in the Durham NAACP, chairing a NAACP membership drive in the early 1960s.[44]

Black Assertion and Mounting Racial Tensions

The growth of black women's organizations and the rising chorus of black demands occurred against a backdrop of heightened racial tensions. Racial conflict was widespread throughout the wartime South, especially in areas with defense plants or military bases. In October 1942, just two months after Camp Butner opened, fifty-nine black southerners convened at the North Carolina College for Negroes in Durham to discuss the crisis. The group issued a statement of demands known as the "Durham Manifesto" that laid the foundation for the creation of the Southern Regional Council, a Southwide interracial organization established two years later.[45] Initially, the *Carolina Times* endorsed the conference and suggested that it should focus on the debate over extension of the Double-V campaign. After the meeting, however, editor Louis Austin dismissed the "so-called southern Negro leaders" for their timidity and exhorted them to "keep their mouths shut and their noses out of what the race should do to secure economic and political freedom."[46]

The upsurge of rumors about notorious "Eleanor Clubs" signaled discontent among black working-class women as well as white anxiety about the new black resolve. Named after the first lady, Eleanor Roosevelt, the clubs allegedly were secret societies created by black domestic workers. Under the motto "Not a Maid in the Kitchen by Christmas," black women reportedly were fomenting a plot to secure jobs in defense plants, obtain "social equality" with whites, and overthrow the U.S. government. One story making the rounds in North Carolina claimed that African American women were using their churches to establish a "blacklist" of white employers. "When a maid quit work she handed the name of her employer to the church group to which she belonged," announced one report. "The name was read from the

pulpit and no person's name who was read could expect to get a maid again."[47] The accusations so outraged Louis Austin that he printed a full-page, signed response to the charges. Suggesting that the rumors were the work of traitorous "fifth columnists," he offered a $100 reward for proof of the existence of any such clubs. But he leveled his sharpest attack at the controversial issue of "social equality," with its implications of "race mixing." Pointing to the various shades and hues among the African American population, Austin boldly asserted that both races clearly had long been "engaging in the highest point of social equality." The fiery editor, whose newspaper supported increased wages for domestic workers, condemned what he saw as the real issue behind the charge: "Social equality is the age-old scarecrow that is always brought out of the attic and dusted off to frighten the weak minded whenever Negroes ask for better wages, better schools and other improvements that will tend to raise their economic standard to the place where they may become respectable citizens instead of liabilities," he fumed. Even C. C. Spaulding, founding president of the North Carolina Mutual Life Insurance Company, dismissed the Eleanor Club rumors. "The best way to improve the domestic servant problem is to pay a living wage," the black insurance company executive averred.[48]

If black women domestics did not organize secret Eleanor Clubs, they did organize. A group of Durham household workers formed the Senior Industrial Club at the Harriet Tubman YWCA, hoping to improve their working conditions. While private domestic service remained the single largest occupation among African American women in Durham until 1970, black women there, as elsewhere, preferred almost any kind of work to domestic service, including jobs in the hot, musty tobacco factories, where layoffs were a constant threat.[49] Mary Mebane, who sought her first job in a Durham tobacco plant in the late 1940s, recalled the white manager who "smiled in satisfaction to behold 'the sea of black women struggling forward, trying to get a job in his factory.'"[50] Thus, Eleanor Club rumors reflected not simply concern over the shortage of black domestics but, more importantly, white anxiety over black women's refusal to assume proper racial deference.

No doubt, racial deference was in the forefront of North Carolina governor J. Melville Broughton's mind when he presided over the 1943 Wilmington launching ceremony of the *John Merrick*, a battleship named after one of the black founders of Durham's North Carolina Mutual Life Insurance Company. Standing at the site of the 1898 Wilmington race riot, North Carolina's worst racial pogrom, in which white Democrats had violently ousted African American officeholders and murdered scores of local blacks, Broughton ap-

plauded the state's racial harmony. But the governor also criticized "certain inflammatory newspapers" and individuals who were using the war to push for integration, "which if carried to their ultimate conclusion would result in a mongrel race." As if to underline the fate that would befall these "radical agitators," Governor Broughton evoked the memory of the Wilmington massacre forty-five years earlier, "when blood flowed freely in the streets of this city, feelings ran riot and elemental emotions and bitterness were stirred."[51]

Allusions to Wilmington were plentiful on both sides of the color line. Louis Austin's brazen taunts about "social equality" and "race mixing" in response to the Eleanor Club rumors were remarkably similar to the black newspaper editorial that presumably ignited the 1898 Wilmington massacre. On the other side of the racial divide, the decision to name the ship after John Merrick signaled white resistance to black demands; after the Wilmington riot, John Merrick, in true Booker T. Washington fashion, had urged blacks to shun voting rights in favor of self-help and economic development. By World War II, however, African Americans had grown impatient with the conciliatory methods of the old-line black establishment represented by Merrick, C. C. Spaulding, and NCC president James Shepard. In a scathing *Carolina Times* editorial entitled "Threads of Nazism," Louis Austin lambasted the governor's speech, claiming it "would do Hitler justice."[52] Such brashness prompted apologies to the governor from Spaulding and Shepard, both of whom concurred with the governor's insistence that North Carolina enjoyed the best racial harmony in the South and assured him that Louis Austin's "radical editorials" belonged in the "waste basket."[53]

Conservative blacks might have reassured the governor, but they could not quell daily battles over public space, particularly transportation, in which black women challenged Jim Crow practices. Interracial strife on Durham buses was not strictly a wartime phenomenon, but by World War II both the frequency and the volatility of such disputes had increased.[54] In 1943, sixteen-year-old Doris Lyon refused to move to the back of a Durham bus and was assaulted by a white plainclothes policeman. Although Lyon reportedly struck the officer after he forcibly removed her from her seat, several "prominent white women" appeared in court to affirm the young woman's "unimpeachable character." The black leadership rallied around her as well, but the court found Lyon guilty of assault and battery and fined her for breaking North Carolina's segregation law, while no action was brought against the police officer.[55]

Racial discord on city buses was so severe that the chairman of the state utilities commission complained to Governor Broughton, "Durham is one of

the worst places we have, due to the large negro population, and further to the fact that there are a great many Northern negro soldiers at Camp Butner and also Northern white officers who do not believe in our segregation laws and encourage the negro soldiers to violate them." He also reported that "it was utterly impossible" for bus drivers and the Durham police "to enforce the segregation laws": "We have already had some open trouble there and I apprehend that we will have more. It is a bad situation."[56]

While most southern blacks believed that direct action against segregation would only provoke white violence, a growing number of African Americans began to reject segregation. Blacks increasingly protested racial discrimination—including segregation—on the job, on buses, and in defense classes. Individual acts of defiance often took place in public, contested spaces where even unsuccessful challenges helped to forge a collective, oppositional consciousness that in turn created the preconditions for more organized protest.[57] Doris Lyon may not have set out intentionally to eliminate bus segregation in Jim Crow Durham, yet she was caught up in an atmosphere of growing racial hostility that had worsened as a result of the war.[58] Racial animosity could easily explode into violent confrontations. In 1943, the peak of wartime racial violence, a riot erupted in Hayti after an altercation between a black soldier and a white Alcohol Beverage Commission official, and several thousand troops from nearby Camp Butner were required to quell the disturbance.[59]

The Murder of Pfc. Booker T. Spicely

Interracial tensions, as well as broader class and gender divisions among Durham blacks, reached a crescendo the following year after a white driver shot and killed a uniformed African American soldier on a city bus. The murder of the black soldier, Pfc. Booker T. Spicely, sharpened the discord between proponents of the more conservative, accommodationist black politics of an earlier era and the new, more militant protest politics.[60] Indeed, the crisis surrounding the Spicely shooting provides a window into the internal dynamics of Durham's black community and the forces that shaped the modern black freedom movement. Although men were the most visible players in the events that transpired, the controversy also opened new avenues for black women's organizational skills to emerge.

The trouble began after a white bus driver ordered Booker T. Spicely, a twenty-nine-year-old assistant business manager from Alabama's Tuskegee Institute, to move to the rear of the bus. Ironically, that same day, the secretary of war had ordered an end to racial segregation in vehicles owned or op-

erated by the government, "regardless of civilian custom."[61] The uniformed soldier questioned why he had to relinquish his seat. "I thought I was fighting this war for democracy," he complained. As he moved reluctantly toward the rear, Spicely let loose a comment about the driver's lack of military service. "If you weren't 4-F, you wouldn't be driving this bus," he muttered. The young soldier's public disavowal of Jim Crow seating was risky in itself, but Spicely's more egregious breach of southern racial etiquette may have been his challenge to the driver's patriotism and manhood.[62] Perhaps realizing his perilous position, the soldier tried to make amends by loudly apologizing before disembarking. But the damage had been done. The driver, Herman Council, a thirty-six-year-old white southerner with little education and a penchant for the whiskey bottle, leapt from the bus with his .38 caliber pistol drawn and fired two shots at close range into the unarmed soldier's chest. By the time police got Spicely to the hospital, he was dead.[63]

As the prosecution prepared for trial, Durham blacks were divided over whether to seek the assistance of the NAACP. Black conservatives such as C. C. Spaulding and James Shepard insisted that the ability to procure a conviction would be hindered by the presence of "outsiders" (a not-so-subtle allusion to NAACP attorneys from the national office) and that a white attorney alone would have a better chance of convicting a white driver in a southern courtroom.[64] The black elite carried the day and lost the case. Two months after Spicely was killed, an all-white jury deliberated only twenty-eight minutes before acquitting Herman Council. An overflow crowd, half black and half white, heard the verdict "with studied silence."[65]

The silence was misleading. Only two hours after the shooting, one of the worst fires in the city's history had roared through the white-owned warehouse district in downtown Durham. "Mammoth clouds of smoke and flames jumped hundreds of feet into the air and the heat could be felt two blocks away," reported the Durham daily. Thousands gathered "to watch the destructive flames eat their way through the entire block." It took 3,000 servicemen from nearby Camp Butner to extinguish the flames, leaving behind "a vast spread of utter destruction." All that night and the next day, cars crawled by the wreckage bumper to bumper, "staring morbidly at the still smoking ruins . . . and the bare skeletons of horses and cows which lay under the open sky." Authorities estimated damages at close to half a million dollars.[66] No one was ever arrested or convicted for what many believed was an act of arson—perhaps the black community's advance retribution against a criminal justice system that too often demonstrated a callous disregard for African American life.

The Spicely shooting was not unlike other racial confrontations that occurred during World War II, particularly in the South. Just a year earlier, nearly 250 incidents were recorded—many at or near military bases—that culminated in the 1943 Detroit race riot, the bloodiest conflagration of the war.[67] The War Department and the FBI launched their own investigations of the Spicely murder, indicating the threat such violence posed to the war effort. The NAACP's *Crisis* warned that blacks were so outraged by the mistreatment of African American soldiers and the inaction of the Democrats that the Durham shooting might cost President Roosevelt the upcoming election.[68]

On the local level, the Spicely affair inflamed already tense race relations in the Bull City. In the immediate aftermath of the shooting, white bus drivers refused to go into black neighborhoods amid rumors that African American soldiers were threatening to shoot white drivers. Six months after the murder, visiting staff from the national YWCA office noted that whites still were uneasy. Indeed, a new spirit of black defiance could be seen in the stickers placed all over town that read simply "Remember." Louis Austin recalled the angry resolve of many in the black community. "[Council] was freed," he said, but "that was the last one."[69]

This defiance was directed not only at white supremacists but also at the black elite. At least some of Durham's black leaders seemed impervious to the broader implications of the Spicely affair. Three days after the shooting, as smoke still curled from the fire's embers in downtown Durham, NCC president James Shepard assured participants at a conference on race relations, "Cooperation between the races in North Carolina is one of the things of which we are proud in this state." However, Louis Austin and Rencher Harris, a local black businessman, articulated a different view when they criticized the small number of whites in attendance and suggested that "sheriffs, chiefs of police, members of grand juries, . . . and *bus drivers* . . . were perhaps in greater need of such information."[70]

The murder also intensified political tensions within the NAACP, both locally and nationally. The Durham NAACP, which formed in 1917 with twenty-five members, had remained relatively small and largely under the influence of the Mutual. In the mid-1930s, the civil rights group enjoyed a brief resurgence and a female majority, due largely to the NAACP's teacher salary equalization campaign; the membership expansion also demonstrated how legal actions could mobilize local people. By the start of World War II, however, the organization had fallen back into the hands of the insurance execu-

tives and was practically moribund.[71] During the Spicely case, an attorney from the national office echoed the complaints of several local blacks: "The [Durham] branch hasn't done anything because the president works for the [North Carolina Mutual Life] Insurance Company and therefore his hands are tied."[72]

National NAACP officials were not surprised by the timidity of Durham's black elite in the Spicely case. Citing obstructions from Durham blacks— particularly Spaulding and Shepard—that had sabotaged the 1933 Hocutt case at the University of North Carolina, an early NAACP effort to deseg- regate graduate education, NAACP attorney Thurgood Marshall castigated "certain Negroes" and "certain Negro groups in North Carolina who believe the only way to handle the problem is to handle it in North Carolina 'without outside influence.'" "One of these days," he said, "North Carolina will realize that none of us can handle our problems alone."[73]

Thurgood Marshall had reason to be concerned. Not only had the war un- leashed a new militancy among blacks, but it also seemed to revive the old conservatism of influential leaders such as C. C. Spaulding. After the Hocutt fiasco, Spaulding shifted gears and utilized the vast network of the Mutual to help organize the NAACP throughout the state. In 1935, Spaulding joined with Louis Austin to create the Durham Committee on Negro Affairs (DCNA), whose motto was "A voteless people is a hopeless people." The DCNA soon became the South's most effective black political machine. But during the war, Spaulding displayed his tendency to exaggerate racial harmony at the expense of legitimate black grievances. Following the 1943 Detroit riot, he released a public statement blaming the disturbance on "un-American agi- tators bent on destroying racial harmony" and decrying "unfounded, false, inflammatory rumors calculated to disrupt the balance of harmony among us."[74]

Arline Young, Ella Baker, and the Durham NAACP

While the Spicely case aggravated class and ideological strains among Durham's black male leadership, it also offered unexpected opportunities for grassroots organizing efforts, particularly among local black women. Within days of the bus driver's acquittal, the Carolina Times called a citywide public meeting of local blacks. In a daring move, the insurgents elected a new slate of NAACP branch officers, including Louis Austin as president and Rencher Harris as treasurer.[75] A local minister and postal worker became vice presi- dent, and R. Arline Young, head of the biology department at Shaw University

in Raleigh, was elected secretary.[76] In commemoration of the slain soldier, the group hoped to rename its reorganized branch the "Booker T. Spicely Durham Branch."[77]

Two African American women, local branch secretary R. Arline Young and Ella Baker, national director of NAACP branches, were key players in the effort to revitalize the Durham branch.[78] Although local branches often chafed under constraints imposed by the national office, in a reverse move Arline Young appealed to the New York office, specifically to Ella Baker, for support.[79] "I want detailed information, history, techniques of organization where lethargy is paramount and leadership adverse," Young implored. Baker, who had helped reestablish the state NAACP conference the year before, concurred that Durham's traditional black leadership constituted a "challenge to those of us who are interested in the progress of the N.A.A.C.P." Always more interested in supporting effective programs than in entering leadership disputes, Baker suggested that "an active program throughout the state [would] be the best means of convincing the Durham community of the value of the Association." By December, the newly organized branch boasted 197 new members. Although it fell far short of Arline Young's lofty goal of "6,000 NAACP members and as many voting in November," the branch had attracted a much more diverse constituency in terms of class, undoubtedly due to the local tobacco union president, who led the membership campaign.[80]

The revolt was more a palace coup than a popular rebellion, but there were clear differences between the old and new regimes. Arline Young and her fellow officers hoped to infuse the branch with new energy and more radical politics. Vowing to "do everything I can to arouse them to an active consciousness of their ability and responsibility," Young pledged to inspire the adults and to organize a "strong Youth Council." In November, the Durham branch sponsored the visit of a Fair Employment Practices Committee official who exhorted a mass meeting and several local unions to support the Double-V campaign and to "fight for [racial] justice and liberty now." Black anger following the Spicely verdict seemed to instill a new determination within the local NAACP. Whether in tribute to Spicely's memory or in defiance of the jury's verdict, Arline Young asked Ella Baker for "the procedure for investigating and protesting the segregation on travel vehicles in this state." The Durham radicals faced an uphill struggle, however, not only against white power brokers but against the local black elite. Aware of the challenge before her, Arline Young ended her note to Ella Baker: "We will need all your help and guidance."[81]

Postwar Struggles

Despite the success of the more radical "new crowd" within the Durham NAACP, the branch had to swim upstream against the entrenched black leadership in the city. By 1945, Durham's NAACP had only 285 members. Some of the problems were self-inflicted. Roy Trice, head of the TWIU Local 208 and part of the new NAACP leadership, failed to conduct the NAACP membership drive in 1945, hence missing an opportunity to attract a larger working-class constituency to the Durham branch. Two years later, however, under the presidency of Rencher Harris, branch membership peaked at just under 1,000, a level unmatched until the sit-in movement of 1960 once again swelled NAACP ranks. But by 1949, membership had dropped so much that the Durham chapter risked losing its charter, leading Kelly Alexander, head of the North Carolina State Conference of NAACP Branches, to complain that "a certain faction in [Durham] does not want the NAACP to get a strong branch organized," a less-than-subtle allusion to Durham's black business elite.[82]

Perhaps weary of the struggle within the local NAACP, Arline Young turned to the Tobacco Workers International Union, hoping the union might become a vehicle for racial and economic justice. In 1945, the TWIU national president and vice president urged her to abandon her teaching position at Shaw University to work full time organizing black tobacco workers throughout North Carolina.[83] Young recruited tobacco workers at several Durham factories, where she pushed voter registration as well as union membership. Often meeting with workers in their homes, Young reported that black women seemed more receptive to the union than the men. But most of the workers were cautious, and some expressed outright fear. Although it was difficult to prove overt employer intimidation, Central Leaf in Durham resorted to typical antiunion practices, simultaneously raising workers' wages and threatening to close the factory should the union prevail. Indeed, rising antilabor sentiment, sanctioned on the national level by the Taft-Hartley Act, made unionizing efforts increasingly difficult, particularly in the South. Despite its "progressive" image, North Carolina was one of the first states to jump aboard the antiunion "right-to-work" movement, giving the state the distinction of having the lowest rate of unionization in the nation by the late 1940s.[84]

A grueling schedule and the strain of her work—including competition from the CIO, the refusal of several local churches to grant her meeting space, and postwar layoffs in the tobacco industry—took a toll on Arline Young. Usually traveling alone, the feisty organizer rode buses throughout

eastern North Carolina and the Piedmont, often catching rides before dawn. Although she remained committed to the workers, who asked for "Miss Young" personally, she complained that riding "much of the night and day" in the "back seats of buses" left her with a "constant headache." Her appeals to the national office for another organizer to ease the strain, however, were rejected.

To add insult to injury, Young experienced firsthand the pain of Jim Crow humiliation. On July 5, 1946, the weary organizer boarded a 6:30 A.M. bus for Rocky Mount and took a seat in the first row of the "colored" section. As the sun rose over Carolina's brightleaf tobacco fields, she perused two magazines for information on the CIO and the AFL southern organizing drives. Thirty-five miles into the trip, the driver ordered Young to the rear of the bus. She refused to move and was arrested. Initially, the union organizer was charged with disorderly conduct and resisting arrest, but the charges later were changed to breaking the state's bus segregation laws.[85]

Young found the national TWIU even more difficult to work with than the Durham NAACP. She chafed under the antidemocratic union bureaucracy and what she called the "perverse surveillance" by the national office. A year after joining the union, Young journeyed to Washington, D.C., to discuss these problems, but AFL officials assured her that the federation "practiced democratic principles." Several months later, however, national TWIU leaders fired Young for failing to submit her weekly reports in a timely fashion. They quickly reinstated her after the office was inundated with protests from North Carolina tobacco workers. Even TWIU national president John O'Hare acknowledged Young's effectiveness as an organizer while simultaneously adding financial mismanagement to the charges against her. Although a Durham attorney and the president of one of the Durham tobacco locals both vouched for Young, she was permanently terminated from the TWIU in the spring of 1947. In a final irony, Young was denied two other jobs over the next nine months—apparently blacklisted for her union activity.[86]

NAACP Youth

Despite Arline Young's problems with the TWIU and the adult NAACP branch, she remained a radicalizing force among Durham youth, who showed signs of increased militancy in Durham and throughout the South in the postwar years. As national NAACP youth secretary Ruby Hurley observed, "Young people's organizations are in some instances taking the lead in working toward the solution of the race problem in the South."[87] Even some old-guard, conservative black leaders such as James Shepard seemed to recognize

that a new day was at hand. Arline Young and Ruby Hurley were "shocked" when the president of the North Carolina College for Negroes offered "no objections" to their request to organize a NAACP college chapter on the NCC campus.[88] Visiting dormitories and standing on sidewalks "until the ice was broken," Young's "untiring" and "courageous" efforts proved instrumental in reviving the college chapter. One student leader hailed Arline Young's leadership, describing her as "a real fighter and worker" who had "made many personal sacrifices in the interest of the N.A.A.C.P." Young's "fighting spirit" was also indispensable in establishing a statewide NAACP youth council.[89]

Durham students, including a growing number of young women, pressed the issue of racial integration in the postwar years, even when adults seemed reluctant to do so. One NCC student wrote to the NAACP national office offering to challenge the "separate but equal" status of the segregated NCC law school. Other students protested the law school's unequal facilities by organizing a picket at the state capitol in 1949. But some adults were ready for bolder action. A group of Durham blacks filed a lawsuit against unequal public schools on behalf of sixty students, signaling a departure from the Spaulding-Shepard style of quiet, behind-the-scenes negotiations.[90] The following year, a combined state and national NAACP legal team challenged North Carolina's segregated schools in the first collective effort by six NCC students to apply to the law school at the University of North Carolina at Chapel Hill (UNC-CH). One of the plaintiffs, Floyd McKissick, a World War II veteran and native of Asheville, North Carolina, who came to Durham in the late 1940s, recalled that "there was a feeling in the air that people were going to be fair and treat you right. You were a returning veteran, and . . . there was a feeling that North Carolina would do some of those things without being forced to do it." McKissick's optimism proved premature. Resistance came not only from whites but from local black leaders as well, including the new NCC president, Alphonso Elder. Denounced as a "misleader of his people" by the Carolina Times, Elder (who assumed the presidency after James Shepard's death in the late 1940s) undermined the NAACP lawsuit by publicly announcing that NCC offered legal training equal to any in the nation.[91]

Although membership in the NCC NAACP chapter, like the city branch, ebbed and flowed in the decade following World War II, Arline Young's work with Durham youth laid an important foundation that was built upon by Floyd McKissick. After successfully challenging segregation policies at the UNC-CH law school in 1951, he began practicing law with Hugh Thompson, one of the local NAACP attorneys in the Spicely case. Like Arline Young

and Louis Austin, McKissick also had radical roots. A member of the NAACP since age twelve, McKissick had protested Asheville's refusal to allow Paul Robeson to appear in the 1930s and had participated in the 1947 Journey of Reconciliation, an early freedom ride challenging segregation in interstate transportation. Later, he served as an officer of the Progressive Party at Morehouse College and was active in Henry Wallace's 1948 presidential campaign.[92]

In the 1950s, McKissick revived NAACP youth councils in Durham, attracting large numbers of young women, particularly in working-class sections such as Walltown, Hickstown, and the East End. By the middle of the decade, North Carolina boasted forty-five youth councils and college chapters, making it fifth in the nation in NAACP youth membership.[93] These youth groups would soon lead the black freedom struggle throughout the state, breaking new ground and charting new directions while also maintaining links to earlier protest traditions. During the 1950s, female students often held leadership positions, particularly in the college chapter and within the statewide NAACP youth division. In the early part of the decade, the NCC branch even boasted a majority female membership. Once direct action erupted in the 1960s, however, males often replaced females in formal leadership roles, possibly because the organization was receiving wider public attention.[94] In the city branch, adult women were more prominent in NAACP entertainment and fund-raising committees as well as in youth work and membership campaigns, which may help to explain women's numerical predominance.[95] Indeed, as the citywide NAACP grew, it attracted greater numbers of black women, boasting a female majority by 1960.[96]

Community Work, Leisure Activity, and Racial Protest

Women in Durham followed the pattern of black female activism across the South. During the 1940s and 1950s, an ever-increasing number of African American women's groups—occupational associations, social clubs, neighborhood groups, charity organizations, and church groups—were meeting throughout the black sections of the city. The *Carolina Times*'s society pages featured traditional black women's organizations such as the YWCA, the LINKS, the Lincoln Hospital Women's Auxiliary Club, and sororities, but the paper also included news about a varied assortment of women's groups, including the Cosmetology Club, the Merry Wives, the Model Mothers Club, the Friendly Circle Club of St. Joseph's African Methodist Episcopal (AME) Church, the Pearsontown Needle Craft Club, and the West End Jolly Sisters, to name just a few. Low-income women, too, found it useful to join forces,

organizing the 6W McDougald Terrace Club, a tenant association, in the city's first black public housing project.

While political protest was not the primary purpose of many or even most of these groups, African American women in Durham, as elsewhere, saw no need to separate their community work—or even their social and leisure activities—from racial justice work.[97] For example, beauty shops fostered an "invisible" network of grassroots supporters for black demands. Beauty workers—who dominated the Durham Housewives League—constituted the single largest occupation among black business owners in Durham, boasting forty-three shops, or about 19 percent of all African American businesses, by the 1950s.[98] Not only did beauty culture offer an alternative to household employment and factory work for black women, it also provided economic independence and autonomy that many eagerly utilized to press for racial progress.[99] Because black beauty parlors were owned and operated by black women and their clientele was African American, the shops constituted "free spaces," or "safe spaces," in black communities. As independent arenas unfettered by white economic or political control, beauty parlors functioned as autonomous social spaces for local women, becoming potential bases for black protest. Beauticians frequently served as confidantes, sharing the personal stories and problems of their patrons. Such intimacies laid the groundwork for political mobilization. One local beautician noted the special influence beauty workers had over their patrons: "We supported every effort to free our people. We have taken advantage of the time that only a beautician has."[100] Beauty shops also operated as communication centers free from white surveillance. Mrs. Cora Macleod, a Durham beautician and member of the Cosmetology Club, remembered that the NAACP often visited her shop during the 1950s and 1960s with flyers that urged people to become involved in civil rights activity.[101] Rev. Wyatt T. Walker, a chief advisor to Martin Luther King Jr., noted that after the church, barber shops and beauty parlors were the "second-best means of communication" in the black community.[102] Mrs. Joyce Thorpe, who graduated from DeShazor Beauty School in 1959, recalled that black-owned corner grocery stores were even more important than beauty parlors in spreading information about Durham's protest activities. But she also acknowledged that women would "go in the beauty parlors and talk about what happened, and what they thought about it[,] but [would] not actually do anything." Thus, beauty shops served as semipublic yet protected spaces where black women could openly explore attitudes and feelings about current events and in the process cement both personal ties and commitment to Durham's freedom movement.[103]

Durham beauticians responded as individuals, but they also acted collectively through their professional organization, the National Beauty Culturists League, as well as in local cosmetology clubs and alumnae chapters of DeShazor Beauty School. Sensitive to the beautician's special obligation to black women and the wider black community, the league appointed a legislative committee in the 1930s to advocate for "domestic, office and factory workers and those persons in the lower wage brackets."[104] North Carolina beauticians were well aware of this legacy. At an annual league convention, noted North Carolina educator Charlotte Hawkins Brown highlighted the accomplishments of millionaire Madame C. J. Walker, the nation's most famous beautician, who had pioneered black women's health and beauty aids while also advancing racial uplift and black civil rights. By the 1950s, black beauticians across the state included the NAACP in their organization's budget. At the 1955 National Beauty Culturists League convention, they called for "economic security" and "political action" under the banner "Beauticians United for New Responsibilities." Two years later, the organization featured Martin Luther King Jr. as keynote speaker at its annual gathering, while league president Mrs. Katie Wickham, the first elected woman officer in King's Southern Christian Leadership Conference (SCLC), urged her colleagues to promote voting rights and political participation among their students, clientele, and family members.[105]

Durham's most prominent beauty college, the DeShazor Beauty School, was probably even more important than the beauty parlors in advocating black freedom. In April 1957, the school's Durham alumnae association won the NAACP trophy for enrolling the largest number of new members in the local branch. The school even formed its own NAACP chapter, and the chapter's president, Nancy Grady, became one of the leaders of Durham's student movement in 1960. Perhaps it was no coincidence that the commencement address at the school's 1957 graduation ceremony was delivered by Rev. Douglas Moore, the man who would lead Durham's first major sit-in at the Royal Ice Cream Parlor a month later.[106]

Along with beauty parlors, drink houses (sometimes referred to as gin houses or juke joints) run by women also comprised critical free spaces for Durham blacks. Juke joints were major gathering places outside of the church for low-income residents of Durham, and most black (and white) working-class neighborhoods could boast at least one drink house. According to one account, "bootleggers flourished." "'Blind tigers,' or retail outlets, were scattered throughout the city, and deliveries were made to the home, or elsewhere, on call." Several juke joints were owned by notorious

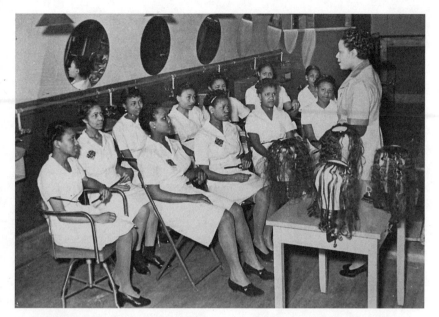

A 1950s classroom scene at DeShazor Beauty School. African American beauticians played an important if often unrecognized role in Durham's black freedom movement. *(Courtesy Durham Historic Photographic Archives, Durham County Library)*

bootleggers and gangsters, men who elicited fear but also a grudging respect from local residents. Patrons often felt safer in the women-run drink houses that operated apart from this male-dominated outlaw world. Women operated both the Shady Rest and Minnie Hester's Place, both well-known drink houses that were popular in Durham during the 1940s and 1950s. Minnie Hester, who is widely believed to have inspired Cab Calloway's song "Minnie the Moocher," catered to an older crowd, but several generations of NCC students also frequented her place from the 1930s to the 1970s. Her establishment served a cross section of Durham's African American community; middle-class, low-income, and even elite blacks would congregate after hours, not just for a drink and some music, but also because Minnie put out one of the best spreads in black Durham.[107]

It is important not to romanticize drink houses or overemphasize the protest potential of leisure activity. As a former civil rights and antipoverty activist remarked, such places were also home to well-known alcoholics who were living testimonies to the debilitating effects of racism, poverty, and broken dreams. Still, juke joints and other working-class leisure settings remained relatively free from white influence, and, as historian Robin Kelley has observed, "the form and content of such leisure activities were unmistak-

ably collective." Durham residents frequently viewed women drink house proprietors as neighborhood leaders, and community organizers discovered that the support of these informal leaders was crucial to any organizing campaign.[108] Such social spaces, particularly gendered spaces where women predominated, shaped a distinctive working-class oppositional culture that in turn could be utilized for collective forms of protest.[109]

Thus, we may need to reconceptualize our understanding of day-to-day resistance among marginalized groups by examining more carefully the ways in which class and gender shaped black discontent. That black women drink house operators, more often than male proprietors, were respected as unofficial community leaders reminds us that conventional notions of leadership and politics can blind scholars to the ways that collective discontent is nurtured and sustained, sometimes congealing into more overt contestations of established power and authority. Similarly, debates about intentionality and working-class consciousness often obscure how certain behaviors may be transformative even in the absence of explicit political motives. As Kelley points out, protest is not merely the outward manifestation of "a preexisting oppositional consciousness." Rather, the relationship is dialectical: collective activities, including protest, also shape working-class consciousness.[110] Visiting a drink house, even when the presumed purpose was to "get trashed" on a Saturday night, also meant engaging in deliberately illegal activity, since Durham remained a dry town until the late 1970s. Precisely because drink houses operated outside the law, their existence depended on the collective cooperation of members of the black community who were complicit in maintaining secrecy about their operations and whose patronage enabled the establishments to survive.

It may be a mistake, therefore, to draw overly rigid distinctions between black women's community work, leisure activities, and civil rights work. Similarly, it is equally misleading to focus solely on formal male leadership and ignore the organizational activities and informal leadership functions of black women. Even social spaces that seemingly had nonpolitical aims supported demands for racial equality.[111] During the 1950s, for example, the Jack and Jill Club collected clothing for needy children in Haiti and organized social activities for black students who had recently desegregated white schools, while local beauticians participated in NAACP membership drives. The Daughters of Dorcas collected garments and sewing materials for a women's sewing class in Johannesburg, South Africa, and supported Durham NAACP Freedom Fund drives. The Year Round Garden Club joined the NAACP, and the Little Slam Bridge Club gave both "financial and moral sup-

port" to NAACP membership drives.[112] Clearly, such women were engaged in far more than simply planting flowers, doing hair, serving drinks, and playing cards.

In Jim Crow Durham, black independent free spaces—whether political in the more traditional sense, religious, civic, or social—provided a bridge to the more overt, collective protest of the late 1950s and 1960s. Frequently, these spaces were also gendered arenas where women developed skills and an oppositional consciousness that both propelled and was transformed by the modern black freedom movement. As we will see, the links often were generational; younger women inherited a historic tradition of community work and racial uplift from their mothers, teachers, and neighborhood women. But the women who came of age in the postwar climate of heightened expectations and failed promises converted the black female tradition of service and collective purpose into organized revolt. Perhaps it should come as no surprise that the Black Solidarity Committee—which launched a seven-month boycott of white Durham merchants in 1968—included only two women on its executive committee, Housewives League member Hazeline Wilson and longtime Walltown activist Belle Bradshaw. The connection between women's organized activity and the black freedom movement of the 1960s thus challenges conventional notions regarding women's presumed quiescence in the postwar years and collapses rigid distinctions between women's voluntarism, leisure activity, and political protest.

In the late 1950s, Ella Baker urged the leadership of the Southern Christian Leadership Conference to utilize black women's organizations in the burgeoning African American freedom struggle. In particular, Baker thought that women's groups should take the lead in the Crusade for Citizenship campaign, a Southwide SCLC voter registration drive that, in North Carolina, targeted Durham as one of six cities for attention. The male ministers who led Martin Luther King's SCLC ignored Baker's suggestions.[113] Like the SCLC, NAACP leaders in North Carolina also disregarded one of their most vital assets—African American women. What Ella Baker understood and what historians are beginning to grasp, however, was that a specifically black female infrastructure was already present *prior* to the emergence of the direct action phase of the civil rights movement. More importantly, this organizational base would be mobilized to promote African American equality—whether the men recognized it or not.

World War II had a major influence on black women's associational life in

Durham and throughout the South. The exigencies of wartime both strengthened existing groups and spurred the establishment of new black women's organizations. Throughout the 1940s and 1950s, African American women solidified their organizational base and increasingly added both their voices and their numbers to the growing demand for black freedom. The war, and especially the Spicely murder, also exacerbated class and ideological divisions among Durham's black leaders. Much of the conflict centered in the local NAACP and on the question of which brand of black leadership would ascend in the postwar years, the old accommodationist brand exemplified by C. C. Spaulding and James Shepard or the new militancy of Louis Austin and Arline Young.[114] Though the new spirit of African American assertion was short-lived, the changes unleashed by the war planted new seeds of black insurgency. This conflict involved several women—Arline Young on the local level and Ella Baker and Ruby Hurley on the national level. Although women were not the most visible players in the formal leadership struggle, the rift inadvertently created more space for women, especially women's organizations, to participate in the developing freedom movement. The struggle between a male-dominated accommodationist politics and a female-inflected militancy continued to plague Durham's protest movement in later years. But the challenge brought by the "new crowd" during World War II laid the foundation for the direct action protests that emerged in the late 1950s and the 1960s. World War II, more than any other influence, sparked the formation of a distinctively black female organizational base and provided the experiences that propelled women into a movement that would change irrevocably not only their lives but the life of a nation.

A Few Still, Small Voices

Black Freedom and White

Allies in the Doldrums

"We want Thurmond!" bellowed a handful of white heck-
lers determined to disrupt Progressive Party presiden-
tial candidate Henry Wallace's appearance before a Durham crowd of 1,500
to 2,000 supporters, evenly divided between blacks and whites. The crowd
was part of a post–World War II progressive alliance that promised to bring
real democracy to the South, a message that seemed to provoke more racial
animosity than racial reconciliation: the hecklers' chant was a reference to
Dixiecrat candidate Strom Thurmond, the South Carolina segregationist who
had bolted from the Democratic Party in protest over the adoption of a civil
rights plank at the 1948 national convention. Despite the tumult, Wallace
remained undeterred. The former U.S. vice president and secretary of com-
merce abandoned his prepared remarks to shout down the interlopers. "I
will not be intimidated. A small group of demonstrators cannot down the
Progressive Party," Wallace thundered. Just moments before, a race riot had
been narrowly averted when twenty young white men, incensed by Wallace's
insistence on speaking only before racially integrated audiences, marched
down the center aisle of the hall carrying inflammatory posters that read
"Wallace, Alligator Bait" and "Send Wallace Back to Russia." Outside the
hall, picketers denounced Mary Price, the white North Carolina native run-
ning for governor on the statewide Progressive Party ticket. In the melee
that erupted, a student was stabbed before Durham police and the national
guard intervened. According to one report, "several persons lay cold upon
the floor" when the scuffle ended. "The picket signs were torn to bits and
the 'rebels' were pushed out" the door while folk singer Pete Seeger led the
crowd in campaign songs.[1]

Henry Wallace was able to appear only after a National Guardsman with a
drawn .45 caliber pistol escorted him through a side door. But the continued

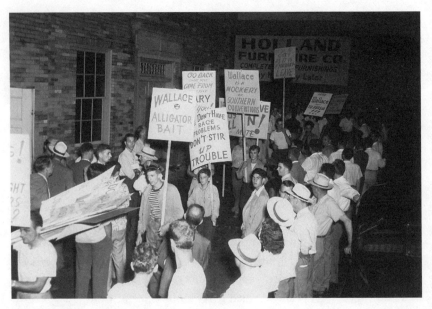

White hecklers stormed the Durham armory in protest over Progressive Party presidential candidate Henry Wallace's insistence on speaking only before racially integrated audiences. Wallace had to be escorted to the stage by an armed National Guardsman, and the candidate's 1948 campaign tour provoked similar outbursts throughout the region. (Raleigh News and Observer, 29 August 1948; courtesy North Carolina State Archives)

heckling, several loud blasts that sounded like gunfire but turned out to be firecrackers, and banging against the bolted door by the ousted picketers led to near panic throughout the hall. "The police were not handling the ugliness in the crowd," recalled Mike Ross, an experienced labor organizer. "We didn't know if we could get [Wallace] out alive. It was that bad." Denied lodging in Durham's Washington Duke Hotel, the beleaguered candidate and his interracial staff found refuge at the home of Maude and George Logan, local black proprietors and Progressive Party activists, and with *Carolina Times* editor Louis Austin. It was an inauspicious beginning to Henry Wallace's North Carolina tour, which met with similar hostility and red-baiting across the state. Nor did it augur well for North Carolina's Progressive Party and its interracial ticket, which included not only Mary Price, the white head of the state's branch of the Southern Conference for Human Welfare (SCHW), but black Durham attorney Conrad Pearson, who was running for attorney general.[2]

Six years later, in the immediate aftermath of the 1954 *Brown v. Board of Education* Supreme Court decision outlawing school segregation, Pauli Mur-

ray, an African American attorney and poet who grew up in Durham, issued another call for interracial cooperation, this time directed specifically at women. In an open letter to her hometown, Murray envisioned teachers and parents of both races taking the lead in school desegregation efforts. She thought black and white mothers were especially suited to the task: "I see the civic spirit of the women of Durham, which has produced such breathtaking beautiful gardens, reaching beyond the Garden Clubs to Negro and white mothers on a new level of mutual cooperation and respect," she wrote. "I see these mothers making an extra effort to teach their children fair play and good breeding."[3]

Nearly two decades would pass before either schools or garden clubs desegregated in Durham, and there would be no interracial progressive coalition like the one Wallace had imagined.[4] Yet Murray's hopes underlined the important role that organized women would play as the South shook off the shackles of segregation even as Cold War politics and racial violence narrowed the possibilities for genuine democracy in the region. Especially after the combined forces of anticommunism and white supremacy squelched the interracial popular front coalition spearheaded by the Southern Conference for Human Welfare in North Carolina, liberal, predominantly white women's groups became one of the few arenas where interracial work was possible.[5] Because black women insisted on being included in groups such as the YWCA, the League of Women Voters, the American Association of University Women, and the Women's International League for Peace and Freedom, these organizations kept alive a vision of interracialism in the South during the late 1940s and throughout the 1950s.[6] Black women's prodding of their white sisters meant that at least some white women raised their "few still, small voices" in defense of black freedom, particularly after Brown, when white liberals across the region retreated.[7] Their efforts could not turn back the wave of massive white resistance that arose with a vengeance against black demands in these years. But African American women and their white allies planted seeds that would bear fruit in later decades in the form of a new women's interracial organization whose major achievement would be the peaceful, if belated, desegregation of Durham's public schools.[8]

Interracialism was not the only or even the primary concern of organized African American women. As black activists and the NAACP struggled to survive the onslaught of racial terror and anticommunism in the postwar era, black women's organizational base became an indispensable resource.

After witnessing an enormous erosion of its membership by the early 1950s, the NAACP began to rebound, spurred by women who often headed branch membership committees and by black organizations, many of them women's groups, that took out NAACP memberships. Thus, paradoxically, the NAACP in North Carolina not only survived but solidified its base at the height of the Cold War and amid intensified racial attacks largely because of the grassroots efforts of black women.

The Southern Interracial Alliance

In the immediate postwar years, a new southern interracial movement emerged from the popular front politics of the New Deal and the unprecedented opportunities for African Americans ushered in by World War II. The Civil Rights Congress, the Southern Negro Youth Congress, and the NAACP, as well as the interracial Southern Conference for Human Welfare and the predominantly white Congress of Industrial Organizations–Political Action Committee, joined forces to expand political and economic democracy in the region.[9] The Southern Conference for Human Welfare, established in 1938, became the first biracial organization in the South to work openly with the NAACP. In 1945, the SCHW formed state committees in Virginia, Georgia, Alabama, and North Carolina. In Durham, both the conservative black elite, including C. C. Spaulding and James Shepard, and militants such as Louis Austin and Arline Young worked with the Committee for North Carolina (CNC), as the state SCHW chapter was known. A number of well-known Tar Heel whites, including University of North Carolina president Frank Porter Graham, the South's preeminent white liberal, also joined. The CNC focused its efforts on voter registration and lobbying the state legislature for labor legislation and equal educational appropriations for both races.[10]

Though mostly drawn from the middle classes, SCHW state committees included both blacks and whites and were distinguished by the prominent role of women. Recognizing the need to attract talented women's leadership, CNC head Mary Price reached out to women's organizations such as the YWCA, which often provided meeting space for the organization throughout the state. Well-known black women such as educator Charlotte Hawkins Brown and prominent white women including former woman suffrage leader Gertrude Weil served on the CNC board. In Durham, Price met with YWCA women and with the Textile Workers Union of America, hoping to create a core group of activists who could respond as issues arose.[11] Liberal whites from the Durham American Association of University Women, including the group's president, Katherine Jeffers, the controversial Mary Cowper, and

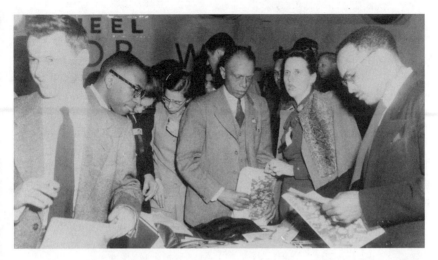

Committee for North Carolina head Mary Price (second from right) and *Carolina Times* editor Louis Austin (third from right) were active participants in the southern interracial alliance following World War 11. *(Courtesy North Carolina Collection, University of North Carolina at Chapel Hill)*

Duke Woman's College dean Alice Mary Baldwin, joined the CNC, as did several white textile union women.[12] In addition to Arline Young, a number of black women in Durham, including Mrs. Leroy Peoples, later an officer in the local Sojourners for Truth and Justice; Jacqueline DeShazor, founder of the DeShazor Beauty School and the local Housewives League; and Rupert Blanchard, director of the Harriet Tubman YWCA, joined the Durham CNC. Several black labor leaders and tobacco workers in Durham were drawn to the CNC as well, especially after Mary McLeod Bethune's stop in Durham during the 1946 voter registration campaign. Typical of most dual-sex organizations, men captured more of the official CNC titles; however, women dominated the staff positions and provided a major source of behind-the-scenes support for CNC projects such as Bethune's visit.[13]

Founder and president of the National Council of Negro Women and FDR's most prominent "Black Cabinet" member, Bethune was perhaps the most widely respected black woman in America. Her Durham appearance was part of a SCHW southern tour designed to bolster its voter registration drive. Given the abolition of the white primary two years earlier, 1946 promised to yield the largest black southern vote since the end of Reconstruction. Black CNC members George and Maude Logan used their movie theater in Durham's Hayti section to publicize the drive and reached over 7,000 African American theatergoers each week. Black veterans, college students, and

women proved especially adept at registering voters, raising the number of black registered voters across the South in 1946 from 200,000 to 600,000. In Durham, black registration nearly doubled, from 3,000 to 5,500 registered voters.[14] White power brokers, however, were determined to maintain electoral control. The following year, despite the fact that blacks were only about a third of the city's population, Durham changed its method of electing city council members from a ward system to a combined ward and at-large system, thereby diluting the black vote.[15]

Nevertheless, Bethune's appearance drew close to 600 new members to the CNC, as well as generous contributions from Durham blacks. C. C. Spaulding, James Shepard, and a number of other black businessmen contributed, as did the local black tobacco unions, DeShazor Beauty School, and the Alpha Kappa Alpha and Delta Sigma Theta sororities at North Carolina College for Negroes. A local black undertaker even funded fifty NCC student memberships. Within two years, the Committee for North Carolina had grown from 150 to over 1,500 members, with city chapters in Raleigh, Charlotte, and Durham as well as five student chapters—one at Duke and another at NCC—that drew overwhelming support from black women.[16]

In addition to voter registration work, blacks and progressive whites throughout North Carolina rallied behind the campaign to raise the state minimum wage. In Durham, the CNC, the AFL, and the CIO sponsored a public hearing on the measure. It was an uphill battle garnering white middle-class support even among sympathetic allies, and the North Carolina legislature failed to pass the bill. Dorothy Height, the most influential black woman on the national YWCA staff, found that Durham Y women were at least willing to debate the issue. Working with black women tobacco workers and white women textile workers, the local Y conducted a survey of the needs and interests of the city's "18,000 industrial girls," who boasted one of the highest rates of female labor force participation in the nation. But publicly promoting labor legislation was another matter, and the Y refused to endorse the measure.[17]

The Collapse of the Southern Progressive Coalition

Despite these problems and the hostile response to Henry Wallace's 1948 presidential campaign, women fought to keep the Progressive Party alliance alive. Headed by CNC director Mary Price, the party's interracial ticket in North Carolina endorsed an antilynching bill, an end to racial segregation and discrimination, and the abolition of the atomic bomb. The state's leading paper, the *Raleigh News and Observer*, called it the "most liberal political

platform ever to come out of this state." Durham NAACP secretary Arline Young and her student activists at NCC (renamed North Carolina College at Durham in 1947) conducted door-to-door voter registration drives in black neighborhoods, underlining the Progressive Party's record on behalf of racial and economic justice. After the debacle and near-riot during Wallace's appearance in Durham, the city's NAACP youth council called for a statewide protest and condemned the local police for aligning with "the forces of Hitlerism." But by election day, the Progressive Party had fallen apart, as supporters feared a Dewey election and defected to the Democratic banner. Henry Wallace received only 4,000 votes statewide.[18]

The collapse of the SCHW after Wallace's defeat, followed a year later by the disintegration of the CIO's Operation Dixie, eroded any possibility for popular front politics in North Carolina and the South. A tenuous alliance from its inception, the postwar biracial democratic movement could not withstand the combination of red-baiting and race-baiting that Wallace's campaign had exacerbated.[19] The election of liberal governor Kerr Scott in 1948 initially promised some hope to blacks and white liberals in the state. However, Scott cast his lot with the moderates who advocated "gradualism" on racial issues, which in practice almost always turned into paralysis.[20] Even more devastating to the future of progressive politics in North Carolina was the 1950 senatorial defeat of former University of North Carolina president Frank Porter Graham. The fallout from the Graham–Willis Smith senatorial campaign, which was marked by the worst race-baiting in the state's history, took its toll on moderate and liberal whites. As more conservative whites resisted even gradual reform and grew increasingly determined to defend the Lost Cause, southern liberals retreated.[21]

Individual white women and liberal women's groups also were vulnerable to the race-baiting and red-baiting of the late 1940s and the 1950s. Committee for North Carolina head Mary Price was accused of being a Communist spy before the House Un-American Activities Committee (HUAC), while CNC staff member Anna Seaburg was labeled a Communist for her affiliation with the Women's International League for Peace and Freedom and her support for the YWCA's industrial girls' program. Conservative whites painted YWCA secretaries in several Tar Heel communities with the red brush for their membership in the Fellowship of Reconciliation, a peace and civil rights group. National AAUW officials were called to testify before HUAC, while the WILPF, although fiercely anticommunist, tried to walk a tightrope between defending both free speech and dissent and condemning Communism. By 1954, however, the women's peace group had succumbed to anticommunist hysteria

ited a set of guidelines to ferret out subversives. Mainstream ganizations such as the YWCA, the AAUW, and the WILPF, both d in North Carolina, survived these attacks by withdrawing from ᴗɩitics and abandoning public support for controversial issues, ᴗɩɩcularly those dealing with race or economic justice.[22]

Civil Liberties Violations, Racial Violence, and Anticommunism

With hopes for an interracial alliance dashed and anticommunism on the rise, black activists found themselves under siege. Postwar civil liberties violations and racial violence, which often revolved around the volatile issue of interracial sex, posed a particular threat. The crisis helped bridge the ideological divisions among Durham blacks while continuing to provide space for black women's activism. The old-line black elite, including Asa Spaulding (nephew of C. C. Spaulding) as well as radicals Louis Austin and Arline Young, joined forces with the CNC, the Civil Rights Congress, and the Chapel Hill–based and female-led Fellowship of Southern Churchmen to counter the atmosphere of terror, much of which centered on a series of cases involving allegations of rape.[23]

Accusations of rape leveled at black men headed the North Carolina State Conference of NAACP Branches' list of concerns for 1947. Although there was little public outcry over attacks on black women, the Carolina Times noted that "the Negro woman has little or no protection from rape in the South so long as her assailant is white." White men were charged with lesser crimes if they were indicted at all, and convictions were rare. More importantly, no white man was ever sentenced to death for raping a black woman, while black men were routinely executed for alleged rapes of white women. "The death penalty for that crime in North Carolina is 'for Negroes only,'" noted Carolina Times editors. Black women rallied to the support of the defendants, many of whom were black veterans. Arline Young, in her position as head of the Speakers Bureau for the state NAACP conference, took up the case of Godwin Bush, a black veteran from Rich Square who miraculously escaped a lynch mob after being falsely accused of the attempted rape of a white woman. Although Governor Robert Gregg Cherry's intervention in the case helped give North Carolina its more progressive image in comparison to other southern states, black defendants remained vulnerable to serious miscarriages of justice and threats of lynching.[24]

Even when black women were not targeted directly, many of these cases had devastating consequences for them and their families. One case that attracted the attention of a short-lived interracial coalition that included nu-

merous black women involved the Daniels boys, two black youths from Greenville who were sentenced to death for killing a white cab driver despite evidence pointing to a jealous husband as the real culprit. Calling the case a "legal lynching," Durham's Progressive Party, the Civil Rights Congress, and several state NAACP leaders joined a number of black women's groups to form a People's Defense Committee for the defendants. Neither national nor international attention, however, prevented white landlord Bruce McLawhorn from retaliating against Mrs. Alice Daniels, the sharecropper mother of Lloyd Ray Daniels, one of the defendants. After evicting Mrs. Daniels and her children, McLawhorn refused to pay "even one penny for their entire year's labor," vowing that "no money made on his farm went to help 'that boy' Lloyd Ray." "If I had him here, I'll tell you what I'd do," McLawhorn said ominously to the distraught mother. "I'd tie him to the back end of my car and drag him down the road." In addition to the gruesome threat, more formidable state and federal forces were aligned against the defendants. Frantic appeals by the boys' supporters to the U.S. Supreme Court ended in failure, and North Carolina executed the teenagers in the gas chamber. Their funeral drew "huge crowds" in Durham from throughout the state and laid the groundwork for future legal victories. But in the short term, the impact was devastating. The federal government had refused to ensure basic civil liberties for African Americans, and North Carolina's state attorney general targeted the Civil Rights Congress as "subversive," sounding the death knell of the organization and of left-leaning politics in North Carolina.[25]

Red-baiting attacks left black activists especially vulnerable, whether or not they were associated with the Left. Arline Young disappeared from the historical record after she was blacklisted in the late 1940s for organizing tobacco workers in North Carolina. The House Un-American Activities Committee targeted Durham blacks for association with allegedly subversive groups like the Southern Negro Youth Congress.[26] Black women who supported the NAACP were frequently attacked as un-American. During the 1950s, HUAC accused Shirley Temple James, a North Carolina College student and president of the statewide intercollegiate NAACP youth division, of being a Communist sympathizer.[27] Louis Austin's *Carolina Times* initially dismissed postwar red-baiting tactics as the latest weapon in the segregationists' arsenal and suggested that if Jesus Christ had come to Durham, he, too, would have been labeled a Communist. But by 1950, the paper had done an about-face, endorsing the suspension of constitutional rights for eleven Communist leaders.[28]

Although segregationists used anticommunism to attack the interracial

movement, African Americans increasingly deployed Cold War rhetoric themselves as a bludgeon against white supremacy. "Every lynching, every act of discrimination is well-known to the Russian propaganda machine," the *Carolina Times* warned on the eve of the Korean War. "We cannot fight an all-out war for democracy abroad when we refuse to grant it at home."[29] Throughout the 1950s, Durham blacks turned to Cold War arguments to buttress their demands for school integration. Citing Soviet advances, the Durham Committee on Negro Affairs warned: "Education is a basic requirement for a strong nation. The waste of a dual or segregated educational system, which is inferior at its best, must be eliminated." Still, while the NAACP's embrace of anticommunism may have helped the organization survive the 1950s witch hunts, red-baiting took its toll. After reaching an all-time high in 1947, Durham branch membership steadily declined in the late 1940s and early 1950s. By 1950, NAACP branches across North Carolina had lost over 10,000, or nearly 75 percent, of their members.[30]

While both black and white activists were subjected to red-baiting smears, African Americans were especially vulnerable to white supremacist violence. As historian Tim Tyson has shown, a revived Ku Klux Klan (KKK) launched a campaign of violence and terror throughout North Carolina in the early 1950s that included scores of shootings, kidnappings, and whippings of Tar Heel blacks. By the middle of the decade, voter intimidation had escalated, especially in the fifteen counties with the largest black populations, and racially motivated bombings were on the rise throughout the state. Although the North Carolina legislature's effort to squash the NAACP ultimately failed, Governor Luther Hodges legitimized these attacks by equating the NAACP with the Klan and dismissing both groups as extremist.[31]

Black Women's Organizations and the Survival of the NAACP in North Carolina

Klan threats and violence frequently were a response to increased civil rights activity among African Americans. The Klan vowed to kill state NAACP head Kelly Alexander in 1951 after he promised to eliminate racial segregation in education.[32] Durham attorney Floyd McKissick's successful lawsuit against the University of North Carolina law school prompted KKK grand dragon Thomas Hamilton to ask a crowd of 5,000 white North Carolinians, "Do you want some burr-headed nigra to come up on your porch and ask for the hand of your daughter in marriage?" Despite the threats, the NAACP in North Carolina rebounded; the number of branches across the

state increased from fifty-three in 1950 to eighty-six in 1961, attracting over 8,000 new members.[33]

Paradoxically, the NAACP strengthened its base in North Carolina even as red-baiting and racist violence forced the organization to expel Communists and modify its civil rights agenda. A look at black women's organizations during the 1950s explains the seeming anomaly and highlights their role in shepherding the movement through a difficult and dangerous period. Despite renewed attacks on civil rights proponents and a decline in individual memberships by the early 1950s, NAACP organizational memberships, many from black women's groups, were on the rise in North Carolina. Group membership provided a measure of protection from reprisals, but it also was a response to a new NAACP strategy.[34] In 1949, the national NAACP specifically advocated working with local groups. Durham attorney and NAACP branch secretary Frank Brower appealed to black residents to push their churches, trade unions, fraternal organizations, and other groups "to go on record in behalf of civil rights and to work for passage of legislation," and he pointed to the important role women and youth could play in this effort. Two days before the *Brown* decision, *Carolina Times* editor Louis Austin specifically connected black associational life with civil rights work by urging that "every lodge, club, fraternity and sorority should make NAACP membership mandatory before allowing anyone to join them."[35]

Black women's organizations took the lead. In the years before *Brown*, when other black groups in North Carolina avoided public demands to abolish Jim Crow, African American women's organizations called for racial integration and joined the NAACP. In Durham, the Year Round Garden Club, the Little Slam Bridge Club, the Volkamenia Literary Society, the Daughters of Dorcas, the Association of Public School Teachers, and several local sororities all maintained organizational memberships in the NAACP. Local cosmetology clubs competed to win annual NAACP membership drive awards, officers from the Durham branch of the Housewives League were active NAACP members, and the women's group pledged contributions to the NAACP.[36] Across the state, the pattern was similar. Between 1954 and 1957, the North Carolina Women's Baptist Home and Foreign Missionary Convention, the Alpha Kappa Alphas, the Delta Sigma Thetas, and the North Carolina Federation of Colored Women's Clubs all boasted fully paid NAACP life memberships.[37] On the national level, too, black women's organizations increasingly supported NAACP efforts. In 1954, in the wake of the *Brown* decision, the national leadership of Jack and Jill of America, a black mothers'

group, urged each chapter to increase its contribution in order to secure a lifetime membership in the NAACP. As northern women wavered, southern black women, "in answering for the mothers of the south," insisted "that no mother, northern or southern, would [refuse] life membership" in the NAACP, and the measure was carried by a majority vote.[38]

Following *Brown*, support for the NAACP reached a crescendo in North Carolina, reflected by the increase in individual memberships. North Carolina NAACP field secretary Charles McLean noted a new sense of "pride" and "confidence" among previously fearful blacks. "Those who once wanted to keep membership a secret are growing more confident and not only boast of their membership, but wear buttons and display emblems on their cars and front doors," he reported in 1955. NAACP official Ruby Hurley captured the new spirit of determination when she declared to a Durham crowd that same year, "In spite of bombs, threats, killings and economic reprisals . . . [white leaders in North Carolina] don't seem to know that the New Negro 'ain't scared no more.'"[39]

African American women, who often headed NAACP membership committees (as well as NAACP youth groups, which also expanded during this period), played a key role in the growth of the NAACP throughout the 1950s.[40] In 1954, Durham NAACP membership almost doubled from the previous year, making the Durham branch the second largest NAACP branch in the state, exceeded only by Winston-Salem. Membership in the Durham NAACP continued to climb, reaching 762 in 1958 and peaking at just under 1,300 by 1960. From 1954 to 1960, North Carolina boasted the largest NAACP membership in the Southeast region.[41]

An Unlikely Sisterhood

Organized black women also were instrumental in keeping alive some semblance of interracial sisterhood during the 1950s. As anticommunist hysteria forced liberal, predominantly white women's organizations in the South to turn inward, black women continued to push groups like the AAUW, LWV, YWCA, and WILPF to become more racially inclusive. Following the collapse of the southern popular front alliance, which struck a serious blow to interracial democracy in the region, mainstream women's organizations—due largely to black women's insistence—offered some of the only public arenas in the region where interracial cooperation was possible even on a small scale. They may not have clamored publicly for racial equality, but internally, and often under the radar screen of public scrutiny, liberal women's organizations underwent their own quiet and reluctant revolutions. Black women's

demands for inclusion met with a mixed reception from organized white women, yet their efforts were not wholly in vain. Thus, despite liberals' retreat in the face of red-baiting and the wave of massive white resistance that swept the region after *Brown*, the Durham AAUW and WILPF joined the small group of whites who publicly promoted school integration.[42]

Women's interracial alliances in Durham and the South had a troubled history. During World War I, black and white women's cooperation in Durham led to the creation of the "central" (white) YWCA in 1920 and the segregated (black) Harriet Tubman "branch" two years later.[43] Yet organized white women's activities were marred by a certain noblesse oblige, leaning more toward racial elevation than racial equality. Thus, the Altrusa Club, a white women's professional and business group, bemoaned the lack of restrooms for black patrons in downtown Durham in the 1930s, raised funds for camp scholarships for black and white Girl Scouts in the 1940s, and donated leftover clothes from a rummage sale to the black Harriet Tubman YWCA.[44]

White churchwomen's attempts to bridge the racial divide frequently proved equally condescending and superficial. In the 1940s, Durham's Church Women United sponsored an annual interracial World Day of Prayer, but after the services black and white women returned to their separate and unequal lives. According to Mrs. Julia Lucas, some white women who had attended these services would later refuse to greet her in public. Martin Luther King's observation that the Sunday morning worship hour was undoubtedly the most segregated of all American institutions was certainly true in Durham.[45] Religious institutions, however, were not the same as religious convictions. Indeed, for some white southerners, the contradictions between their Christian beliefs and the "southern way of life" spurred not only crises of conscience but genuine interracial efforts. As one white southern liberal explained, "[We were] haunted by God."[46]

Beth Okun was one such white southerner who was haunted by God. Although her parents were outspoken segregationists in the tiny Texas town of 900 where she was raised in the 1930s and 1940s, she took seriously the message of Christian love she read in her Bible. Slowly, she began to question southern racial mores, wondering why the black woman who worked as a maid for her family had to live in the segregated section of town. "Do you want to sleep here or go down to Niggertown?" her father replied when she asked him. Okun quickly learned not to challenge the color or class lines that defined her social world. But her decision to attend Texas Woman's College in Denton, fifty miles outside of Dallas, in the 1940s provided a refuge from the constraints of her small-town upbringing.[47]

After moving to Chapel Hill in the early 1950s, Okun quickly became part of a small group of southern white radicals and progressives. She joined the Durham–Chapel Hill Women's International League for Peace and Freedom, becoming president of the branch in 1957, and gravitated to the Community Church, a nondenominational, unaffiliated church that was just forming under the leadership of the controversial Rev. Charles Jones, who had been ousted from the local Presbyterian church for his racial views. Jones had become the center of controversy during World War II after he invited an African American navy band to worship at his church in Chapel Hill. A confidential War Department report noted that the white minister's nineteen-year-old daughter was seen on a "date" with "one of the Negro members of the band . . . walking in a lonely section of the campus late at night." According to the report, this violation of the South's most sacred taboo might provoke "serious trouble" in the tense aftermath of the racially motivated murder of black soldier Booker T. Spicely by a white Durham bus driver just days before.[48] Despite the controversy, Jones continued to promote racial egalitarianism, and the Community Church soon became a gathering place for like-minded whites and for a handful of progressive blacks, including Durham activists Sadie Hughley and her husband, Rev. Neal Hughley.[49]

Black Women and the YWCA

Throughout the 1940s and 1950s, black women were more influential than biblical imperatives in challenging white women and liberal women's organizations to become more racially inclusive. Since the 1930s, black Y women, "in a nice but firm way," had repeatedly raised the issue of black representation on the YWCA board of directors only to be met by white assurances that they "hoped to do it soon." Most white Y women worried about "community reaction" to a racially integrated board and the costs of violating "individual and community tradition," and many harbored their own personal misgivings about including black women on an expanded basis.[50] These tensions came to a head during World War II, when the national YWCA conducted a study of interracial practices that culminated in a call for racial integration. The report elicited widespread hostility among white Y women in Durham, whose response reflected the racial atmosphere following the Spicely murder. The racial climate was so volatile that the white Y director thought it best not to accompany a national Y official to a meeting at the Tubman branch. Even the Y's Interracial Committee failed to meet for over eighteen months, and several members reported "some pretty ugly community attitudes" following the white bus driver's acquittal in the

Spicely case. A year and a half later, interracial community groups had ceased to use the Y building for meetings.[51]

Black Y women, however, refused to acquiesce to white women's racial anxieties. In 1942, the national Y organized the Negro Leadership Conference to discuss interracial concerns within the YWCA, particularly the relationship between the branch and central associations and the Y's lack of democratic procedures. Black women resolved to push for racial inclusion within the central Y while simultaneously insisting on maintaining black branches "until there [was] full and complete participation in all areas for Negro members." Black women's "separatist base" in the Y branches enabled them to exert pressure on white YWCAs, although throughout the 1940s and 1950s the pattern was for black women to be assimilated into the predominantly white central YWCAs.[52] In 1946, black women's demands led to the appointment of NAACP activist Arline Young to Durham's central Y board, making her the only black member. A national Y official visiting the city described Young as "an aggressive, smart, wide-awake person who wants the Y to 'go places,'" but the official feared that the "slowness" of the Y might drive Young out of the association. Not long after her appointment, Young grumbled that her role on the board had degenerated to merely "witnessing" the white women's proceedings. The central Y women had almost no interest in integration and treated the Tubman branch as an "extra," black women complained. Indeed, another decade would pass before black Y members could convince their white sisters to fully integrate the organization.[53]

One of the barriers to black women's leadership revolved around white fears of "Negro domination." Dorothy Height, the most prominent black Y official in the country, had tried to show white women that overcoming individual personal prejudice was only the first step in combating racial discrimination. She pushed white Y members to take a broader view of racism and to understand its organizational manifestations, particularly in the area of leadership. White women could not represent the interests of African American women, Height insisted, but had to learn to share leadership. However, white women in the Durham Y worried that "Negro electors would outnumber whites and that the leadership would pass from the white women to the Negro ones." Trying to find a middle ground between white apprehensions and black demands, the Durham Y decided to implement racial quotas.[54]

Despite such difficulties, the YWCA remained among a handful of public spaces in Durham where blacks and whites could engage in constructive dialogue. By the early 1950s, white Y women noted that the YWCA was "one of the very few places in Durham where joint meetings of white and Negro per-

sons [could] take place" and boasted, "with respect to the community as a whole, our program in this field is outstanding."[55] While white women saw this as evidence of real progress, black women often perceived these efforts quite differently. As Tubman director Rupert Blanchard confided to a fellow branch director in Winston-Salem, "Things have developed very slowly or not in the direction which we thought was desirable."[56]

But in 1954, just months before the U.S. Supreme Court issued its landmark school desegregation decision, Durham Y women were about to make their own history. In January, the Durham YWCA held its first truly interracial annual meeting and adopted the national Y resolution mandating equal status for black and white women. As the women entered the auditorium, a huge mural created by branch and central women greeted them. The mural depicted the history of both black and white Y women in Durham and helped ensure an atmosphere of "easy informality." According to Tubman director Rupert Blanchard, the membership ratified the revised constitution "without a fuss." Black women had achieved equal standing in the Durham Y for the first time. The following year, Mrs. Josephine Clement, a member of Durham's black elite, and Louise Latham, dean of women at Durham's North Carolina College, became the first elected black members of the central Y's board. Each victory portended yet another struggle, however, for the white majority prevented black board members from taking on any long-term responsibilities. Black women remained undeterred, and three years later, seven out of twenty-eight Y board members were African American.[57] But the supposedly "common decision" among black and white Durham YWCA women to forgo dinner meetings suggested that old habits died hard.[58]

The AAUW and Racial Politics

Like the YWCA, the American Association of University Women responded to pressures from black women for inclusion and struggled with the contradictions between its egalitarian ideals and its exclusionary practices.[59] While Durham AAUW women cooperated on joint projects with local black women, the issue of integration remained formidable for these reluctant reformers. Technically, the national AAUW had only one criterion for membership: any woman with a degree from an approved institution was eligible to join. AAUW general director Kathryn McHale acknowledged that branch membership was "another matter," and black women who secured national AAUW membership often were excluded on the local level. Throughout World War II, the organization did its best to avoid the issue, but some members questioned the AAUW's discriminatory practices. A white North Carolina

AAUW national board member criticized "the inability of women (who so blithely expect to own an international order) to rationally discuss the race problem." Expressing her own class snobbery even as she predicted America's postwar difficulties internationally in light of the nation's unresolved racial problems, she exhorted the AAUW to "stand specifically for the thing that binds us together and respect minorities that are intelligent and well-dressed as well as those that are vocal, shabby and ignorant." Failure to do this, she reasoned, would undoubtedly raise serious questions about the organization's qualifications "to even think about the Post-War problems of races in Europe and Asia and Africa."[60] By the mid-1940s, increasing numbers of AAUW chapters were reporting black members as well as growing pressure from black women to eliminate policies that even implicitly promoted racial discrimination.[61]

Mary Church Terrell, founder of the National Association of Colored Women, forced the issue by filing a lawsuit against the national AAUW after the Washington, D.C., branch refused to grant her membership in 1946. In response, the national office mandated that any branch failing to adopt the AAUW's nondiscrimination policy by 1948 would be barred from the association. Following a court ruling in favor of the branch, the national office decided to amend AAUW bylaws, and an overwhelming majority of AAUW members voted to adopt a nondiscriminatory membership policy for all branches.[62]

Ruth Smith, president of the Durham AAUW, noted the implications of the case for the local chapter and emphasized the need "to educate the club members in tolerance." Smith urged her group to "work with the educated negroes in Durham . . . through already [established] interracial groups." But her instructions mirrored the gradualist approach of the state's moderate leadership. The organization "would have to go slow," she warned, "and not antagonize the people of Durham, nor discredit the A.A.U.W. organization in any way." But the unanimous resolution by the 1951 North Carolina AAUW annual convention commending the University of North Carolina for "admitting Negroes to its Medical College" seemed to herald a new consensus behind racial integration.[63]

When black women sought membership in the Durham branch in the mid-1950s, however, white women's racial prejudices were put to the test. In 1954, a black woman, unnamed in AAUW records, attended a Durham AAUW meeting and presented her credentials for membership. The black woman's "affront" threw the local organization into a quandary about its meetings, which it held over dinner at Harvey's Cafeteria, a popular downtown res-

taurant that refused to serve blacks. The executive board hoped that "as a group of educated women, [the Durham AAUW might] meet this problem with calmness and open-mindedness." The officers seemed less sure of the group's enlightened sentiments regarding race, however, and decided to avoid an open discussion of the issue among the general membership. After polling the members and receiving no clear mandate on how to proceed, the executive committee made a unilateral decision to move meetings to the local YWCA, where interracial dining facilities were available. Meanwhile, white AAUW members Frances Jeffers and Wally Hackett contacted the "leading women" at North Carolina College. Soon after New Year's Day, 1956, thirty-six white women and four women from NCC, including Louise Latham and Rose Butler Browne, met at the local YWCA. Duke dean Alice Mary Baldwin gave the blessing as the AAUW gathered not only for its first racially integrated meeting but for its first interracial dinner as well.[64]

Not everyone was pleased with the AAUW's new openness. Between 1955 and 1958, the organization lost nearly 30 percent of its white members. But membership loss was less drastic in the crucial years of 1955 and 1956 when the Durham AAUW desegregated; during this period, about 17 percent of the members departed.[65] For several years after desegregation, the Durham AAUW "had a rough time" and appealed to the national office for "further guidance" since "a large number" of its members had "been so unhappy about integration." Many white members refused to undertake committee work or attend AAUW programs, while others complained about meetings at the racially integrated YWCA and pushed the AAUW to resume dinner meetings at the segregated restaurant. Although the state AAUW urged the Durham branch to hold interracial meetings without meals, the Durham AAUW stuck both to its racially inclusive membership policy and to its interracial dinner meetings at the YWCA. Meanwhile, several AAUW women and Barbara Benedict, the new associate director of religious life at Duke's woman's college who encouraged white students to reach out to their black sisters in the region, pushed Duke University to alter its prohibition against interracial meals on campus. Duke's board of trustees, however, refused to change the policy.[66]

Contesting "Private" Spaces in the LWV, AAUW, and WILPF

By 1961, Duke's Florence Brinkley reported that racial integration had strengthened the Durham AAUW, but she acknowledged that the group was still having trouble finding meeting places for study groups. Members claimed that lack of time rather than racial prejudice was the major obstacle

to setting up study groups, which met in the women's homes. Most interracial contact in white homes occurred between black employees and white employers, a relationship shaped by a racial caste system that required deference and subordination from black women. Thus, for many white AAUW women, the new level of interracial intimacy that study group meetings in members' homes demanded was more threatening than crossing the racial divide to break bread together.[67]

The Durham League of Women Voters faced a similar dilemma. Like the AAUW, the league operated in ways that discouraged black membership. General league meetings were held in semipublic arenas such as churches, and as early as 1950 the Durham LWV sponsored integrated meetings in black public spaces such as Hillside High School. LWV study units, however, met in private homes. Like AAUW members, Chris Greene (no relation), a white woman who joined the LWV in the 1950s, believed that time constraints more than racial factors accounted for the LWV's difficulty in keeping black women in the organization. Although Greene insisted that the LWV never officially excluded black women, she also recalled "big discussions about the comfort of people—would black people come to white homes." Several black teachers and librarians overcame their alleged discomfort and joined the Durham league, and by 1958 the LWV was hosting integrated meals at the local YWCA. Yet according to Josephine Clement, who was among the handful of black women who joined the LWV in the 1950s, "[white women] began to bring black women in, but they still were in control of the organization."[68]

Clearly, white women in the 1940s and 1950s faced impediments to the more-than-token inclusion of African American women. The social character of women's organizations posed particular challenges to racial inclusiveness. Like many women's groups, the LWV and the AAUW provided arenas for social interaction where bonds of friendship were created and nurtured, forming a distinctive "woman's culture" that had long been a hallmark of women's voluntary associations. Black and white YWCA women in Durham presumably devised a solution to this dilemma by their "joint" decision to abandon dinner and luncheon meetings. But LWV and AAUW subcommittees met in members' homes, intimate settings where official business functions and leisure activities easily overlapped.[69] Black women's demands for inclusion thus transformed white women's homes into semipublic arenas of racial contestation, collapsing the rigid boundaries between public and private spaces.

The most effective women's organization at bridging the gap between public and private space was the Chapel Hill–Durham Women's International

League for Peace and Freedom. During the early 1950s, the women's peace group supported federal civil rights legislation outlawing racial discrimination, a bold move for a southern, predominantly white organization. According to Beth Okun, who joined the WILPF after arriving in Chapel Hill in the early 1950s, the group "made several desperate efforts" to attract African American women but seemed unable to do so until several years later.[70] The local pattern was similar to that of the national WILPF, in which only about 10 percent of the membership was black.[71] During the 1950s, local black and white WILPF women met in both black and white public spaces—including North Carolina College and the University of North Carolina—but they also shared potluck dinners in one another's homes.[72] The difference between the WILPF and the YWCA, AAUW, and LWV stemmed in part from the way the WILPF integrated its branch, enabling black women to assume leadership positions alongside whites. The WILPF was probably the only predominantly white local women's organization that not only boasted an interracial membership but also elected black women, such as Sadie Hughley, Dessa Turner, Selena Wheeler, and Bessie McLaurin, as officers and convention delegates.[73]

The *Brown* Imperative and Southern Liberalism

Black women's demands for inclusion in predominantly white women's organizations became more insistent after *Brown*, even as a wave of massive white resistance and racist violence erupted with renewed force across the South. In response to the high court's decision, the North Carolina state legislature adopted the Pupil Assignment Act and the Pearsall Plan in 1955. Both measures effectively forestalled school desegregation throughout the state for over a decade by decentralizing decision making and placing the burden of school desegregation on individual blacks.[74]

Perhaps never before had southern white progressive voices been more desperately needed than in the aftermath of *Brown*. A few white women spoke out against white resistance, but they did not reflect a consensus even among women who considered themselves sympathetic on questions of race. Doris Betts, a southern writer who taught English at UNC-CH and later gained national prominence, abhorred the white violence that greeted Dorothy Counts, the black girl in Charlotte, and the nine black children in Little Rock as they entered formerly all-white public schools. "While the trumpets are blowing hard for Southern tradition, it would also be well if a few still, small voices quoted the old-fashioned words of the Golden Rule and applied them to Dorothy Counts and nine children moving through screams and saliva in order to reach a classroom," Betts appealed to her fellow white southerners.[75]

The responses of liberal women's organizations to Betts's call and to pressure from black women's groups illuminate both the possibilities and the limitations of southern liberalism in the post-*Brown* years. Among Durham's mainstream women's groups, the WILPF offered the most unequivocal support for the Supreme Court decision. Bessie McLaurin's influence with the national WILPF undoubtedly trickled down to the Durham–Chapel Hill chapter, in which she also was active. Following *Brown*, McLaurin and several other African American women convinced the national WILPF to act immediately, warning that any hesitancy would be perceived as "contempt for the Supreme Court ruling." The national board endorsed the black women's resolution, opposed "more subtle but equally violent means of discrimination," and pledged the organization's resources to implementing school desegregation.[76]

The Durham–Chapel Hill WILPF's most dramatic undertaking was its public opposition to the Pearsall Plan. In a bold move, members presented a statement to the North Carolina General Assembly outlining their criticisms of the plan and urging the legislators to reject the measure. Charlotte Adams, founding president of the local WILPF, convinced the organization to publicly demand the desegregation of public schools beginning with the first grade in 1957. The women's peace group also proposed that proportional black representation should be mandatory for any group dealing with questions of integration.[77] Even more striking was the organization's backing of NAACP lawsuits to force compliance with the high court's decision.

WILPF members concentrated their efforts on educating children about racial tolerance and providing opportunities for interracial experiences. The group joined the local Interracial Fellowship for the Schools, devising programs for first graders to learn about integration "before they receive a near-lethal dose of prejudice," as one member explained. In 1956, WILPF opened an interracial children's art class, hoping to "allow white and Negro children to meet each other casually and naturally," and soon drew an equal number of black and white students to the project. The women also offered scholarships to local African American students to attend an interracial summer work camp in North Carolina sponsored by the American Friends Service Committee, a Quaker group working to support school integration. Although WILPF members remained frustrated by their small numbers and their inability to wield greater influence, by the end of the 1960s membership had more than doubled.[78]

The AAUW's reaction to *Brown* was more ambivalent, although there were striking differences between the responses of the national office and those of

the North Carolina and Durham branches. Hoping to skirt the volatile issue, the national AAUW office advised southern branches to avoid taking a direct vote on school desegregation and to serve as mediators in community struggles over the court's mandate. The organization's reticence was at least partially a reaction to the devastating impact of McCarthyism; allegations of links between civil rights activists and Communists divided women who had formerly worked in unison, leaving behind an atmosphere of fear and mistrust. The group's bitter experience with integration in the branches had magnified these divisions, creating an "institutional depression" within the national association during the 1950s. The days of remaining neutral on racial matters of such momentous significance, however, were long gone, particularly for a national organization, and failure to rally behind *Brown* was tantamount to supporting segregation. In the end, the national AAUW's lack of leadership on school desegregation presaged its declining influence, as members relinquished action for abstract study and ceased to be players on the national stage.[79]

Initially, the North Carolina AAUW followed the lead of the national organization. Anticipating the Supreme Court ruling, the state AAUW formulated a policy of moderation that failed to endorse racial integration explicitly and advised branches to "work quietly for a positive plan on the part of local school boards for meeting wisely whatever situation develops." Above all, state officials admonished local groups to "discourage public agitation, study carefully techniques conducive to reduction of racial tension, and seek to develop situations which will avoid emotionalism and ill-will."[80] But the state AAUW also established a Committee on Integration in Education and organized a special workshop for AAUW members, "The Crisis in Public School Education." The one-day meeting coincided with the Supreme Court's second *Brown* decision in 1955 ordering school desegregation to proceed "with all deliberate speed," and it attracted the attention of acclaimed television journalist Edward R. Murrow's national television feature on segregation and public schools.[81]

The following year, as officials throughout the South threatened to close public schools (Arkansas and Virginia did so in 1958), the executive committee of the North Carolina AAUW decided to make preservation of public schools a major focus of the organization's work for the coming year. In adopting a resolution drafted largely by Chapel Hill historian Guion Johnson, the state AAUW reaffirmed its support of the U.S. Constitution and heralded both the *Brown* decision as "the law of the land" and "support of the public schools as essential to our way of life."[82] Hoping to influence state officials,

the AAUW sent its statement to the governor, the head of the state board of education, and other public school officials. In the aftermath of the Southern Manifesto and the North Carolina Pearsall Plan—both of which marshaled southern white opposition to school desegregation—the AAUW's stance was not inconsequential. Echoing the state AAUW's position, Duke's Florence Brinkley urged the Durham chapter to "take an active part in supporting the stand of the AAUW against the Pearsall Plan."[83] While the women's efforts had little impact statewide or in Durham, where voters approved the measure by a wide margin (almost exclusively along racial lines), a majority of voters in Chapel Hill, Charlotte, and Winston-Salem did cast their ballots against the Pearsall Plan.[84]

White AAUW and WILPF members were not the only southern whites to decry pupil assignment schemes like the Pearsall Plan, but there were not many white voices raised in opposition. Even some of North Carolina's most noted white liberals, including those in Durham, jumped on the Pearsall bandwagon.[85] Mary Duke Biddle Trent Semans, a former Durham mayor pro tem and city council member in the early 1950s, expressed liberal ambivalence about the Pearsall Plan.[86] Semans served on Durham's first Human Relations Committee in 1957 and was critical of the slow pace at which Durham finally desegregated its schools. However, twenty-five years later, she defended Senator Thomas Pearsall's proposal. "It was a tidying-over plan," she explained. "I just had a feeling that it was a step, another step along the way [toward desegregation]." African Americans, however, saw matters through a different lens. For those forced to wage yet another protracted legal battle after the *Brown* victory, "everything was considered a stalling technique," Semans conceded.[87]

In contrast to both the AAUW and the WILPF, the national LWV failed to take any position on the *Brown* decision. The national office knew that a crisis was brewing and feared that members would be caught between their principles and their interest in maintaining the organization, especially in the South. "The League must find a way to exert a calm, unemotional, and wise leadership in the search for solutions," the national president advised southern LWV members.[88] But pragmatism prevailed over principle, and the LWV chose instead to bury its head in the sand.[89]

The Durham LWV, founded in 1947, followed the lead of the national office and refused to comment publicly on either *Brown* or the Pearsall Plan.[90] The LWV's reticence was neither surprising nor unexpected, for it was a nonpartisan political advocacy organization that promoted "political responsibility through informed and active participation of citizens in government."

According to its bylaws, the LWV could take public positions only after study and only by consensus, which precluded support for *Brown* or any progressive legislation on race.[91]

After the *Brown* decision, some southern branches of the LWV enhanced their voter service projects, hoping to forge a more moderate course between advocates and opponents of school desegregation.[92] Promoting black voting rights in Durham, where African Americans were a numerical minority and a ward system diluted black electoral strength, was far less threatening to the racial status quo than backing school integration. Thus, the league's emphasis on voting had conciliatory and even conservative aims as well as more liberal goals. At the same time, black electoral weakness depended on a homogenous white voting bloc, which did not always materialize. While voter service often entailed providing womanpower at the polls and organizing public forums for candidates, it also opened possibilities for interracial coalitions. By the 1960s, as more black women joined the Durham LWV (including Grayce Thompson, wife of Booker T. Spicely's attorney Hugh Thompson, and Tubman Y director Pauline Newton), the organization grew bolder. It opposed the state's 1963 speaker ban law, reversed its support of controversial urban renewal plans, and even publicly defended some of Durham's most controversial black militants. Black women had planted the seeds.[93]

Throughout the 1940s and 1950s, white organized women exhibited a mixed record on race. Prodded by their African American sisters, these sometimes reluctant reformers may have faltered more often than not. Still, women promoted racial equality more frequently than men did, especially in the 1950s, when opportunities for interracial cooperation had diminished. Anne Braden, a white Alabamian civil rights activist, captured the power of women's organizing when she wrote to a male activist in 1959: "I am at a loss to know how you think you're going to win any of these struggles without the women. . . . all my experience in the integration movement has led me to the firm conviction that the most convinced and dedicated people are women; *this applies to both Negro and white women*" (emphasis added). In part, this phenomenon stemmed from women's traditional role in community and civic work—what Arlene Kaplan Daniels calls women's "invisible career." As historians of women in the postwar era have begun to demonstrate, white, middle-class women, including southerners, were urged to combine their conventional roles as mothers and wives with volunteer work. Indeed, southern white women had their own distinctive tradition of community work, one that

grew out of—and paradoxically was fueled by—segregation. But in the post–World War II years of racial crises, during a period once known as the "doldrums," white women's civic work led them, sometimes inadvertently, into the thick of southern and national racial politics.[94]

Mary Duke Biddle Trent Semans articulated this vision of white women's community responsibility in an address to a group of Duke sorority women in 1957. Semans's message was alternately constrictive and liberatory. She feared that women's participation in community activity had been "over-emphasized . . . not for a noble cause or a victory over some current injustice, but as a social custom." Semans expressed particular concern about the kind of voluntary activities that white, educated women pursued. While stressing the beneficial impact of women's voluntarism on husbands and families, she urged her listeners to "enter public life" and to "volunteer for civic work . . . rather than immediately striving for the nearest country club." But Semans's seemingly conventional message concerning the virtues of motherhood and wifely duties also justified women's political involvement, even their protest activity. She condemned the "conservative sameness" and the "inner fear of the witch-hunting methods" that McCarthyism had spread over campus life. Sounding a dissident note, Semans insisted that dissent was a patriotic duty. "What will happen to our culture if there is a continued decline in the American tradition of protest?" she asked. In an almost motherly rebuke, she exhorted her audience, "It is high time that we assume our respective responsibility."[95]

As white organized women discovered during the 1950s, it was difficult to become involved in civic affairs in the segregated South without also touching on racial matters. Moreover, black women's growing assertiveness forced white women to confront racial discrimination, especially within liberal women's organizations. Certainly by mid-century, black women had compelled some white women to take bolder stands on issues like school desegregation. Even then, white women often failed to forcefully or fully champion black freedom.

How then should we assess the actions of white women in the postwar South? In the 1940s and throughout the early 1950s, southern whites could view themselves as progressive or liberal for supporting racial equality even if they did not advocate racial integration. As Morton Sosna has remarked, prior to 1954, most southern white liberalism was "essentially moderate in its approach." In fact, it was even possible for whites to call themselves "moderate" or "liberal" in the 1940s South and still support segregation.[96] But the postwar anticommunist hysteria stalled liberal reform efforts and silenced even the mildest dissent.[97] White supremacist violence and red-baiting also

made it increasingly difficult for the interracial southern progressive alliance to move forward. In effect, the range of permissible white opinion on the subject of race had so narrowed in the postwar years even before Brown that the handful of southern whites who advocated racial integration were considered "radicals" or Communists and were often shunned by white mainstream society. By the mid-1950s, particularly following the Brown decision, fence-sitting on desegregation became more difficult, especially in the face of massive white resistance and the obsessive fear that anything short of total vigilance regarding white supremacy would destroy the "southern way of life."

A window of opportunity may well have opened in the South following the 1954 Supreme Court decision, as some scholars have claimed. Southern whites did seem to be poised either to follow the law of the land and move quickly and peacefully—if not altogether enthusiastically—toward racial integration or to dig in their heels and flock to the banner of white supremacy. But there was a massive failure of white leadership, both northern and southern, after Brown, crushing nearly all hopes for genuine democracy.[98] According to Mary Semans, by the end of the 1950s, "those of us on the [Durham] City Council who were a little bit progressive were considered 'way out' [by the School Board]." School board chairman Frank L. Fuller Jr. may have grown up with Semans's mother, but in an ironic inversion of the Confederate lament he dismissed Mary Semans as "a lost cause" when she backed school desegregation.[99] Even mainstream liberal reform organizations such as the League of Women Voters, which remained neutral on school desegregation, provoked "mistrust," Semans recalled. But if wealthy Mrs. Semans, a descendant of one of Durham's first families, was dismissed, other whites paid a heavier price for their apostasy. School board member Ruth Dailey, who was neither a liberal nor an activist, received bomb threats after she made the motion to accept the first transfer of eight black students to all-white schools in 1959. Three years earlier, Wilbur Hobby, a white labor leader from the white, working-class Edgemont section of Durham, was defeated for precinct captain after the KKK and the White Citizens Council passed out leaflets to union members accusing him of "selling the people's jobs to the NAACP." "The race issue was the prime thing," Hobby bitterly recollected. "These were my own members, my own people that I worked with, out there voting against me simply because I had become known as a nigger-lover."[100]

All three developments—the chilling effect of anticommunism on social activism, the rise of white violence and harassment, and the retrenchment of mainstream white leadership on the issue of race, particularly after Brown—help to explain the failure of white progressivism in the South and the nation.

The focus on failure, however, obscures the extent to which a few still, small voices—those white allies of black freedom—managed to survive. Often muffled, sometimes barely a whisper, the voices of white women who rallied behind black demands for a new racial order were important nonetheless. Although they proved no match for the reactionary forces that dominated southern politics, the seeds planted by black women and their white female supporters in the postwar years would eventually bear fruit in later decades, most notably around the volatile issue of school desegregation.

Among the few white southern women willing to buck the racial status quo in their homeland, religious faith was probably their most important internal inducement. Radical and liberal political ideologies also fueled white dissent. Other white women, concerned with voting or education or simply seeking companionship in the women's culture of voluntary associations, found themselves unable to address civic and public affairs without running into black women's demands for inclusion. Sometimes all these influences combined with more personal factors such as marital status to shape white women's responses to southern racial mores. It may be no mere coincidence that some of the most dedicated white advocates of racial justice in Durham were unmarried women such as Mary Price, Frances Jeffers, Florence Brinkley, Alice Mary Baldwin, and Barbara Benedict. Already eschewing the traditional gender conventions of marriage and motherhood—and the claim to "respectable womanhood" that accompanied these conventions—it was perhaps not such a great leap to become racial renegades, as well. As Jesse Daniel Ames, founder of the Association of Southern Women for the Prevention of Lynching, remarked, "In the South, an unmarried woman is an unwanted woman[, and] marriage even to a 'gatepost' . . . is the only estate to which a woman should aspire. . . . Missing it, all is lost." The *Durham Morning Herald* invoked traditional gender roles to denounce Southern Conference for Human Welfare leader Mary Price, suggesting that what she needed "was to marry a stalwart farmer and mother a brood of children."[101] Already marked as "deviant," unmarried white women might well have enjoyed greater social license to challenge the status quo. White supremacists frequently tied their antipathy to racial integration to a defense of traditional gender roles and denounced race traitors, sexual outlaws, and political radicals as joint conspirators in a grand scheme to destroy the southern way of life. Before dismissing these allegations too quickly, we might do well to read "against the grain" and discover what historian Jacquelyn Dowd Hall calls some "partial truths" in such rantings. Lillian Smith and, to a lesser extent, Katherine Du Pre Lumpkin, both southern lesbians, were outspoken critics of white supremacy in the

1940s and 1950s, and though neither publicly acknowledged her sexual orientation, Smith in particular seemed well aware of the links between sexual and racial "deviancy." Of course, neither marital status nor sexual orientation alone were determinative of racial attitudes, much less activism.[102] Indeed, two of the South's most dedicated white civil rights activists in the 1940s and 1950s—Virginia Durr and Anne Braden—were married women. Yet Anne Braden, who worked closely with men, including her own husband, Carl, a radical activist in his own right, sometimes found that husbands impeded women's activism: "Women are held back from taking the position they want to take by husbands or other poor excuses of the male species," she complained to a male colleague. "I sometimes get to the point where I think if we could just get rid of all the men this problem would be solved overnight." Although she conceded that her proposal was not really "serious," she did contend that "husband-trouble is a very real problem of many would-be militant women in the South."[103]

To the extent that southern white women rejected white supremacy, black assertion, particularly African American women's insistence on equal treatment from white women, remained the decisive factor in spurring them to action. Despite their weaknesses, limitations, and even outright failures, some predominantly white women's organizations provided an arena where racial divisions could be overcome. These spaces became ever more important as Cold War politics squelched more radical groups' efforts to expand democracy in the South. Although many white women withdrew from coalition politics and retreated from public advocacy roles, liberal women's organizations nevertheless kept alive a vision of racial justice in the postwar south and afforded a collective space where white women dissenters found support. By 1957, black and white YWCA women had fashioned a new unity. "Visiting the Durham Association was an encouraging experience," Hattie Droll, a national Y official, observed, "for there seems to be understanding and practice of the policy of inclusiveness, good cooperation, [an] ability to face problems honestly in board and staff, and to plan ways of work in difficult situations." But typical of the turmoil that characterized American race relations, Droll noted two years later the gap between the Y's racially egalitarian principles and its practices. Nevertheless, the Durham Y could point to the African American woman who chaired its annual meeting and could boast that the association had become clearly identified in the community as an interracial organization as opposed to a biracial organization. "Women who do not accept this principle are not interested in being identified with the YWCA," Droll observed. In a city about to witness the start of

a black-initiated direct action movement demanding immediate integration of all facilities, this was indeed a noteworthy accomplishment.[104] Moreover, the efforts of at least some predominantly white women's organizations in the postwar years became bridges or, in some cases, "fragile threads" to white participation in the black freedom movement of the 1960s.[105] Of course, local blacks remained the primary advocates for racial justice in Durham and throughout the South, and African American women worked more often in concert with black men than with white women. White women, even the most dedicated, took their cues from a protest movement that was black initiated, black led, and black supported.

African American women's activism in the postwar years suggests a reassessment of Cold War influences on both southern liberalism and the NAACP. Black women pushed liberal, predominantly white women's organizations to become more racially inclusive. This was an important step in advancing black freedom, especially after the conservative forces of anticommunism and white supremacy decimated the southern progressive coalition, making interracial cooperation in Durham and throughout the region increasingly difficult. Black women's organizations also helped the NAACP in North Carolina survive the ravages of racial violence and anticommunist intimidation during these years. Both efforts would bear fruit in the coming decades. As Durham blacks continued to press their demands for freedom, a revived local NAACP, marked by ever-increasing numbers of youth and women, forged the way.

The Sisters behind
the Brothers

The Durham Movement, 1957–1963

"As far as your eyes could see, there were people; I mean all the way to the highway. That was a day to remember. The weather was right, the timing was right." Vivian McCoy reminisced about the thousands of Durham blacks—the majority of them women and girls—who gathered on May 19, 1963, in the largest mass demonstration in the city's history. Putting their bodies on the front lines in a dramatic show of defiance, hundreds of black students from North Carolina College and Hillside High School sat down in the local Howard Johnson's parking lot. Vivian McCoy and NCC football captain Bobby Mormon led the youthful protesters in freedom songs, and a chorus of voices belted out "We Shall Overcome" and "We're Going to Eat Those Twenty-eight Flavors." Police threatened to teargas them if they did not disperse, but when one of the protest leaders countered that it would have little effect outdoors, the students remained. Officials backed up a bus and gunned the engine, blasting exhaust fumes over the edge of the assembled mass of humanity. Still, the youthful freedom fighters refused to budge. According to the NCC student newspaper, the *Campus Echo*, police "jerked, dragged and tossed [demonstrators] to the pavement," especially female students. Before the day was over, police had arrested over 700 protesters, resorting to Alcohol Beverage Commission officers to help handle the huge numbers. With a jail capacity of only 120, authorities were forced to place young offenders in the nearby courthouse, where they filled three floors. Throughout the night, jailed students sang old gospel tunes and protest songs to bolster their spirits. A NCC reporter described the effect: "a multitude of strong young voices . . . part lament, part battle cry, and part prayer," the sound drifted out of windows and carried for blocks.[1]

It was the second of three days of black mass action unlike any Durham had ever witnessed. Four to five thousand protesters—the majority African

American girls and women—backed by a supportive black adult community overturned segregation not only at Howard Johnson's but across the city. Without the efforts of local women, legal segregation might well have prevailed in Durham until the following year, when the federal Civil Rights Act of 1964 sounded the death knell for the "southern way of life."

The 1963 Durham street protests were partly an expression of local black outrage over recent events in Birmingham, Alabama, where police had brutally attacked and arrested Dr. Martin Luther King Jr. and 2,000 nonviolent demonstrators. A shocked nation recoiled at photographs of snarling police dogs lunging at kneeling black children and of white officials setting fire hoses on peaceful protesters. Spurred by the brutality unfolding in Birmingham, national civil rights organizations demanded federal intervention to wipe out Jim Crow and called for mass protests to underscore black frustration and discontent. National goals converged with local grievances as Durham activists joined thousands of angry citizens throughout the country. By the summer of 1963, police in 115 cities across 11 southern states had arrested 20,000 demonstrators in the most spectacular show of black mass action in the nation's history.[2]

Both in Durham and across the country, African American women were critical to marshaling the community support that made black insurgency effective—whether in the legal struggles of the 1950s against school segregation or in the mass demonstrations that swept Durham and much of the region the following decade. The community organizing campaigns that African American women and NAACP youth undertook in support of school desegregation in the 1950s were critical not only to NAACP legal strategies but also to later mass-based protest. When activists launched the sit-ins, marches, demonstrations, and boycotts that characterized the movement in the 1960s, they drew upon the grassroots base that black women had played a key role in organizing during the 1950s.[3] An examination of black women's efforts to desegregate Durham schools reveals the links between legal strategies, grassroots organizing, and mass, direct action protest, illuminating the continuities between the 1960s movement and an earlier protest tradition.[4]

Although men dominated most of the visible leadership positions of groups like the National Association for the Advancement of Colored People and the Durham Committee on Negro Affairs, women did not simply follow male leaders.[5] African American women were active participants in these groups, constituting a majority of NAACP members by 1960. Frequently, they did the bulk of what Ella Baker called "spade work"—the day-to-day, nuts-and-bolts work that kept organizations functioning. But black women

also used their own organizations as an alternative base of power and leadership in the fight for black freedom. While the 1960s struggle for black freedom was fueled primarily by youth—the same NAACP youth groups from the 1950s school desegregation campaigns—the movement drew upon black community support that depended in large measure on the leadership, networks, and organizing work of African American women.

Between 1957 and 1963, Durham blacks, including the women who often outnumbered male activists, pressed their claims for freedom in an escalating pattern of negotiations, court challenges, and direct action. Although the Bull City avoided the more brutal violence of Mississippi or Alabama, white Durhamites were reluctant to yield to African American demands. More concerned with racial "harmony" than with racial justice, white power brokers in Durham and across the state generally made concessions only when forced by blacks, and typically only in response to lawsuits or mass demonstrations.[6] Even then, white officials conceded as little as possible and often backed down on promises. On the other side of the color line, old fissures threatened to undermine the newfound racial solidarity that marked Durham's freedom movement. As black activists grew increasingly militant in the face of white obstinacy, class and ideological differences once again reared their heads. These struggles—whether interorganizational disputes between the NAACP and the Congress of Racial Equality (CORE) or tensions between the old guard black establishment and proponents of a nascent Black Power politics—portended important shifts within the Durham movement and for African American women activists.

The Royal Ice Cream Parlor Sit-in

The mass demonstrations of 1963 were the culmination of a local black freedom movement that had slowly gained momentum over the preceding several years. Durham had been the site of a thwarted sit-in at the Royal Ice Cream Parlor in 1957, the first such action in the city to result in arrests. Led by twenty-eight-year-old Reverend Douglas Moore, an iconoclastic young black minister from Hickory, North Carolina, the sit-in elicited scorn and derision rather than praise from the wider black community. Three years later, when Durham youth joined the sit-in movement that swept the South, the response from local blacks would be markedly different.

The 1957 sit-in began with a trip to a local ice cream parlor one evening in late June. A group of black youth accompanied by Moore piled into cars, thinking their biggest decision that day would be which ice cream flavor to select. They entered the Royal Ice Cream Parlor through the rear door marked

"colored" and then settled comfortably into several booths. When Moore placed their orders at the counter, the startled clerk ordered the students to move to the "colored" side of the restaurant. The booths were reserved for white customers, while African American patrons were required to stand on the other side of the wall. No one budged. The frazzled clerk summoned Louis Coletta, the Greek American owner, who threatened to call the police. Invoking both the Bible and the U.S. Constitution, Moore insisted that the group must remain seated. When the police arrived, they took the minister and six youths—three girls and three boys—into custody. At the trial, a white jury deliberated for less than an hour before finding all seven of the defendants guilty of trespass. Not only did they lose on appeal, but the judge increased their fines and charged them court costs to boot. Another appeal a year later in the state supreme court was equally unsuccessful.[7]

Virginia Williams and Mary Clyburn, two of the women defendants, claimed they did not expect to be arrested that day at the Royal Ice Cream Parlor. Two years earlier, when Hillside High School student Marjorie Hill refused to relinquish her seat to a white passenger on a Durham bus, police had escorted the offending student to school rather than to jail.[8] During the late 1950s, the Durham NAACP Youth Crusaders (as the citywide group was known) challenged segregation in bus stations, restaurants, and other public facilities. In most instances, authorities apparently responded much as they had in the Hill case: managers simply closed the establishments temporarily in order to avoid a public confrontation, effectively foiling black efforts to topple racial segregation.[9]

The Royal Ice Cream Parlor sit-in provoked a storm of controversy within Durham's black community similar to the divisions surrounding the Hocutt case and the Spicely murder trial in earlier decades. By the time the turmoil subsided, Durham's first major sit-in had fizzled under the reproach of an adult leadership inclined to view the protesters less as freedom fighters than as troublemakers led astray by the irresponsible antics of a radical young minister who was, after all, an outsider.[10] The young activists expected hostility from whites, but the condemnation of the black community came as a blow. Mary Clyburn, who hid her involvement in the sit-in for many years, remembered the "ugly faces" of blacks looking "madder than the white folks." Virginia Williams recalled that many in the black community held Moore responsible for the alleged fiasco; but they also were concerned about securing legal counsel for the youth. Still, even though local NAACP lawyers Conrad Pearson and Hugh Thompson (from the Hocutt and Spicely cases, respectively) represented the defendants' legal appeal, the Durham NAACP refused

to back the sit-in.[11] Nor did "respectable" African American women rush to the defense of the young activists. At the Harriet Tubman YWCA, where Mary Clyburn lived, Clyburn's supervisor claimed that the sit-in would bring shame to the Y. "I didn't hear *nobody* being happy about what we'd done," Clyburn recalled bitterly.[12]

Many Durham blacks were piqued by Moore's end run around the traditional black leadership. Some accused him of wanting to be another Martin Luther King Jr. Whatever personal rivalries may have fueled the controversy, Moore *had* failed to notify local blacks, including his most likely male allies, Floyd McKissick and Louis Austin, of his intention to stage a sit-in. Austin, the fiery editor, would have been an especially promising ally for the impatient Moore. Just a week before the sit-in, Austin's *Carolina Times* accused the "old guard" black leadership of "smother[ing the] efforts of the younger and progressive members to push the segregation question to the front." In a scathing denunciation of the city's black clergy, one editorial announced, "Rev. Sambo Waxes Fat at the Flesh Pots." Austin called for "new blood" and "new ideas" to wrest the "struggle for freedom and human dignity" from those who would sacrifice black equality "on the altar of greed and power merely to obtain a few crumbs for the few."[13]

Perhaps Moore's most egregious oversight, however, was his failure to involve the women of the surrounding community, particularly those active in the East End Betterment Society. Their rich history of civic involvement could have provided the broader community backing the sit-in lacked. Nor did the brash young minister bother to notify the Union Baptist Church, located across the street from the Royal Ice Cream Parlor and a base of local black activism. Both institutions would soon lend their energies to the growing black insurgency.

The 1957 sit-in, however, did prompt local blacks to debate strategies for dismantling Jim Crow. Some thought that the timing was not right. Others believed that challenging a private establishment was too risky and that a defeat might set a dangerous legal precedent. At the time, the local NAACP was gearing up for a protracted legal struggle against Durham's segregated schools and may have worried about diverting energy and resources from that effort. The Durham Committee on Negro Affairs's Economic Committee, headed by Floyd McKissick and small business owner Nathan White Sr.—both of whom would play important roles in later protests—discussed whether to launch a boycott of the ice cream parlor. But several committee members raised questions about the tactical wisdom of targeting the Royal Ice Cream Parlor, because its owner, Louis Coletta, was a Greek American.

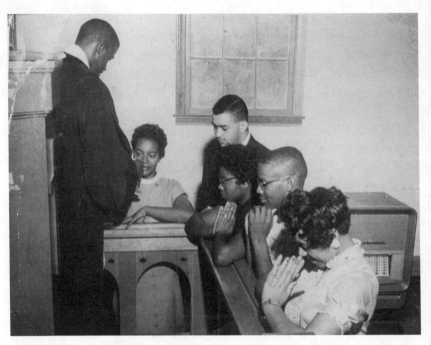

The Sunday before they were to appear in court, Rev. Douglas Moore served Communion at Asbury Temple Methodist Church to five of the youths who sat in at the Royal Ice Cream Parlor in 1957. *Left to right*: Douglas Moore, Mary Clyburn, Claude Glenn, Virginia Williams, Melvin Willis, and Vivian Jones. *(Courtesy Virginia Williams and the Civil Rights Heritage Project, Durham County Library)*

Even Douglas Moore, who backed the boycott proposal, noted that Coletta was "a member of a minority group," implying that protest against a "white" merchant might be more effective and hinting at the nebulous claims to "whiteness" of some white ethnic groups in the 1950s South. Although the DCNA refused to back the Royal Ice Cream protesters, McKissick's committee developed plans for a community-wide selective buying campaign to be implemented at some future date and suggested both Royal Ice Cream and Duke Power Company (which ran the city bus service and refused to hire black drivers) as possible targets.[14] Thus, despite the failure of the 1957 sit-in to elicit widespread support, it did point black Durham toward the community-based black boycotts and direct action protests of the 1960s. For the time being, however, none of the major black institutions would publicly back the young protesters.

Youthful enthusiasm once unleashed was not so easily contained, and Durham youth, including substantial numbers of girls, continued to chal-

lenge both segregation and the timidity of their elders. About fifteen to twenty high school NAACP members—at least half girls, largely under the direction of Floyd McKissick—organized regular pickets outside the Royal Ice Cream Parlor. One of the picketers, Vivian McCoy, recalled that students would alternate between walking the picket line and doing homework at the Union Baptist Church across the street.[15] Jim Crow did not die easily in the Bull City, however. Not until the spring of 1963 was discrimination abolished at Royal Ice Cream: Louis Coletta simply sold the establishment to a local dairy company, which reopened it without any seating at all.[16]

Despite their reluctance to support the ice cream parlor sit-in, Durham blacks were deeply dissatisfied with the slow pace of change. Some hoped to use black economic leverage to end the discriminatory practices of Durham employers, and once again black women played crucial roles in these efforts. In 1956, the predominantly female NAACP chapter at North Carolina College joined the DCNA Economic Committee, the American Friends Service Committee, the Durham Friends, and the citywide NAACP youth councils to launch the Merit Employment Project. Students conducted a survey, "Where the Negro Spends His Dollar," in fifteen major downtown stores to determine which stores had the largest African American clientele. The group planned to pressure white businesses to hire blacks for positions other than janitor, porter, and maid by pointing out the merchants' dependence on African American patronage. Two years later, the local Tubman Y sponsored a largely female, interracial group of student volunteers and faculty, which surveyed almost 400 local businesses about their hiring practices in an effort to open up job opportunities for local blacks. In a move enthusiastically endorsed by prominent Duke family daughter Mary Duke Biddle Trent Semans, project organizers printed stickers that read "I Support Equal Employment" and asked white women to place the stickers on their checks when paying bills.[17] Other efforts were aimed specifically at easing discriminatory barriers to black women's employment. St. Mark's AME Church established an employment agency that sought to place black women as sales clerks in downtown stores by reminding the owners that more than 40 percent of their patrons were African Americans. None of these efforts, however, yielded substantive results.[18]

Gaining Momentum after *Brown*

Meanwhile, as organized white women equivocated over admitting black women to their ranks, local blacks mounted more aggressive campaigns to desegregate Durham's public schools. Just days after the 1954 U.S. Supreme

Court ruling that declared racial segregation in schools unconstitutional, over 1,000 Durham blacks crammed into St. Joseph's AME Church, the largest crowd ever assembled for a Durham Committee on Negro Affairs meeting. Although the purpose of the gathering was to endorse candidates for the upcoming election, school desegregation remained a primary concern.[19] Black Parent-Teacher Associations rallied the community and sponsored public discussions to "prepare Negro children for public school integration."[20] Shortly after the 1955 U.S. Supreme Court ruling that schools should be desegregated "with all deliberate speed," 800 parents together with representatives from the leading black organizations covering a cross section of Durham blacks signed a petition calling for the immediate integration of Durham's public schools. The petition drive was part of a broader statewide campaign by African Americans to force compliance with the high court's ruling. In one well-publicized incident, 300 black leaders from across the state converged upon both Governor Hodges and the North Carolina General Assembly to decry official efforts to circumvent the *Brown* decision. The campaign bypassed the black elite's typical pattern of negotiating behind the scenes with influential whites and threatened more drastic measures by reminding white officials that "most of the gains [blacks had made] were achieved against the backdrop of coercive action of the courts." Black fears concerning white obstinacy were soon confirmed. After 75 local African American leaders presented the petition to the Durham City Board of Education, school board chairman Spurgeon Boyce thanked the delegation, passed the petition on to the appropriately named Segregation Committee, and proceeded on to other business.[21]

Although many whites in Durham opposed school desegregation, school board members were especially resistant. The most common delay tactic was the board's refusal to grant reassignment requests from black students to white schools. Even more maddeningly, officials responded to serious overcrowding in black schools by trying to institute split sessions and by reopening an abandoned white school building for African American students while leaving vacant classrooms unoccupied in white schools. When parents objected, the board provided buses to transport students to a segregated school in Walltown, a small, black, working-class Durham neighborhood. Black PTAs, the DCNA, and the local NAACP rejected these "remedies" and pressed for "prompt and reasonable and good faith efforts" to desegregate Durham schools. The board once again thanked them and assured the groups that their concerns "would be given consideration."[22]

The state legislature buttressed such local diversionary maneuvers with

the 1955 Pupil Assignment Act and the Pearsall Plan. School boards received wide latitude and a host of justifications to deny black reassignment requests without ever mentioning race. Only after exhausting all administrative appeals could blacks seek legal redress. For example, when the Durham school board informed African American parents that they had run out of reassignment forms, the parents made copies of the forms only to be told that their requests for reassignment were invalid because they had failed to use the original forms.[23] As clever Tar Heel politicians realized, "voluntary segregation" and token desegregation proved far more effective than the flamboyant defiance employed by their Deep South neighbors. North Carolina thus managed to escape federal court intervention while maintaining both segregation and its progressive image. These obstructionist tactics worked better than anyone could have predicted. By 1961, North Carolina reported a desegregation rate of 0.026 percent, a figure lower than that of Virginia, Tennessee, Arkansas, and Texas.[24]

But white intransigence also fueled black resolve. In order to avert the token desegregation of schools that had occurred in Greensboro, Charlotte, and Winston-Salem, black Durhamites would need scores of families willing to take on white authorities not only on the school board but also in the courts.[25] In 1957, fourteen African American parents requested the reassignment of their children to all-white schools in Durham. Nearly all lived in Walltown or Hickstown, smaller working-class African American neighborhoods where black students were forced to pass white schools in order to attend segregated schools across town. Attorneys reasoned that such blatant segregation would make it easier to prove racial discrimination and to demonstrate that the Pearsall Plan and the Pupil Assignment Act were therefore unconstitutional. After the Durham school board denied the parents' requests and twice rejected appeals made by nine of the families, the black community mobilized its resources for the protracted legal battle that lay ahead.

School Desegregation, NAACP Youth, and Women's Grassroots Organizing

The efforts of youth and women proved to be as important as the attorneys' legal skills. Between 1956 and 1959, the DCNA and the local NAACP, particularly its youth chapters, worked with the black PTAs, the Ministerial Alliance, and neighborhood women to persuade African Americans to petition the school board for reassignment as required by the Pupil Assignment Act.[26] It was difficult work convincing black working-class parents to take the

risks that reassignment requests and legal confrontations entailed. In one Durham neighborhood, a rumor circulated that a black woman had lost her housekeeping job at Duke University after her son defied segregationist policies at the University of North Carolina in nearby Chapel Hill. Although several ministers successfully recruited plaintiffs, men often had difficulty appealing to black parents, and the male-dominated DCNA turned to women for assistance.[27] Women, whose social relationships were deeply embedded in families, neighborhoods, and local organizations, became key resources to successful community organizing drives. Drawing on their dense associational and personal networks, neighborhood women proved particularly adept at overcoming black apprehension. The Walltown Community Council (which had boasted an entirely female leadership two years after its founding in the late 1930s) and a local woman whose daughter had agreed to become one of the plaintiffs successfully convinced scores of families to join the fight. Providing what sociologist Belinda Robnett has called "indigenous bridge leadership," local women linked residents with formal organizations like the NAACP. Key neighborhood women such as beautician and Housewives League head Callie Daye, who added her daughter's name to the list of plaintiffs, undoubtedly reassured residents.[28] By 1958, the combined efforts of NAACP youth and women had inspired over 200 black families to bring the first widespread challenge to Durham's segregated schools. Male leaders also relied upon women's fund-raising drives such as "Tag Days," in which local women exhorted their neighbors to support the cause by donning tags that boasted simply, "I Gave My Dollar—Did You?"[29]

While these activities signaled growing black support for a direct assault on school segregation, disagreements surfaced over tactics and strategies. More militant blacks charged that the mayor's newly formed Human Relations Committee was a ploy to derail the school desegregation suit. The biracial group scheduled its first meeting with the school board at the end of January 1958, the same time that local black attorneys planned to file a lawsuit against the Durham school board. In a conciliatory move, the plaintiffs agreed to delay their suit until after the committee met with the school board. The meeting was a disaster. Board members responded with stony silence to the committee's timid request for desegregation to proceed "as slowly as wisdom dictates but as fast as good faith would allow." When the mayor's group pressed for an explanation, school board chair Frank Fuller Jr. responded cryptically, "Silence means silence." With no official power, the Human Relations Committee could do little to counter the board's hostility.[30]

That same month, the city council appointed Rencher Harris, a local black

businessman, to the school board, making him the first African American on the board. Harris remained conservative through 1958, even voting against black reassignment requests. Upon his reappointment the following year for a full four-year term, however, Harris immediately called for making school assignments on the basis of geography rather than race.[31]

African American parents did not simply wait for the only black member to secure a more strategic position on the school board. In May 1958, a year after board members denied their requests for reassignment, Mrs. Evelyn McKissick, wife of attorney and militant NAACP leader Floyd McKissick, and Mrs. Rachel Richardson, a Walltown resident, filed the first direct legal challenge to Durham's segregated public schools on behalf of their daughters, Joycelyn McKissick and Elaine Richardson, and of "others similarly situated." According to Floyd McKissick, Evelyn Richardson "was a fighter who understood what would happen in the courts."[32]

In August 1959, realizing that a decision on the Durham desegregation suit was imminent, the school board reassigned 9 black students—including 5 girls—to formerly white schools. But the board offered no explanation for denying the reassignment appeals of 165 other black students. Moreover, board members continued to use racially identifiable school attendance maps until a 1962 federal court order forbade the practice. By 1961, even though blacks had filed more reassignment applications in Durham than anywhere else in North Carolina, only a handful of students attended formerly white schools. Across the state, school boards granted only 89 out of 1,000 black requests for reassignment.[33]

The Early Years of School Desegregation

African American girls frequently were the majority of students desegregating Durham schools in the early years.[34] Parental fears of retaliation against sons for real or imagined contact with white females offer one explanation for the disparity. Although black girls certainly were targets of physical abuse and harassment, anecdotal evidence suggests that black parents worried that boys would be more vulnerable to white violence.[35] After 1954, dire warnings about "miscegenation"—by which whites meant relations between black males and white females—became a rallying cry for white opposition to school desegregation across the South. Few issues had the same power to send the defenders of the Lost Cause into a frenzy as did the volatile mixture of race and sex.[36]

The battle for school desegregation drew allies from all segments of black Durham, some of whom found ingenious ways to participate. The *Carolina*

Times and the NAACP youth council organized a "Freedom Scholarship" college fund for two low-income girls who desegregated Durham High. Black tobacco workers kept watch from factory windows as the courageous young students came to and from two newly desegregated schools. According to Evelyn McKissick, whose three children were the first to attend formerly all-white schools, "No one could see them but we knew in the street that they were all round . . . the first day especially."[37] In another show of community support, residents rented a limousine from a local undertaker to transport Lucy Mae Jones, the first black student to desegregate Brogden Junior High in September 1959. The gesture underlined the solemnity of the event, but it also offered protection to Jones from possible white retaliation.[38] The black community's response to these youthful trailblazers reflected a historic tradition, explored by historian Stephanie Shaw, in which African American women helped mobilize their communities to pool resources so that at least some members could secure an education. After *Brown*, however, that tradition was expanded in the hope that all African American children might enjoy the same opportunity.[39]

While black women were instrumental in solidifying broad community backing for school desegregation, they participated in other, less visible ways as well. Local college students and teachers helped the trailblazing students by setting up tutoring sessions at the Walltown Community Center. African American school personnel provided comfort and support to students who faced harassment and physical abuse from white students. Joycelyn McKissick fondly recalled the two black women cafeteria workers at Durham High School who helped her endure those early days of desegregation.[40] In order to alleviate some of the isolation that black students suffered during the initial years of token integration, black women's groups such as Jack and Jill and the Junior Mother's Club organized dances and other social activities for the students.[41] As Evelyn McKissick explained, "I had to keep them from moping and getting lonely."[42]

Despite the community's support, the first students who desegregated Durham's schools faced a daunting task educationally, psychologically, and socially. The most common complaint was that teachers and administrators failed to discipline white students who abused or harassed black students, girls as well as boys. In one incident, twelve white boys surrounded Andree McKissick, Joycelyn's sister, and spat at her on her way to English class; the English teacher claimed she was powerless to intervene, since the episode occurred outside her classroom. One student emptied a fountain pen all over Joycelyn McKissick's new yellow dress, while other students tripped her in

the hall, shoved her into lockers, and pushed her head into a toilet. Black students also were subjected to humiliating public displays of racism. In a 1962 talent show at Durham High School, a white boy walked onto the stage in blackface with a chain around his neck. When several African American students complained to the principal, they were told they "only had a chip on their shoulder and shouldn't be mad."[43]

Frequently, whites met black protest with increased harassment. After black students demonstrated at Durham High School over a speech by Governor Terry Sanford about improving education, a white girl hit Claudia Dixon, other students flung food at her during lunch, and someone scrawled "KKK will kill all niggers" on her desk. Following Durham's largest mass demonstrations in May 1963, Frances Marrow was shoved into a water fountain from behind and pushed down the stairs at Carr Junior High School. When she asked the dean if she could leave school, the administrator responded that she would only "be running away from the problem." Floyd McKissick's recollections of these early years of desegregation were especially vivid: "The kids would come home from school every day crying," he said. "Many of them didn't want to go back. . . . [They'd] come home with an inch of hair pulled out of their heads, ink, glue, molasses on them. . . . [Teachers] wouldn't let them go to the bathroom sometimes. . . . To clean those kids up every day and pray with them at night and send them back to school every day was one hell of a fight."[44]

Early desegregation efforts put intense strains on families, and black women often bore the brunt. Evelyn McKissick held down a job, worried about her three children who were desegregating the schools, and supported her husband Floyd's activism, but the stress created tension in their marriage and took a toll on her physical health. In another black family, one of the girls reported that she and her siblings often went without lunch so that their sister could buy her lunch at Durham High. "We didn't have clothes, you know; we wore hand me downs and shoes with holes in them and things like that so that she would look . . . good going to Durham High. . . . It was really traumatic on our family," she recalled.[45]

The Sit-in Movement

By the late 1950s, legal action, petitions, surveys, and threats had yielded little change. Black youth were growing impatient with white resistance and black adult leadership. A year after the Royal Ice Cream sit-in, the North Carolina College NAACP chapter chafed at the Durham Committee on Negro Affairs' refusal to back a publicity campaign against Durham's segregated

theaters. "How long can we patronize segregated movie houses and eating places and yet hope to escape from complete and eternal Jim Crowism?" the NCC *Campus Echo* wondered. Dismissing their elders' more cautious tactics, the editors exhorted their peers to refuse to patronize segregated theaters, enter "colored" waiting rooms, or drink from "colored" water fountains. In the fall of 1959, participants at a statewide NAACP youth conference urged adults to adopt more militant strategies and discussed "sit-down strikes in eating places such as bus and train stations and dime stores."[46] But at the January 1960 state NAACP meeting, adult leaders insisted that voter registration would be their focus for the upcoming year.[47] Two days later, four black students in Greensboro ignited a movement across the South that forced adults to reorder their priorities.

One week after the Greensboro lunch counter sit-ins, about twenty male and female youth sat in at the Woolworth's, S. H. Kress, and Walgreens lunch counters in downtown Durham.[48] The protesters were mostly NCC students, but the group also included three white Duke students and a white CORE worker from New York. By the end of the week, blacks in Raleigh, Fayetteville, Winston-Salem, and Charlotte were sitting in as the movement spread throughout the region. White store owners in Durham panicked at the sight of the dignified and well-dressed protesters; girls wore dresses, while boys sported shirts and ties. At Woolworth's, the manager closed the entire store after someone telephoned in a bomb threat. When the protesters, now about forty to fifty strong, moved on to Kress's, the manager hastily shut down the lunch counter. The group then marched toward Walgreens but found the lunch counter already roped off. Rose's responded by making sure that white customers had taken all the seats by the time the protesters arrived.[49]

Hoping to paint the sit-ins as the work of white "outside agitators," police made no arrests but detained a white Duke divinity student and the white CORE official, Gordon Carey. Rev. Douglas Moore, leader of the abortive sit-in three years earlier, and attorney Floyd McKissick hurried to the police station and demanded to see the two white men. "I told them they could see them after we finish our questioning," Detective W. E. Gates said. "[You are] getting on dangerous ground," McKissick warned the police. Although local activists had invited Carey to North Carolina, his New York address fed charges that the sit-ins were the work of northern troublemakers. "We are not going to tolerate this agitation from outsiders," the local police captain admonished. The *Durham Morning Herald* fanned white fears of Yankee instigators by featuring a front-page photograph of Douglas Moore seated next to Gordon Carey at the Kress's lunch counter sit-in, pointing out that Carey was

from New York and erroneously reporting that he had been "arrested" and "booked for investigation."[50]

On the other side of the color line, however, the response was quite different. "Praise the Lord!" proclaimed a local black woman upon hearing about the lunch counter sit-ins. Certainly, she captured the sentiments of many in the African American community who rallied behind the youthful protesters. The *Carolina Times* praised the students and justified the sit-ins as the "results of years of pent-up suffering, humiliation and injustices." Despite the initial apprehension of some adults, the sit-ins received considerable backing from the traditional black leadership. Meeting on the evening of the first sit-ins, Durham's black Ministerial Alliance, which had refused to endorse the Royal Ice Cream sit-in three years earlier, passed a resolution pledging its "moral, spiritual and financial support." After the Reverends Martin Luther King Jr. and Ralph Abernathy appeared in Durham to cheer on the nascent protest movement, the Durham Committee on Negro Affairs also publicly endorsed the sit-ins.[51]

At White Rock Baptist Church, one of Durham's most prestigious black churches, an overflow crowd of 1,500 gathered to encourage the youthful demonstrators. Rising to address the audience, Rev. Douglas Moore hinted at more drastic measures: "I wonder how many would refuse to patronize the merchants who are unwilling to serve Negroes seated at lunch-counters." And in a direct appeal to black women, Moore asked, "How many would be willing to give up Easter outfits to help finance our work?" The crowd leapt to its feet in answer, a visible symbol of the new determination sweeping through black Durham.[52]

While black women did not attract as much publicity as some of the more visible male leaders, they were critical players in Durham's first massive direct action protest. In one group of student pickets in the spring of 1960, eighteen of twenty-two protesters were female; at a Walgreens protest, seven females and three males demonstrated, while protesters at Woolworth's and Kress's were evenly split between males and females. More males than females appear to have been arrested, although not by huge numbers and not in every case; for example, in a group of Hillside High School students who were arrested, girls outnumbered boys two to one.[53]

Black Protest and White Reaction

Mayor Emmanuel Evans responded to this new level of black insurgency by urging the Human Relations Committee to negotiate a settlement. Despite their misgivings, the demonstrators agreed to halt further protests while ne-

gotiations proceeded. Woolworth's and Kress's closed their lunch counters in the "interest of public safety," insisting that their policy was "to go along with the local customs on the question of segregation." Rose's adopted the novel approach of removing all its stools, prompting Harry Golden, wry editor of the *Carolina Israelite*, to propose his "Vertical Negro Plan" as a solution to the state's segregation problem: since whites seemed to object only to sitting with Negroes, the wag suggested, why not simply remove all seating from public facilities and schools?[54] The lunch counters soon reopened on a segregated basis, confirming student suspicions that the negotiations had been merely a stall tactic. Calling the merchants' action a "serious breach of faith," student demonstrators from North Carolina College, Durham Business College, Hillside High School, and DeShazor Beauty School (who reportedly received extra course points for demonstrating) targeted the three stores. One placard underlined the absurdity of Jim Crow: "We Cook Here, Why Can't We Eat Here?"[55]

Black youth may have seized the initiative, but white officials and the established black leadership proceeded as they had for decades, negotiating behind the scenes and excluding women and youth. When the protests resumed in early March, Human Relations Committee chair Rev. Warren Carr, hoping to resolve the crisis, convened a secret group of about thirty black and white leaders. No women were invited, and student activists and merchants were absent as well. Watts Hill Jr., one of Durham's leading white power brokers, helped select the white participants, making sure to bar any die-hard segregationists, while North Carolina Mutual Life Insurance Company president Asa Spaulding chose the black participants, who were mostly other black businessmen.[56] However, this was a new day, and neither the traditional black leadership nor the Human Relations Committee, which had no official power, could devise a solution acceptable to all parties. Nor could they halt the demonstrations.

Most white Durhamites looked with trepidation and even outright hostility at the struggle emerging on their streets and in their region. The *Durham Morning Herald* accused the protesters of "trying to accomplish an end by force . . . [which even if] non-violent, constitutes a hazard to community life and relations" and warned that "the militant approach" would only sully Durham's reputation.[57] Not only did most whites refuse to support desegregation, white antagonism mushroomed in response to black protest. In the Democratic gubernatorial primary in June of 1960, I. Beverly Lake, an ardent segregationist who had actively opposed school desegregation as assistant attorney general, narrowly defeated white moderate Terry Sanford in Durham

(although Sanford won statewide). The following year, a poll revealed that 63 percent of Durham whites favored segregation and only 15 percent of whites endorsed integration compared to 86 percent of blacks.[58]

Even the white clergy offered only lukewarm support and refused any leadership role. The members of Durham's white Ministers Association promised to encourage community support, but only "so far as we are able." Although they assured local merchants that they would patronize desegregated establishments, ministers stressed they could do so only as individuals. Rather than condemning racial discrimination and white violence, these men of the cloth chose instead to castigate the protesters for resorting "to open, aggressive and coercive demonstrations."[59]

At the all-white Duke University, student anger at missing a football game elicited greater indignation than did racial injustice. The university continued to back segregation, and the student government blocked a campus NAACP chapter from forming.[60] Some Duke students, administrators, and faculty, however, were more sympathetic. Five hundred Duke faculty and students signed a petition supporting the demonstrations, identifying themselves as "non-Negro persons [who] reside or shop in Durham" since most white officials dismissed Duke faculty and students as unrepresentative of majority white opinion in the Bull City. The Duke Woman's College Student Government Association expressed its "sympathy for this attempt to attain justice for the Negro" and endorsed nonviolent protest by a 2–1 margin while also leaving the decision to "act or abstain from action . . . to the conviction of individual consciences."[61]

Religious organizations such as the YWCA, the YMCA, and the Methodist Student Union inspired the most support for civil rights activity on campus. Sara Evans and Charlotte Bunch found their way into the movement through such organizations. Evans recalled the influence of Barbara Benedict, the associate director for religious life at Duke's woman's college. Benedict arrived in Durham in 1956 and had worked steadily to broaden the horizons of campus Y women, especially on matters of race. Although the YWCA was one of the most popular organizations on campus, Duke students had been slow to join the postwar student Y movement in the South, which grappled with issues ranging from international peace and economic exploitation to racial injustice.[62] By 1961, however, Benedict reported "a significant new mood on campus in contrast with my first one or two years here at Duke . . . [and with] the real apathy to social issues . . . which existed five years ago."[63] Movement participants counted Benedict among the stalwart white allies of Durham's black freedom movement, and in the early 1960s she worked with the campus

Y to recruit student pickets to protest racial segregation at downtown lunch counters, movie theaters, and stores.[64]

Among some Duke students, religious conviction prompted genuine commitment to the black freedom struggle. Joan Nelson, a devout Christian from Macon, Georgia, was a case in point. She participated briefly in the demonstrations in Durham before going to Mississippi as a freedom rider and landing in Parchman Penitentiary in 1961, where she mediated disputes between northern white women and southern black women activists. But Nelson did something even more unusual for a white southern woman that left black activists with fond memories of her dedication: she chose to get married (becoming Joan Nelson Trumpauer) at St. Joseph's AME Church, one of Durham's most prominent black churches and the meeting ground for black student activists. Moreover, she was married by Rev. Melvin Swann, the pastor at St. Joseph's and one of the most active black ministers in Durham's freedom movement.[65]

Although white allies were never as vulnerable as black movement participants, they sometimes paid a price for their activism. Duke threatened to revoke the scholarships of several students who had been arrested in the Durham sit-ins in the spring of 1960; others were lambasted in the student press by staunch defenders of so-called southern custom.[66] The Durham County Welfare Department censured two white caseworkers, Edith Back and Nan Pattie, for picketing segregated movie theaters in Chapel Hill, even though the women picketed during nonwork hours and the theaters were not in Durham County.[67] Another woman's public support of the sit-ins drew a note of appreciation from Floyd McKissick. In a letter to the Durham Sun, Jerry Ann Peoples, a white nurse at Duke Hospital, pointed to her southern heritage as a basis for racial harmony and rejected store owners' insistence that local custom mandated segregation. "Perhaps the manager of a store here in town would like to know that he lost at least one white customer today," Peoples announced.[68] Floyd McKissick understood the risk she took. "More than anything else I admire you for your courage . . . and secondly for being able to express your views in the face of severe criticism and possible ostracism," he wrote. "I believe many whites may share your opinion but few would ever have the moral conviction or courage to write the same and have it published as you have done."[69]

Far less vulnerable was Mary Duke Biddle Trent Semans, the prominent daughter of the influential Duke family, who urged white women in particular to lend their "special qualities . . . [of] sympathy, humanity and special understanding of the individual and his problems" to the cause of black

freedom. Evoking essentialized notions of womanhood, Semans called on white women whose "responsibility for maintaining the moral standards and values" of community life meant that they were "needed on human relations councils in every community to give their best to ease racial difficulties and social strife." Among recently integrated women's organizations, the Women's International League for Peace and Freedom stood out for publicly applauding the "Negro student movement" and pledging its support to the young protesters.[70]

White merchants erroneously assumed the demonstrations would cease when North Carolina College students left town for the summer. But protesters kept up the momentum, picketing and boycotting local stores and braving scores of arrests. Rumors of extending the boycott to the entire downtown shopping area worried other business leaders, as the protests showed no signs of weakening. Finally, at the end of July, the store managers relented, making Durham the seventh city in the state to desegregate its lunch counters.[71] Durham had indeed turned a corner, but only because black youth refused to back down. On the one hand, it was a quiet revolution, years in the making. From another vantage point, it was just the beginning of the long march toward freedom.

Expanding the Movement

Buoyed by their victory at the five-and-dime stores in July 1960, civil rights activists attacked segregation in theaters, motels, and restaurants. But they were equally concerned with the limited employment opportunities available to blacks. For example, white employers had repeatedly refused to hire African American sales clerks even for temporary jobs during the Christmas season, claiming that none were qualified. Hillside High School set up a sales training course, but after nineteen black women successfully completed the course, store owners continued to employ only white clerks. In January 1961, one department store promoted a black cleaning woman who had worked at the store for several years to salesperson in the children's department, but there were no other signs of progress. At a joint meeting, Durham's seven NAACP youth chapters, whose combined membership totaled about 1,000, decided to give store owners one last chance to implement nondiscriminatory hiring practices. Employers refused to budge. Within twenty-four hours, NAACP youth groups located nine cars and drivers and distributed 20,000 handbills throughout black neighborhoods, calling for a boycott of downtown stores to coincide with the Easter shopping season. The next morning, the Carolina Times carried a front-page story listing the targeted stores and

explaining the rationale for the boycott. Several days later, NAACP official Ruby Hurley addressed a crowd of 2,000 at St. Joseph's AME Church, helping to rouse black support for the boycott. Students maintained up to ten pickets outside the targeted stores, designating certain days as Family Day, University Day, or Minister's Day in order to sustain broad community backing. White students and faculty from Duke University also joined picket lines. Meanwhile, a negotiating committee comprised largely of NAACP youth members clung to its ground rule: demonstrations would cease only if each targeted store hired at least one black employee. Students compiled a "Weekly Approval List" of stores to patronize and distributed the list at both black and sympathetic white churches throughout the city. Soon, most of the targeted stores had capitulated. After years of complaining that they could find no qualified Negroes, twenty-three employers hired over fifty Negroes for nontraditional jobs. It had taken less than two months and the determination of youthful protesters backed by a supportive black community.[72]

By 1962, Durham's citywide NAACP youth council, which boasted a number of talented young black women activists, had become one of the most effective NAACP youth chapters in the nation. "I can think of no other group (youth or adult), NAACP or otherwise, which is doing a better job of carrying on as militantly and yet, tactfully, as our young people in Durham. . . . thanks and congratulations . . . for the fine example which they have set for the organization throughout the nation," an NAACP official from the New York office wrote.[73] Statewide, however, NAACP membership had begun to decline after rising steadily throughout the 1950s and enjoying a boost in the wake of the sit-in movement. Activists blamed the decline on national leaders' refusal to fund more field workers and their equivocation over direct action protest, which resulted in students drifting to other groups, such as the Congress of Racial Equality. In response, the national office agreed to help finance the NAACP Youth Commandos, a select group of seasoned student activists in North Carolina. Most were from Durham, and a third were female, including student movement leaders Joycelyn and Andree McKissick, Vivian McCoy, and Minnie Fuller. The exclusively black group journeyed to cities and towns throughout the state, sharing its enthusiasm and expertise. The Commandos even formed a singing group, adding an important dimension to their movement skills.[74] Despite the large number of females in the new youth organization, the all-black group adopted some of the accoutrements that would later become associated with Black Power machismo. Sporting black jackets with "Commandos" emblazoned in large white letters

on the back, the activists traveled in teams, training local people in nonviolent tactics and helping to organize direct action protests.[75]

Nonviolence and Armed Self-Defense

Despite movement leaders' commitment to nonviolence, Durham blacks were not uniformly passive, especially in the face of white attacks. After white thugs tossed firecrackers and bricks into a crowd of black demonstrators, attacked a black man, and broke a black woman's leg in 1963, African American youth retaliated by stoning cars in the downtown area, some with white passengers inside. The *Carolina Times* denounced such behavior and called for black residents to report the offenders to the police. Yet black anger was not easy to contain, and Floyd McKissick frequently pulled knife-wielding protesters off picket lines. Similarly, distinctions between well-trained, nonviolent demonstrators and black onlookers who sometimes resorted to violence often blurred. As Joycelyn McKissick remarked, "I'm not so sure nonviolence was a natural state for an adolescent to have assumed."[76]

At times, black women were particularly adept at bridging the gap between nonviolent protest and armed protection. During a meeting of 700 to 1,000 student activists one evening at St. Joseph's AME Church, a crowd gathered outside the church. According to Mrs. Bessie McLaurin, the church had received bomb threats, but the night darkness made it difficult to determine who was outside. She was sure some of them had weapons, but McLaurin decided to confront them and, she hoped, prevent racial combat. After someone in the crowd called to her, she recognized the boy as one of her former students. The black youth then formed a protective human barrier around the church while she and others called for cars to transport the students inside safely back to campus. Undoubtedly, McLaurin's prestige as a teacher and a well-known community worker enabled her to negotiate a truce between the proponents of nonviolent resistance and those who insisted on armed self-defense.[77]

To prepare student activists for peaceful civil disobedience, adult black women and men drilled them both before and after demonstrations. Floyd McKissick organized prayer meetings and classes on nonviolence. "Direct action requires a greater risk," McKissick explained some years later. "You are out there when you take a direct action. You are totally exposed." Following each demonstration, activists reconvened, usually at St. Joseph's Church and often under the direction of adult black women such as Sadie Hughley, to analyze what had happened and to learn from their mistakes. Those who

eschewed nonviolence made picket signs, cooked, and arranged for transportation. But even activists who accepted nonviolence, whether philosophically or merely tactically, found it a struggle.[78]

It would be a mistake, however, to assume that only black males were ambivalent about nonviolence. Women and girls also sometimes found nonviolent discipline difficult to maintain. The physical and verbal abuse white students leveled at Joycelyn McKissick at school subsided after she finally hit someone back. Whites ceased harassing Cora Cole-McFadden at Durham High School after she retaliated verbally by calling the offending boys "crackers." Mrs. Margaret Turner, a tobacco worker whose teenage children had pulled her into the movement, recalled vowing to strike back if a nearby policeman hit her with his billy club during a demonstration outside an Eckerd's Drug Store. When a white male poured hot soup on Vivian McCoy and Audrey Mitchell during the 1960 lunch counter sit-ins, McCoy remembered her reaction: "I got mad as hell," she said. Although at the time she refrained from retaliating, she admitted later, "I wanted to knock the shit out of him." In fact, McCoy's impulse to fight back influenced her decision not to desegregate Durham schools.[79]

Nor should such apparent inconsistencies surprise us, for, as historian Tim Tyson has pointed out, nonviolent protest and armed self-defense coexisted in the southern black freedom movement "in tension and in tandem." The "official" protesters at times openly accepted the assistance of blacks who explicitly disavowed the principles of nonviolence. Reflecting the cooperative relationship between Floyd McKissick and the Black Muslims, the local Fruit of Islam protected activists from hostile whites during the May 1963 demonstrations. Sporting black berets, the Muslims locked arms in a human barricade along Pettigrew Street, the line separating black and white Durham. They parted "like the Red Sea," allowing the marchers to proceed downtown, and then closed ranks to keep white hecklers out of the black section of town. After Evelyn McKissick received several bomb threats and neighbors reported suspicious behavior from a white driver in front of her house, the Muslims acted as armed guards of the McKissick home for a month. "They had weapons, they were ready," Floyd McKissick recalled. Most activists may have been publicly committed to nonviolence, but just as Daisy Bates and Martin Luther King Jr. had secured armed guards after their homes were firebombed and dynamited, so too did Durham blacks understand the reality of racist violence in the Jim Crow South, and they took precautions to protect themselves and their families.[80]

Malcolm X Comes to Durham

Both Joycelyn McKissick and Vivian McCoy, student leaders in the non-violent protest movement, admired and respected Malcolm X, perhaps America's most vilified advocate of armed black revolution. When Floyd McKissick, over the FBI's objections, agreed to debate the renowned Black Muslim leader, Durhamites on both sides of the color line were irate. While there were important differences between the two men, particularly regarding nonviolence and nationalism, there was much that united them. Unlike a number of black leaders, including Louis Austin, who refused to print news about the Durham Muslims in the hope "that [they would] wither away from lack of public attention," McKissick enjoyed amicable relations with the Black Muslims in Durham.[81]

Not surprisingly, white officials were apprehensive about Malcolm X's arrival in town and refused to allow him to speak at a city recreation center, forcing the nationally acclaimed black nationalist to appear at a privately owned black auditorium. Addressing a packed audience, he announced: "The white man in America is on a sinking ship. His time has come to suffer the mistreatment of the black peoples by his ancestors." He linked the African American struggle for freedom to third world liberation movements and warned: "All countries which have participated in colonialism have suffered except America. Now her day has come." Even those who disagreed with the eloquent Muslim leader were impressed. "He was my idea of an orator," Vivian McCoy remarked. Floyd McKissick seized the opportunity to remind whites that more militant tactics might be necessary and predicted that the Muslims, who numbered about 200 locally and recruited followers from pool halls, street corners, and prisons, would continue to grow unless whites made "a more conscientious effort to meet the reasonable demands of more peaceful Negro protest groups." When students at North Carolina College tried to schedule a second appearance by Malcolm X, President Alphonso Elder, who was vulnerable as the head of a state college, refused to allow him on campus. Joycelyn McKissick offered her blue Studebaker to the controversial leader, who stood atop the makeshift speaker's platform and delivered another fiery oration. McKissick's exercise in free speech earned her a suspension from the university for two weeks.[82]

The NAACP and CORE

As some movement participants wavered between nonviolence and self-defense, the Durham NAACP contended with growing internal divisions exacerbated by the national office's ambivalence regarding direct action. The

tension created space for the Congress of Racial Equality's emergence in Durham and throughout the state as a cutting-edge advocacy group. CORE, founded in 1942, had begun as a nonviolent interracial organization based in the North, but as the organization moved South it became blacker and more militant. Much to the chagrin of the NAACP, CORE rekindled protests throughout North Carolina in 1962 and 1963.[83] Although CORE had played a role in the 1960 sit-in movement in a number of Tar Heel cities, including Durham, its 1962 Freedom Highways crusade enhanced the organization's influence throughout the state; the following year, Durham activists formed a local CORE chapter. CORE's Freedom Highways project was designed to desegregate all eating establishments on major highways in the East, targeting North Carolina and Florida in particular. CORE worked closely with the NAACP in Durham, even as national NAACP officials worried that their organization might not receive its share of credit or publicity. Most students, however, cared little for such interorganizational disputes. "When you get out there and get your heads busted in together, nobody gives a damn about whether it's NAACP or CORE," remarked Joycelyn McKissick. "Everybody was one family."[84]

CORE offered new opportunities for women activists to lend their energies to the movement. About twenty-five CORE members arrived in Durham in 1962 and set up headquarters at Rev. Melvin Swann's St. Joseph's AME Church, while local black women activists, including Sadie Hughley, Evelyn McKissick, and Bessie McLaurin, housed and fed them. CORE focused on integrating public restaurants and also backed local NAACP efforts to secure more jobs for blacks. Together, CORE and the Durham NAACP targeted Howard Johnson's and Eckerd's Drug Store, setting up pickets in late July 1962. Although Eckerd's had desegregated its lunch counter and African Americans comprised half its customers, managers refused to hire black clerks. In early August, police arrested four youth at the local Howard Johnson's for requesting service during what one local wag called a "stand-in." The youths—including two African American women, Joycelyn McKissick and Guytana Horton, NCC student and president of the state NAACP intercollegiate division—refused to pay a trespass fine. The judge sentenced them to thirty days in jail, forcing the men to do their time on the county road gangs while ordering the women to the county work home, where they worked as maids caring for elderly patients.[85]

The students' jail sentences, particularly those of the young women, galvanized local blacks. Supporters gathered nightly outside Joycelyn McKissick's and Guytana Horton's jail cells and sang spirituals to boost the women's

spirits (and perhaps also as a measure of protection for the young women). Within a week, NAACP executive director Roy Wilkins and CORE director James Farmer arrived in Durham to address a huge crowd at St. Joseph's. Inspired by the rally, more than 1,500 blacks crammed into 200 cars and 4 buses for a spontaneous demonstration outside the Howard Johnson's where the jailed protesters had been arrested. Described by one veteran Durham observer as "one of the greatest displays of racial unity" in the city's history, factory workers, taxi drivers, and domestics stood alongside North Carolina Mutual executives, attorneys, housewives, and students. Whatever class, generational, or political differences may have divided them, Durham blacks stood united, at least for now. The following week, as CORE-sponsored protests spread to Statesville, Raleigh, and Charlotte, 1,000 blacks braved "tropic-like humidity" at a freedom rally in a Durham church where Floyd McKissick, Louis Austin, and James Farmer called for "stepped up efforts" against discrimination. Heeding the call, 500 demonstrators once again headed to Howard Johnson's, where a trio of white, "grim-faced" men, including manager Clarence Daniels, stood ready to block anyone who dared to challenge Durham's racial dining etiquette.[86]

CORE and the NAACP vowed to continue their demonstrations, and black women readily lent their voices and bodies to the effort. Ruby Hurley, the NAACP southeastern regional secretary, addressed a crowd of 2,000 at St. Joseph's AME Church, promoting community support for the students' actions. Black women's social clubs, sororities, and even garden clubs invited students to tell their stories and donated funds.[87] By the end of August, over 80 protesters had been arrested, and 15 activists in Durham, Raleigh, Charlotte, and Statesville had received thirty-day jail sentences as a result of the Freedom Highways project, with no end in sight. By fall, half of the Howard Johnson's restaurants in North Carolina had agreed to desegregate, but Durham's manager remained intransigent.[88]

In September, Joycelyn McKissick and Guytana Horton obtained early release after serving eighteen days of their thirty-day sentences. The two women fought back tears as they stood before hundreds of well-wishers who had come to "welcome them back to freedom." Horton and McKissick immediately set out for the Howard Johnson's where they had been arrested. Manager Clarence Daniels met the women at the entrance, but when they tried to shake his hand he snarled: "Get out of here niggers. I told you not to come back anymore."[89] Clarence Daniels's racial slur was not the last word on the matter, however, for Howard Johnson's policies would soon become the target of the largest mass action by Durham blacks in the city's history.

Although activists were frustrated by white obstinacy, in October a ruling by the U.S. Court of Appeals for the Fourth Circuit in the school desegregation case offered an opportunity for celebration. The court reversed a lower court decision dismissing the NAACP suit and ordered the Durham school board to accept all previously rejected reassignment requests from black parents. The court also ordered the board to submit a desegregation plan for court approval by May 1963. The *Carolina Times* hailed the decision as a "second emancipation," while national NAACP lawyers called the ruling the most significant decision since *Brown*. But the victory was marred by the agonizingly slow pace of change, for it would take several more court battles before Durham's public schools finally desegregated.[90] Nor was substantive change forthcoming in other areas of concern, such as public accommodations, employment, and housing. Despite black frustration with the slow pace of change, however, direct action was difficult to sustain. The black community was growing weary of sacrificing so much for so little gain, and the old class divisions that had plagued the "capital of the black middle class" threatened to fragment black unity.[91]

The May 1963 Demonstrations

Although momentum built slowly, several issues of particular concern to black women presaged a new direction in the movement and helped to rekindle black insurgency during the spring of 1963. White merchants who had hired African Americans two years earlier had quietly fired them and demoted a number of saleswomen to maids. "In one store the Black saleslady wears a white uniform while other salespersons wear street clothes," an investigation by the local NAACP youth chapters found. "In another store Black salespersons are hidden on an upper floor or in the basement and are found cleaning and scrubbing rather than selling." Students organized a boycott of sixteen downtown stores timed to coincide with the Easter shopping season. Protesters demanded that each store immediately hire two to three blacks in nonmenial jobs while pledging to hire more. By the second month, class tensions—which would intensify over the next few years—once again threatened to splinter the movement as NCC teachers and administrators crossed picket lines and other middle-class blacks continued to patronize the targeted stores by calling in their orders. In spite of the wavering middle-class support, eleven of the sixteen stores eventually complied with the pickets' demands, making the Easter boycott the most successful action since the 1960 lunch counter sit-ins. On the other hand, blacks still had relatively little to show for three years of continual protests. A disturbing pattern had

emerged: white officials acted only when forced to by black protest and then did as little as possible, frequently substituting token gestures for meaningful change.[92]

In April, a fire at the segregated East End Elementary School dramatized white obstinacy and catapulted black working-class women into a controversy that drew directly on women's neighborhood networks and leadership. On the evening of April 24, 1963, a ninth-grade African American boy lit a wad of tissue paper and tossed it into a cloakroom at the all-black East End school. Shuffled in and out of foster homes since the age of two and angry at a teacher, the disturbed youth allegedly went on a fire-setting rampage throughout eastern Durham, venting his rage. By the time the fire department was summoned, it was after 3 A.M., and the school was engulfed in flames. Firefighters managed to save only a dozen classrooms, the library, and the gymnasium, and even these suffered water and roof damage. Total damage to the school was estimated at half a million dollars. Residents in the black, working-class East End neighborhood were shaken by the fire chief's report that this was the worst school fire in the county's history and by city reports that insurance could not fully cover the cost of repairs. But a much larger battle loomed just ahead.[93]

The day after the blaze, with photos of the school's charred remains plastered all over the city's two dailies, the Durham school board announced that the students in the all-black East End Elementary School would resume classes in the partially damaged building, using the dozen classrooms left standing and the gym. The principal's office would be moved into the library. To accommodate the more than 700 students, the school board implemented split sessions, eliminated lunch and recess, and informed parents that students would receive extra homework assignments to make up for the shortened school day. School superintendent Lew Hannen conceded, "This is not a good way to run a school." But in a statement that defied credulity, Hannen and the school board insisted, "The pupils themselves with whom we are chiefly concerned overwhelmingly prefer to remain in their own school." Apparently, Hannen and his colleagues had not bothered to check with the East End community, for parents were outraged at the gross indifference white officials displayed toward black schoolchildren. Adding insult to injury, the school board repeatedly refused to allow the East End students to attend a nearby and only partially filled white school, and it even ignored an offer by East End parents to allow segregated classes within the white school.[94]

Neighborhood women such as Christine Strudwick, wife of a tobacco worker and an active member of the East End Betterment Society, launched

into action. Four hundred predominantly working-class parents, local residents, and members of the East End Betterment Society—three-quarters of them women—signed a petition protesting the school board's decision, and a delegation representing the community presented it at a city school board meeting. Board members were unmoved. The next day, 500 parents and local residents voted to boycott the East End school and set up pickets outside the school. Students from North Carolina College NAACP and CORE chapters joined the picket to show their support and offered to set up tutoring classes for the boycotting students. A news photo showed groups of young black girls marching with signs while NCC students lifted their spirits with songs, including "I Want My Freedom" sung to the tune of "You Are My Sunshine."[95]

Within a week, attendance at the school had dropped by 50 percent, and "absences" soon swelled to two-thirds of the student body. White officials refused to yield, promising only to rebuild the all-black East End Elementary School by the fall. One school board member even hinted that the city might enforce the truancy law on the boycotters. But the black community remained steadfast. Rev. A. D. Mosely, spokesman for the East End Betterment Society, captured its determination: "What Birmingham can do, Durham can do," he warned. Mosely's defiant challenge appeared in the *Durham Morning Herald* alongside photographs of the brutality unfolding in Birmingham, Alabama, where thousands of peaceful demonstrators, including scores of black children, were braving fire hoses, police dogs, and mass arrests in one of the most violent civil rights demonstrations the nation had ever witnessed. After three weeks, only 170 out of 750 students were in attendance at the East End school. Adding legal pressure to street protests, black attorneys included the East End school controversy in a broader legal motion filed with the U.S. district court rejecting the court-ordered school desegregation plan formulated by the school board.[96]

Blacks increasingly were unwilling to leave questions of justice to the courts, however, and the segregationist policies of Howard Johnson's once again became the target of black anger and frustration. Local activists, working primarily through local NAACP and CORE groups, organized three days of the largest mass protests in the city's history, which culminated in a massive demonstration at Howard Johnson's. Women's mobilizing skills were on full display, for the majority of the 4,000 to 5,000 demonstrators who gathered outside Howard Johnson's were African American women. The Durham protests coincided with both the May election of Durham's new mayor, Wense Grabarek, whom the Durham Committee on Negro Affairs had supported, and with the events in Birmingham that had drawn national attention

after police brutally attacked peaceful protesters. The first demonstration began on May 18, 1963.[97] Several hundred marchers set off from the NCC campus to the downtown business section of Durham. Singing and clapping, young people brandished signs exhorting citizens to "Vote to Make Democracy More Than a Word" and mocking the "Progressive City of Discrimination." Demonstrators strode into several stores that had continued their discriminatory policies despite the Easter boycott. Most merchants quickly summoned police. But Harvey Rape, owner of the most popular cafeteria in town, sat at the entrance of his establishment with a shotgun resting on his knees, vowing "to shoot any black man that walked into that cafeteria." When police arrived, they quickly arrested the students, who sang all the way to jail.[98]

As night fell and election returns announced Grabarek's victory, a crowd milled around the jail. Although Grabarek would not be officially sworn in until Monday, Mayor Evans had left town, creating a power vacuum. Police chief William Pleasants called the mayor-elect and asked him to come downtown. "I barely could walk the middle white line of Main Street," Grabarek recalled. "That's the only thing that was separating the two groups, white on the north and blacks on the south."[99] Grabarek met with attorney Hugh Thompson, the designated movement spokesman, who asked for food and cigarettes for the jailed youth. The mayor-elect instructed the police chief to grant their request, and the crowd dispersed.

The next day, 4,000 to 5,000 protesters, mostly women and girls, turned out for the largest black protest Durham had ever witnessed. It began as a rally at St. Joseph's, where national civil rights leaders James Farmer from CORE and NAACP executive director Roy Wilkins addressed a crowd of 1,000. But local movement leaders, hoping to keep the demonstration plan secret from white officials, who might have cordoned off the area around the restaurant, had carefully orchestrated a much larger event at Howard Johnson's, which still refused to desegregate its facilities. Their strategy was to pressure the more conservative black leaders, who might come to hear Farmer and Wilkins but would balk at attending a protest march, into joining the "HoJo" demonstration. Organizers waited until the crowd had assembled at the church to announce the rally at Howard Johnson's. Meanwhile, volunteers, about half of whom were young women, made coordinated announcements at black churches throughout the city. As the word spread, thousands of angry Durham residents headed to Howard Johnson's. Hundreds of students began a spontaneous sit-down strike in the restaurant parking lot and refused to move. Police soon began hauling the students away, at times drag-

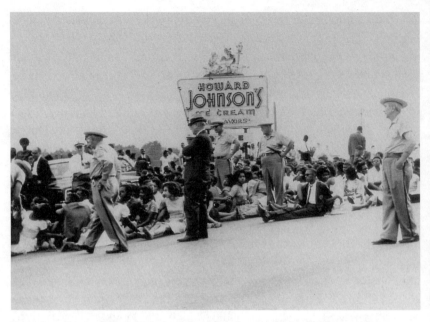

Demonstrations at Howard Johnson's in May 1963 were the largest mass-action protests in Durham's history, and they forced the city to abolish racial segregation in public facilities. *(Courtesy Robert Preston Harriss Papers, Special Collections Library, Duke University)*

ging some of the women. By the time they were done, the jail and the courthouse literally overflowed with protesters.[100]

The huge turnout at Howard Johnson's was a visible symbol of black resolve orchestrated to get the attention of the new mayor. "We sent him one loud and strong [message]," declared Vivian McCoy. "We had to let him know that 'You're taking the weight now, baby.'" The strategy seemed to work; not only did the rally draw more folks than even the planners had expected, but many who might not otherwise have agreed to be arrested were caught up in the excitement, suddenly willing to put their bodies on the line for freedom. According to NCC student Quinton Baker, the momentum and the cameras emboldened many. "The decision to be arrested was sort of made on the spot," he said. Baker, who had agreed ahead of time to avoid arrest, returned to NCC to organize a rally and lead students downtown to show their support for the jailed demonstrators. Hundreds of white hecklers, however, had also gathered downtown. According to Baker, white adults and youth often gathered in spots where blacks had protested the previous day, ready to pelt black demonstrators with apples whose cores had

been replaced with broken glass. "Main Street was a no man's land, with whites and Negroes separated by forty nightstick-wielding policemen," the *Durham Morning Herald* ominously reported. Despite the police presence, whites threw firecrackers into the crowd, and fistfights broke out between blacks and whites. Police arrested only four whites, one for carrying a concealed weapon. Local organizers pledged to begin thirty consecutive days of mass demonstrations. According to one observer, "Durham was right on the brink of racial violence."[101]

On Monday, May 20, a group of students presented their demands to the city council, calling for the immediate desegregation of all public facilities and the adoption of nondiscriminatory hiring policies, especially for municipal jobs. Later, they demanded action on public school desegregation as well. That afternoon, just hours after the new mayor was sworn into office, blacks marched on City Hall. A local minister encouraged the crowd: "Our blood, our sweat, our labor are in American soil. . . . If we continue to demonstrate and pay the price, then we will succeed." Once again, violence erupted, marked by rock throwing and broken windows. Young white men hurled bricks and attacked a black man; in the fracas, a black woman's leg was broken. Another group of whites taunted black protesters and threw firecrackers into the crowd. Police arrived but engaged in only a halfhearted pursuit of the fleeing white teenagers. Yet law enforcement officials wasted no time in forcibly ejecting a group of black students who were peacefully protesting inside the Holiday Inn lobby. In the melee, an officer allegedly hit and kicked Joycelyn McKissick in the stomach. As tempers flared, police summoned the fire department with its hoses. With images of Birmingham still fresh in the minds of many, the crowd quickly dispersed, averting a near riot but leaving behind massive property damage. Three days of demonstrations had resulted in the arrests of 1,400 young protesters—a record number in Durham.[102]

The mass action panicked city leaders. Despite several years of sit-ins, boycotts, and demonstrations, Durham had never witnessed such widespread and continuous protest activity. Unlike most white officials, Mayor Grabarek chose to meet with youth leaders from all the protest groups rather than dealing exclusively with the "established" adult black male leadership. He also appeared to sympathize with some of the movement's demands. The following day, the mayor stood before a gathering of over 1,000 blacks at St. Joseph's AME Church and assured the crowd, "The demonstrations . . . have accomplished their intended purpose to the extent of alerting the entire city of the seriousness and sincerity which the Negro attaches to them." Many blacks were impressed by the unprecedented appearance of a white Durham mayor

at the African American church, and they chose to ignore Grabarek's paternalism as well as his standard defense of order over justice. "[Your] agreement to forego demonstrations at this point proves to me that you deserve the rank of first-rate citizens," Grabarek intoned. The crowd responded with a standing ovation. Calling for the "cooperation and understanding of all people," the mayor promised that "the peace, tranquility and good will" of the city would prevail. John Edwards, one of the student leaders, even accepted a ride home from the mayor that evening. "We felt Grabarek was going to be one of the most liberal mayors Durham ever had," Edwards recalled some years later.[103]

Despite their huge numbers at the demonstrations, black women once again failed to attract official notice. The next day, the mayor announced the formation of the eleven-member Durham Interim Committee (DIC), which included only two African Americans, businessmen John Wheeler and Asa Spaulding, and no women. Grabarek believed that the white community had to change and that most whites were loath to accept direction from Durham blacks. In a politically shrewd move, Grabarek appointed his rival in the mayoral election, Watts Carr Jr., one of the scions of white Durham, to head the DIC.

At first glance, it looked like the same old response—white officials forming a committee of prominent white businessmen and civic leaders, giving token representation to the traditional black male leadership. But Wheeler, in particular, was careful to clear any DIC decisions with the protest movement, which was represented by an eleven-member negotiating committee cochaired by Floyd McKissick and NCC student leader Joyce Ware. Women (among them Bessie McLaurin and Sadie Hughley) as well as youth were well represented on the negotiating committee. In a letter signed by Joyce Ware and Floyd McKissick, movement participants warned Grabarek that they would "not be bound by any decisions" of the mayor's appointed committee if its recommendations did not "correlate with" the participants' "outlined objectives," which they had shared with the mayor.[104]

Early on, however, there were signs of white equivocation. According to Grabarek's instructions to the DIC, any agreement had to be reached free of coercion. Racial justice, therefore, would hinge on the "voluntary" consent of white segregationists. Blacks had agreed to call off any further protests while the DIC met, but both sides understood that demonstrations would resume if substantive results were not forthcoming. By July, the DIC had negotiated an agreement with the city. Although Durham did not officially repeal its 1947 ordinance mandating segregation in public eating places until the

fall, 90 percent of restaurants, all eleven motels, and the one hotel in Durham "voluntarily" agreed to desegregate. The high level of compliance among restaurants was due partially to the influence of Harvey Rape, the gun-toting owner of the popular Harvey's Cafeteria, where the AAUW had held dinner meetings until black women forced the group to abandon its segregated meals. The volatile restaurateur initially refused to join the DIC. But at 11 P.M. one evening, Rape telephoned the mayor in tears, explaining that he'd experienced a religious transformation and decided that segregation was a sin. Rape agreed to sit on the DIC and to serve as a liaison to local proprietors.[105]

Although the settlement clearly hinged on the threat of mass demonstrations, it was important to white politicians and business owners to maintain the illusion that they had acted voluntarily to preserve the city's peace and reputation. Yet plenty of behind-the-scenes arm-twisting and compromise had accompanied the "voluntary" agreement. Banker Watts Carr reportedly applied economic pressure by threatening to call in loans on several local businesses if they refused to support the settlement. But by clinging to the fiction of a voluntary settlement, white leaders hoped to obscure the real reason for change: they had been forced to desegregate by the unwavering resolve of a united black community.[106] Moreover, the foundation of that unity was critically dependent on black women. Still, despite the gains of the May demonstrations, it remained uncertain just how long Durham blacks would abide by white definitions of progress in the crucial matter of African American freedom.

Linking the 1950s School Desegregation Campaigns and 1960s Direct Action Protests

The community organizing drives that women and NAACP youth waged during the school desegregation campaigns following *Brown* proved indispensable to the direct action phase of the movement in the 1960s. Many of the youth activists involved in the 1960s protests came from working-class neighborhoods—particularly Walltown, Hickstown, and the East End—where black families had stepped forward to challenge the school board's discriminatory pupil assignment policy. Marva Bullock, a high school student from the East End, and her younger sister, Linda Mae, were plaintiffs in the 1958 NAACP lawsuit against the Durham school board. When the sit-ins began in 1960, Marva joined one of the protests at Walgreens, where she was kicked in the stomach by a white man. Joycelyn McKissick and Maxine Bledsoe were among the handful of students who desegregated Durham's schools

in 1959 and 1960, and both became deeply involved in the direct action movement in the early 1960s.[107]

Many student leaders in the 1960s movement came from the same working-class neighborhoods where Floyd McKissick had reactivated NAACP youth chapters in the 1950s, attracting large numbers of girls. Alma Turner, whose mother, Margaret Turner, was a tobacco worker, and Vivian McCoy, whose mother was a licensed practical nurse and whose father was an itinerant preacher, joined NAACP youth groups in the 1950s, becoming prominent figures in the sit-in movement.[108]

Some African American girls were drawn into the movement by older friends. Cora Cole-McFadden, who desegregated Durham High School in the early 1960s, grew up in the tight-knit black working-class neighborhood of Brooktown, located near Duke University. Cora's father worked as a janitor at the county courthouse, and her mother took care of a white boy. Following Cora's father's death and her mother's illness, her older sister became "the primary breadwinner for the family." When the demonstrations started in Durham, Cora was about thirteen or fourteen, and she ventured downtown with her friends to watch. "We could see people marching and [we] were just [real] excited," she recalled. Her mother, who suffered from a heart condition, was terrified for Cora's safety and refused to allow her young daughter to participate. "You never knew what was going to happen to you from day to day," Cora conceded. But her desire to join the demonstrations outweighed both inhibitions and prohibitions. "Well I would march, but I would get behind someone else [to hide.] . . . I've always been fairly adventurous," she explained.[109]

Redefining Women's Leadership

Women, especially among the youth, sometimes held influential positions in the direct action movement, and some occupied formal leadership positions. North Carolina College student Guytana Horton was president of the statewide NAACP intercollegiate division. Nancy Grady was president of an active NAACP chapter at DeShazor Beauty School and was a recognized leader in the early 1960s student protest movement.[110] More frequently, women assumed informal leadership rather than titled positions. Both Joycelyn McKissick and Vivian McCoy were part of an unofficial strategy committee of six students who planned and organized demonstrations throughout the early 1960s. Even behind-the-scenes work involved more than simply licking envelopes or running mimeograph machines; it could and did frequently entail leadership. "We didn't have leaders in terms of elected [peo-

ple]," explained one of the students. "We had people who became leaders . . . because they took the bull by the horn[s] and were there everyday and made the sacrifices. That's who were the leaders."[111]

Scholarly focus on student participation in the Student Non-Violent Coordinating Committee (SNCC) and the Congress of Racial Equality, where young black women often enjoyed new opportunities for activism and leadership, has obscured the extent to which a similar pattern was evident among many NAACP youth councils. In cities like Greensboro and Durham, NAACP youth chapters were in the forefront of local community struggles, and student activists often performed similar tasks regardless of gender. Throughout the 1950s and 1960s, both male and female youth canvassed Durham residents in voter registration drives, babysat while adults went to the polls, leafleted, and led pickets. In the winter months, after protests resumed, Betty Jean Bledsoe took charge of the picket lines, rotating people every half-hour so no one got too cold. Churches also offered opportunities for young women activists to address large groups. During the 1960s sit-in movement, females made up at least half of the students who visited local black churches to solicit community backing for the movement.[112] Much as the nonhierarchical nature of SNCC enabled women to take on duties and roles usually reserved for men, in NAACP youth groups Durham women seized opportunities for activism and leadership.[113]

At the same time, new roles for women did not eradicate sexism within the movement. Men spoke much more often than women at mass meetings. Even when they were in the majority, women sometimes relinquished public roles to males. At a July 1961 Durham NAACP Youth Crusaders meeting, fourteen of the eighteen members present were female. When the group decided to sponsor a fifteen-minute radio program to acquaint the public with youth activism, the group appointed two young men who were not even present to head the effort. When it came to the nuts and bolts of organizing work, however, women had the tools. Thus, when the youth volunteered to contact students and encourage them to join the NAACP and the picket lines, eight of the eleven volunteers were female.[114] According to Joycelyn McKissick, black women in the movement showed little concern at the time over the predominance of male leadership. "Let them lead," was their attitude, she said. More recently, however, black women activists, including Vivian McCoy, Cora Cole-McFadden, and even McKissick herself, have been less tolerant of male dominance. At a 1994 reunion of Durham civil rights activists, Joycelyn McKissick angrily declared: "There were male chauvinist pigs in the civil rights movement. Black women did all the work!"[115] While McKissick's shift-

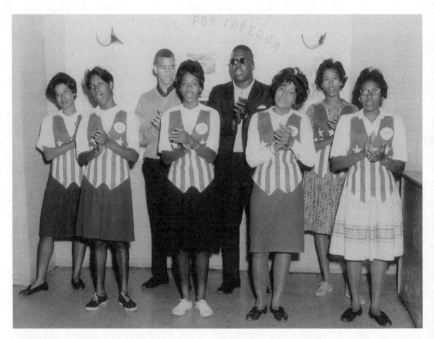

Durham NAACP youth rally. Girls and women often outnumbered males in the NAACP and at the marches and demonstrations that characterized the early 1960s movement. *(Courtesy Floyd McKissick Papers, Southern Historical Collection, University of North Carolina at Chapel Hill)*

ing attitudes toward sexism within the movement seem to indicate an evolving consciousness about gender divisions, her remarks also underscore the extent to which black women's contributions were overlooked and undervalued, sometimes even by the women themselves.[116]

As in the school desegregation struggles, the full extent of black women's participation in direct action was not always visible to those outside the community. Women organized fund-raisers to help defray legal fees incurred by student arrests, and black women's social clubs, sororities, and garden clubs invited students to tell their stories, frequently giving the youth "unsolicited contribution[s]."[117] Nor did such support come only from the middle class. Low-income women willingly endured financial hardship to sustain the movement. Norma Royal, wife of a local tobacco worker and one of the Tag Day fund-raisers for school desegregation efforts in the 1950s, penned a moving note to the Durham NAACP youth following the May 1963 demonstrations: "As a token of appreciation, I send this small [donation], hoping it will help in your (our) fight for freedom. . . . It will be hard to budget. But I feel that I should share part of it with you."[118]

Black women's activism went well beyond fund-raising and taking care of the myriad behind-the-scenes details. Too often, however, observers have identified only such tasks traditionally defined as "women's work" as the full extent of women's participation. But Durham women were full-fledged activists in their own right. Although women frequently (though not always) were denied titled positions in mixed-sex organizations like the NAACP or CORE, they held prominent positions in black women's organizations and brought key resources and skills to the movement.[119]

Women Are the Movers! Age and Class Distinctions

Although black women constituted the majority of civil rights activists in the early 1960s, class and age distinctions shaped their participation in direct action protest. While some middle-class adults—men as well as women—actively backed the movement, others were indifferent. Louis Austin, editor of the *Carolina Times*, called more affluent blacks who refused to honor the 1963 Easter boycott of white downtown merchants "Uncle Toms" who were "living off the blood sweat of the Negro masses." Echoing Austin at a Durham civil rights reunion many years later, former NAACP youth activist Vivian McCoy denounced the "black bourgeoisie"—men as well as women—calling them "the late bloomers who took credit for what we had done." Mrs. Callina Smith, a factory worker who founded Durham's Welfare Rights Organization, claimed that some elite black men had taken part in the movement but that their wives had not. "The wives just looking on. They just looking on. They're not in it," Smith insisted.[120] Working-class women such as Margaret Turner, a tobacco worker who later became statewide NAACP youth coordinator, were more apt to attend protest rallies.[121]

When middle-class black women participated, they often operated behind the scenes. Mrs. Selena Wheeler, wife of business leader and DCNA head John Wheeler, provided office space on Pettigrew Street that became a convenient resting place for students picketing downtown movie theaters.[122] Mrs. Bessie McLaurin, a teacher at the East End Elementary School, attended demonstrations as an "observer" and performed crucial but often "invisible" tasks. For example, she took charge of the church keys so that movement participants could hold their evening meetings—led by local librarian and activist Mrs. Sadie Hughley—at St. Joseph's AME Church. Like many of the "mamas" of the movement, Bessie McLaurin, Sadie Hughley, and Evelyn McKissick housed and fed volunteer civil rights workers. Louise Latham, dean of women at North Carolina College, quietly ignored curfew restrictions for female student activists and served as an informal liaison between

student protesters and NCC president Alphonso Elder, whose position at the state-supported black college circumscribed his ability to support student demonstrators overtly.[123]

Like many southern black women educators, Louise Latham, who had been one of the first black women to desegregate the Durham AAUW in the 1950s, tried to impart an expansive vision of black women's community responsibilities to her female students. When Martin Luther King Jr. visited Durham during the 1960 sit-ins, Latham invited Coretta Scott King along with the twenty-seven-year-old woman leader of the Tanganyika African National Union to address women students at the NCC annual "Coed Weekend."[124] Cora Cole-McFadden, one of the first students to desegregate Durham High School, recalled that black school teachers "were automatic mentors" for the student activists. Others remembered the influence of Mrs. Lyda Wray and Mrs. Pearl Cordice, particularly their lessons in African American history. Like Nell Coley in nearby Greensboro, who told her students "that the way you find things need not happen. . . . you must not accept that [treatment]," these women conveyed a vision of a world where blacks were afforded dignity and justice.[125]

Middle-class women were not alone in passing on a sense of civic involvement and community responsibility to young people. Working-class women, whose community work extended back to the 1950s and even the 1940s, also infused the larger movement with the tradition of black women's activism. Young movement participants Callina Smith, Vivian McCoy, and Cora Cole-McFadden repeatedly pointed to older women such as Christine Strudwick, wife of a tobacco worker and a stalwart of the East End Betterment Society, as instrumental in shaping their own activism.[126] Vivian McCoy, who lived in a stable working-class neighborhood in north Durham, noted how both of her parents shaped her rebellious spirit. Her mother was one of the first black licensed practical nurses to integrate Duke Hospital, yet she encountered other indignities as hospital administrators forced her to go from the fifth floor, where she worked, to the basement in order to use the "colored" water fountain. Despite this affront, Mrs. McCoy vowed that no one would call her a "nigger." "The first one to spit on me, I'll stomp 'em," she threatened. Mrs. McCoy imparted this sense of entitlement as well as defiance to her daughter, Vivian: "My mother always told me, 'you go where you want to go.' I would never drink out of the black fountain," Vivian recalled with pride. "I said, 'What color is water?'"[127]

Cora Cole-McFadden was similarly inspired by her female elders. "My mother [who worked as a nanny for a white family] was a very strong woman

and I just assimilated her [values]," she explained. Community women such as Mrs. Mary Horton broadened Cora's sense of possibilities for her own life. Horton was a restaurant worker who had headed both the Durham Housewives League and the Hillside High School PTA. A longtime NAACP member, Horton had participated in the "coup" that attempted to bring new life and militancy to the NAACP following the Spicely murder. "[She] was just like a mother to me," Cole-McFadden remarked.[128]

Community women could be role models for men, as well. Ben Ruffin was a student activist who later headed up Durham's low-income and militant neighborhood federation, United Organizations for Community Improvement; Ruffin noted the impact of two women on his own sense of civic commitment. One was his high school teacher, Mrs. Johnnie McLester, wife of a local minister and an activist in her own right. His mother, Mrs. Catherine Ruffin, a tobacco worker and domestic worker, was one of the founders of the Lyon Park Community Center. "If someone in the community got ill, everyone pitched in and helped. Mother always reached out to help people. . . . [She] taught us to share with people," he said.[129] Black women, whether working-class or middle-class, bestowed a rich legacy of community work and racial uplift to a younger generation that, in turn, converted that tradition into collective revolt.

Black churchwomen of all classes also lent their support to the movement. Frequently a majority of church members and attendees, African American women formed an often unrecognized source of church backing for movement activities.[130] Several black churches served as meeting places for the Durham NAACP from its inception, and a number of local ministers were well known for their activism. When direct action emerged in the 1960s, a number of black churches provided spaces for community organizers to hold strategy sessions and mass meetings.[131] But the "black church" in Durham was neither monolithic nor solidly committed to racial protest. Black women sometimes publicly chastised their ministers for failing to take the lead in the freedom struggle. Sara Dodson, a local beautician and officer of the Durham Housewives League, had long urged ministers to "become active because they could be [an] inspiration to others and their communities."[132] Behind the handful of activist ministers stood scores of churchwomen whose spiritual and financial assistance to the movement, and to youth activists in particular, was unbounded.[133] "[There was] always a bunch of . . . church women . . . who would . . . be there for us, hugging us and feeding us and making sure everything was just so," Joycelyn McKissick recalled. "Sometimes you knew 'em and sometimes you didn't, but you knew somebody was going to

take you in their arms when you walked off that picket line. . . . There's no way you can match that kind of contribution."[134] Cora Cole-McFadden summed up black women's involvement in the movement: "Women are just basically the movers in everything that you do, not just civil rights. In the church, everywhere that you go, women are the movers," she said.[135]

Most observers, then and now, however, have seen only the efforts of a small number of individual, heroic black women who attracted national media attention rather than the existence of a distinctive African American female organizational base. In a 1957 *Carolina Times* editorial, "The Leadership of Negro Women," Louis Austin praised the "courage and fortitude" of women such as Rosa Parks, Wilhelmina Jake, and Autherine Lucy who had inspired "their men to greater sacrifices and efforts in the struggle for a fuller measure of democracy." According to Austin, the freedom movement might never have materialized without such women.[136] But in Austin's portrayal, a few exceptional women inspired the men, while the hundreds and even thousands of ordinary black women who joined the movement remained invisible. As the movement grew, however, some male leaders conceded their reliance on women. "Women are among the principal supporters of the NAACP and we must do more of utilizing the talent and abilities of our women," the North Carolina State Conference of NAACP Branches noted in 1962.[137] Not surprisingly, black women seemed more likely to fully appreciate other women's abilities. Rose Butler Browne, a professor at Durham's North Carolina College, wife of a local minister, and a community leader in her own right, proclaimed, "You get the sisters behind the brothers and between them, anything can be carried forward to success."[138] Like Ella Baker, Browne fully understood the power of organized black womanhood. Despite these contemporary references to black women's participation, however, our master narrative too often has relegated women to the margins of the movement.

Historian William Chafe's comment that "women comprised, in many people's views, the backbone of the demonstrations, always ready to march and picket and get arrested" was true not only of women in Greensboro and Durham but throughout the South.[139] However, emphasis on traditional areas of leadership, where men were dominant, not only obscures women's contributions but misses a critical dimension of the story and a crucial aspect of protest activity in general. As historian Kathy Nasstrom has observed, by defining leadership so narrowly, we are left with a "composite portrait of civil rights leadership that has a male face." If we look beyond conventional definitions of leadership, however, black women's participa-

tion becomes more visible. The activities of neighborhood women, female students, and churchwomen make clear that women were critical to the movement. When Mrs. Humely and Mother McLaurin, two cafeteria workers at North Carolina College, made sandwiches for jailed student protesters, they were not simply doing "women's work" but were literally nurturing the freedom movement.[140]

Nor did black women simply follow the directives of male leaders. Black women convinced scores of black families to challenge discriminatory school board policies and add their names to NAACP lawsuits; female teachers and students persuaded blacks to join both the NAACP and the movement; black women's organizations raised money to support the movement; adult women housed and fed protesters and often were advisors to the youth groups; and female students and adult women helped plan and coordinate mass protest activities. And then, having done a good portion of the so-called behind-the-scenes work, without which NAACP lawsuits as well as black protest would have floundered, black women frequently turned out in larger numbers than men to the sit-ins, marches, demonstrations, and pickets that characterized the 1960s movement. In short, African American women drew on leadership skills and resources that built and sustained the decades-long struggle for black freedom.[141]

By 1963, African American women, in partnership with African American men, could point to a number of achievements. Movement activists, largely young and frequently female, had toppled segregation in Durham's public accommodations and had secured a commitment from private businesses to hire on the basis of merit, not race. Major federal civil rights legislation enacted in 1964 and 1965 bolstered these victories. But concessions regarding school desegregation were token at best, and a federal court order rejecting the school board's desegregation plan combined with hundreds of black student reassignment requests for the 1963–64 school year portended ongoing racial battles.[142] Economic gains also were limited, as the city failed to create a local Fair Employment Practices Committee, which blacks had urged. Thus, despite the accomplishments of the May 1963 demonstrations as well as the presence of an influential local black business elite, the majority of Durham blacks continued to face poverty, racism, and a virtually segregated school system. As the Durham movement shifted from its earlier emphasis on dismantling legal segregation and employment discrimination to a more

sustained (and more difficult) effort to eliminate institutional racism and urban poverty, African American women remained critical players in organized black protest. Only now, the collective presence of low-income black women would shape both the direction and the agenda of Durham's black freedom movement.

The Uninhibited
Voice of the Poor

African American Women

and Neighborhood Organizing

"Step through that door and I'll blow your brains out!" came the desperate voice from behind the locked door. The Durham County sheriff, who had come with an order to evict the tenant and padlock the apartment, was taking no chances on that September day in 1965. He hastily retreated to summon assistance, perhaps thinking about the Watts, Los Angeles, racial uprising that had exploded just weeks earlier following an incident of police brutality involving a white officer and a black citizen. The devastation left thirty-four dead, over one thousand injured, thousands more arrested, and more than $40 million in property damage. It also rattled white Americans, many of whom were shocked by the depth of rage and despair harbored by poor urban blacks.

The distraught voice from inside the apartment at McDougald Terrace, Durham's oldest black public housing project, belonged to Mrs. Joyce Thorpe. Thorpe was a single mother of three children; she also was the president and founder of the McDougald Terrace Mothers Club. As president, Thorpe had requested meeting space from Housing Authority officials so the tenants could plan a child care center. The next day, the Housing Authority informed Thorpe that her lease would be canceled, effective in three weeks. Many in the black community believed her leadership in the mothers' club was the reason for her eviction, but Thorpe had little recourse against public housing authorities who removed tenants at will. Four years later, the U.S. Supreme Court decided otherwise. In a landmark victory for tenants' rights, the high court ruled in favor of Joyce Thorpe, prohibiting landlords from evicting public housing residents without cause. At the moment, however, she found herself alone in a potentially violent standoff with a white official.[1]

Three months before Thorpe's showdown with the sheriff, Mrs. Plassie Midgette was suddenly fired from her job in the public school cafeteria where she had worked for over twenty years. The official explanation read "[termination for] some problems in the kitchen," which was later clarified as "insubordination and other complaints." School authorities also dismissed three other women, all cafeteria workers, all African Americans, and all members of the recently formed School Employees Benevolent Society, a workers' organization designed to deal with workplace complaints. The women—and most of black Durham, especially the vast number of residents who labored for poverty-level wages—were convinced there was a connection between the women's termination and the formation of the new employees' association.[2] Twelve days before she was fired, Mrs. Midgette and thirty members of the School Employees Benevolent Society had petitioned the Durham City School Board and the North Carolina state legislature, calling for an increase in their meager salary of $0.57 per hour to the federal minimum wage of $1.25 per hour. The women's insistence that their employers use courtesy titles to address them suggests that contests over respect, recognition, and control were as important as the struggle over wages. When officials refused to consider their grievances, 200 cafeteria and maintenance workers walked off the job, forcing at least seven school cafeterias throughout the city to close.[3]

In the seemingly more idyllic setting of Duke University's magnolia-lined campus, Oliver Harvey, an African American night janitor, had been struggling for fifteen years to raise salaries to minimum wage levels, secure medical benefits, and open job opportunities for black employees. When Duke unveiled a $200 million development campaign in 1965 and asked for support from "all persons necessary for the advancement of the University," Duke's nearly 3,000 low-wage, predominantly African American nonacademic workers decided they fit the definition of "all persons necessary." Framing their demands in the university's own development campaign rhetoric, they formed the Duke Employees Benevolent Association and affiliated with the American Federation of State, County and Municipal Employees as Local 77.

Duke responded with time-honored union-busting techniques: management granted small wage increases, agreed to a slight reduction in workers' hours, and made several other concessions, but refused to recognize the union. The following year, Mrs. Hattie Williams and Mrs. Viola Watson, two African American housekeepers who had eleven years of work experience between them and no complaints from supervisors, were suddenly laid off.

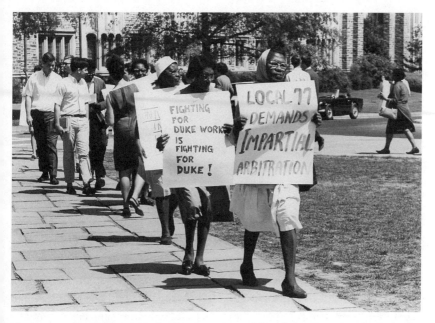

Black women housekeepers and cafeteria workers picketed at Duke University in April 1967 during a union organizing drive. *(Photograph by Bill Boyarsky; courtesy Civil Rights Heritage Project, Durham County Library)*

Both were active union members, and Williams was a union steward. "Those women will never work here again," gloated one supervisor. A few months later, Duke dismissed twenty-one-year-old Shirley Ramsey, one of the first black food service workers to have been promoted to cashier. When a supervisor singled her out for pie-cutting duty (which cashiers did not perform and which none of the white cashiers were asked to do), Ramsey, a union member who wrote for Local 77's newsletter, *We the People*, refused and was fired.

Again, employees and the wider black community noticed a connection between the assertive behavior of "uppity" black women and employer retaliation. Mrs. Hattie Williams managed to force the university to reinstate her, which encouraged food service workers, janitors, and maids. Sixty pickets—members of Local 77—appeared outside the university's main administrative building. Several days later, over 200 Duke student and faculty supporters joined the picket line in a show of solidarity with the workers. By 1968, Local 77 had launched an all-out campaign for union recognition and had formulated plans for a campuswide strike of food service and housekeeping staff. As one union activist explained, "The housekeepers started it all."[4]

Low-Income Blacks and Rising Discontent

Something was happening in Durham. Despite the retribution these organizers suffered, similar, seemingly spontaneous, and disconnected outbursts continued to erupt among low-income blacks throughout the city between 1965 and 1968. In December 1967, Mrs. Irene Joyner, domestic worker and cochair of the Durham Tenants Steering Committee, led a group of tenants into the Housing Authority office and demanded an explanation for recent exorbitant rent increases. When Housing Authority director Carvie Oldham refused to allow the women to view their files collectively (some needed help to interpret the information), they began a spontaneous sit-down demonstration. After the police arrived and threatened the women with arrest, they decided to call it a day and left. But a month later, 150 residents from three public housing projects launched Durham's first rent strike. The Housing Authority retaliated by obtaining a restraining order not only against Irene Joyner and four other black women but also against the officials of United Organizations for Community Improvement (UOCI), a neighborhood federation representing poor blacks that Oldham was sure had organized the strike. Irene Joyner voiced the frustration of tenants and their pent-up grievances as well as their pride in taking independent, collective action. "We have been wanting to strike for a long time. We did it on our own," she insisted.[5]

Something was happening all right, and, when viewed together, these events signaled a new direction in black protest in the Bull City. Most striking of all, the new black insurgency centered largely on the demands and collective strength of low-income African American women. Not all their struggles were completely successful, but the resurgence of black activism underscored the movement's new emphasis on economic and housing issues. In a letter to the federal government, Durham attorney Floyd McKissick, who had become national chair of the Congress of Racial Equality, underlined the convergence of racial and economic concerns, especially among low-income blacks. The strike by city school workers "might appear to be mere union discrimination rather than a racial issue," McKissick wrote, but "the union is composed almost exclusively of Negro employees and some of their major complaints have related to discrimination of various kinds."[6]

Although the youth and students who had dominated the Durham movement from the late 1950s to 1963 did not totally abandon protest activities—indeed, activists continued to pressure officials to comply with the promises made during the 1963 demonstrations—increasing numbers of low-income blacks were becoming organized and mobilized. As in the earlier demonstra-

tions, most of the participants in this phase of the movement were women. They contributed more than sheer numbers, however, for low-income African American women also held leadership positions, at least on the neighborhood level.[7]

The concerns of low-income black women shaped the agenda and tone of the freedom movement as it shifted from civil rights activism to neighborhood organizing, antipoverty agitation, and economic development efforts. This unprecedented activity by poor blacks, among the most effective statewide and even nationally, threatened entrenched white economic and political interests, and local and federal white power brokers struck back. In fact, black insurgency in Durham sparked a government crackdown on similar activity across the state and nation, illustrating the contradictions facing community organizers who tried to harness government authority and resources to empower society's dispossessed.[8]

The War on Poverty and the Changing Nature of Black Protest

The image of Joyce Thorpe barricading her door against the county sheriff illuminates the changing nature of black protest—one that was predominantly poor and overwhelmingly female. She may have huddled, alone and terrified, behind her door, but she was far from alone in Durham. Just as middle-class and working-class black women had drawn upon a distinctive tradition of community work to propel them into civil rights activity in the 1950s and early 1960s, so too did informal kin and neighborhood networks among low-income women form the basis for the broader collective protests of poor black women.[9] From the mid-1960s until the end of the decade, impoverished African American women often deployed distinctive modes of resistance, at times transforming "social problems" (such as female-headed households or neighborhood juke joints) into social assets and foundations for wider community protest. Their growing militancy also spurred the formation of the low-income black neighborhood federation United Organizations for Community Improvement, which boasted a female majority and quickly became the major black protest organization in the city.

The seemingly spontaneous outbursts among poor blacks revealed white failure to contain black demands, which officials had hoped to do primarily through control of Operation Breakthrough (OBT), Durham's antipoverty agency. Local officials created Operation Breakthrough in 1964 largely in response to black protest. Part of Governor Sanford's 1963 statewide antipoverty initiative, Operation Breakthrough was one of eleven target projects in North Carolina funded largely through private foundations and fed-

eral grants and administered by the newly created North Carolina Fund (NCF). OBT founders initially hoped only to coordinate better services for the indigent and run several experimental educational programs.[10] However, officials had underestimated the full implications of "maximum feasible participation of the poor," which the NCF and the federal War on Poverty mandated.[11] In Durham, white power brokers, including Mayor Grabarek, quickly took control of Operation Breakthrough and defined the "maximum feasible participation" stipulation to mean token black representation on the Operation Breakthrough board; the poverty agency began organizing neighborhood councils from which black representatives would be selected. But creating neighborhood councils let the genie out of the bottle. Low-income blacks—and it was mostly African Americans who participated—had their own ideas about "maximum feasible participation," and their plans bore little resemblance to those of the mayor. Poor blacks wasted no time in clamoring for expanded services and, more crucially, for an active voice in shaping the policies that directly affected their lives. Joyce Thorpe's showdown with the sheriff, therefore, was a dramatic example of the new militancy taking hold among Durham's impoverished black residents.[12]

From Public Housing Tenant to Supreme Court Litigant: The Joyce Thorpe Case

At first glance, Joyce Thorpe's behavior appears to have been the spontaneous and perhaps irrational act of a lone woman. In fact, her actions were part of a larger collective effort that drew on the strengths and resources of various African American communities—rural and urban, low-income and middle-class—and included both formal and informal associational life, such as neighborhood and kin ties and local and national black organizations. Even her threat of violence, initially an act of desperation, evolved into a deliberate, collectively planned strategy of resistance involving a range of tactics including duplicity and trickery, public pickets and demonstrations, behind-the-scenes pressure tactics, lawsuits, and court orders. Moreover, Thorpe's fiery standoff galvanized the mass protest movement that was emerging among low-income blacks in the 1960s, and it became a direct catalyst for the creation of United Organizations for Community Improvement, an all-black, independent neighborhood federation.[13]

Joyce Thorpe's life had been typical of many black women who grew up in the segregated South just prior to the direct action protests of the 1950s and 1960s. She was originally from Roxboro, a rural community about thirty miles north of Durham, where her father was a semiliterate but skilled car-

penter and farmer and her mother taught school. After Thorpe married in the 1950s, she and her husband commuted to Durham each morning, where he worked as an auto mechanic and she attended DeShazor Beauty School. But when she graduated in 1959, Thorpe decided that "doing hair wasn't what I wanted to do." She enrolled at North Carolina College (the historically black college in Durham), where she planned to study math and chemistry. By then, she and her husband had moved to Durham and bought a house. Although she was older than many of her classmates, she participated in civil rights demonstrations organized by NCC students in the early 1960s.

When her marriage broke up, she was out of work with two small children and pregnant with a third. Forced to quit school, Thorpe lost her home and moved into the segregated McDougald Terrace public housing project in 1964. "[It] was devastating," she said. "Here I am coming from a middle-class neighborhood to public housing. . . . I'm bringing my children from a house with a yard to an apartment." Joyce Thorpe, like many low-income women, had fallen from divorce into poverty. She was appalled at the conditions she found in the projects. "[There were] all kinds of little things that made you feel very inhuman. . . . I just could not tolerate it," she said. Chatting with her neighbors—"You know how you sit out and you talk," she remarked—Thorpe began to realize that they all had "the same problems." More importantly, she came to believe that only collective action could provide a solution. "We need to try to get together and then present these problems to [the housing] administration, as a group, because a group can do more than one person can do," she pointed out. Such conversations helped to cement neighborhood bonds among tenants, which in turn became important bases of support for more overt confrontations. Building on informal tenant networks within the project, Thorpe helped establish the McDougald Terrace Mothers Club. She never planned on heading the mothers' club, which attracted about thirty-five tenants, but, as she explained, "I was one of the folk who spoke out."[14]

Joyce Thorpe's leadership in the mothers' club and her showdown with the sheriff began a series of events that had both local and national repercussions. Although she was unarmed when she threatened to shoot the officer if he entered her apartment, no one knew it at the time. Recalling her dread at the thought of landing on the sidewalk with three children and no place to go, she said: "I was panicky. I was irrational, I was literally insane." Yet Thorpe's behavior was more than an impulsive act on the part of a "crazy" woman trying to protect her children, for her community quickly transformed her stand into a larger cooperative effort. The wide range of strate-

gies employed by both Thorpe and those who rallied to her side included more traditional responses such as litigation as well as the less formal weapons of resistance deployed by those with little official power such as acts of duplicity, threats of violence, and acting crazy.

Thorpe's success was predicated on a widening circle of black community support. A woman neighbor contacted Thorpe at school and tipped her off that the sheriff was on his way, illustrating the importance of informal neighborhood ties as resources of support and communication. Thorpe's threat of violence, while initially a reckless, spontaneous act, became a weapon of collective resistance. When Operation Breakthrough organizers Howard Fuller and Joan Alston arrived at Thorpe's apartment, they called civil rights attorney Floyd McKissick for legal advice. While waiting for McKissick to arrive, they devised an ingenious delaying tactic. They decided that Thorpe and Fuller would keep the commotion going so that McKissick could obtain a stay of execution against the Housing Authority. The stay would postpone the eviction while the matter was settled in court. So, turning the racist stereotype of black irrationality on its head, Thorpe played the part of "crazy nigger" for the next three and a half hours until McKissick arrived with the legal papers.[15]

Thorpe and OBT organizers combined both creative duplicity and community organizing to recruit other segments of black Durham. For a short time following Thorpe's run-in with the county sheriff, tenant involvement in both the mothers' club and protest activity diminished, largely due to fear of reprisals. But Howard Fuller and Operation Breakthrough wanted to rally wider support for Thorpe to reassure the other tenants that they were not alone. Since only eight or nine tenants were willing to picket the Housing Authority, Fuller recruited fifty students from the local black college to walk the picket lines with them. He also instructed the pickets that only tenants should speak to the press. Consequently, the newspapers reported that sixty tenants were picketing the Housing Authority.[16]

Thorpe also drew on an increasingly wider network of personal, local, and national black ties and organizations as she continued her struggle. Her parents put up the family farm as collateral to secure a $10,000 bond for an escrow account to cover the rent while her case made its way through the courts. Attending school served the cause as well, since the prospect of earning a degree made her less vulnerable. Thorpe explained: "These other folk have been here [in the projects] for a while; they don't see a way out. [But] if I graduate, I have a way out and [the Housing Authority] can't hurt me." The incident also attracted local black middle-class attention and eventually even

national interest. The Durham Committee on Negro Affairs circulated a petition in the community demanding an investigation of the case and simultaneously appealed to government officials. When federal investigators exonerated the Durham Housing Authority of attempting to wrongfully evict Thorpe and local newspapers reported that only a few "troublemakers" had been involved in the incident, other influential blacks began to exert their own pressure. As a result, the public housing officials met with 150 tenants and conceded to a number of demands, including the preparation of a new lease that contained a clause requiring the landlord to provide a reason for eviction.[17]

The incident had even wider national implications. Thorpe's lawsuit became one of the first cases taken on by the NAACP Legal Defense and Education Fund (LDEF), a new litigation program aimed at protecting poor people. When the U.S. Supreme Court ruled in Thorpe's favor four years later, declaring that landlords in public housing projects must provide cause and adequate notice for evictions, the decision was hailed as a landmark tenants' rights victory.[18] Black women's protest networks, shaped over decades, transformed Joyce Thorpe from an embattled "crazy" woman barricaded behind her door and threatening to shoot a white man with a gun she did not have to a victorious Supreme Court litigant.

Poor Black Women and Strategies of Resistance

Organized protest by low-income black women such as Joyce Thorpe drew on resistance strategies traditionally utilized by those with little formal power. Challenges to overt authority were often, although not always, disguised, but such behavior, while seemingly individualized, spontaneous, or devoid of political intent, had a direct impact on collective, confrontational protest and on more formal political movements. By ignoring the dissident behavior of weaker members of society, we overlook their vibrant political existence and miss much of the foundation of collective protest. Informal conversations among tenants at McDougald Terrace, while seemingly insignificant and apolitical, constituted what anthropologist James Scott calls a "hidden transcript" in which tenants, free from surveillance or retaliation, spoke candidly about the conditions in the projects.[19] In Thorpe's almost casual remark, "You know how you sit out and you talk," we catch a glimpse of an informal "free space" where tenants aired grievances and in the process forged a group identity and contemplated collective protest.[20] Joyce Thorpe's behavior, when viewed from this perspective, emerges as part of a tradition of black working-class women's resistance that incorporated a wide range of

tactics and strategies and often blurred distinctions between overt confrontations and more covert acts of duplicity and dissemblance.

The nature of Joyce Thorpe's poverty illustrates another characteristic of those most likely to engage in activism and underlines the fluidity of class location among low-income black women. Thorpe's changing life circumstances, notably a divorce, condemned her to public housing and poverty, but multiple levels of family, neighborhood, and community support enabled her to leave her impoverishment behind. Her shifting economic position suggests that the first overt act of defiance was likely to occur not among those most destitute and alienated from society but among those who had some stake in the social order and simultaneously had been denied full participation in it.[21]

Other black women had similar, if not quite as dramatic, experiences, and several, such as Mrs. Ann Atwater and Mrs. Pat Rogers, emerged as effective community organizers. Originally from Whiteville, North Carolina, Ann Atwater had a tenth-grade education when she came to Durham in 1953 with her husband. After he left her with a small baby and another on the way, she met a white woman who took her in and paid her to clean and babysit. When the baby was born, she was forced to quit, and she applied for Aid to Families with Dependent Children (welfare) benefits. The combination of divorce and motherhood landed Atwater in poverty, just as it had Thorpe. For some time, Atwater survived on fifty-seven dollars a month, eating rice, cabbage, and fatback.

Like Thorpe, Atwater claimed to have had no prior organizational involvement except through her church before participating in Operation Breakthrough. After her children started school, Atwater occasionally attended school meetings but felt put down and dismissed because of her poverty. "Me being low-income, I would attend PTA meetings and they wouldn't pay me no never-mind. They counted me as a nobody," she said. When OBT organizers Howard Fuller and Charsie Hedgepath appeared at her door one day, she was a single mother in her late twenties with two young daughters, and behind on her rent. "I was living in a house that was leanin' toward the street," she recalled. "The boards were broken in the floor and the water would shoot up in the bathroom. My kids would call it Niagara Falls."[22] The community organizers helped Atwater raise the rent money, but, more importantly, she learned to demand repairs from the landlord, Mickey Michaux Sr., a local black realtor, before paying the back rent. "From that day I found out that you could go to the landlord and talk to him like that," she said. "So I went around the neighborhood telling everybody that you don't have to sit home and worry

about the problems you got. They got people that can show you how to go downtown and look it up on the books." Fuller recruited Atwater for his Operation Breakthrough community organizing project, and later she became a supervisor for neighborhood workers and head of the Housing Committee for United Organizations. By 1967, Atwater knew more about public housing regulations than most bureaucrats in Washington, D.C.[23]

Like many of the low-income women most likely to become community organizers, Mrs. Pat Jones Rogers's shifting life circumstances accounted for her poverty. Rogers, who helped found the Durham Tenants Steering Committee, had grown up as the only girl among five children in a stable working-class family. Her father was a tobacco worker at the Liggett and Meyers factory in Durham, and her mother worked at the Harriet Tubman YWCA as a cook. When Pat married Jim Rogers, who was one of ten children, she entered an impoverished family burdened with serious problems. Jim's mother, who had a "drinking problem," had divorced his father when Jim was still a baby; shortly after Pat and Jim married, they went to live with his mother and six sisters to provide income for the destitute family. "I learned how to survive. I learned how to struggle," Pat Rogers recalled. "I learned how to take one cabbage, some beans, a small strip of fatback meat and make it go through a household. I learned how to save the grease off of the fatback and make some gravy and save a little bit more and turn some cornbread over in a pan for a whole family." Rogers blended her working-class culture with the daily survival strategies of her impoverished in-laws, and together they maintained a sense of dignity and pride despite their poverty. "They would take old clothes that had been given to them and they taught me how to take the top off, press the material out, take the hem part and make it the top of the curtain, and hem the side that came off the bodice," Rogers explained. "Then we would take some wire clothes hangers, stick those clothes hangers through the hem of that dress and pull it up tight around some nails at the window. After you hem that piece that came off the bodice and you pressed it and you put it up to that window, you couldn't tell where it came from."[24]

Rogers translated such creative resolve and down-to-earth survival strategies into wider efforts on behalf of her community. She recalled how Howard Fuller and Joan Alston rekindled a sense of hope and possibility rooted in the collective determination of poor people: "They taught me that although you're poor and although you're in the projects, take what you have learned during your struggles in life, united together, and we can live honest lives as poor people."[25] When her marriage broke up—"I organized myself out of a marriage," she said—Rogers's parents tried to persuade her to return home

with her five children. "But I couldn't leave the projects," she explained; "I couldn't separate myself from the community." Indeed, women such as Pat Rogers and Ann Atwater derived a sense of identity and purpose from their community work. Both were also motivated and sustained by a deep and abiding religious faith. Years later, Rogers described her community activism as "the work that God has given me to do."[26]

The experiences of Joyce Thorpe, Ann Atwater, and Pat Rogers, along with those of the school cafeteria workers and the Duke housekeepers, first of all suggest that collective resistance is not only the province of the young, the middle-class, or the more educated, but that it frequently originates with poorer folks who, in a kind of "trickle-up" process, can mobilize broader middle-class and even national support. Secondly, they demonstrate that women drew upon both informal and formal networks of support and communication, including neighbors, family, and organizations such as churches, labor unions, Operation Breakthrough, the Durham Committee on Negro Affairs, and the NAACP. They show, moreover, that the women utilized traditional as well as unconventional modes of resistance, including legal challenges, pickets, strikes, spontaneous sit-ins, duplicity, and acting "crazy." The lines between such resistance tactics often were blurred, and behaviors that appeared spontaneous or individualized frequently were deliberate and collective: recall Thorpe barricaded in her apartment threatening to shoot the sheriff, quietly egged on by OBT organizers as Floyd McKissick hustled to prepare legal briefs. Thus, an examination of poor women's protest also counters the myth that resistance by the poor is usually isolated, spontaneous, and disconnected from a broader tradition of struggle or from seemingly more stable organizations. Finally, the women's experiences illuminate poverty as a fluid component of working-class and even middle-class women's lives and not a fixed attribute of certain kinds of people. The lives of Thorpe, Atwater, and Rogers—all of whom became respected community leaders and were able to "get off welfare"—illustrate a fact of public assistance generally ignored by critics of "welfare dependency": that most women turned to welfare as a temporary and expedient survival strategy in times of crisis, not as a voluntary way of life.[27]

United Organizations for Community Improvement

Just as informal women's networks in McDougald Terrace provided the foundation for challenging coercive housing policies, so too did black women's networks and relationships help to sustain a citywide protest movement. Many of the women involved were linked through family, church, or

neighborhood ties. Although the incidents mentioned earlier appeared to be unrelated, protesters frequently joined their efforts with those of other poor blacks throughout the city. For example, one of the first activities of the OBT neighborhood councils was to provide support to the school cafeteria strikers and to Duke housekeepers and janitors in Local 77.

Moreover, Thorpe's brazen confrontation with the sheriff apparently sparked the creation of United Organizations for Community Improvement, the citywide, all-black neighborhood federation. In the months after Thorpe's widely publicized confrontation, members of five OBT neighborhood councils, including the McDougald Terrace Mothers Club, began talking about organizing a coalition separately from Operation Breakthrough, and four of the five councils identified housing issues as their most pressing concern. In early 1966, they formed UOCI as a new federation of low-income neighborhood councils. By 1967, United Organizations had grown to sixteen neighborhood councils and about 500 to 600 members, and by the following year the neighborhood federation boasted 1,000 members and twenty-three councils representing 20,000 predominantly low-income black residents, or between one-fifth and a quarter of Durham's population. Significantly, United Organizations was about 80 percent female.[28] The creation of UOCI was a critical step in the organization and mobilization of poor blacks, and the neighborhood federation quickly became the major black protest organization in the city.

United Organizations' focus on housing soon brought it into a head-on collision with white power brokers. Indeed, Joyce Thorpe's altercation revealed just how explosive the issue had become by the mid-1960s. The housing issue came to a head around the city's urban renewal projects and highlighted the dilemma community organizations faced as recipients of state and federal funds. Since the late 1950s, urban renewal had been the cornerstone of Durham's vision of economic prosperity and was closely tied to its self-image as a New South city. Most locally owned white businesses were connected to real estate interests that stood to benefit from urban renewal—including lumber, insurance, and construction—and all were well represented on the city council.[29] But urban renewal, or "Negro removal," as most blacks called it, exacerbated an already acute housing crisis. All too often, the policy was formulated without any input from local blacks and resulted in the forced removal and dislocation of scores of families (mostly low-income) and the destruction of African American neighborhoods and businesses.

The conflict created by urban renewal policies was more than simply a contest over adequate shelter. Both sides understood that low-income blacks

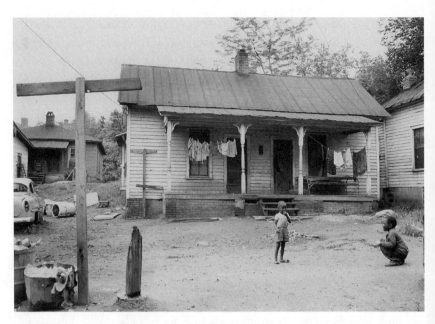

Dilapidated houses such as these were typical throughout Durham's low-income black as well as white neighborhoods, prompting residents to demand enforcement of housing standards and affordable rents. *(Photograph by Billy Barnes; courtesy North Carolina Collection, University of North Carolina at Chapel Hill)*

were demanding a fundamental change in the way political and economic power was exercised, not simply in Durham or in North Carolina, but in towns and cities throughout the nation. White officials, however, had weapons of their own; Operation Breakthrough's reliance on federal funds offered a way of undermining the poverty agency's ability to organize and mobilize poor blacks. This was the major reason black activists had decided to separate from OBT and establish United Organizations, an independent power base "speak[ing] out as the uninhibited voice of the poor."[30]

Although it was a separate organization, United Organizations built on the effective organizing work of Operation Breakthrough, and the two organizations frequently cooperated, especially on the neighborhood level.[31] Despite the political and racial difficulties that beset OBT from its inception, the antipoverty organization made significant headway in organizing some of Durham's most impoverished residents, particularly in black neighborhoods. One outside evaluator reported in 1967: "It was in Durham that [we] found one of the most significant experiments in resident participation sparked by the anti-poverty program. . . . This was community action in Durham: tough, massive, and black."[32]

Organizing and Mobilizing Poor Black Neighborhoods

Undoubtedly, much of Operation Breakthrough's success in organizing Durham's poor black residents was due to the agency's selection of Howard Fuller to head the community organizing work. Howard Fuller was born in Shreveport, Louisiana, in 1941. At age six, he moved to the Milwaukee housing projects, and in 1962 he graduated from a small college in Wisconsin, where he was one of a handful of black students. Fuller earned a master's degree in social work from Case Western Reserve University in Cleveland and participated in voter registration drives, school boycotts, and various direct action protests with CORE before taking a job with Chicago's Urban League. He was hired by Operation Breakthrough in 1965 not for his organizing skills, which few in Durham knew about, but because his credentials and his affiliation with the moderate Urban League made him acceptable to the white Operation Breakthrough leadership. Tall, dark, and handsome, the basketball star's six foot four inch frame and charismatic presence made a lasting impression on Durham. Thirty-five years later, George Esser, a white southerner and director of the North Carolina Fund, claimed that Howard Fuller was "the best community organizer I ever came across."[33]

Fuller recognized that community organizing had far greater potential than simply recruiting black representatives for Operation Breakthrough's board of directors. His organizing philosophy emphasized nurturing indigenous leadership and was remarkably similar to that of veteran civil rights activist Ella Baker, who had visited Durham in the early 1960s. "The first thing we tried to do was to convince people that they, themselves, were the ones that were the key to doing something about their problems. That they had to organize," Fuller explained. "What we have got to do is to bring the leadership from places where there was no leadership before. And we've got to get some of those people who've got it. Got the potential, but no one had ever listened to them, or no one has ever tried to develop them," said the talented organizer.[34] Joyce Thorpe described how organizers like Joan Alston and Howard Fuller helped to empower local people: "Miss Alston . . . was the foundation for us to get started on. She gave us the courage that we needed to go on and gave us the feeling that we really were people, you know." Fuller and Alson "had a gift that was super," she said. "They made you feel that this was something that you just had to do. And even though they were pushing you, they did it in such a manner that it made you feel as if it was your idea." Fuller soon was revered as a "Black Jesus" by poor blacks throughout the state. He was so effective at creating local leadership and staying behind the scenes that it was over a year before the white power

structure realized his impact. It remains a timeless irony that the most effective black radical in 1960s North Carolina was hired because he was acceptable to white moderates.[35]

Although Operation Breakthrough offered new opportunities for organizing and mobilizing poor people in Durham, organizers built on older black traditions, especially those in which women predominated. For example, Mrs. Callina Smith, who worked in a local factory before being recruited by Operation Breakthrough, drew on a long family history of community work in organizations such as the East End Betterment Society and Mt. Gilead Baptist Church. When Smith and Mrs. Christine Strudwick, an officer of the East End Betterment Society who had organized the East End Elementary School boycott in 1963, were recruited by OBT to survey the community's needs for the antipoverty project, both women were already respected community workers. Within a few years, Smith cofounded the Durham Welfare Rights Organization.[36]

United Organizations soon became even more confrontational than Operation Breakthrough, its parent organization. At its first annual meeting in May 1966, 200 blacks, almost all women, representing sixteen neighborhood councils, assembled at Hillside High School and elected Mrs. Rubye Gattis, a former domestic worker, as United Organizations' first president.[37] Sixteen-year-old Othelyn Little, who had braved several arrests before the age of fifteen for protesting racial discrimination, was among the other officers elected.[38] The nationally prominent civil rights leader and Southern Christian Leadership Conference officer Rev. C. T. Vivian delivered the keynote address, underlining the link between earlier civil rights protests and antipoverty organizing.[39] Stressing the importance of community solidarity, the minister told the crowd, "There is a big difference between living in a part of town, and having a community—one is just rows of houses, the other is a place of oneness together." Vivian warned white officials that demonstrations would not end until black people had "obtained good housing and political power," but he also pointed to the benefit that protests had for the participants themselves: "There is something about demonstrating that does something for you, for your dignity; it tells the truth."[40]

The neighborhood federation wasted no time in dramatizing its support for the concerns of low-income black women. An hour after the meeting adjourned, UOCI turned out 500 demonstrators to register their outrage at the city school board's rejection of federal funds for Head Start programs and several hundred summer jobs for teens in the Neighborhood Youth Corps. Durham school board members were willing to forgo much-needed commu-

nity programs rather than comply with federal minimum wage and anti-discrimination regulations, and this infuriated poor blacks. Despite the refusal of the *Durham Morning Herald* to cover the demonstration—claiming it did not want to help "coalesce Negro strength" or "to hurt the city's image as a progressive city"—the presence of hundreds of angry protesters forced the school board to relent and accept the funds.[41] The uninhibited voice of the poor was growing louder.

Gender and Community Organizing

Most of the indigenous organizers hired by United Organizations were low-income black women; one observer described them as "strong females," "all of them with a militant bent." Black women were included in UOCI from its inception due in part to the astuteness of community organizer Howard Fuller, who initially recruited neighborhood women. According to Pat Rogers, Fuller refused to run one of Operation Breakthrough's first community action program workshops unless Rogers and two other low-income black women—Ann Atwater and Louise Ballentine from McDougald Terrace—could participate.[42] Fuller's definition of the black community included the low-income neighborhood women as well as black men in official leadership positions:

> The whole plan for the black community needs to be discussed with the black community. [City officials] must come and sit down with the black people who live in these area[s]. It['s] not enough anymore to talk with the redevelopment commission. They need to talk with Ann Atwater, Rubye Gattis, Mrs. Joiner [sic], with these kind of people along with Mr. Wheeler [president of Mechanics and Farmers Bank and former head of the Durham Committee on Negro Affairs], Ben Ruffin [executive director of UOCI] and discuss this plan for the city of Durham. And not uptown either. But to come down to St. Joseph's [AME] Church and not with defensive attitudes and a lot of jazz but to discuss the plan and see what the people have to say about and if they want to add to it. You think they would do that? Hell no![43]

By 1968, Fuller was claiming that United Organizations had developed between twenty-five and fifty "very strong community leaders"—many of them black women—and that the neighborhood federation could depend on "as many as three hundred people to turn out for an important meeting or demonstration."[44] Thus, within a relatively short period, community organizers had created a highly effective cadre of indigenous leaders who played a criti-

cal role in the black protest movement from the mid-1960s into the following decade.

Of course, low-income black men also participated in the resurgence of activity among Durham's poor, but most saw neighborhood organizing in gendered terms. Although there were a few exceptions—among them Mc-Duffie Holman, a warehouse machine operator and president of the East End Neighborhood Council—most low-income men seemed to think that attending meetings was "women's work." Those who did participate in community affairs, such as Oliver Harvey, founder and president of Local 77, were more likely to participate in traditionally male organizations such as unions.[45] Community organizers often bemoaned the lack of male participation in the neighborhood councils and at community meetings. According to one organizer, working-class men were too tired "after a long hard day at work . . . to be bothered with the women's work of community activity." Mrs. Nichols, who recruited members for the UOCI Welfare Committee and worked with the Peachtree Verbane Council, explained that "men don't feel right sitting in a meeting with a lot of women." Howard Fuller suggested that some young black men who eschewed more formal organizations participated in movement activities on an ad hoc basis by joining a demonstration or perhaps even hurling rocks at white hecklers, "just regular black brothers off the block who won't belong to nothing." Male avoidance of community organizations, therefore, did not necessarily or always translate into passivity.[46]

Local organizers found creative ways to enlist male participation as well as wider community involvement, often by relying on neighborhood women. During a voter registration campaign in one neighborhood, Pat Rogers noticed that "a lot of the men worked all week and drank all weekend, and said they didn't have time." So she decided to stop by the local "liquor house with . . . one of the neighborhood women who [was] well known in that area," and the two women "finally persuad[ed] them to register." Rogers understood that the first rule of successful community organizing was to make connections with a trusted neighbor—in most cases a middle-aged mother—who could serve as a conduit to other black residents.[47] Talking with their neighbors in house-to-house visits, such women urged Durham's poor to participate in the neighborhood councils. Not surprisingly, women usually had better success persuading other women to become involved. Although residents initially were unresponsive to the entreaties even of these trusted neighborhood representatives, one North Carolina Fund project evaluator discovered that women organizers were able to "keep alive an informal communications

network which contribute[d] to the tacit support on which community organization [relied for its success]."[48]

Other factors beyond women's formal and informal bonds also contributed to the predominance of women in the neighborhood councils and in United Organizations. According to Joyce Thorpe, women seemed more receptive to the philosophy behind community organizing, especially organizers' inclusiveness: "They were encouraging everybody to get involved, not just the affluent, but the nobodies like me," she explained.[49] There were also structural explanations for the large numbers of women. Especially in the public housing projects, organizers were more likely to find women than men, partly a reflection of pernicious welfare and public housing policies that promoted the breakup of poor families.[50]

Seeds of Insurgency amid Neighborhood Blight

While welfare experts saw female-headed households and neighborhood drink houses as unmitigated problems, Durham's community organizers often used them to considerable advantage, stitching together networks of women and organizing in the places where people came together. Conversely, the involvement of men and the role of religion, generally lauded as hallmarks of stable neighborhoods, could also foster conflict and division and impede community organizing campaigns. Mike Nathan, a young white Duke student trained by Howard Fuller, worked with black residents in the Edgemont section of Durham. Historically one of the city's poorest white areas, Edgemont had become a "transition" neighborhood by the mid-1960s —meaning that urban renewal had forced poor blacks into the area, where they made up 60 percent of the neighborhood's 5,000 residents by 1968. The area bore all the familiar markers of poverty, including substandard housing, unpaved streets, poor health, large numbers of female-headed families, and high unemployment.[51] However, a group of young, black, single mothers, known derisively as "that Toby Street crowd," seemed especially receptive to community organizing and provided core support to the newly reorganized Edgemont Community Council, which soon became one of the most militant neighborhood councils in the city.

This section of Edgemont was home to several "bootleg houses" that, "coupled with the behavior of the residents, [gave it] a 'wild' reputation," according to OBT organizer Nathan. Instead of recognizing the women's friendship networks as a useful community asset, Nathan condemned "the indiscriminate behavior and the stronger personalities of the women" and complained that the absence of men "led to a social club atmosphere in the

[Edgemont Community] Council and at the OBT office." Nathan's longing for male participation, which he believed would enhance the community's strength and political effectiveness, blinded him to the strengths of the indigenous women who participated, and it reflected a masculinist conception of male-headed households as the only kind of stable homes. Yet according to Nathan's own reports, the women he discounted were the very women "who stood up and spoke in the mass meetings and asked the pointed questions" of city officials. In contrast, when local men attended neighborhood council or city council meetings, even Nathan conceded that "they were silent."[52] Similarly, although bootleg houses were usually derided as a sign of "blight" or dismissed as places of leisure (or worse), they also functioned as neighborhood centers, providing spaces where collective identities, friendships, and social ties were established and nurtured. The "women who ran liquor houses had a great deal of influence on the neighbors and could act as informal leaders," observed Nathan.

In contrast to the Toby Street crowd and the female drink house operators, another section of black Edgemont was characterized by a "more stable family structure with a husband present or an older woman with no boyfriend." The women in this section were also more "religious" but were unable to translate either their family structures or their church connections into viable community action. On the contrary, these women reportedly remained "quiet and expressionless in conversation and council meetings" and frequently made "disparaging remarks" about the "wild" women in "that Toby Street crowd."[53] Although Nathan's descriptions of the two groups of women may reveal more about his prejudices than they do about the women, they also suggest the need to reexamine conventional notions regarding both the poor and women's informal leadership and friendship networks in black community organization. In effect, the Toby Street crowd's ability to merge personal, social, and political spaces provided the basis for effective community organizing efforts. Certainly, the conditions that assailed poor women and their families were more debilitating than uplifting, and the poor sought to alleviate, not to celebrate, their poverty. Nevertheless, at times, low-income black women discovered sources of strength and unity in their plight and transformed destitution into collective action.

Taking on the Slumlords

Poor black women's newfound solidarity found expression in the reorganized Edgemont council, one of the first neighborhood councils to capture local headlines, in a dispute with the Durham City Council and both black and

white real estate interests. The confrontation erupted into public view in 1966 when United Organizations, Operation Breakthrough, and the Edgemont Community Council picketed local slumlord Abe Greenberg. Greenberg, who owned substantial rental property in Edgemont—most of it substandard or dilapidated—was described by one local observer as a "maverick real estate developer" and "the closest thing to a 1960s 'wheeler dealer' of whom Durham could boast."[54] The immediate catalyst for the protest occurred when Greenberg purchased forty additional houses in Edgemont in 1965 and promptly increased the rents, many by over 50 percent, without upgrading or improving the properties. Holes in the ceilings and floors, the lack of bathtubs and hot water, missing screens, broken-down porches, and the presence of roaches, rats, snakes—these were just some of the complaints residents wanted addressed. One house had not been painted in forty years, while another required the use of a hammer to close the back door. "When it rains all the furniture gets wet," complained one tenant.

Demonstrators, the majority of them low-income black women and girls, congregated not only at Greenberg's office and at City Hall, where the zoning commission was meeting to consider his request for a variance so he could build more apartments, but also at his home. Defying a host of conventions governing race and class relations as well as notions of southern civility, the pickets in front of Greenberg's home were particularly provocative: "Your Neighbor Is a Slumlord" read one sign, while another announced, "Mrs. Greenberg, My Children Sleep with Rats." Edgemont residents had appealed to Greenberg, the city council, and the housing inspector for almost a year prior to the demonstrations, but to no avail. The city continued to grant extensions to Greenberg in spite of his failure to comply with housing code regulations, while the poor kept writing letters and marching to City Hall demanding that Greenberg's houses be condemned and closed. At one point, residents were so frustrated by the city's inaction that they proposed organizing a rent strike, and twenty-five families agreed to live in a makeshift "tent city" if they were evicted—an extreme measure under any circumstances, but especially in light of the severe shortage of affordable housing for blacks. Ignoring the residents' yearlong entreaties, Mayor Grabarek lectured the protesters that they needed to use the appropriate City Hall channels, where, as one wag sarcastically observed, "all hope of improvement lay." The mayor insisted, "In order to accomplish anything, we need to take individual problems one at a time rather than being repetitive about certain cases," as if fixing too many rotted roofs or floors at once would create a problem of redundancy.[55]

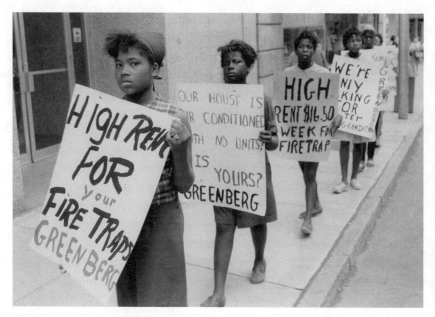

Exorbitant rents and numerous housing code violations in Abe Greenberg's rental properties fueled angry protests from low-income blacks, such as this 1966 demonstration in front of Greenberg's office. Blacks also picketed Greenberg's home in a clear violation of southern racial etiquette. (Photograph by Billy Barnes; courtesy North Carolina Collection, University of North Carolina at Chapel Hill)

United Organizations eventually won somewhat better enforcement of the housing code in Durham's poor neighborhoods. Although Greenberg's houses were never fully brought up to code requirements, other landlords, fearful of similar demonstrations, made some repairs shortly after the demonstrations began. But more importantly, the neighborhood federation developed leadership skills and a greater sense of cohesion, which were critical gains for the young organization.[56]

Officials Take Aim at the War on Poverty

The Edgemont protest also alerted powerful whites and their conservative black allies to the threat posed by community organization among the poor. David Stith, an African American associate of Greenberg's who was angered by pickets outside his home and business calling him "Uncle Tom Stith, Greenberg's Nigger," discovered that Operation Breakthrough had provided vehicles to transport protesters. When OBT director Robert Foust defended his organization and refused to change its policy of providing transportation

to protesters, conservative whites retaliated. Meanwhile, a heated debate erupted among Operation Breakthrough board members about the proper advocacy role of the antipoverty group. In a show of cross-class racial solidarity, Dr. Charles Watts, representing the black middle and professional class, and Mrs. Ann Atwater, spokeswoman for the needy neighborhoods, argued that for Operation Breakthrough to "'desert' them now—'to throw a rock and run,'" would seriously damage the agency's reputation among the city's impoverished black residents. But when several OBT board members learned that the federal Office of Economic Opportunity (OEO) had recently ruled against using federal funds in similar protests sponsored by War on Poverty projects elsewhere, the board voted to prohibit the use of Operation Breakthrough funds or vehicles for picketing.

Attacks on the poverty agency continued, however, as several elected officials sensed a political opportunity. In an alliance between northern and southern Republicans, Fred Steele, Durham's Republican congressional candidate, and New York congressman Charles Goodell announced a federal investigation of Operation Breakthrough's finances. Even though OBT eventually was cleared of major wrongdoing, the controversy alienated a majority of Durham's white population from the city's poverty programs.[57] The investigation indirectly affected United Organizations as well, since the white public rarely distinguished between Operation Breakthrough and United Organizations.

Although Operation Breakthrough survived the partisan attack, more trouble lay ahead when Republicans and Democrats joined forces to prevent the poor from exercising their political muscle at the ballot box. Both UOCI and OBT had been registering voters and organizing low-income residents to attend Democratic Party precinct meetings. According to one report, "The appearance of poor Negroes at these meetings formerly attended only by middle and upper class whites caused an immediate reaction not only from political representatives but from most segments of the local community as well."[58] Republican Fred Steele, who had lost his bid for election the previous year, charged that OBT vehicles had been used in connection with city elections, and both Steele and Durham's Democratic representative, Nick Galifianakis, called for a congressional investigation. Operation Breakthrough countered that since city elections were by definition nonpartisan, it had not violated prohibitions against partisan political activity. Harassment of poor blacks seeking to vote was "hardly in keeping with the established concept of American democracy," the Operation Breakthrough director argued. Black

residents in one neighborhood council similarly claimed their rights as citizens: "Is it not important that every registered voter have a feeling of belonging? . . . Is it because there were Negroes that caused such a stir?" they wondered.[59]

The attacks on Operation Breakthrough became so outrageous that even the Durham Morning Herald felt compelled to defend the antipoverty program. OBT again was cleared of any wrongdoing, but the widespread publicity further damaged the agency's already tarnished image, especially among whites. The conservative Durham Sun editorialized: "Regardless of whether or not any Federal law, civil service regulation or . . . rules has or has not been broken . . . enough smoke has curled up . . . to lead many to the suspicion that there is a spark or smoldering ember somewhere in the woodpile"—a blatant reference to the racist phrase "a nigger in the woodpile," and a sign of what lay ahead.[60]

The Housing Crisis and the Summer of 1967

The Greenberg controversy was only the beginning of the clashes over housing, for few could deny that housing conditions in Durham's poorest areas rivaled those of a third world country. When SCLC official Rev. C. T. Vivian, who was working with the Urban Housing Center in Chicago, came to Durham in 1966, he was shocked. "I have ridden through the streets of Durham—never before have I seen a Southern city that looked so much like a depressed backward country," he said. Unpaved streets and substandard housing plagued low-income black and white neighborhoods alike. Nine thousand homes—or over 27 percent of Durham's housing—had either unsound plumbing or none at all. Some had no electricity. One Durham family was forced to carry water in a bucket from a stream a quarter of a mile away for both bathing and drinking. The areas targeted for urban renewal were even worse; in one Hayti neighborhood, 80 percent of the housing (2,180 out of 2,790 houses) was substandard or "totally dilapidated."[61]

Black residents thus initially welcomed urban renewal. It soon became clear, however, that the poor would have no voice in its implementation. For example, when the Redevelopment Commission announced plans in 1966 for the construction of the East-West Expressway, 200 predominantly black and low-income families were threatened with eviction. The crisis was aggravated by a waiting list of over 1,800 families for existing public housing; construction plans for additional low-income housing units were at least a year away. Yet white officials seemed impervious to the pleas of the city's most destitute citizens. In a remark that rivaled Marie Antoinette's infamous state-

ment of disregard for the poor, one official referred to the families threatened by the expressway as "people you have to talk Georgia talk to" and dismissed them as "50 whiskey-making families standing in the path of the freeway." When a representative of the housing industry reassured critics that the poor would "house themselves as they always [had] in the past . . . without any strain on the rest of the community," Durham's dispossessed could have few illusions about official concern for their predicament.[62]

By the summer of 1967, racial tensions in Durham, as in urban areas all over the country, were reaching a boiling point. During several days in July, low-income African Americans, largely under the direction of United Organizations, converged en masse on the Durham City Council to demand an overhaul of city housing policies. They also organized mass rallies that attracted hundreds and prompted the mayor to call out the National Guard.[63] White obstinacy and black anger pushed the city ever closer to racial violence, but they also gave birth to an unprecedented show of black solidarity that drew together public housing tenants and bankers, maids and teachers. Most importantly, the new alliance was fueled by low-income black women.

The long-simmering tensions exploded at a "long, loud and stormy" July 17 city council meeting when 150 African Americans arrived to oppose a proposed public housing project and to demand that the city enforce its housing code. In a dramatic performance of the racial polarization that engulfed the Bull City, local Ku Klux Klansman Lloyd Jacobs swept into the council chambers in full red regalia and stood silently in the rear, leaving shortly after the meeting began.[64] Howard Fuller captured the defiant mood of Durham's indigent black population:

> I didn't come to beg, and I didn't come . . . with my hat in my hand, because we've come up here too many times with hat in hand. . . . We're tired of you white folks turnin' down everything that will benefit Negroes. . . . [Y]ou all better wake up to what's happening, and you better listen, because these are the voices of the people and they're the people that you have forgotten, they're the people that you have pushed across those railroad tracks, they're the people that you have moved out of urban renewal areas. . . . 'Cause they're tired, and they're frustrated, and people who get tired and frustrated do things they wouldn't ordinarily do.[65]

During the proceedings, several speakers alluded to the racial uprising that had decimated Newark, New Jersey, just days before. Viola Holman, a twenty-two-year-old former school cafeteria worker and a neighborhood organizer for United Organizations, reportedly warned, "Durham will be another Viet-

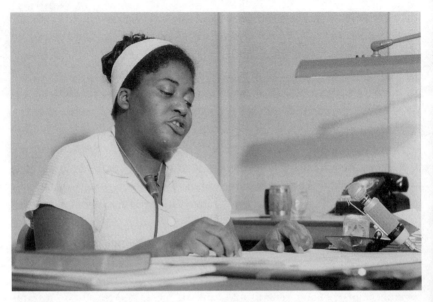

At a July 1967 press conference, UOCI president Rubye Gattis hinted that violent uprisings such as those that had recently decimated Watts and Newark might erupt in Durham if white officials continued to ignore the legitimate grievances of Durham's poor black residents. (*Photograph by Billy Barnes; courtesy North Carolina Collection, University of North Carolina at Chapel Hill*)

nam."[66] The following morning, the *Durham Morning Herald* added to the mounting tension by proclaiming with an eight-column, front-page headline, "Another Newark Threatened Here."[67]

The next day, UOCI organized a mass meeting at St. Joseph's AME Church and drew up a list of grievances to present to the city. A list of demands could not contain black frustration, however, and the meeting dissolved into a protest march on City Hall by 200 to 350 blacks. During the march, several stragglers broke windows, and a police officer and bus driver were injured by flying objects. United Organizations subsequently paid for the broken windows.[68]

United Organizations' president, Rubye Gattis, issued a statement that was both conciliatory and threatening. On the one hand, she reaffirmed the organization's aversion to violence and pledged to work with anyone "who genuinely wants to listen to the voices of the poor." But she also predicted a violent explosion among the city's disaffected if their pleas went answered: "We do not believe that Watts and Newark are the answers. . . . But unheard protests lead to frustration and the accidents that have created difficulties," she admonished.[69]

The city council responded to the July events much as it had during the demonstrations of 1963: it appointed a committee. The committee's purpose was to coordinate meetings with representatives from United Organizations and various city agencies and officials. UOCI issued a list of over one hundred grievances concerning housing, employment, education, adequate representation of blacks on city boards, and recreation. More than material issues were at stake, however, for the poor also demanded to be treated with dignity and respect. Black women in particular voiced bitter complaints about Housing Authority director Carvie Oldham's "rudeness," "bad attitude," and mistreatment of public housing tenants. To represent its demands in the meetings and broaden its constituency, United Organizations reached out to the black middle-class and business elite. The gesture signaled the birth of a new unity within the black community, one that would come to fruition the following year in a newfound racial solidarity that blurred the age-old class divisions in the capital of the black middle class.[70]

Black solidarity, however, did little to prevent Durham from teetering on the edge of a full-scale race riot. Three days after the stormy July 17 city council meeting, United Organizations members attended a scheduled gathering at St. Joseph's but announced specifically that they would not march that night. However, Mayor Grabarek, in an inflammatory move made without consulting the city council or any black leaders, called out the National Guard. As night fell across the city, 350 bayonet-wielding National Guardsmen joined riot-equipped local police, highway patrolmen, and sheriff's officers to patrol Durham's streets. The provocation proved too much for the city's already incensed black community. "We had to march; it was a challenge," explained one leader. That night, 300 to 400 African American marchers took off for the downtown business section, where they were met by a large, hostile crowd of white hecklers. "Durham was on the edge of civil disorder," one observer noted ominously. After white onlookers began attacking the marchers, a number of angry blacks tried to retaliate. Howard Fuller and United Organizations director Ben Ruffin, sensing the imminent danger of an all-out racial battle, quickly intervened by physically restraining several young black males who were attempting to strike back at the violent whites. Later that evening, white snipers shot two African Americans in their own neighborhoods, but local blacks refused to retaliate. As one report concluded, "Durham had escaped."[71]

The demonstrations and Grabarek's provocative maneuver prompted the black business elite and middle classes to publicly condemn city officials while simultaneously endorsing the actions of United Organizations. John

Wheeler, chair of the Durham Committee on Negro Affairs and president of the Mechanics and Farmers Bank, issued an official statement backed by the leading black business, church, and civil rights organizations in the city. Joining the poor in warning about the consequences of continued white implacability, the statement read in part: "If the people of Durham are wise, they will insist that the city officials will come to grips with these vital issues [such as housing, employment, and education] rather than wait in blindness or in hate for violence and disaster to strike. We stand united in support of the efforts of UOCI in its protests against intolerable conditions under which many of the citizens are forced to live in Durham."[72] United Organizations, Operation Breakthrough, the North Carolina Fund, and especially Howard Fuller would need all the support they could muster, for, instead of heeding the warnings of black leaders, white power brokers mounted a vigorous bipartisan attack that aimed to put the poverty program and its support of poor black aspirations out of business in North Carolina.

White Officials and the Assault on UOCI, OBT, and the OEO

The struggle that ensued was not simply a spat about federal funding priorities; it quickly escalated into a concerted, conservative white effort to disempower newly organized poor blacks not only in North Carolina but throughout the nation. The mayor and North Carolina's Democratic and Republican congressmen called for OEO head Sargent Shriver to fire Howard Fuller, convinced the FBI to launch an investigation of events in Durham, and pressured both the OEO and the Ford Foundation to suspend funding for the North Carolina Fund. Insisting that the NCF was "a political action machine," Republican congressman James Gardner demanded that the state legislature abolish it completely. In a partisan effort to dismantle the entire federal War on Poverty program, Gardner, who had earlier accused the OEO of responsibility for the Newark uprising, now held the federal agency responsible for the racial polarization in Durham as well. "It is a dangerous and deplorable situation indeed when the Congress funds a program to help the poor people . . . and finds that under the inept leadership of Sargent Shriver, employees of these programs are deeply involved in inflammatory activity," he charged. In no time, a slew of investigators and auditors from the OEO, the Ford Foundation, the Labor Department, and even the Justice Department descended upon the Bull City.[73]

Women's groups such as the League of Women Voters joined with both liberal whites and black leaders to counter the political attacks. Many pub-

licly decried the charges against Howard Fuller in particular. Retired North Carolina College professor Rose Butler Browne called Fuller "an earnest, eager young man who took his work seriously." "That is his crime," she said. Even black conservative Asa Spaulding came to Fuller's defense, although he averred that the fiery organizer's language was not always "non-abrasive and/or diplomatic."[74] In a remarkable sign of the fissures among Durham's white elites, Watts Hill Jr., a member of one of the wealthiest and most prominent families in the state, wrote an open letter to Sargent Shriver supporting Howard Fuller. Hill's letter, which appeared in newspapers throughout North Carolina, not only defended Howard Fuller but leveled a blistering attack on Durham's "white power structure." The city's white power brokers were, according to Hill, "highly conservative, divided for many years, easily panicked, motivated to act only by the strongest pressure, quick to relax and above all short on leadership."[75] White officials, however, turned a deaf ear to Hill's rebuke. Mayor Grabarek used the dispute as an excuse to wrest control of Operation Breakthrough from local black organizers and to return it to "the 'nice' and 'responsible' elements in the Durham community"—that is, the conservative group he had first appointed three years earlier. Meanwhile, Governor Dan Moore distanced himself from the controversy by reminding voters that the North Carolina Fund was a private agency "over which the state [had] no control," and he affirmed his administration's commitment to law and order.[76]

Government officials once again cleared OBT of any wrongdoing, but the accusations and negative publicity had taken their toll. Operation Breakthrough did not fold—it is still in existence—and the organization even received OEO funds the following year. However, OBT head William Pursell submitted his resignation shortly after the federal government absolved Durham's poverty agency. North Carolina Fund director George Esser summed up the devastation: "The investigators came, found the evidence flimsy, and they went back to write their reports, which came in months later, after the damage to the agency's reputation had been done, with a clean bill of health."[77]

The Durham fracas continued to reverberate in Washington, lending momentum to conservative attacks on the OEO and helping to undermine the entire War on Poverty initiative. By the end of the year, Congressman Gardner was blasting the OEO as "the worst administered and least effective agency within the Federal government." Unable to abolish the OEO, he managed to attach amendments to the congressional appropriations bill pro-

hibiting "poverty agencies and its employees from engaging in any partisan or non-partisan political activity" and redundantly outlawing "any unlawful demonstration, rioting, or civil disturbance."[78]

The events of 1967 exacerbated racial tensions locally as well. Howard Fuller emerged as the state's most visible black radical activist, feared by whites and venerated by disempowered blacks. Poor blacks may have hailed him as a "Black Jesus," but conservative whites were certain he was "a revolutionary ogre whose activities had to be watched and curtailed." Despite the concerted attacks by white politicians, activists built upon the successful organization and mobilization of low-income blacks, especially women, in planning their next move. Unwilling to lose the momentum of African American militancy that had been unleashed across the state, a number of activists broke away from the North Carolina Fund and formed a new organization, the Foundation for Community Development (FCD). The FCD hoped to alleviate poverty among North Carolina blacks through community economic development and community organization of the poor. The new FCD director, Nathan Garrett, a black North Carolinian and former deputy director of the North Carolina Fund, justified the need for a new organization by denouncing NCF board members. They were among "the wealthiest and most powerful men and women in the state," he charged, and were therefore incapable of advancing the needs and interests of the state's poor black residents. Durham's UOCI was one of the first groups to receive funds from the FCD, but soon poor people's organizations in Raleigh, Rocky Mount, Greensboro, Fayetteville, and Wilson all received FCD support. By 1969, the organization had trained hundreds of community organizers and indigenous leaders in poor black communities across North Carolina.[79]

Meanwhile, during the tumultuous summer and fall of 1967, United Organizations members attended over two dozen "stormy" meetings with various city agencies, private groups, and the city council to press their demands. Little was accomplished. At one session with local business leaders, a UOCI representative was forced to correct the chairman of the Merchants Association's Committee for Equal Opportunity after he used the term "nigger."[80] In August, the Carolina Times accused Durham's Wense Grabarek, who had previously received the DCNA's endorsement in the 1963 mayoral election, of being an "on again off again mayor" and described him as a "southernized yankee," the "worst white person to deal with when it comes to racial matters."[81] Grabarek repaid the compliment by campaigning against the "block vote" (a term that was a less-than-subtle allusion to the DCNA black vote and that originated with segregationist Jesse Helms). The race-baiting tactic worked,

and Grabarek roused enough white support to win a second term. In September, United Organizations threatened a boycott of downtown merchants but for the time being was dissuaded by the "elders of the Negro community."[82]

Such obstinacy on the part of white officials drew the black community closer and cemented its resolve. Male leaders even publicly acknowledged the contributions of local women. As if to underline the black community's newly forged cross-class racial solidarity, the *Carolina Times* named none other than United Organizations leader Mrs. Ann Atwater as "Woman of the Year" for 1967. Atwater had received community-wide recognition during her wrangling with the Housing Authority, in which she forced officials to accept tenants with "illegitimate children" and police records. She also managed to halt the illegal eviction of thirty-five families by the Durham Redevelopment Commission, which claimed they stood in the path of the East-West Expressway.[83]

Although few of United Organizations' demands had been met, the members could point to several important victories, especially concerning issues African American women had identified as priorities. The Housing Authority canceled a proposed housing development in response to black criticism that it would increase racial ghettoization, and it upgraded recreational facilities in another housing project. For the first time in Durham's history, white officials agreed to construct a predominantly black public housing project outside the historically black southeast quadrant of the city. The Merchants Association similarly made concessions regarding employment.[84] The uninhibited voice of the poor—and it was primarily the collective voice of low-income black women—seemed finally to have found an audience. It remained to be seen, however, whether these gains represented the beginning of real progress or whether they were concessions made under duress by a white power structure unwilling to entertain even the idea of a genuine shift in the economic and racial status quo.

The emergence of United Organizations is important for several reasons. First, it demonstrates that low-income black women were critical players not simply in numbers but in setting the agenda of the African American freedom movement as it shifted its emphasis to community organization among the poor.[85] Black women also provided the core of grassroots leadership, particularly at the neighborhood level. Utilizing personal bonds as well as more formal networks and deploying a range of tactics, poor women organized their communities and then mobilized them for mass actions. Their roles as

mothers responsible for the welfare of their children frequently fueled their activism. But they also claimed rights as workers and as citizens, not only by insisting on voting rights, but by demanding expanded and more justly distributed services from their employers and the state. Equally as important as their demands for increased wages, better working conditions, or adequate shelter was low-income women's insistence that they be treated with respect and dignity by those with formal authority. One Operation Breakthrough organizer explained: "There are other kinds of poverty too. There is the poverty of not knowing, of being 'left out' in community affairs, of lack of self-respect."[86]

The organization and mobilization of the poor, however, also exposed the dilemmas that arose for local blacks when they relied on government support. On the one hand, the federal government in particular was a vital source of much-needed funds for local programs and a critical ally in enforcing new civil rights laws. Because War on Poverty funding was tied to antidiscrimination regulations, community organizers could use the promise of federal largesse as both a carrot and a stick in their dealings with Durham power brokers. But local officials had federal clubs of their own, and as the uninhibited voice of the poor grew more insistent, whites harnessed federal power to squelch the collective strength of Durham's impoverished black residents. However, white retaliation revealed as much about the new level of black insurgency as it did about white anxieties. Too much had changed, locally and nationally, for white retribution to be entirely successful. The earlier achievements of the civil rights movement in eradicating legal segregation and the newfound organizational power of the poor forced both powerful whites and the traditional black leadership to take notice. The uninhibited voice of the poor threatened a new day—one that moved beyond blacks and whites eating hamburgers together at lunch counters—and shook the remaining vestiges of white supremacy to their core.[87]

In the days and months ahead, United Organizations would embrace seemingly opposite and contradictory ideologies and strategies, including racial integration, interracial coalitions, and black separatism. Far from being disparate, competing trends of the late 1960s, in Durham, at least, these strands frequently coalesced in women's activism. Indeed, the new cross-class racial solidarity that emerged in Durham in the late 1960s did not prevent low-income black women from reaching across the racial divide to seek alliances with white women, both low-income and middle-class.[88]

More that the sum of its achievements, the real significance of United Organizations lay in its ability to forcefully project the newfound voice of the

poor, a voice that would grow louder and more insistent as the decade drew to a close. "There has been a tremendous change in the attitudes of poor black people, a whole new dignity about themselves, a new feeling that they can play a part in deciding things about their lives," Howard Fuller explained. "And," he added, "there has been a redistribution of *power*."[89] Neither local nor national leaders were prepared for what the War on Poverty unleashed—the unrelenting aspirations of black people for full participation in all realms of social, economic, and political life fueled by the collective muscle of low-income African American women. "There are no better fighters," Fuller remarked. "They know how to hang in when it gets rough. . . . And when it gets a little bit rougher, they're not gonna quit." A member of United Organizations echoed a similar sentiment: "We have been organizing the people like we never been organized before," she said. "And we're gonna stay this way—cuz, you know, we're strong."[90]

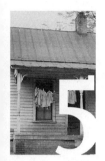

Someday, . . . the Colored and White Will Stand Together

Organizing Poor Whites

"It's just another example of the people not being consulted or given any say whatsoever," observed the angry mother at the end of the 1969–70 school year. Residents in one of Durham's poorest neighborhoods had just discovered that the Edgemont School, a racially integrated elementary school, would close in September. Parents were furious that the Durham school board had failed to notify them directly, even bypassing the Parent-Teacher Association. Instead, residents learned of the decision when they picked up their morning newspapers. Ironically, as most white Durhamites mounted a last-ditch effort to resist integration, white and black parents in Edgemont fought to save a racially integrated school that was 60 percent black. According to mothers of both races, racial tensions were minimal at the school. Parents claimed to have no problem with Edgemont's racial composition, even though the white student population was lower than the ratio demanded by the NAACP lawsuit.[1]

Defying stereotypes of white working-class opposition to school integration that would soon dominate national headlines, white and black mothers launched a petition campaign and in one afternoon collected over 350 signatures opposing the school board's decision to close their children's school.[2] A biracial delegation made plans to go to the Durham school board "and raise Cain," but the school superintendent convinced them to wait for the court decision in the Durham school desegregation case. Weeks later, a federal judge upheld the school board's decision. "We turned the petition in to the district judge, but he didn't say heck to us," complained Mrs. Christine Richardson, a white mother with two boys at the school. Although official explanations for the school closing varied, many local residents believed the decision was retaliation for Edgemont parents' demands for a voice in school decisions. Others felt certain the school board considered the cost of maintaining Edge-

mont School to be too high, especially for a poor folks' school. In the end, the closing of the neighborhood school was yet another reminder to poor Durhamites, both black and white, about who really called the shots in the Bull City.[3]

Biracial Coalitions and White Supremacy

More striking than the defeat was the fact that low-income southern whites had found common cause with their black counterparts in connection with the volatile issue of school desegregation. Yet whites' ability to forge a biracial alliance concerning a specific, well-defined issue did not mean that they had somehow relinquished all claim to white supremacy. On the contrary, most whites in Durham—low-income as well as the more affluent—harbored deep-seated racial prejudices and fears. The Ku Klux Klan experienced a revival across the state after 1964, and in Durham the KKK and White Citizens Council were in control of the segregated tobacco unions. Just a few years before the Edgemont School closing, nearly 8,000 whites had flocked to a KKK rally at a Durham stadium; while Vice President Humphrey addressed a Duke crowd seven miles across town, imperial wizard Robert S. Shelton of Tuscaloosa, Alabama, lambasted President Johnson for publicly announcing the arrest of three men in connection with the recent Alabama murder of Mrs. Viola Liuzzo, a white Detroit housewife and civil rights activist.[4] Yet by the late 1960s, low-income blacks and whites—particularly women from the Edgemont neighborhood—also tentatively and cautiously reached across the racial chasm to cooperate on a range of fronts, from protesting the media's depiction of their neighborhoods to opening a racially integrated community health clinic. Indeed, by the early 1970s, a local KKK leader and one of Durham's most respected black community activists would join forces in a partnership that few could have predicted.

Interracial Cooperation versus an Interracial Movement

The interracial poor people's movement that many civil rights activists, including Martin Luther King Jr., had envisioned may not have come to fruition, yet numerous instances of interracial cooperation did emerge. And as the examples above illustrate, women were key to these efforts.[5] Black and white low-income women often found common ground rooted in similar class-based conceptions of motherhood, neighborhood, and citizenship. But they joined forces on the basis of immediate needs and perceived self-interest, not on the basis of some abstract ideology about interracial coalitions. As one of the young women organizers from Duke explained, "The ultimate goal was

social and economic justice." Thus, their shared experiences of oppression—as women, as mothers, and as impoverished citizens denied full participation in society—fueled their alliances. Indeed, for white women especially, the initial experience of working jointly with black women sometimes opened the door to other cooperative endeavors. The ability of low-income women to work cooperatively across the racial divide suggests that the basis for a transformed "beloved community"—one based not simply on shared moral or religious values but on similar experiences of economic exploitation—was more than a faded dream of naive activists.[6]

Of course, not all their efforts were successful, and many low-income white women also clung to their white supremacist assumptions. In the end, persistent racism (among both low-income whites and white officials), historical timing, and organizers' failure to fully appreciate neighborhood women as vital assets undermined any chance of sustaining a genuine interracial movement of the poor. Still, that poor whites and blacks, two groups typically perceived as least likely to work together, could find any area of solidarity was noteworthy, particularly in the late 1960s, when Black Power, racial violence, and a white backlash made such alliances unlikely—or so we have been told by scholars and activists alike. The ideological predisposition to see Black Power and interracial alliances as mutually exclusive, the focus on formal male leadership, and the tendency to see the workplace as opposed to the neighborhood as the arena most likely to foster interracial cooperation have combined to obscure the history of women's interracial efforts. Similarly, the failure of movement activists to establish an interracial movement among the poor has kept scholars from seeing how the work of local women built and sustained community projects, some of which were biracial.

The biracial alliances that formed in Durham in the late 1960s were the fruit of several years of organizing campaigns in both black and white communities that began with Durham's antipoverty program, Operation Breakthrough.[7] From its inception, Operation Breakthrough deliberately targeted poor white areas as well as black neighborhoods and hired both white and black staff. But although the program was biracial, it was not really racially integrated, and organizers generally did not attempt to bring blacks and whites together in the same groups. One OBT evaluator explained, "Always the pattern has been 'white on white,' white staff working with the white clientele."[8] Despite OBT's efforts, many low-income whites resented and feared the antipoverty program, seeing it as "just for the colored."[9] The emergence of United Organizations for Community Improvement, with its style of militant confrontation and its Black Power rhetoric, did little to quell their anxieties.

Modeling White Organizing on Black Efforts

White racial animosity, however, does not tell the entire story. Acutely aware of their own grinding poverty and paralyzed by political powerlessness and economic insecurity, low-income whites looked across the racial divide at the events of the 1960s with both fear and admiration. "One thing about the blacks, they'll stick together and get what they want," a white Durham mill worker observed. "Whites will never do that. . . . white kids can be starving, [but] it don't make no difference to the big shots."[10] Despite their resentment, Durham whites modeled their own community organizing campaigns and a low-income white neighborhood federation, ACT, after those of blacks.[11] Mrs. Bascie Hicks, a former textile mill worker and ACT member, explained: "You see, the colored people already had something to stand up for them. . . . But whether our people want to admit it or not, we're taking a lesson from [Operation] Breakthrough. Someday—I don't know when—when everybody sees there's something in it for him, I think the colored and white will stand together."[12] In order to blunt white anxieties, white organizers developed Experiment in Parallel Organization (EPO), a project that focused exclusively on organizing low-income whites. Out of these efforts, ACT, a neighborhood federation loosely modeled on the all-black UOCI, was born. Between 1967 and 1971, ACT organized twenty-one neighborhood councils of low-income whites as well as a new welfare rights group. And just as United Organizations drew in overwhelming numbers of poor black women, ACT also relied on informal networks of local white women. ACT organizers would inadvertently come into contact with and utilize these female networks, but it was not because they sought them out. It was simply that local women came to meetings and did the work.[13]

Both internal dilemmas and external forces impeded ACT's white organizing campaigns as well as its attempts to form biracial coalitions. One of the most detrimental yet least noticed obstacles was ACT's failure to see local women as important assets. Rather than building on indigenous women's networks and women's needs, ACT's largely middle-class, male leadership initially focused on recruiting marginal men. ACT leaders also adopted gendered definitions of politics and protest that favored mass confrontations with white officials while dismissing the need for services that benefited women, such as child care.[14] Thus, ACT seemed beset by a curious paradox: women outnumbered men in the organization, but men retained most of the key decision-making positions. The inability of ACT's male leadership to fully recognize its female staff or the neighborhood women as important re-

sources in their own right reflected a gender myopia that undermined community organizing efforts and impeded cross-race alliances as well.

Initial Efforts to Organize Poor Whites

The creation of EPO and ACT reflected broader shifts in the civil rights movement. After 1964, civil rights leaders both nationally and locally began to think more seriously about the need for whites to organize in white areas rather than continuing to work with black organizations or in black communities. Organizers in Durham felt that if poor whites were to be successfully allied with blacks, whites needed to develop a stronger sense of community among themselves.[15] In the mid-1960s, white organizers, including Duke University students Harry Boyte and Dick Landerman, made sporadic efforts to organize low-income white neighborhoods in Durham. On the surface, there seemed little similarity between the two young men. Boyte was a native of small-town North Carolina, and his father had been Martin Luther King Jr.'s first white staff member. Before coming to Duke, where he started a campus CORE chapter and supported black workers in Local 77, the younger Boyte had worked in SCLC citizenship schools in Saint Augustine, Florida, and in eastern North Carolina.[16]

Dick Landerman, on the other hand, was a transplanted Jewish Yankee who had first come to Duke as an ROTC student. He recalled that during drills young ROTC recruits would chant, "There's a nigger in the grass with a bullet up his ass." Although the overt racism made Landerman uncomfortable, he kept quiet. But when demonstrations started in Chapel Hill, he found himself participating, and soon Landerman joined the black freedom movement in Mississippi, returning to Durham in 1965. Hence, both Boyte and Landerman had honed their skills and broadened their horizons in the southern black movement before embarking on white organizing projects in Durham. Although the two young men made impressive headway in white neighborhoods and even developed an innovative theory about organizing low-income southern whites, they failed to fully appreciate the contributions of local women.[17]

Efforts to organize poor whites in the spring of 1966 initially met with little success. Most whites were reluctant to participate in neighborhood councils with black residents.[18] But when Harry Boyte, working with Operation Breakthrough, organized whites separately from blacks, residents were more responsive. One of the first local residents Boyte met was Bascie Hicks. Hicks reassured neighbors that Boyte could be trusted, which proved espe-

cially useful after the local Ku Klux Klan started following him. Bascie and her husband, Doug Hicks, also a former mill worker and Textile Workers Union of America steward, along with another neighbor, led a neighborhood struggle to secure a stop sign and change their block to a one-way street. Meanwhile, in a nearby neighborhood, a ninety-three-year-old white woman and another couple led a fight to get an abandoned lot cleared. As a result of these small victories, two neighborhood councils had emerged by the end of the summer.[19]

Dick Landerman seemed an unlikely organizer of low-income southern whites, but his working-class background gave him a certain affinity with neighborhood residents. Sporting a black leather jacket, he spent hours walking the streets, talking to people, carrying groceries, and running errands. "I liked Dick from the start. . . . You couldn't get rid of him if you wanted to," recalled Deborah Cook, a neighborhood woman who was in her late teens with two small children when she first met Landerman. Cook later worked for Operation Breakthrough and was one of the founders of ACT. "Dick was different from most people that we knew around our neighborhood," she said. "But he didn't act like those college students or anything. . . . He always said [you] didn't need to have much college as long as you had common sense."[20]

At the first neighborhood meeting Landerman called, only one person showed up, "out of curiosity," but that person was Mrs. Patti Harrington, a young woman in her mid-twenties with two children. She was married to an unstable, brawling alcoholic who was in and out of jail. In the neighborhood, she was known as "good little Patti"; however, a local journalist described her as "a sharp neighborhood woman who liked the idea of organizing people." Meeting with neighbors and hearing their concerns, Dick Landerman and Patti Harrington laid the foundation for a community organizing campaign among poor whites in Durham. Although local residents were suspicious at first (Harrington initially thought Landerman was a census taker and then a welfare department spy), neighborhood women began meeting together in living rooms, kitchens, and on porches to discuss community problems—an unpaved street, the lack of streetlights, the need for a park or a recreation center, housing code violations—and to formulate solutions.[21] Soon, residents of one area joined together and built Patlock Park, named after the two neighborhood people who initiated the effort, Patti Harrington and Cuba Matlock, a respected family man in his fifties. The park quickly became a center for neighborhood activities, helping to cement bonds among community residents.[22]

Developing a Theory of Organizing Poor Whites

Out of these initial efforts, Harry Boyte and Dick Landerman developed a theory of white organizing that formed the basis for Experiment in Parallel Organization and its offshoot, ACT, established in 1968 with a federal grant from the Office of Economic Opportunity.[23] Although their analysis contributed important insights to the problems of organizing indigent southern whites, the young men's failure to fully appreciate the gendered dimensions of low-income southern white community life left serious flaws in both their theory and their practice.

Rather than focusing on the racism of poor whites, organizers tried to provide experiences that would enable white residents to see that low-income blacks and whites shared mutual concerns. This could best be accomplished, Boyte and Landerman believed, by getting white neighborhood groups together to work on small, everyday issues that were of immediate concern and that were winnable, such as securing a stop sign or streetlights. The experience of working together and achieving victories would provide the neighborhood groups with a basis for pursuing larger goals, but Boyte and Landerman also thought it would lessen the threat poor whites might have felt from black accomplishments. Organizers encouraged confrontations with powerful white institutions such as the city council "in order to clarify relationships of power." Through such confrontations, poor whites would presumably see how key political and social institutions served the interests of the wealthy and powerful; this realization would then compel whites to seek common cause with indigent blacks.[24]

Organizers also focused on the strengths of poor white communities.[25] Low-income whites could rise above mainstream society's individualist ethos, they maintained, by building on indigenous community traditions and celebrating working-class life and culture. ACT's newspaper, Action, featured articles on the history of southern white radicals and carried a regular column on current grassroots struggles called "Fighting Side," but it also included items on stock car racing, recipes for inexpensive meals called "Action Recipes," and even a humor section. Rejecting the contemptuous and patronizing critiques of white, middle-class liberals and radicals who dismissed low-income whites as victims of "false consciousness," ACT leaders claimed that low-income whites had genuine needs that had to be recognized. Poor whites faced the same social forces that alienated blacks and youth, "an inchoate isolation and powerlessness and feeling lost in inhuman bureaucracies." It was this sense of alienation, not simply racism, ACT leaders insisted, that attracted poor whites to George Wallace's presidential campaign.[26]

ACT organizers believed that whites were hostile to antipoverty programs and demonstrations not simply because they were associated with the black freedom movement but because impoverished whites perceived any improvement of opportunities for African Americans as a threat to their own precarious security.[27] Cultural barriers, in particular "the lesser sense of community" that seemed pervasive among poor whites, posed even greater difficulties to organizing white communities. Unlike African Americans, whose color "[set] them apart and encourage[d] a feeling of solidarity," impoverished whites shared a racial identity with the dominant society.[28] Whites also internalized an ideal of individualism that discouraged them from seeing the structural causes of their problems and from seeking collective solutions. Their poverty thus became for them a symbol of personal, individual failure. Dick Landerman explained: "Whereas the black people have a history of advance through organized activity, in low-income white communities, it's each man for himself. They see little reason to pull together for the common good." A survey of low-income communities confirmed that Durham blacks had much higher levels of participation in social, political, and religious groups compared to whites, and it found that whites were often "resentful and bitter."[29] One observer remarked, "In every cooperative effort, the blacks ran things because they understood the ways of the world so much better." Harry Boyte articulated what soon became ACT's overriding philosophy, the belief "that the central problem with organizing low-income whites stemmed from their lack of a collective analysis of their problems and a collective understanding of solutions." Thus, Boyte believed, whites needed to develop a sense of collective identity. The critical component "in developing such a common identity," Boyte asserted, "[was] that whites should meet separately in order to form a solid group identity and avoid being overshadowed, before coalescing with black groups."[30]

Masculinist Bias and Women's Networks

Poor whites might not have participated in formal organizational life to the same extent as poor blacks, but low-income white communities had highly developed informal networks similar to those within poor black neighborhoods. Just as African American women's kinship and friendship networks had formed the basis for organizing campaigns in poor black neighborhoods, white women's networks were equally indispensable to organizing poor white neighborhoods. ACT's greatest failure was its inability to build a more solid community base. There were many reasons for this, but chief among them was ACT's disregard for the gendered dimensions of com-

munity life; this blindness, in turn, prevented ACT leaders from fully utiliz-
ing one of their most critical assets—neighborhood women's networks.

Not only did ACT neglect local women, but the male leadership initially
targeted those in the community "with the least to lose"—unemployed men,
ex-convicts, and corner kids—who were thought to be "quickly radicaliz-
able."[31] This strategy, coupled with a romanticization of working-class male
bravado, led Boyte and Landerman to recruit two young neighborhood men
and make them president and vice president of ACT. Their decision almost
proved catastrophic. A sympathetic journalist and activist described what
happened: "To state it charitably—the two men turned out to be less than de-
sirable additions to the staff, reflecting in large measure many of the same
negative social attributes of other poor whites in the neighborhood." To put
it more bluntly, they were hustlers: one, an ex-convict and a mean and "crazy"
drunk, was "a local legend for his wild exploits," which included running a
bootleg house and shooting a cop.[32] Along with their rough charm, the two
men drained staff energy and resources; more critically, they also "damaged
ACT's legitimacy" among the very people ACT hoped to reach—the neighbor-
hood residents.

Even after the hustlers moved on, ACT's vision remained male centered.
The organization shifted its focus to "mature leaders in communities—stable
families who were respected," but organizers defined "stable" families as
synonymous with male-headed nuclear families. Although ACT did recruit a
"few stable blue collar families, the basic constituency continued to be poor,"
and, though few noticed it at the time, largely female.[33] Thus, ACT missed
an opportunity to develop the activism of many local women and, in turn,
failed to create a more substantive mass base. This is not to say that no local
female leadership emerged—in fact, most of ACT's neighborhood councils
were headed by women, and two-thirds of the ACT staff were neighborhood
women—but women's predominance in ACT was inadvertent rather than
the result of a self-conscious or intentional strategy. Moreover, men retained
most of the top decision-making positions. In effect, there was no organized
plan that focused on women as critical to neighborhood organization.

Despite this failure, white neighborhood women quickly became key to
ACT's success, much as black women had done in United Organizations.
Probably the most extraordinary neighborhood woman on ACT's staff was
Mrs. Bascie Hicks, who lived in Edgemont.[34] Hicks had grown up in a south-
ern textile mill family, and she followed her mother into the mills at age
nineteen during World War II. After the war, Bascie met her future husband,
Doug Hicks, in the mill, and both joined the Textile Workers Union of Amer-

ica, a CIO union. Like many low-income southern whites, Bascie had enjoyed a fair amount of contact with African Americans who lived in adjacent neighborhoods, and she included blacks among her friends. Yet Hicks was not unaffected by white supremacy. One day during the war, an unemployed black man with few options and a family to feed came to the mill, but the "boss man" claimed he could not hire him on account of his color. "I wonder now why I didn't speak out for the black man," Hicks chastised herself twenty years later.[35]

After meeting Harry Boyte during an ACT organizing campaign in her neighborhood in the mid-1960s, Bascie Hicks joined the staff and began writing a regular column, "People Power vs. Money Power," for the *Action*. Hicks covered a wide range of topics, among them brown lung, labor unions, the Vietnam War (which she opposed because "working people [were] the hardest hit"), and the right to vote. She articulated radical views, but Hicks refused to relinquish the cultural symbols that were increasingly associated with conservative whites—God, country, and law and order: "All my life I have been a 'God-fearing,' 'law abiding,' tax paying citizen of the United States," she declared proudly.[36]

Bascie Hicks was widely respected among neighborhood residents and organizers, male and female alike. "Bascie was a very special person," recalled Dick Landerman: "[Sometimes] you get a few kind of saintly people who seem to know the right thing to do and do it for the right reason and [who] are just personally very generous. . . . She was a woman in the neighborhood [who] helped out all the other neighborhood kids; [she] was just there." Another organizer described her as "both leader and strategist," someone "who contradicted the whole notion that people who understood organizing strategy were cut off from the community."[37]

Bascie Hicks was what anthropologist Karen Sacks has identified as a "centerwoman" (or a "bridge leader," according to sociologist Belinda Robnett). Centerwomen frequently have great responsibility but little formal authority. However, their reputations and the respect they have earned within neighborhoods and families help to legitimize organizing campaigns.[38] As Tami Hultman, a native North Carolinian and Duke student who canvassed Edgemont neighborhoods with Hicks, explained, "Bascie knew a lot of people, so we had that advantage." Years later, Dick Landerman also noted the importance of friendship networks in building community organizations: "You met friends and friends of friends." Patti Harrington's first contact with Landerman came when he knocked on the door of a friend she was visiting. Mrs. Virginia Watkins, a Durham native of thirty-nine years and mother of

seven children, was attracted to ACT after she saw how the organization had helped her sister. Watkins soon became president of the Orient Street Council, and she and another neighbor, Mrs. Betty Cook, "went house to house to round up members."[39] Whether the male EPO and ACT leadership fully understood the gendered base of community networks or not, it was the women who showed up at meetings and kept the councils going. Local women quickly became the backbone of neighborhood councils, and a number even assumed leadership positions in the councils. However, men such as Boyte and Landerman continued to dominate ACT's decision-making positions.[40]

Women's numerical dominance in the neighborhood councils reflected the ways in which almost every aspect of daily life was segregated by gender in the household, at work, and in social settings. "Guys would hang out with their friends and women would hang out with their friends and sisters," Landerman noted.[41] Women's domestic responsibilities tended to build neighborhood networks based on notions of cooperation and reciprocity as women shared child care duties, offered cooking tips, or helped with sick relatives. Women's networks, especially among poor women, may have been derided as "gossip rings" (middle-class women's gatherings similarly were dismissed as "coffee klatches"), but they formed an important aspect of low-income women's daily survival strategies.[42] Feminist activist and future women's historian Sara Evans, who was married to Harry Boyte and worked briefly with ACT, observed the conventional gender roles that characterized low-income white families in Durham: "Men tend to consider women's concerns as either trivial or mysterious," she said. "Women, on the other hand, expect the men to be uninterested in child care or housework. [As a consequence], both men and women . . . seek out members of their own sex in whom to confide their emotional and daily concerns. Thus, many women communicate more fully with their mothers, sisters or girlfriends than with their husbands."[43] Traditional gender roles were no less prominent in more affluent families, but there they did not usually translate into the same kind of intimate neighborhood bonds that became part of poor women's daily survival.

Other community women such as Deborah Cook and Patti Harrington were the "stable" forces in disruptive households. A movement journalist noted that although they were "obviously oppressed by their men, as well as by everything else in their worlds, the women were sharper, somehow more 'together' than most of the men, more able to respond to someone, to something new."[44] Women's daily lives promoted a sense of neighborhood solidarity that could be translated into political action through the neighborhood

councils. The councils in turn became vehicles to more active public roles for low-income women, which included speaking out at public meetings, confronting city officials, or organizing petition drives and press conferences.

A kind of neighborhood machismo frequently discouraged male participation in the neighborhood councils. "Men would drink and drive around in their cars. [Attending meetings] wasn't a particularly manly thing to do," Landerman recalled. Some men, such as Cuba Matlock, were very active in the neighborhood councils, but according to Deborah Cook, "You could hardly get a man there." Low-income white men tended to see meetings as a woman's activity in much the same way that poor black men often viewed community work as women's work. But if men found it difficult to participate, women found the experience of working with ACT empowering, and many acquired the experience, skills, and support to become public advocates for the poor. Perhaps most importantly, the organization gave poor people a sense of self-confidence "that [we] thought [we'd] never have," Deborah Cook remarked as she bitterly recalled the patronizing disregard she had felt from middle-class teachers. Thus, public or civic life, frequently considered to be exclusively or predominantly male, also had a distinctive and overwhelmingly female character in certain working-class settings.[45]

Broader economic changes also help to explain women's responsiveness to ACT. Since the 1950s, Durham had witnessed a steady decline in manufacturing jobs that enlarged the ranks of the working and nonworking poor among both blacks and whites. ACT estimated that close to 70 percent of Durham families in 1970 had annual incomes of under $9,000, the official "moderate standard of living." Both the changing nature of women's responsibilities within families brought on by male unemployment and the War on Poverty's grassroots organizing campaigns compelled women to demand increased support from the state and led to a rise in neighborhood women's activism.[46]

Day-to-Day Organizing and ACT's Gender Tensions

Although neighborhood women dominated the neighborhood councils, a gendered, class-based hierarchy was perpetuated within ACT. "The heads were white males" because they had simply worked their way up to leadership levels, Landerman explained. But he also acknowledged that the division of labor along gender and class lines caused problems, as male leaders used their positions to delegate tasks they considered tedious and unglamorous to neighborhood women and female students. "The neighborhood people and the newer students were the ones who were stuck out there doing canvassing

while . . . people like me and Harry . . . were going around . . . like movement honchos. Basically there was a fair amount of self-promotion," Landerman admitted. "Door-to-door organizing is very difficult in the long run for most people," he said. "On a good day you might find one in ten, one in twenty [who are receptive]. . . . It's like being a door-to-door salesperson."[47]

Not all women found organizing tedious, perhaps because they were often better at it than the men.[48] Tami Hultman loved canvassing, for it resonated with her southern upbringing, in which face-to-face relationships and informal interactions among neighbors were highly valued. Hultman's father was a country preacher and World War II veteran who had worked in several restaurants and at Burlington Mills before taking advantage of the GI Bill to secure a bachelor's degree and then a divinity degree at Duke University. Tami's mother came from a long line of North Carolina mill workers and had gone to work at age nineteen in one of the Piedmont's textile mills. Tami was born shortly after the war ended and spent a happy and "typical, Southern rural, Bible-belt childhood" driving across North Carolina with her mother and itinerant preacher father and "going from church to church." However, Tami's idyllic family life came to an abrupt end in 1954 after her father delivered a provocative sermon in his wife's hometown. The outspoken minister claimed he did not care what color man his daughter married just as long as he was a good Christian. The shocked congregation, still reeling from the *Brown v. Board of Education* decision, was in no mood for such apostasy from one of its own. The deacons hastily called for the minister's resignation. Hultman's family moved on, but they held on to their principles. Tami never forgot those early lessons about Christian charity, racial tolerance, and white supremacy, a confusing and volatile mix for a young white girl in the 1950s South. When she attended Duke University in the mid-1960s, Bertie Howard, one of the first black students admitted to the university, was her roommate. Tami quickly became involved in the progressive Christian student movement, served as president of the Duke YWCA, and was active in a wide range of protest activities on and off campus.[49]

After graduating from Duke in 1968, Hultman took a full-time position with ACT as a community organizer. She and Bascie Hicks knocked on doors in Edgemont and were frequently invited in for a slice of pie or biscuits and homemade jam. Sipping iced tea in living rooms or on porches, the two women talked to residents about their lives. "It didn't seem like hard work. . . . because, well, I was a Southern girl," Hultman explained. "These were the people I grew up with. . . . There was no difference [between] those people and my family." Although neighborhood canvassing was critical to building

a mass organization, the male leadership in ACT did not value organizing to the extent it might have, perhaps because of who did the organizing work.[50]

Although men may have wielded disproportionate influence in ACT, the organization was formed in 1968 at the same that the women's liberation movement was getting off the ground, and the movement had a direct impact on ACT's internal staff relations.[51] Tami Hultman joined the Charlotte Perkins Gilman group, a women's liberation group in Durham started by Sara Evans and Charlotte Bunch. Hultman and other young women soon brought their feminist politics into ACT staff meetings. "Feminism was part of the air we breathed . . . [and] we weren't gentle about it," Hultman recalled. Bertie Howard, who was also part of a feminist reading group at Duke and who worked with black neighborhoods in Durham, described these radical white women as "kick-butt feminists." Although Hultman insisted that "those [ACT] guys [were] respectful towards women," she acknowledged that the men also held most of the top leadership and decision-making positions in ACT.[52]

ACT's gender tensions were exacerbated during the summer of 1969 when a group of ACT women raised complaints about the lack of democracy in the organization. The issue came to a head after the new male EPO director fired four women and two volunteers without notice. The Operation Breakthrough board (which served as the umbrella organization for EPO and ACT) denied the women's appeal of their termination, a move that had devastating consequences for ACT.[53] Harry Boyte publicly defended the women and denounced EPO's draconian actions. ACT struggled on for several more years, but the turmoil over the women's dismissal decimated the organization. "The internal fighting discouraged a lot of people. I remember everybody said okay, now we'll go on, but it never seemed to get cranked up again," Dick Landerman lamented.[54]

External forces also took a toll on ACT. Just as Operation Breakthrough and United Organizations had struggled with the dilemmas posed by government funding, so too did the ACT crisis underscore the contradictions of trying to create democratic, grassroots organizations while remaining accountable to outside control. According to Boyte, EPO's dismissal of the ACT staff demonstrated how federal funding could impede community control of the organization. "Because of its standing as a part of the federal poverty program, EPO is finally responsible only to the government, not to the people whom it serves," Boyte complained. "ACT members could have no input into the current problems within EPO which affect ACT itself." Rumors of financial mismanagement led to an outside investigation of ACT's finances. The

investigation never drew the same kind of negative publicity as the OBT or NCF controversies, and ACT eventually was cleared of any wrongdoing. However, the group's reputation suffered "severe damage," and the controversy forced at least one neighborhood woman to quit in disgust.[55]

The dispute over funding also unleashed a debate over ACT's direction that further aggravated class and gender tensions within the organization. Boyte and other ACT leaders believed that the large grant EPO/ACT received from the OEO paradoxically undercut its long-range success, for it turned ACT away from the goal of building a strong, democratically based local social change movement into a service organization that attempted to provide needed services for impoverished residents. Federal funding also exposed the organization to interference from Operation Breakthrough, which further undermined ACT's ability to build an independent, mass-based, democratic organization. But by presenting the choice between providing services and effecting political mobilization as mutually exclusive, ACT leaders failed to recognize how services could provide a foundation for mobilizing low-income communities, particularly if those services were directed at women, who were critical to grassroots organizations.[56]

Even the ACT day care center, a clear effort to make women's concerns an organizational priority, was hampered by internal divisions in ACT, and the center became another missed opportunity to cement ACT's grassroots base. Like Joyce Thorpe and the black women in McDougald Terrace, white neighborhood women had long identified child care as a pressing need. As part of a deliberate effort to "deal more directly with the oppression of working women," ACT opened a day care center. Male leaders in ACT, however, never fully appreciated the liberatory potential of the center for women; at best, they envisioned day care as "a service which was to solidify the organization, involve parents and form a base for demands made on other city institutions."[57] Indeed, it might have, but the center was also a victim of bad timing; the internal bickering and the firing of the female staff members had badly damaged ACT's morale, leaving little foundation for a mass-based movement and even less energy for projects like the day care center. Unfortunately for the women and for ACT, the center had a relatively brief existence.[58]

The Edgemont Clinic: An Interracial Success Story

The Edgemont health clinic, a community-based interracial project, offers a dramatic example of how providing needed services for low-income blacks and whites helped build a foundation for biracial cooperation in other arenas. As its name indicates, the clinic opened in Edgemont, a former "Mill

Hill" and low-income white neighborhood that had been on a downward spiral since the Depression. By World War 11, it had become "one of the most blighted white areas in Durham." Twenty-five years later, a local journalist offered a more colorful description (and perhaps a not-so-subtle allusion to its shifting racial composition): "The mean part of town: fatback and hominy grits. A bootlegger province. It was a neighborhood one avoided on the Sunday drive."[59] By then, Edgemont was known as a "transition neighborhood," meaning that urban renewal had prompted white flight; by 1968, 60 percent of the community's 5,000 residents were African American.[60]

But white racism—notably, white apprehension about their declining social status through association with and proximity to blacks—was not the only explanation for white flight. In fact, the first blacks to move into Edgemont reported little or no trouble from white residents, who were far more concerned with rising rents and housing code violations than with the skin color of their new neighbors.[61] But as African American families moved in, unscrupulous landlords like Abe Greenberg continued to increase the rents. Whites, regardless of their racial attitudes, were forced to find less expensive housing elsewhere, and blacks with fewer options replaced the whites.

Other neighborhood characteristics also may have helped to diminish racial friction in Edgemont. For example, although the neighborhood was integrated, most streets remained racially segregated, with blacks and whites on adjacent blocks. Thus, blacks and whites enjoyed fairly close proximity but still maintained a certain degree of racial separation. The fact that many Edgemont residents were renters as opposed to home owners may have made them somewhat more amenable to cross-racial alliances. ACT member Deborah Cook recalled that east Durham whites (including whites from Edgemont) were far more receptive to organizing efforts and to interracial work than were the slightly more affluent former mill workers in west Durham, most of whom were home owners. "They were more secure than what our East End bunch was, so, see, that made a lot of difference," Cook explained. "All these [people in west Durham] were home owners [and] mostly retired folk[, whereas people in the East End and Edgemont had] more poor housing, less jobs, more welfare." Significantly, most of the successful collaborations between low-income blacks and whites occurred in Edgemont. Yet racial tensions in housing projects suggest that white home ownership alone was not the only factor feeding white racism. Moreover, even if white renters presumably were less wedded to racially exclusive neighborhoods than were white home owners, as a group they also were more transient, providing a less stable community base to organize.[62] Re-

gardless of their willingness to work cooperatively with blacks, most Edgemont whites also harbored deeply ingrained racial prejudices. For example, whites refused to participate in Edgemont Community Center programs after blacks started attending and even approached the center's staff about opening the building at certain times for whites only. Still, white racial attitudes and behavior were fluid, complex, even contradictory. As one contemporary observer remarked, "Whites continue their verbal abuse of the blacks, but on an individual level their prejudices fall away to some degree."[63] Thus, the seeds of both racial antagonism and interracial cooperation were present in these "transition" neighborhoods.

The Edgemont Community Health Clinic offered one such opportunity for interracial cooperation. The clinic provided free medical services to residents on a walk-in basis. It was a black-initiated project that grew out of a series of community health workshops organized in the fall of 1968 by an African American woman from Edgemont, Mrs. Inez Gooch. A mother of twelve, Gooch was a full-time health aide and later headed the clinic board. An Operation Breakthrough community worker described her as "a woman in her middle thirties, full of life," and like Bascie Hicks she was well respected among her neighbors. Gooch had assumed the presidency of the Edgemont council in 1967 and reunited two warring black neighborhood factions. Formerly a white council, the Edgemont council had become all-black by 1966, and it quickly became one of the most vocal and militant neighborhood groups in United Organizations. But Inez Gooch also believed that working cooperatively with poor whites could prove useful to neighborhood blacks.[64] Hence, both black separatism and interracial cooperation operated side by side.

When ACT was formed, Gooch asked several doctors to approach the new organization about the idea of white participation in the Edgemont clinic. Bascie Hicks agreed to join the clinic board and soon became treasurer. According to Inez Gooch, "That eased people's suspicions and whites got confidence that they would get good care." Mrs. Eileen Newcomb, a white woman who worked with ACT, echoed similar sentiments: "It's wonderful,—everything is nice and friendly, much better than at Duke. . . . About everybody in the community uses it." The clinic operated one night a week and was run by volunteers; medical students from Duke and the University of North Carolina provided health care, while neighborhood residents cleaned and worked as receptionists and health aides. Most importantly, it was a community-controlled project. "People feel a part of the clinic," said Gooch. "It's ours, not something doctors plopped down on us. The doctors are working

for us." In response to a query about who really ran the clinic, Mrs. Gooch glanced around the crowded room full of clients and said proudly, "We all."[65]

Despite the clinic's popularity among both blacks and whites, two fires set several hours apart destroyed the building shortly after it opened; many believed the fires were the work of arsonists. Black and white residents were determined to reopen the clinic. "We didn't want the neighborhood to think we let them down," Gooch explained. Bascie Hicks persuaded a landlord to rent the community-based project new facilities, and by the following year the clinic had expanded its hours to two nights a week and was serving 50 to 100 people each week.[66]

The Edgemont clinic did more than provide much-needed health services to impoverished blacks and whites. Above all, it created a bridge between two communities that often viewed each other with fear and suspicion. Hicks described the project's success: "Both races use the clinic about equally. And I think working together on the clinic has meant a difference in other areas as well; it's taught people to get along better." Another resident claimed, "I don't know what the community did without it, and it's brought us together as a community on other issues too."[67] Deborah Cook suggested that the community-controlled project politicized local residents, especially poor whites, by introducing the notion of health care as a right. It also taught them that when poor people stuck together, they could be effective. One clinic supporter, Daphne Lassiter, a white mother of five and the wife of a mill worker, saw the clinic's success as proof of the power of collective action by the poor: "He's got to back down sometime, the big man up there, if we stick together long enough," she said. "One individual isn't gonna change anything[, but] . . . [w]ith a group, you can change it."[68]

The success at Edgemont clinic sometimes inspired other interracial efforts. In 1969, United Organizations and ACT persuaded Edgemont residents to vote against a proposed regressive sales tax, making white Edgemont the only poor white section in the city to do so. At times, black and white Edgemont residents even engaged in biracial protests despite the concern of some whites that demonstrations and public protests constituted "civil rights" (that is, black) activities. After a teenager was shot outside the Edgemont Community Center in the spring of 1970, both black and white residents were outraged by media coverage that portrayed their community as violence ridden. An interracial group of neighborhood women, including Bascie Hicks, Inez Gooch, and Annie Nichols, all of whom were active with the Edgemont clinic, helped organize two meetings with Edgemont residents; called a press conference; and finally, in order to guarantee that the

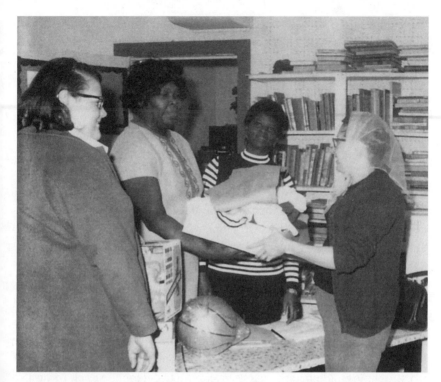

Low-income black and white women sometimes reached across the racial divide to cooperate on joint projects. This photograph was taken in the 1960s at Durham's Edgemont Community Center. (*Courtesy Edgemont Community Center Papers, Special Collections Library, Duke University*)

white newspapers covered their protests, accompanied a larger group of black and white residents to a city council meeting. Bascie's daughter, Theresa Hicks, who was active with an ACT teen group, expressed the community's outrage: "The stories in the paper were used to make Edgemont look bad. This often happens to low-income and working class communities and we don't like it." Other women active in the clinic—among them Bascie Hicks, Inez Gooch, and Daphne Lassiter—spearheaded a biracial campaign to rid their neighborhood of drugs. The following year, another coalition made up of ACT, United Organizations, and the 1199 Health and Hospital Workers Union protested Duke's rejection of a federal plan that would have provided health benefits to 38,000 Durham residents.[69] The male leaders of ACT who claimed that providing services diverted energy from political mobilization missed the point; the success of the clinic offers tangible evidence of the ability of poor blacks and whites to find common ground on a range

of fronts even at the height of black separatism and white backlash in the late 1960s and early 1970s. Perhaps most striking of all, women's activism demonstrates that neighborhoods—often sites of bitter racial conflicts—could also become arenas for interracial cooperation.

The Limits of Interracial Cooperation among the Poor

Even as low-income women reached across the racial divide, they simultaneously insisted on some degree of racial separation, underscoring the limits of interracialism. For example, both black and white women participated in the Christmas House, a project enabling poor parents to "shop without cash" for gifts for their children, but the biracial effort was successful precisely because the women participated through racially separate organizations. Shirley Sherron of ACT made explicit the limits of interracial cooperation: "This is for the people of Edgemont, whites and blacks, but separated by the community organization groups. ACT is working with whites and United Organizations . . . is working with blacks."[70]

By the late 1970s, pernicious city policies and economic forces had sounded the death knell for the clinic, underlining the powerful institutional forces arrayed against poor blacks and whites. The Edgemont neighborhood, like the clinic building itself, had been allowed to deteriorate by city officials, who predicted that the area would eventually be condemned and razed and therefore refused to allocate urban renewal funds for it. As new zoning laws allowed industry to intrude into the community, many Edgemont residents left. Soon, most of the clinic's patients came from the East End, a black, working-class section of the city that was well organized. Due to dwindling community involvement, the staff voted to close the Edgemont Community Health Clinic, and in 1979 it was relocated to the predominantly black East End section and renamed the East End Health Clinic. In the end, decisions made by city officials with little regard for neighborhood residents undermined one of the most successful interracial experiments Durham had ever witnessed.[71]

As the Edgemont school closing and the clinic experience suggest, most interracial cooperation between low-income blacks and whites revolved around issues that women traditionally embraced, especially those involving children and families. Certainly, such concerns could just as easily promote racial conflict as cooperation, and most low-income whites did not easily or readily abandon their allegiance to their "southern way of life."[72] But under the right circumstances, the shared experiences of poverty and the common concerns of motherhood enabled some women to transcend racial divisions,

at least to some extent. Nor was motherhood simply a biological role, for it had a social and political dimension in which the women understood that their problems were neither private nor individual and that they therefore necessitated collective solutions.[73]

ACT's success, however limited, raises important questions about the complexities of racism among low-income whites. Although ACT fostered biracial cooperation around specific, well-defined, short-term goals or issues, the group was less successful at creating a biracial poor people's movement for economic and social justice.[74] Still, that groups thought most likely to come into open conflict with one another—low-income blacks and whites —could find any area of unity was indeed noteworthy, particularly in the late 1960s.[75] Low-income whites were racist and, at times, willing to find common cause with low-income blacks; and they were more likely to do so than were middle-class whites, in part because of their closer proximity to blacks both in neighborhoods and in the workplace.[76] But poor whites also defined themselves as not black, and their embrace of "whiteness" in effect stymied their ability to struggle against their own exploitation.[77] Many poor whites were loath to participate in antipoverty projects and reluctant to engage in collective protest, frequently because they perceived these as "black" activities and therefore by definition anathema to white modes of behavior.[78] Sometimes poor whites who worked alongside blacks became targets of white retaliation. Deborah Cook, who worked with Operation Breakthrough for many years and also was an active ACT member, reported that local whites called her a "nigger lover" and burned a cross in her yard to discourage her activism. "If you worked for Breakthrough you were considered black," she recalled. But as we have seen, white supremacy was neither monolithic nor uncontested, and there were also fissures in white attitudes about race and whiteness. While poor whites might have resented black demonstrations against discrimination and oppression, they also were envious, and some even had a grudging admiration for perceived black accomplishments. As the experience of ACT demonstrates, the extent to which organizers were able to foster the latter attitude among whites determined in large measure whites' ability to struggle against their own subjugation.

Yet in history, as in politics, timing is often everything. Perhaps had it not been the late 1960s, marked by all the cross-currents and conflicts concerning the direction and meaning of social protest, including divisive pressures from powerful whites opposed to the empowerment of poor people, especially poor blacks, an interracial coalition might have been more successful. Yet, paradoxically, whatever success ACT enjoyed was because the black free-

dom movement of the 1960s—particularly the organization and mobilization of low-income black women—had laid the foundation. Much of ACT's weakness stemmed from its inability to recognize local women as key resources, which in turn weakened the organization's base. Similarly, ACT's failure to more fully support women's biracial efforts, many of which involved service projects, deprived the organization of interracial experiences that in turn might have provided a stronger foundation for more extensive cross-race alliances. In effect, ACT's narrow, gendered definition of politics subordinated women's needs to other activities that the male leadership thought were more conducive to building a radical movement.

The Klansman and the Activist

The relationship between Durham Klansman C. P. Ellis and black activist Ann Atwater provides a fascinating case study of the transformative potential of interracial experiences as well as the limitations of even enlightened personal relationships in the absence of a mass-based protest movement. C. P. Ellis was a white maintenance worker and the son of a Durham mill worker. His father died at age forty-eight from brown lung disease when C. P. was only seventeen, forcing the teenager to quit school in order to support his mother and sister. In and out of odd jobs, C. P. married young and had four children, one of them severely handicapped. Ellis's father had been a member of the KKK, and so it was not surprising that the son was also drawn to the white supremacist group. C. P. recalled his initiation into the secret society: "I will never forget it. . . . We promised to uphold the purity of the white race, fight communism and protect white womanhood. After I had taken my oath, there was loud applause. . . . It was a thrilling moment." Ellis soon became president (exalted cyclops) of the local KKK and began attending Durham City Council meetings and other public forums during the 1960s to ensure that his organization's views were represented. With his .32 pistol tucked in his belt in full view, Ellis would launch into racist diatribes. At one stormy city council meeting, Ellis was, by his own admission, "mean as the devil." "We're just tired of niggers taking over Durham," he announced to the packed room. The comment drove black city councilman John Stewart and an African American minister from the room, warning Ellis as they left, "You better learn how to say 'Negro.'" United Organizations worker Ann Atwater had a more visceral response. Focusing on a small spot on Ellis's neck, she lunged toward the Klansman, knife in hand. Bloodshed was averted when Atwater's friends restrained her. "You act up and they'll throw you in jail. . . . you don't want that," one of them whispered in a fran-

tic effort to defuse the potentially deadly confrontation. Several years later, the black activist and Klansman would confront one another again in roles neither could have predicted.[79]

In the early 1970s, state AFL-CIO president and former Edgemont resident Wilbur Hobby secured a federal grant to help ease school desegregation in the wake of a federal court order. Ann Atwater was selected to chair the city-wide school committee (known as a "charrette") funded under the grant, but after a local White Citizens Council member convinced C. P. Ellis that as taxpayers they had a right to participate too, C. P. agreed to cochair the committee with Atwater. Initially, Ellis was overtly hostile to Atwater; he refused to sit at the same table with her and carried a machine gun in his car trunk to their meetings, which he made sure to show her.

One of the first cracks in Ellis's racial attitudes was inspired unexpectedly by southern gospel music. Church choirs sometimes opened the school charrette meetings that he and Atwater chaired, and C. P. found himself tapping his foot and humming along with the familiar melodies. Before he knew it, he had joined in with black participants, clapping his hands, pounding out the rhythms to the hymns of his childhood. "Oh-oh, we got 'im. . . . He's comin' on over," Atwater recalled thinking. Perhaps C. P.'s response was not so surprising, after all, for segregation had always emphasized racial subordination over racial separation. Southern gospel sounds were proof that while Jim Crow might have been somewhat better at separating black and white bodies (though the various shades and hues among African Americans gave the lie to that claim), sound drifted even more easily across the color line. But the "gospel impulse," as black music scholar Craig Werner has so artfully demonstrated, was more than just a hybrid of southern black and white culture: "Testifying to the power of love, gospel gives us the courage to keep on pushing for a redemption that is at once spiritual and political. Gospel reminds us that we're all in it together though the definition of 'we' varies." Gospel is, Werner argues, "the belief that life's burdens can be transformed into hope, salvation, the promise of redemption." C. P.'s journey toward salvation, however, was neither painless nor smooth. Enduring months of sleepless, tormented nights, Ellis wrestled with his conscience and his southern tradition. One day, Ann Atwater acknowledged the personal toll of her affiliation with Ellis: "My daughter came home cryin' every day. She said her teacher was makin' fun of her in front of the other kids," she confessed to Ellis. C. P. was stunned, for his son had experienced similar humiliations from teachers and classmates. "I begin to see, here we are, two people from the far ends of the fence, havin' identical problems, except her bein' black

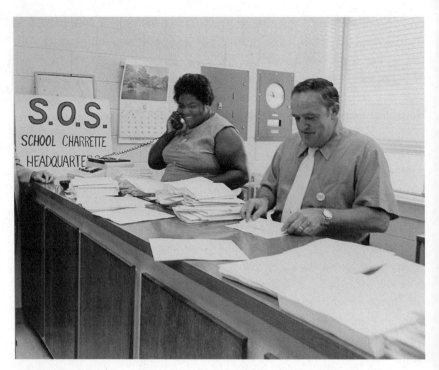

Ann Atwater, well-respected activist from United Organizations for Community
Improvement, and local KKK member C. P. Ellis formed an unlikely partnership in
an effort to ease the court-ordered desegregation of Durham public schools in 1971.
(Photograph by Jim Thornton; courtesy Durham Herald Sun)

and me bein' white," he later recalled. Ellis soon left the Klan and his south-
ern way of life behind him. But the wrenching pain and redemptive promise
of that epiphanic moment shook him to the core. Years later, he sobbed
openly as he recalled his conversion: "From that moment, I tell ya, that gal
and I worked together good. I begin to love the girl, really." Today, the two
are still friends.[80]

The cooperation and eventual friendship between a local Klansman and
one of Durham's most respected community activists was indeed striking.
However, few KKK, ACT, or United Organizations members attended the
citywide school desegregation forums. Moreover, Ellis was ostracized by
many whites, and Atwater was similarly rebuffed by local blacks. Because
both ACT and United Organizations had declined in numbers and influence
by the time that Atwater and Ellis became friends, there was no mass base
rooted in women's neighborhood networks upon which the experiences of
the former Klansman and black activist might have been expanded. In a final

irony, the media attention that the "odd couple" attracted alienated some of the local residents, even activists such as ACT member Deborah Cook, who simply dismissed the two as opportunists and publicity seekers.[81]

From another perspective, the fact that any interracial cooperation occurred at all in this period seems astounding. The story of ACT and United Organizations challenges the conventional narrative about social protest in the late 1960s and 1970s that has emphasized racial polarization. While a white backlash was certainly a prominent feature of these years, its emergence has prevented us from examining more carefully both the achievements and the failures of neighborhood women's cross-race alliances. Too often, biracial alliances (aside from those formed in the workplace) have remained largely invisible to historians and activists alike. Perhaps nowhere has this omission been more glaring than in the study of the South, and especially in neighborhoods, where pejorative stereotypes of poor whites as "rednecks," "poor white trash," and "ignorant crackers" have substituted for historical analyses. As historian William Chafe has observed, scapegoating low-income whites as the most racist of whites has allowed more affluent whites to escape their own culpability in perpetuating racial injustice. Even more importantly, the focus on the personal prejudices of individual poor whites diverts attention from the ways racism and economic exploitation were and remain institutionalized, from restrictive zoning regulations and real estate practices to discriminatory employment and banking policies. Neither the enlightened racial attitudes of a reformed Klansman nor interracial friendships alone could alter such formidable obstacles without also addressing the ways in which power and resources were allocated. Feeding this narrative of lower-class racial bigotry has been the tendency to see black separatism and interracial cooperation as mutually exclusive, especially by the late 1960s. Just as these seemingly contradictory impulses could find common ground, both racism and interracialism also coexisted, sometimes in an uneasy truce, for poor whites did not necessarily abandon their racism before joining hands with fellow blacks.

The emphasis on activists' failure to build an interracial *movement* of the poor also has obscured the extent to which interracial *cooperation* among the poor, largely among women, did succeed, however limited or ephemeral its effects may have been. Too often, scholars and activists have either ignored women's activities, especially those of poor women in neighborhoods, or considered them to be outside the realm of political activism. As political theorist Martha Ackelsberg reminds us, "Unless we begin to change our conceptual framework to incorporate a broader conception of politics, and

of who can and does participate in it, much of the radical potential of actions that are already taking place will be lost—even to those who participate in them."[82]

Clearly, a multitude of factors inhibited the development of biracial unity among Durham's poor, not the least of which was white supremacy among both the poor and the elite. But the failure to build an interracial poor people's movement in Durham was also a matter of timing. ACT was formed in July 1968, the same month that the largely female, all-black neighborhood federation, United Organizations, forged an alliance with middle-class blacks and launched what became a seven-month boycott of white merchants. More importantly, ACT was in reality a hollow organization with no organized mass base at that time, and this fact posed structural barriers to any kind of alliance between ACT and black activists. While United Organizations was not opposed to interracial efforts, the black neighborhood federation had more pressing matters to deal with in the late 1960s. As black community organizing came under increasing assault from government officials, its very survival was at stake, and the external attacks gave added urgency to the push toward racial solidarity. Both United Organizations and ACT, for different reasons, were on parallel but distinct historical paths that ultimately diverged. And the black community's nascent cross-class racial solidarity was about to be put to its greatest test, one that drew its power from the persistent militancy of low-income African American women.

I Can't Catch Everybody, but I Can Try Black Power

Politics, the Boycott, and the Decline of Neighborhood Organizing

"We're not y'all with a lot of shoes and clothes," exclaimed the exasperated woman. Her annoyance was directed at Howard Clement, an executive at the North Carolina Mutual Life Insurance Company and chair of the Black Solidarity Committee (BSC). It was January 1969, the seventh month of an economic boycott waged by Durham's black community against the city's white-owned businesses. But class tensions, always a sore spot in the capital of the black middle class, threatened to splinter the unity of the BSC, the new Black Power organization that had organized the selective buying campaign. After months of boycotting, many were growing weary of the sacrifices that weighed on the black community, especially the low-income African American women in United Organizations for Community Improvement who were the heart and soul as well as the backbone of the longest mass-based struggle in Durham's black freedom movement. The middle-class male leaders of the BSC might have served as the official spokesmen for the boycott, but low-income women had made it work.

Despite the gains of the boycott, by the end of the decade a new form of hypermasculinized Black Power politics had obscured the critical contributions of women to Black Power projects, particularly those undertaken at the local level. Even more devastating, heightened repression by white officials undermined the movement's grassroots, predominantly poor, female base, decimating the organized struggle for racial justice in Durham and throughout North Carolina. As they had done for generations, low-income African American women struggled as best they could under increasingly difficult conditions to survive and to protect their families. Carrying on a legacy of

black women's community work, only now without the collective power of UOCI, they simply "kept on keepin' on."

Women and Economic Boycotts

Economic boycotts may well have been among the least heralded yet most decisive tactics of the modern black freedom movement.[1] Selective buying campaigns and the key role of women in them have not received the same attention from either the media or scholars as more confrontational protests, especially those campaigns that took place during the era of inflammatory rhetoric among both Black Power advocates and white supremacists. Boycotts, however, directed black strength where it was most likely to have an impact—at white economic interests. A successful operation demanded the widespread collective support of the black community, drawing in many more people over a longer period of time than did shorter-term pickets or one-time demonstrations and marches.[2] Boycotts were likely to be effective precisely because large numbers of people could participate without becoming vulnerable to economic reprisals, physical attack, or arrest.[3] The extent of women's participation and support was usually the critical factor in the success or failure of such economic campaigns, for women utilized their traditional role as primary consumers within families together with their pivotal place in family and neighborhood networks to mobilize community support.[4]

Although class divisions repeatedly threatened the racial unity of the Black Solidarity Committee, poor women's collective strength and perspective was pivotal in creating and sustaining the boycott that eventually won at least some concessions from the white power structure. The 1968–69 campaign was the longest, most successful, and broadest-based protest ever waged by Durham blacks. Organized low-income women used their collective muscle to force concessions from the white power structure; first, however, they had to confront the men in the BSC, forcing the middle-class male leadership to make women's concerns central to the boycott. With their internal house in order, women then used their collective strength to mobilize the wider black community, especially other women, to support the boycott.

The broader class divisions that had long plagued Durham's black community were reproduced within the BSC and centered on both low-income black women's determination to make poverty a major focus of the boycott and their persistent criticism of the BSC's middle-class bias. The women's insistence on these points underlined a key dilemma for the BSC: if boycott organizers highlighted the concerns of the poor, they risked exacerbating

class divisions within the black community and thereby weakening the cross-class racial unity they had worked so hard to establish.[5] On the other hand, if the BSC refused to address the interests of the poor, it risked losing support from the very people who were critical to sustaining the boycott: low-income African American women. Thus, racial solidarity demanded attention to class and gender politics as well as racial politics.

The impetus for the boycott was the sudden dismissal of thirty-one black workers from Watts Hospital in 1968 after they affiliated with the American Federation of State, County and Municipal Employees' Local 77 and staged a one-day walkout. Looking across town, where the same union was in the midst of an all-out campaign for recognition from Duke administrators, Watts Hospital officials undoubtedly were eager to squelch similar activity among their employees.[6] In response, black Durhamites reached across the class divide in a show of unprecedented racial unity to form the Black Solidarity Committee for Community Improvement. "It was time for the black community to solidify and plan common strategy for crises such as the Watts firings," the BSC announced. The BSC was initiated by United Organizations, and both the Black Power ideology that has come to be associated with the late 1960s and the neighborhood federation's influence were evident in the BSC's chosen name. The BSC was a cross-class, exclusively African American grassroots organization that included businessmen, ministers, community organizers, students, and public housing tenants. Despite the predominantly female support base of UOCI, however, the BSC's formal leadership was almost exclusively male.[7]

On July 26, 1968, the Black Solidarity Committee delivered a fifteen-page memorandum to the Durham Chamber of Commerce and the Merchants Association that outlined eighty-eight "essential" demands covering employment, education, representation of blacks on local boards, and relations between the police and the black community. Most of the BSC demands had been formulated initially by UOCI the previous summer, and they included issues of central concern to low-income black residents, especially women, such as welfare, housing, and recreation—indeed, welfare demands headed the BSC list. Apparently, women defined—though men articulated—the agenda of the organized black community.

Two days after delivering the list of demands, the BSC launched a boycott of white Durham merchants that lasted seven months and became one of black Durham's most successful cross-class actions.[8] Although UOCI had been persuaded by the traditional black leadership to put aside its plans for a boycott of downtown merchants the previous September, the intervening

year had brought little, if any, progress. It was now time for the city's well-organized black community to speak in one voice, and in a language that white officials could no longer ignore.[9]

1968: Racial Polarization in Durham and the Nation

The boycott occurred against a backdrop of heightened racial tensions and violence both locally and nationally. Radical activist Howard Fuller captured the despair and fury of Durham's impoverished black residents as he spoke to a crowd of 150 stalwart movement participants gathered at St. Joseph's AME Church in the aftermath of the Watts hospital firings. "Ain't it a shame," railed the charismatic organizer. "It's killing and it's more killing. And it isn't going to stop. You know why? Because everybody says, 'Ain't it a shame' and then goes back to their business." Fuller recited the names of well-known martyrs in the freedom struggle, black and white alike: Malcolm X; James Chaney, Andrew Goodman, and Michael Schwerner; Viola Liuzzo; and Martin Luther King Jr. North Carolina's most well-known Black Power activist even included John F. Kennedy, though some might have questioned the assassinated president's commitment to civil rights.[10] A few days later, the president's brother, Robert F. Kennedy, would be added to the list of the fallen.

As the fiery orator "harangued, petted and joked" with the faithful, his words seemed to one observer like a "religious revival bond," lifting their sagging spirits as they rallied to confront the latest explosion in the minefield that characterized Durham's racial politics in 1968. No one had been killed, but there had been some close calls. Earlier that year, in a scene eerily reminiscent of Birmingham, Durham firemen turned their hoses on a peaceful crowd protesting the police shooting deaths of three African American students in nearby Orangeburg, South Carolina. Ironically, the fire hoses became the spark that set off a night of vandalism, leaving thirteen stores damaged, including two that were black owned. During the melee, Fuller was arrested for assault after trying to prevent a police officer from striking a black man whose hands were pinned behind his back. (Fuller was later cleared of all charges.) Two months later, King's assassination ignited the city in a weeklong war of firebombing, looting, and shooting. Eleven buildings were torched, including two owned by slumlord Abe Greenberg, and scores of others suffered damages. Miraculously, no one was injured or killed. Throughout 1968 and 1969, however, arson seemed like it might replace demonstrations as a new form of racial protest among both blacks and whites in the Bull City.[11] From another perspective, Durham blacks showed remarkable restraint, especially

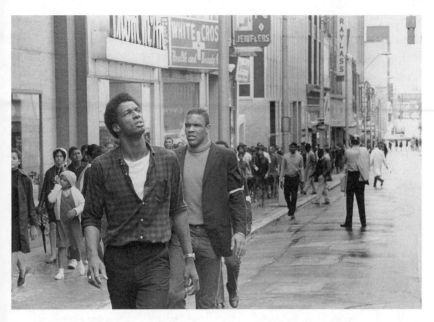

Howard Fuller (left front) served as a marshal at a protest march in downtown Durham the day after Martin Luther King Jr. was assassinated. *(Photograph by Billy Barnes; courtesy North Carolina Collection, University of North Carolina at Chapel Hill)*

when compared to the urban rebellions exploding in other areas of the country. Just two months before King's assassination, the National Advisory Commission on Civil Disorders released a devastating indictment of race relations. The United States, the commission warned, was "moving toward two societies, one black, one white—separate and unequal." Even more troubling, the commission clearly implicated whites in the problems of the inner-city ghetto: "White institutions created it, white institutions maintain it, and white society condones it." Durham might not have been Watts or Detroit, but the uprisings in those cities served as alarm bells reminding white Durham residents of the deep discontent that festered in much of black Durham.[12] The Watts Hospital firings became the last straw, and Durham blacks mobilized their forces to hit the city's power brokers where it would hurt the most—in white pocketbooks.

The Black Solidarity Committee and Poor Women's Concerns

Throughout the boycott, poor black women pushed class and poverty issues to the forefront of the Black Solidarity Committee's agenda. Their organized base ensured that BSC demands included issues that were of para-

mount concern to poor women. But they addressed procedural issues as well. African American women demanded the full participation of low-income people in planning sessions and at mass meetings. The willingness of the BSC, particularly its predominantly middle-class, male leadership, to accommodate the needs and perspectives of Durham's most impoverished and dispossessed was critical to the BSC's ability to sustain the long boycott.[13]

Black women spoke not simply as individuals; rather, they grounded their demands in the collective experiences of poor blacks. Above all, they spoke from a position of strength, for by 1968 low-income black women had amassed large numerical majorities in several organizations, including the Durham Welfare Rights Organization, the Durham Tenants Steering Committee, and, most importantly, United Organizations, the catalyst for the boycott. Although low-income men sometimes voiced similar concerns, black women's collective voice on behalf of Durham's poor black communities was repeated, insistent, frequently angry, and often eloquent.

Low-income African American women were both marginalized and empowered in ways that were distinctive, and their contradictory position enabled them to forcefully articulate the concerns of Durham's most impoverished blacks. Class differences within the BSC were fundamentally gendered, and it was no coincidence that the primary contestants were low-income women and middle-class men. For one thing, black women were disproportionately the poorest people in the population. This was partly the result of a historic pattern of discrimination that placed black women at the bottom of the wage and occupational ladder. In 1960, black male median earnings were slightly less than half (48 percent) of the median income in Durham, while black female income was only one-fifth of Durham's median income. By 1970, African American women had made significant occupational shifts, most notably out of domestic service, and they had narrowed the wage gap somewhat, but they still lagged behind whites and black men, and almost a third of all black families in Durham remained in poverty. Even black professional women's median income was less than half (43 percent) that of black professional men.[14]

State and local policies also were responsible for black women's poverty, especially for the rising numbers of female-headed households. In North Carolina, welfare regulations required that a woman applying for Aid to Families with Dependent Children sign a warrant against her children's father charging him with nonsupport. The program's eligibility requirements also mandated that a man could not be present in the household of a woman who received aid, thus encouraging the breakup of poor families. Com-

pounding the problem was the Durham Housing Authority's refusal to rent to single mothers with "illegitimate children," a policy that United Organizations organizer Ann Atwater helped to reverse.[15]

Class Tensions and Racial Solidarity in Durham's Black Community

The tensions within the BSC signaled an important shift that had taken place within Durham's black community. By 1968, three years of organizing and direct action campaigns among Durham's low-income African American communities through Operation Breakthrough and United Organizations had fundamentally altered the scope of black protest and exacerbated class and political differences. Louis Austin, the outspoken editor of the *Carolina Times*, acknowledged the gap between the older black leadership and the new, younger, and more militant movement, although he ignored its female dimension. "Fuller and his movement embarrass other Negro leaders, especially us older men, who don't stand up the way he does," Austin noted. "Most of today's adult Negro leadership is hopeless. The future is in these young people," he observed.[16]

Despite the organization's radical impulses, however, UOCI sought alliances with Durham's African American elites, and during the crises of 1967 the traditional black leadership had stood firmly behind the neighborhood federation. But building alliances with the black middle and professional classes while also remaining sensitive to the needs of impoverished blacks was a difficult balancing act for United Organizations. Traces of Durham's legacy as the capital of the black middle class were evident within United Organizations and eased the formation of a cross-class coalition, at least to some extent. The neighborhood federation promoted economic development (or "community capitalism") projects that drew on older traditions of economic self-sufficiency. Yet community capitalism, or the "new black capitalism," as some called it, was not the same as old-style capitalism. Black capitalism, as it was envisioned by groups like the Foundation for Community Development and United Organizations, promoted black business not to benefit individual entrepreneurs but to keep capital and resources within the black community.[17] Hence, class divisions and differences in political style between UOCI and the black elite remained.

The urban renewal crisis perhaps best illustrates the widening rift between low-income and more affluent blacks. Durham's urban renewal bond measure had passed by a narrow margin in the early 1960s due largely to the backing of the Durham Committee on Negro Affairs, which, until United Organizations' emergence, had virtually controlled Durham's black vote for

decades. The black community was swayed by promises of better homes, a new mall, and improved municipal services. But when the redevelopment plans were implemented, the impact was devastating. Hayti, a thriving business district with over one hundred independently owned black enterprises, was destroyed; homes were bulldozed, leading to a housing crisis that was aggravated by the shortage of low-income housing in Durham; and the promised mall where the businesses were to be relocated never materialized.[18] Nat White, co-owner of the Service Printing Company, the only black business remaining in the former Hayti section, caustically remarked, "We made the knife that cut our own throats." Worst of all was the lingering suspicion that in spite of the havoc wreaked on the African American community by urban renewal (or "Negro removal," as some called it), certain black financial interests had benefited from the fiasco. "There's a lot of speculation and there has been for some time in the Black community that some Black leaders actually sold the masses down the drain. . . . all the evidence certainly points in that direction," recollected Vivian Edmunds, who succeeded her father, Louis Austin, as publisher of the *Carolina Times*.[19]

At the same time, the dominance of the black middle-class and business elite had been seriously eroded by groups like United Organizations. Perhaps the clearest sign of the elite's waning control was the ability of United Organizations and Operation Breakthrough to increase black voting strength from 10,600 to 16,700 in just two years. White power brokers seemed to recognize the new relationship between the black elite and the masses; no longer could black leaders guarantee control over the wider community, and their traditional behind-the-scenes negotiations with white officials suffered as a result.[20] The DCNA had tried to regain some influence over the new power base among low-income blacks by offering its support during the Joyce Thorpe case and by presenting its annual civic award to the neighborhood councils and to the striking school employees. In effect, the established black male leadership was playing catch-up to a movement that had become overwhelmingly poor and female.

On the other side of the equation, Durham's low-income communities, notwithstanding some victories, had been repeatedly frustrated in their efforts to influence a largely intractable white power structure. In effect, low-income and elite blacks needed one another: United Organizations wanted to broaden its constituency by recruiting middle-class black influence and talent; middle-class and elite blacks needed the mass base of United Organizations in order to regain their influence within the wider black community and with white power brokers.

Black Demands and White Responses

Reflecting the new relationship of cross-class unity, low-income women's concerns became an integral part of BSC demands. Echoing one of the central goals of the National Welfare Rights Organization, the BSC demanded that local caseworkers inform recipients of all funds available to supplement their monthly grants. "The present welfare program in Durham County does not encourage welfare recipients to get off welfare," the BSC complained. But less tangible issues were also at stake. Welfare recipients were outraged by their lack of privacy and the intrusion of officials into their personal affairs. In one instance, a caseworker, after noticing a strange car parked outside a woman's apartment, forced her way into the apartment to investigate whether the woman was violating the "man in the house" rule.[21] The BSC also wanted a new, independent Human Relations Commission with formal subpoena powers reinforced by a local antidiscrimination ordinance to take the place of the old Human Relations Committee. The boycotters insisted that the city recreation department place a priority on programs in low-income neighborhoods and hire neighborhood residents, and they demanded reinstatement of the Watts Hospital strikers as well as the appointment of a new black director of the public Housing Authority. And, finally, the BSC took aim at specific businesses, demanding assurances that blacks would be recruited for jobs at all levels.[22]

Initially, the boycott targeted only Northgate Mall, the Model Laundry, and the Coca-Cola Bottling Company. Although the BSC refused to comment publicly on the selected stores, these were strategic targets, aimed at the Housing Authority and the mayor's office. A member of the Housing Authority owned the laundry, while one of the mayor's relatives owned Northgate Mall and Coca-Cola, both of which had discriminatory hiring practices. Northgate, where blacks made up only 10 percent of patrons, also bordered Walltown, a well-organized black working-class community. Thus, the BSC established a nearly 100 percent successful demonstration model that showcased black resolve without placing too much strain on the city's merchants. By beginning on a small scale, the BSC offered the white business establishment an opportunity to exert its influence on city officials before the boycott became more widespread. But white businessmen refused to budge. In response, the BSC extended the boycott to more stores every week, so that eventually nearly every white merchant in the downtown area, where African Americans comprised over 50 percent of patrons, was included.[23]

White businessmen complained bitterly that they had been targeted unfairly. After all, they pointed out, local merchants did not formulate Housing

Authority or city recreation department policies, and Washington, D.C., was responsible for welfare regulations. But Durham blacks utilized a tactic that had been deployed effectively by other African American communities throughout the South that had discovered white businessmen needed black cash more than white politicians needed black votes.[24] By flexing their collective economic muscle, blacks hoped to force Durham's white business leaders to use their influence to bring about substantive change, especially for poor blacks. Moreover, the boycott was "a good Anglo-Saxon custom," said Rev. Philip Cousins, pastor at St. Joseph's AME Church and a BSC Steering Committee member. "The merchants and the City Council comprise the power structure. The merchants are not a legalized lobby, but they lobby all the time," Cousins pointed out.[25]

The merchants' response to the BSC demands revealed the chasm that separated the two groups. Several days after the boycott began, the Chamber of Commerce criticized the boycott by claiming that "substantial progress" had been made on nearly all the issues included in the BSC grievances. In a catch-22 explanation that defied logic, white employers proclaimed that they were "equal opportunity" employers. Forced to acknowledge the absence of blacks among their employees, they nevertheless maintained that this had nothing to do with race. Employers hired only on the basis of merit, they insisted, all the while refusing to acknowledge that "merit" meant past experience in jobs from which blacks had been systematically excluded.[26]

Newspaper coverage by the *Carolina Times*, Durham's black weekly, and by the two white-owned dailies also highlighted the distance between white and black perceptions. Calling the boycott a "last resort" on the part of Durham's black citizens, the *Carolina Times* held the "white power structure" fully responsible for denying "even the crumbs of citizenship" to African Americans. The editors pointed to violence-torn cities in the North and warned that if the BSC demands were not met a "successor" would emerge "that [would] make the [BSC] look like a prayer meeting band."[27] In contrast, the *Durham Morning Herald* frequently portrayed BSC demands as unreasonable and the merchants as well-meaning victims of an unjust action. The newspaper also repeatedly characterized the boycott as emotionally charged and beyond rational debate, thus reinforcing racial stereotypes. Editors expressed little hope for fruitful communication or compromise, attributing the dilemma to immutable racial differences: "The simple fact in many cases appears to be that white officials attempt to solve Negro problems with white solutions and that Negroes evaluate white positions and actions by purely Negro standards."[28]

Of course, the *Herald* did not represent all white opinion in Durham, and white liberal and radical groups publicly endorsed the boycott and lent their assistance.[29] But while the BSC welcomed such support, Howard Fuller, in an address to an interracial audience, announced that Black Power was the order of the day. Biracial groups were "no longer enough because these 'integration' instruments [did] not speak to the real needs of Black people and poor people," he told the largely white crowd. The terms of white participation, Fuller declared, had to be determined by blacks, and real integration was possible only "with increased equality in the power arrangements in . . . society." Biracial groups were fine, he explained, but it was time for whites to get over their "jilted suitor complex" and understand that blacks and whites had "a new relationship." Echoing the stance taken by civil rights groups such as SNCC and CORE, Fuller urged whites to work in their own communities.[30]

"I Don't Know Nothing about No Robert's Rules of Order": Low-Income Women and Middle-Class Men

The Black Solidarity Committee was far more concerned with its own internal relations, however, than with its relationship to white supporters or detractors. The BSC was plagued by gendered class tensions that erupted in struggles primarily between middle-class black men and low-income black women. Although the BSC included issues the women had identified as priorities in its list of demands, BSC meetings were conducted in ways that often excluded participation by poor people and women. Men tended to dominate discussions, and meetings were conducted according to Robert's rules of order. Poor people who were accustomed to attending neighborhood council meetings, in which participation was much less formal and more democratic, frequently found the arcane rules unfamiliar and alienating.[31] Moreover, some participants invoked parliamentary procedure as a diversionary measure, calling out "point of order" to suppress arguments or confrontations over controversial issues. Although women tended to sit quietly at BSC meetings, usually on the periphery, one woman was finally provoked beyond endurance. "I'd like to say something about this point of order you all keep calling," she began. "I don't know nothing about no Robert's rules of order." Why conduct meetings according to "white" procedures that were devised by people who think "we ain't nothin' but a bunch of niggers?" she asked. Her remark was met with good-natured laughter, but the group moved on, avoiding the larger issue of poor people's participation.[32]

This was hardly the end of the matter, however. At another meeting, someone again criticized the middle-class style of BSC meetings, arguing that this

was no way to build racial solidarity, which some defined as the absence of debate and acrimony. "This is the place where we got to argue and blow off steam and spend hours [going at it] . . . if we have to," one man claimed. "Whether we like it or not, this has become a middle-class meeting ground," he declared. His comment was met by a chorus of "Amens" from the side-lines, spurring him on. "Now, we got to face the fact that we going to have to represent all the people or we going to have to forget about it. . . . We're go-ing to have to get the people back in here, [or this will] be a select group," he reminded the gathering.[33]

The following week, however, the BSC was forced to deal directly with poor people's participation after United Organizations placed the issue on the meeting agenda. Charsie Hedgepath, a community organizer and sec-retary of the BSC (one of the few black women in a leadership position), opened the discussion. "Many people from poor communities feel reluctant about coming to these meetings," she began. "We don't address ourselves to people from all segments . . . particularly to poor people," she continued. "The same people scream and talk. A lot of people [are] trying to put things on the table and make suggestions and they're either shouted down or told to shut up . . . and that's why they don't come." Hedgepath pointed out that low-income people were rarely featured on the programs of BSC weekly mass meetings, which were held in different black churches throughout the city to sustain community support for the boycott. In response, John Edwards, a former student leader of the sit-in movement and then director of the North Carolina Voter Education Project, tried to shift the responsibility to the poor themselves; he suggested that Hedgepath and UOCI should provide names of poor people for the program. But Ann Atwater rejected such tokenism as window dressing. "The names is the whole black community," she retorted. Mrs. Pearlie Wright, a community organizer for United Organizations and cofounder of the Durham Welfare Rights Organization, voiced similar senti-ments. The solution was not simply to include more low-income representa-tives at mass meetings, she said. Wright complained that she frequently was silenced at meetings by being told to "shut up or sit down." But she remained undaunted and undeterred: "I came back because you ain't gonna run over me anytime," Wright said defiantly. "I ain't one that can be easily backed down, 'cause I argue to the very last." But not everyone could do that, she pointed out, especially poor folks who often felt intimidated. They came and tried to speak but "were told to shut up or overruled," Wright complained. Thus, the mode of interaction within the BSC—perhaps inadvertently but nevertheless effectively—excluded input from the poor, especially women,

and simply adding more poor people to "a middle-class meeting ground" without transforming the way in which meetings were conducted would do little to change that dynamic of exclusion. Indeed, even as she spoke, Mrs. Wright sensed the power of intimidation directed at her. Apparently detecting that the chair wanted to move on, she yelled sharply, "I ain't through, Howard Clement!"[34]

Ann Atwater pressed the group for a solution: "I'd like to know what the committee gonna to do about it. Not no 'thank you,' but what you goin' to do about it. You always say 'thank you' when somebody brings a suggestion, . . . but we got the same problem next week." Maybe a committee could be created to represent the neighborhood councils, offered one member, a rather odd proposal given that United Organizations, a federation of low-income black neighborhood councils, already existed. Exhorting the steering committee to get out into the black community and listen to poor people, Atwater dismissed the idea: "You're going to committee yourself to death," she scoffed.

As the group continued to debate the issue of poor people's participation, tempers flared. Ben Ruffin, executive director of UOCI, complained that too many neighborhood people just did not want to speak at mass meetings. He was willing to reach out once more to low-income people, he conceded, but in the same breath he seemed to place himself above such tedious tasks. "I got a lot of stuff I got to do. I'm not going to have time [to follow up on this]," he added. Hedgepath exploded: "Well Ben, I'm gonna tell you, you were one of those people that they are afraid of," pointing out that he had told a low-income person that very evening to "shut up."[35]

Nat White Sr., a BSC Steering Committee member and small business owner who had formulated plans for a future boycott following the aborted 1957 Royal Ice Cream sit-in, tried to defuse the tensions. But in so doing, he exhibited the very class and gender privileges that drew complaints from low-income women. Participants were not excluding or silencing people, White insisted. The disagreements simply reflected differing personal styles of interaction. Many elite and middle-class blacks also felt excluded from the BSC "because they can't take the kind of thing we're doing," he said. "I've probably been told to 'shut up' . . . more [often] than anybody," White added. The women were not persuaded. Maybe so, Ann Atwater replied, but "you didn't have to go back and apologize. I had to do that. I personally had to do that."[36] Atwater's rejoinder implicitly underlined the unspoken codes of appropriate behavior and the ways in which public space was shaped by both class and gender constraints, giving men greater license to speak in meet-

ings. Although it was difficult for the group to devise specific remedies for such dynamics, the BSC did agree to promote greater inclusion of low-income residents and to listen respectfully to each person at meetings.[37]

Even more explosive was the problem of class exploitation within the black community, an issue that frequently pitted poor black women against more affluent black men. At one meeting, an unidentified BSC member alluded to the middle-class privilege and hypocrisy of some BSC members who expressed sympathy for the poor: "You've got people talking in here, and I know two of 'em wouldn't even loan a poor person five dollars."[38] Ann Atwater made the criticism more explicit in her reference to black slumlords. "We have some black Carvie Oldhams," she charged, alluding to the widely despised white director of the Durham Housing Authority. "Black people are still messing with our black people," she added. It was becoming increasingly difficult to insist that the white power structure was the only source of black oppression. Perhaps recalling the African American realtor who had tried to evict her several years earlier, she wondered how the BSC could talk about the white man when "our black folk is doing the same thing," she said. "Some of these people we are asking to stay out of those stores are being hurt, not by the white man. [They are] not working for the white man. [They are] not paying . . . rent to the white man."[39]

Although Atwater was raising a particularly divisive issue, her accusations were tame compared to Howard Fuller's bitter denunciation of the black bourgeoisie. "What I'm beginning to see is that UOCI represents not only a threat to white people, but seemingly it represents a threat to some of our good black brothers and sisters who are scared of it too," he proclaimed to a mass meeting of the neighborhood federation. "And the only reason it could represent a threat is because their interests are the same as white folks' interests. . . . The white man has no greater tool than a low-down, dirty, Uncle Tom nigger who will sell-out his people for a dollar."[40]

Middle-class blacks, however, continued their appeal for racial solidarity despite class differences, even suggesting that bringing up such matters played directly into the hands of their white opponents. The real issue was race, Nat White claimed. "We're talking about the oppression that has been placed upon us as black people. . . . We can't be all things to everybody," White insisted. "One of the methods that the white man has used to keep us from getting freedom is to . . . try to divide us. . . . [T]he easiest way for us to be defeated is not from the outside, it's from the inside. . . . I know that black people are not perfect, and I know that they're doing a lot of things [that are not right,] but that's not the point of our fight."[41]

Nat White's call for racial unity, while simultaneously ignoring class cleavages within the black community, was tantamount to silencing poor black women. In response, African American women drew on their new-found strength in numbers and rejected White's reasoning. Increasingly, they defined racial unity in class terms, drawing attention to economic exploitation between blacks. The issue was about fairness, and all injustice, even intraracial grievances, demanded attention if racial solidarity were to be maintained, claimed Ann Atwater. "A system [for addressing these complaints] ought to be worked out if we are going to work together," she insisted.[42]

The Boycott's Impact

Women may have felt silenced at BSC meetings, but they supported the boycott nonetheless, and it was having an impact. According to one report, the Merchants Association's September "Fair Days" was "a bust," leaving downtown streets deserted while across town the BSC's "Black Pride Days" drew nearly 10,000. Sales were down by as much as 25 percent in downtown stores, with an estimated loss of close to $1 million. Even as business leaders grumbled that they were being unfairly scapegoated for Durham's racial and economic problems, they began to exert pressure on city officials. In September, the city council established a Human Relations Commission and named a black director. The Durham Housing Authority announced a new policy regarding excessive utility bills in public housing projects, saving tenants an estimated $13,000. Duke Power began to hire more than a token number of blacks. By November, the Durham Merchants Association had promised to employ more African Americans and had pledged that it would hold regular biweekly meetings to work out other grievances if the BSC would call a moratorium on the boycott during the all-important Christmas buying season. Citing a lack of substantive progress on the remaining grievances, the BSC turned down the proposal. United Organizations' Mrs. Mary Walker expressed the black community's resolve: "For those who think we're about to quit, tell them we're looking forward to a Black Christmas."[43]

Indeed, "Black Christmas" became an ingenious and successful effort to ease the burden of the boycott, which fell most heavily on women, the primary consumers in African American families. The BSC organized a black Santa and a black Christmas parade to coincide with the annual Christmas parade sponsored by the Durham Merchants Association. Almost every African American organization in the city was represented in the parade, and the event drew an estimated 20,000 observers. The week after the parade, the

Chamber of Commerce had its first formal meeting with representatives from the BSC to discuss their demands, but little was accomplished.

As the boycott dragged on into the seventh month, the strain on the black community became more apparent. Uncertain about how much to yield to the pressures of the Merchants Association and Chamber of Commerce—the daily papers were portraying the BSC as rigid and uncooperative—and yet highly sensitive to the continued strain the boycott was placing on the poor, the BSC wrestled with how to proceed.[44] One woman suggested that the selective buying campaign should be called off because the poor had been forced to break the boycott out of necessity. "We're not y'all with a lot of shoes and clothes," she said, once again highlighting the class differences among BSC members.[45]

Howard Clement, the BSC chair and an executive at North Carolina Mutual Life Insurance Company, tried unsuccessfully to mute the rising class tensions. Using the language of class to invoke racial solidarity, Clement asserted: "Of course all black people are poor." His comment provoked a stir of muffled dissension throughout the room, but he went on. "Poor people *do* have a strong voice in decision making," the business executive insisted, adding, "Now I could be wrong." "Yes, all of us are poor," one woman agreed. "But . . . there are a lot [who are] more poor than us. . . . Maybe we should plan a new strategy."[46] Others made thinly veiled threats to name the names of black residents who were breaking the boycott. Charsie Hedgepath finally moved the discussion to new ground by pointing out that it was unrealistic to expect that the entire black community would or even could support the boycott. Low-income folks could not sacrifice for as long as some of the rest could, she remarked. Nevertheless, the campaign was hitting whites where it hurt the most—in their pocketbooks. "We're still pinching the [white] man," Hedgepath reminded the BSC.[47]

The women who were active in the BSC were respected community leaders, and they spoke out most persistently on behalf of Durham's poor black communities. Repeatedly, they emphasized the substantive goals of the boycott and raised the problematic question of how BSC meetings should be conducted. Women such as Ann Atwater and Pearlie Wright were what sociologist Belinda Robnett has called "indigenous bridge leaders" who linked the BSC and the low-income neighborhoods that were essential to the success of the boycott.[48] United Organizations gave poor black women the organizational base and leverage to place their demands on the BSC agenda and to mobilize community support for the boycott. The claims they advanced were collective, not individual, and it was this collective grounding

in the concrete daily lives of poor black families and communities that gave legitimacy and force to their protest. Without these women who formed the majority of United Organizations membership, who were key to eliciting the support of low-income residents, and who were the primary consumers within families, the boycott could never have been sustained. And the men knew it.

Marginalized and Empowered:
The Social Location of Poor Black Women

Low-income African American women were uniquely positioned to mount an effective critique of the class-based, exclusionary practices of the BSC. Unlike affluent black women, who were forced to grapple with the constraints of middle-class respectability, poor black women utilized their marginality to subvert conventional class and gender relations.[49] Ann Atwater's location within a specific set of gendered, racialized class relations allowed her to publicly confront the middle-class male leadership of the BSC, while Mrs. Elna Spaulding, club woman and the wife of former North Carolina Mutual president Asa Spaulding, operated in less confrontational ways. During the boycott, Mrs. Spaulding established a biracial, predominantly middle-class women's organization, Women-in-Action for the Prevention of Violence and Its Causes, hoping to defuse racial tensions in the city. Spaulding described the low-income black women who attended WIA meetings: "Because they were suffering extreme problems . . . they could ask the gut questions with no fear. And they could come out and say it any way they wanted to," she noted.[50] North Carolina Mutual executive and BSC chair Howard Clement's description of Ann Atwater, Durham's best-known black woman activist, was similarly revealing: "She was big, black and bad," he said, recalling her activism of the 1960s. "She frightened everybody," he added.[51] Clement's allusion to Atwater's body and behavior as "big" and "bad" and Spaulding's observations of low-income women were at once complimentary and derogatory. But what exactly was "frightening" about how low-income women behaved? Certainly, they had little real power, at least in a formal sense. Yet they were not entirely powerless either. Denied the trappings of middle-class respectability in class-conscious black Durham by their poverty, by their lack of formal education, and by their confrontational style, Ann Atwater and other low-income women turned the traditional, class-based definition of black womanhood on its head by speaking out "any way they wanted to" on behalf of the poor. Poor women derived their authority to subvert conventional notions of female respectability both from their day-to-day experience with poverty and from

their organizational strength. Whether intentionally or not, black women manipulated both black and white middle-class fears of the "uninhibited voice of the poor" and intruded into the "middle-class meeting ground" of the BSC and Women-in-Action, where they demanded and were granted a hearing. Having honed their skills and increased their numbers over the past three years, organized poor women challenged not only white power brokers but the traditional black leadership and middle-class women reformers as well. And this was undoubtedly unsettling at the very least, perhaps even "frightening," to many blacks and whites alike.

Women like Ann Atwater could be found throughout the South. Indeed, she was the prototypical "strong, Black woman."[52] Yet too often the twin tropes of the "strong, Black woman" and the "victim of triple oppression" have reduced low-income black women to stereotypical figures, obscuring the full dimensions of their contributions to the black freedom movement. Atwater's life and activism caution us to be wary of romanticizing the poor and remind us that poverty was more often debilitating than liberating. But low-income black women were not simply victims of the combined forces of class, race, and gender oppression; rather, their social positioning (as women, as poor people, and as African Americans) and their contradictory experience of marginality and empowerment gave them an angle of vision and an organizational base that helped to broaden the agenda and mission of the BSC and, as we will see, of WIA too.[53]

Ultimately, the BSC was unable to resolve all the problems facing Durham's most impoverished black residents. But that the issues were raised at all was because low-income black women insisted that their concerns be included. Even more important, because tensions and differences could be aired, the BSC was able to maintain racial solidarity among Durham's economically diverse black community and to sustain the boycott for seven months. As Nat White observed at the end of one particularly rancorous meeting, "This is the most dialogue I've seen since I've been in Durham [, and] I've been [here] . . . since 1939."[54] Thus, conflict and the willingness of the BSC to deal with intraracial friction actually strengthened racial solidarity. Both the organized presence of low-income African American women and the largely conciliatory responses black middle-class men made to their demands were critical to the BSC's success. Racial unity was neither automatic nor static. Rather, the BSC became an arena where class and gender power was contested. And that was the key. Whatever the outcome of the boycott, low-income black women played a central role in shaping a more inclusive political process.

The Aftermath of the Boycott

While not all the boycotters' demands were won, those they did achieve were not unimportant. Some victories were symbolic, such as the selection of a black policeman by the Merchants Association as policeman of the year. But other victories were more substantive. Durham blacks secured more and better jobs. Some racial barriers were finally and permanently dismantled. Two African Americans were appointed to the Housing Authority board, a Human Relations Commission with a black director was established, an African American realtor was named an associate member of the Durham Board of Realtors, and six biracial committees with representatives from the Merchants Association, the Chamber of Commerce, and the BSC were created, with each committee focusing on one of the major areas of concern to the BSC: employment, housing, welfare, education, recreation, and board representation.[55] Other gains, though seemingly small, dealt with concerns that had been raised specifically by low-income black women, including the abolition of excess utility bills in public housing projects and the creation of a new decision-making role for youth and the poor in city recreation centers.

In the end, the Black Solidarity Committee had remained intact and sustained Durham's longest economic boycott but had failed to effect a significant reallocation of material resources. One problem was that no amount of racial unity could topple a white electoral majority. Still, even the most pessimistic observer conceded that protest in Durham during this period yielded at least "a general if very slight improvement in the lives of a majority of the city's black residents."[56] Moreover, white power was neither total nor uncontested. In May 1968, several months before the boycott began, a coalition of blacks, labor leaders, and white liberals gained control of the local Democratic Party. In two historic firsts, Mrs. Ann Atwater was elected party vice president and two black candidates were nominated for the five-person county commission in the Democratic Party primary. Indeed, it may well have been such victories that encouraged local blacks to organize the boycott.[57]

Although basic economic arrangements had not been fundamentally altered, movement participants could confidently claim that a new era had arrived in Durham, one that would stand the test of time and would not be rolled back when black protest receded. All of this was premised on the widespread mobilization of poor black communities, which in turn spurred a new kind of racial solidarity in Durham—one in which the black elite took its cues from the poor. And more often than not, those cues came from the collective, oppositional voices of low-income African American women. Thus, no longer could the Durham Committee on Negro Affairs operate as it had

for decades, negotiating behind the scenes with white power brokers while ignoring the concerns of the mass of local blacks.[58]

Women and Black Power Politics

While Durham blacks had forged a more resilient cross-class alliance, the problems they confronted remained enormous and complex. Indeed, in many respects, the Black Power–initiated boycott was the "last hurrah" of Durham's organized black freedom movement. Black activists came under increasing fire from conservative forces emboldened by Richard Nixon's recent election, and the Durham movement lost touch with its grassroots base and splintered. Although African American women were important participants in the new Black Power politics—most notably in local projects—that dominated the movement at the end of the decade, black men assumed even greater prominence under the banner of a hypermasculinized Black Power ideology. The combined forces of Black Power machismo and the conservative attack on black community organizing left little room for black women, especially the low-income women who had formed the foundation of Durham's black freedom movement from the middle of the 1960s to the end of the decade. With little organized mass base and the movement in disarray, poor black women reasserted older traditions of women's community work and struggled to meet the needs of their families and neighborhoods.

Black Power is a vague and elusive term that encompassed the full ideological spectrum of African American politics, from black capitalism to armed revolution.[59] But as historian Tim Tyson has shown, Black Power had deep roots in an indigenous, African American, southern culture, and it did not suddenly emerge in the 1960s. Long before Stokely Carmichael shouted "Black Power!" small towns and communities throughout the region claimed nearly all the elements that came to be associated with Black Power ideology —independent black politics, a focus on black economic advancement, cultural pride, and the use of armed self-defense.[60] Certainly, all of these elements had been present in Durham for decades. Even armed self-defense coexisted with the nonviolent integrationist movement of the early 1960s, and NAACP leaders such as Floyd McKissick cooperated with separatist organizations like the Nation of Islam. But as the decade wore on, older black radicals, including Conrad Pearson and Louis Austin, became increasingly critical of Black Power, especially of black separatism.[61]

If Black Power was not new, neither was it exclusively or always predominantly male. In Durham, as elsewhere, calls for black liberation frequently were articulated in masculinist terms, a fact that has obscured the impor-

tant role of African American women in the Black Power movement.[62] It is striking that an ideology so often associated with black machismo was also championed by United Organizations, an organization dominated by low-income African American women. By the late 1960s, UOCI publicly identified itself with Black Power. Whites, too, connected the organization with Black Power, partly due to Howard Fuller's association with the group. Fuller, who quickly became the state's most well-known Black Power advocate, did not preach violence, but neither did he reject it, especially as a form of self-defense. Most whites, however, made little distinction between inflammatory rhetoric, violence (including armed self-defense), and militant, confrontational protest.[63]

Howard Fuller may have grabbed local and even national headlines, but women such as Mrs. Pat Rogers canvassed black communities, making sure that low-income residents supported United Durham, Incorporated (UDI), a United Organizations cooperative. "I'd take my car and tell 'em we got to start bypassing white folks' stores and go straight to [the UDI] supermarket if you want to have any capital in your neighborhood. And it wasn't teaching hatred, it was teaching unity," she said. Despite white anxieties about UOCI, the neighborhood federation repeatedly disavowed the use of violence, distinguishing between violence and militancy. And black women such as Pat Rogers were far more likely to embrace militancy—an uncompromising, mass-based confrontational politics dedicated to ending racial and economic injustice—than violence. The neighborhood federation also challenged the white focus on black violence by emphasizing that violence took many forms, including poor housing, inadequate education, and employment discrimination.[64]

Although United Organizations publicly condemned violence as a tactic for achieving black liberation, its leaders were not above making veiled threats, as Rubye Gattis had done during the summer of 1967. Some women also advocated armed self-defense, and others engaged in retributive violence. Some, like Ann Atwater, admitted wanting to "bust up" Durham during nonviolent protests. But even activists who accepted nonviolence sometimes found it impossible to suppress the urge to strike back at the hated symbols of white supremacy. While Atwater helped to keep demonstrations peaceful, she also boasted that she "could make a Molotov cocktail better than the man who invented it," and she even hinted at having participated in the mysterious firebombing of the Housing Authority offices at the end of 1967. As we have seen, her attempt to take a knife to KKK member C. P. Ellis at a city council meeting the following year nearly had fatal consequences.

When firebombs exploded throughout Durham two days after Martin Luther King's assassination, Atwater acknowledged diverting police attention away from sites she knew had been targeted for torching. How typical Atwater's behavior was remains unclear, for we still have little idea of how many sisters may have been behind the brothers' more visible acts of violence that erupted in communities across the country during these years. Still, like the women in United Organizations, most black women seem more likely to have endorsed militancy than violence. As a Durham union official joked about a successful strike by an all-female, biracial local, "It is difficult to run a strike with all women. They don't want to incite no riot, they don't want to get into no rock throwing contest."[65]

The majority of black women activists were not alone in shunning violent tactics, for, despite white anxieties, Durham witnessed few major disturbances in comparison to the urban revolts that rocked other cities. Most of the destruction that did occur in Durham was limited to property damage. Yet white officials seemed far more concerned with the potential for black uprisings than with white supremacist violence or threats. They raised little ruckus, for example, when several truckloads of whites, prominently displaying their weapons, drove through the Duke campus one night during a black student sit-in in the spring of 1969. In contrast, white fears of Black Power, which many equated with black violence, verged on the irrational. For example, few whites acknowledged that most local blacks avoided the Black Panthers after they arrived in Durham in 1968. According to Duke student and black activist Bertie Howard, "It was clear to everybody that [the Panthers] were informants because they were very disruptive people and people kind of shied away from them." Howard Fuller also downplayed the influence of the Panthers not only in Durham but statewide. "Sure you've got a couple of Panther chapters—like in Greensboro, Winston-Salem and [maybe a few members] in Charlotte," he said. But white condemnation of the Panthers, Fuller insisted, was "just an effort to find a scapegoat."[66]

After black students and activists established Malcolm X Liberation University in Durham, whites were in a near panic. According to North Carolina Fund head George Esser, who supported the endeavor, it "scared the living daylights out of [most of the white] people." Fuller's remarks at the opening celebration of the school did little to assuage white fears. "Injustice must be fought with words or with blows or with both. . . . Those of us at Malcolm X University can no longer endure the oppression," he told a crowd of over a thousand supporters.[67]

The confrontation between Duke administrators and black students who

occupied the main administration building in spring 1969 served as the im-
mediate catalyst for the creation of Malcolm X Liberation University, which
opened in fall 1969.[68] But its founders felt the cooperation between black
students and neighborhood people made the experimental school the next
"logical thrust of the Black movement in Durham." Rooted in the "Pan-
African liberation struggle," the school had as one of its central goals to "de-
velop a Black Revolutionary Ideology" by offering "a real alternative for Black
people seeking liberation from the misconception of an institutionalized
racist education." The curriculum was designed as an eleven-week intensive
course of study "for persons who wish[ed] to work with the problems of
Black people." Proposed course offerings ranged from African American His-
tory to The Psychology of Racism to Revolution and the Third World. The
school operated with volunteer faculty, mostly from Duke and the former
North Carolina College, which was renamed North Carolina Central Univer-
sity in 1969; however, "non-academic persons with expertise in particular
fields" were incorporated in courses such as Study of the Black Community.
Because many of the students also had jobs, most courses were scheduled to
meet in the evenings. Class attendance was "compulsory" because, as the
founders put it, "The process of obtaining an education involves discipline,
and the students at this university are no exceptions." Above all, the founders
hoped to subvert the traditional power relations between student and
teacher: "This superior-inferior relation will not be present in the class-
room." In a final departure from traditional educational institutions, the
founders proclaimed, "The accreditation for the university will be granted by
the Black community." Any student who accepted the university's loosely
defined goals and philosophy was eligible to apply.[69]

Male-female participation in local Black Power projects, including the
Malcolm X Liberation University, followed a familiar pattern. Although Fuller
was the most visible spokesperson attached to the experimental school and
men dominated much of the formal leadership, black women, including BSC
secretary Charsie Hedgepath and Duke student Bertie Howard, who had
worked with the North Carolina Fund and the Foundation for Community
Development in black voter registration drives, did much of the organiza-
tional work. Durham was selected as a site for the school because it had two in-
gredients that its founders felt were "essential for Black self-determination,"
and both were predicated on black women's activism: (1) extensive neighbor-
hood-level organization of poor blacks, and (2) a strong link between stu-
dents and neighborhood people. Black neighborhood activists such as Ann
Atwater publicly endorsed Malcolm X Liberation University, but on its open-

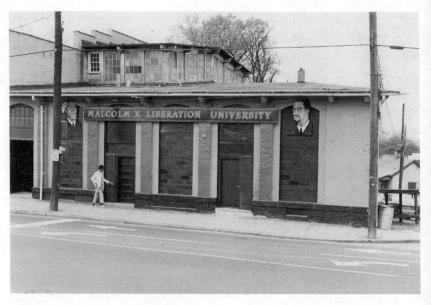

African American students from Duke joined with black community activists in Durham to establish Malcolm X Liberation University in 1969. (*Photograph by Bill Boyarsky; courtesy Civil Rights Heritage Project, Durham County Library*)

ing day the local neighborhoods and working-class blacks were represented by two men: Oliver Harvey of Duke's Local 77 and United Organizations president James Potter, who had replaced Rubye Gattis. Yet women were not entirely absent, and they spoke out as vehemently as the men did. While dashiki-clad men patrolled on nearby rooftops, Betty Shabazz, the featured speaker and widow of the assassinated Malcolm X, sent a warning to white supremacists: "You can kill as many black people as you like, but the revolution will go on," she declared. In between the speeches, the Harambe Singers, a six-woman a cappella group from Atlanta, led the audience in song, promoting black pride and racial solidarity. Despite the prominence of men, the school might never have gotten off the ground without the organizing efforts of women.[70]

Even a cursory examination of low-income African American women and Black Power suggests the need for a reevaluation of this elusive and often misunderstood ideology. As historian Chana Kai Lee observes in her biography of Fannie Lou Hamer, the black nationalism that poor black women such as Hamer endorsed was class based. Like Hamer, Ann Atwater, Pat Rogers, and Pearlie Wright advocated black nationalism—particularly the tenet of self-determination—and eagerly embraced the notion that African American peo-

ple were an oppressed community that had the right to direct its own destiny. But they also conflated race and class, becoming what Lee calls "race loyalists."[71] Thus, racial solidarity was not simply or automatically a function of membership in a particular racial group. Rather, one had to prove racial allegiance through action in support of poor blacks. This dynamic was clearly evident in the Black Solidarity Committee during the Durham boycott. Moreover, low-income women participated simultaneously in separatist movements, such as the Black Solidarity Committee or the Malcolm X Liberation University, and in biracial coalitions, including the Edgemont health clinic and, as we will see, Women-in-Action. Finally, the tendency of both scholars and the public alike to focus on the more sensational aspects of Black Power and on black violence has diverted attention from some of Black Power's more lasting and significant aspects and from projects initiated by women. Malcolm X Liberation University created a furor among whites, although it remained in Durham for only a short period before moving to Greensboro, where it folded after several years. Few people, however, recall one of its more important legacies, the Betty Shabazz Preschool, which lasted far longer and undoubtedly had a much greater impact on poor women's lives.[72]

The Government Crackdown and the Erosion of Black Women's Grassroots Organizing

By the early 1970s, grassroots black activism in Durham had begun to fade, just as it had in countless towns and cities throughout the South. Although a number of factors, including ideological divisions, were responsible for its demise, government attacks made it virtually impossible to continue organizing the low-income black women who were the foundation of the Durham movement. But internal factors were also to blame. It seems that the lessons of the boycott were soon forgotten. In a pattern similar to that experienced by the Student Non-Violent Coordinating Committee several years earlier, the black freedom movement in Durham lost touch with its grassroots base in poor neighborhoods as students became the focus of the movement. Although the Malcolm X Liberation University was intended to unite students and the community, without a primary commitment to the neighborhood base it was an ephemeral if noble experiment. Much as the militants who flocked to SNCC in the late 1960s had declared Fannie Lou Hamer "irrelevant" to the new Black Power movement, so too did Ann Atwater become increasingly irrelevant to the Durham struggle for black liberation. Howard Fuller may have changed his name to Owusu Sadaukai, but there was a terrible irony in leaving behind the Mrs. Atwaters of the Durham movement, for

Atwater was every bit as much a proponent of Black Power as were Fuller and the students who organized the Malcolm X Liberation University.[73]

The shift in focus from neighborhood organizing to students, which marginalized low-income black women, was driven not only by Black Power politics but by tactical considerations, reflecting the increasing harassment by white officials of African American organizers in Durham and throughout the state. By 1968, black student unrest, especially following the Orangeburg, South Carolina, massacre of several black students, was on the rise in North Carolina and the nation. Fuller and others in the Foundation for Community Development thought that they could tap into this student militancy by recruiting college students rather than neighborhood residents for work in poor black communities. While hiring students rather than residents undermined the community base that had been the foundation for FCD projects, other forces had a far more devastating impact on organizing projects in poor black communities.

The FCD soon drew the attention of white power brokers, who had grown increasingly uneasy at the effective organization and mobilization of poor blacks throughout the state. Opposition to the FCD—and by implication to United Organizations—also had partisan political overtones, as Richard Nixon's election to the presidency the previous year had energized conservative Republican forces in the state and throughout the South. The Foundation for Community Development was a convenient target for southern Republicans intent on dismantling former president Johnson's antipoverty programs, and in 1969 North Carolina Republican Party chairman James Holshouser asked the Nixon administration to delay the disbursement of an Office of Economic Opportunity economic development and venture capital grant to the FCD totaling almost $1 million. The grant was intended to support United Durham, Incorporated, but Holshouser wanted an investigation of FCD, because he said it hired "militants" and "trouble-makers" like Howard Fuller. It hardly mattered that FCD had no plans to involve Fuller in the UDI project. The two Durham dailies leapt into the fray; one even ran a cartoon of Howard Fuller dressed as a Nazi pilot. So incendiary was the local newspaper coverage that before long the renowned segregationist Senator Strom Thurmond of South Carolina and Republican John Rarick of Louisiana began quoting the *Durham Morning Herald* and the *Durham Sun* on the House and Senate floors, linking the FCD and Fuller with "Marxism," "campus riots," and "insurrection."[74] The FCD approached the Ford Foundation for support to tide it over until the furor over the federal grant subsided, but Congress had enacted restrictions on private foundation donations as well. The federal Tax Reform Act of 1969—

passed partly in response to the controversies in North Carolina surrounding black community organizing—severely restricted the ability of private foundations to fund nonprofit community organizing projects like the FCD or United Organizations.

FCD realized that the organization would have to redirect its focus away from community organizing if it was to survive. The group terminated all grants to nine poor people's groups throughout the state, including United Organizations. To soften the blow, FCD transferred all of these groups' personnel to the FCD payroll, but the decision had a ruinous effect on United Organizations. The Ford Foundation, adhering to federal guidelines, awarded several grants to FCD for community economic development, leadership training, and research, but not for community organizing. The shift enabled FCD to survive in the short run, but it had dire consequences for the low-income black women who were the majority of participants in community organizing campaigns.[75]

FCD troubles, however, were not over. The furor that arose over the 1969 police shooting of a black student, which was followed by several days of racial disturbances in nearby Greensboro, was the final kiss of death to black community organizing throughout the state. During the melee, Greensboro police found weapons that turned out to belong to Howard Fuller in the trunk of a car being used by two FCD employees, and newspapers used the incident to fuel conspiracy theories about a statewide Black Power plot hatched by the Black Panther Party and the FCD.[76] When Greensboro's police chief denounced Fuller before the Senate Subcommittee on Investigations, the impact was devastating. The fact that Fuller had legally purchased the rifles after receiving so many death threats that even the Durham police provided round-the-clock monitoring of his home was a detail lost on most whites. White accusations that the FCD was "staffed by a group of gun runners who go about the state fomenting riots" received an additional boost when the media reported that FCD head and Durham resident Nathan Garrett also sat on the board of the Inter-Religious Foundation for Community Organization. Resorting to McCarthyite tactics of guilt by association, the press noted that the religious foundation had sponsored the first national Black Economic Development Conference in Detroit, which endorsed the "Black Manifesto," demanding $500 million in reparations from white churches and synagogues. Fuller, however, remained at the center of the criticisms of FCD, and in July he resigned to focus his energies on both the newly created Malcolm X Liberation University and national Black Power developments. By 1971, Fuller had left North Carolina for Africa. But the damage was done. In the end, the

government attacks and the shift away from community organizing seriously undermined black women's influence and ultimately decimated the freedom movement.[77]

The Office of Economic Opportunity's repeated refusal to release the UDI grant to FCD even after Howard Fuller left the state confirmed activists' suspicions that the fiery organizer was simply a scapegoat, or, as the *Carolina Times* called him, a "smokescreen." Fuller himself shrugged off the attacks. "What can you expect?" he asked a reporter. "They're scared because they know no white man can control me." The real issue was white fear of the growing militancy and empowerment of poor blacks in Durham and across the state. As one North Carolina Fund report caustically remarked, "One million dollars in the hands of poor blacks! This is not the traditional mode of economic development in Durham."[78] The Nixon administration never released the promised funds to FCD, but it did finally award a $300,000 OEO grant to UDI for a modular home factory. FCD managed to survive for several more years before giving way to other efforts.[79] In the absence of FCD support, United Organizations launched a local fund-raising campaign, but without federal funds or foundation grants the neighborhood councils soon foundered and collapsed. The long-term impact of the political turmoil—and the more damaging consequence—was the neglect and deterioration of the grassroots base that had provided the impetus for Durham's black freedom movement throughout much of the decade, a foundation that was overwhelmingly female.

Black protest in Durham and across the state did not disappear with the cessation of federal support or with the demise of United Organizations. North Carolina remained the site of violent racial conflicts that drew national and even international attention throughout the 1970s, including the Wilmington Ten shootout, the Joan Little sexual assault and murder case, and the "Death to the Klan" march in Greensboro. With the exception of the Little case, which spurred Durham's East End activist Mrs. Christine Strudwick to organize Concerned Women for Justice (CWJ), much of the protest activity of the 1970s proceeded without the widespread, organized presence of low-income black women. Instead, black women like Ann Atwater, Pat Rogers, Callina Smith, and others carried on the tradition of African American women's community work, though on a smaller scale. They simply did what black women have done for centuries; they picked up the pieces and continued to fight for Durham's poor black neighborhoods in any way they could. Indeed, their commitment remained the same. As Ann Atwater described her ongoing work on behalf of Durham's low-income blacks, "I can't

catch everybody, but I can try."[80] But before fading entirely, the ripple effects of the grassroots organizing campaigns of the mid-1960s made an unlikely appearance in a newly formed biracial, middle-class women's organization where low-income African American women once again flexed their collective muscle.

Visiting Ladies

Interracial Sisterhood and

the Politics of Respectability

Just days before the Black Solidarity Committee an-
nounced the start of the boycott, Mrs. Elna Spaulding, a
member of Durham's black elite and wife of retired North Carolina Mutual
president Asa Spaulding, left a meeting in New York City determined to help
ease racial tensions in her hometown.[1] In a move that must have raised eye-
brows among some of Spaulding's fellow elite club women, she wrote a let-
ter to the *Carolina Times* exhorting middle-class women in Durham to emulate
Mrs. Ann Atwater. "In all probability the citizens of Durham would have ex-
perienced far more violence had not one woman spent her time and energy
in securing 'new rights and better living for many Negroes in Durham,'"
Spaulding declared.[2] In fact, Atwater was not quite the individual heroine—
the example of "what one woman can do"—that Spaulding claimed. Rather,
Atwater was a dedicated and effective community organizer who worked not
alone but through grassroots organizations such as United Organizations
and the BSC. And while it was true that Atwater's work undoubtedly helped
spare Durham from the violent conflagrations that gripped other cities, the
skilled organizer was not averse to threatening (and even using) violence to
further the aims of the black poor. Still, the reversal of age-old patterns of
class deference by one of black Durham's leading ladies spoke volumes
about the evolution of the freedom movement in the capital of the black
middle class. Just as the traditional black male leadership had been forced
to play catch-up to a movement driven by low-income African American
women, so too did middle-class women, both black and white, accommo-
date themselves to the evolving social relations. The shift, however, proved
ephemeral, for the convergence of racial and class-based divisions that per-
meated nearly every aspect of Durham's political and social life could not be
overcome by resorting to outdated modes of women's voluntarism, as Elna

Spaulding had so fervently hoped. Middle-class and elite women might have found room to breach the racial divide and use their new class-based sisterhood to ease the final phase of school desegregation. But in the end, those most marginalized—poor black women—were once again left behind. Still, that black and white women found any area of commonality in the late 1960s and early 1970s defies the stories of racial polarization that have dominated our narrative of the black freedom movement in this period.

Creating Women-in-Action

Mrs. Spaulding had written the letter to the *Carolina Times* after attending a meeting of over 200 representatives of women's organizations in New York City. The meeting was convened by *McCall's* magazine to discuss the theme "Womanpower in Action: Toward the Reduction of Violence."[3] The idea was for small groups of women to take on short-term local projects with support from the national Womanpower-in-Action Steering Committee headquartered at *McCall's*. The women discussed a range of issues, but in the summer of 1968 none loomed as large as "interracial relations."[4]

That emphasis undoubtedly compelled Elna Spaulding to place a notice in the local papers calling on all Durham women to unite "in a project to eliminate violence in our lives." In response, 125 women—black and white, well-to-do and low-income, reform-oriented and radical—gathered at the local YWCA on September 4, 1968. By the end of the evening, this somewhat unlikely group had formed an explicitly biracial women's organization, Women-in-Action for the Prevention of Violence and Its Causes, which is still in existence. Membership fluctuated but averaged about 125 women, with an additional 400 to 500 on the group's mailing list. In 1971, WIA organized a statewide conference in response to inquiries from women across the state, and Raleigh and Wilmington soon established WIA chapters.[5]

Women-in-Action members were largely middle-class and middle-aged, and they included a significant number of African American women, about 40 to 45 percent of the group.[6] Most had been active during the 1950s in a wide range of civic and voluntary groups such as the National Council of Negro Women, the Harriet Tubman YWCA, the NAACP, literary clubs, and mothers' clubs. Many of the white women had been involved in women's organizations that had been forced to include black women during the 1950s, including the YWCA, the League of Women Voters, and the American Association of University Women.[7] Even after desegregating these groups, black women remained a small minority in them. Nevertheless, the seeds for WIA had been planted in these earlier efforts. Class fissures proved more difficult

to navigate for these middle-class reformers, but here too WIA showed promise, for initially WIA attracted low-income black women from groups such as United Organizations for Community Improvement, the Durham chapter of the National Welfare Rights Organization, Operation Breakthrough, and from tenant groups.[8] Thus, both black and white Women-in-Action members came to the organization with a long and varied history of activism in women's reform and community groups, though often separated by race and class.

In certain respects, WIA was a relic of an earlier era of women's benevolence and civic activity in which the politics of respectability informed the style and substance of both black and white middle-class women's reform efforts. However, there were important differences between Women-in-Action and these earlier female reform organizations. First of all, WIA was deliberately and self-consciously biracial, and, unlike other biracial women's groups such as the YWCA, Women-in-Action was established by an African American woman. Secondly, the influence of low-income African American women reversed the historic relationship between middle-class reformers and their downtrodden sisters. Not only were poor black women in Durham instrumental in shaping the agenda and procedures of the Black Solidarity Committee, they also played a critical role in determining the focus of Women-in-Action. Still, though Women-in-Action responded to issues that were raised initially by low-income African American women, the extent to which more affluent black and white women would be willing to give their full support to the aims of poor black women remained to be seen.

Race and Maternalist Politics
The desire of Women-in-Action members to become mediators in Durham's racial politics was grounded in similar attitudes of both black and white women concerning domesticity, motherhood, and class-based notions of respectability. Some of their ideas reflected essentialist notions of womanhood that frequently transcended racial divisions. Certainly, racial differences informed black and white experiences of motherhood and domesticity; however, the convergence of gender and class also provided a basis for certain shared values.[9] Many black and white WIA women believed that women's roles as mothers, nurturers, and caregivers made them more "naturally" interested in their children and their children's futures and that this perspective gave them a unique and special role that men did not share. But they also took this line of thinking a step farther in much the same way that Mary Duke Biddle Trent Semans had done, arguing that it also made women

more effective at resolving racial conflict.[10] At the same time, black women in particular articulated conceptions of womanhood that reflected both the "natural" and the social dimensions of women's roles. Elna Spaulding explained why women had created a group like WIA: "In my view, women can do things that men cannot do. They have sensitivities. . . . They're more people oriented . . . because they're of a nurturing nature, of a caring nature. And it's part of them to show it. For men, they're not trained to show that they care that much. So [because of] the differences [between men and women], it was perfect to have the women do it."[11]

WIA's interracial discourse on woman's nature, however, also blinded some white women to the realities of racial difference. Chris Greene, a white WIA member, articulated a racially constructed conception of motherhood in explaining why WIA was a women's organization. Calling women "peacemakers," she asked rhetorically: "Who would hit a woman? Who would hit somebody's mother?" But Greene's essentialist view of "everywoman" ignored a history of violence and abuse against all women and promoted a racialized mythology that obscured the sexualized racial violence that black women had borne for centuries.[12]

Black and white WIA members also drew on similar traditions of middle-class women's voluntarism; however, their priorities and activities historically had been quite different. Black women invariably linked their community work and even leisure activities to demands for racial equality in ways that white women, including those who supported racial justice, did not.[13] Moreover, despite shared attitudes toward domesticity and maternalism, black women's historic exclusion from mainstream white society's definitions of respectability meant that their claims had a dissident quality decidedly different from those of white WIA women.[14] On the other hand, similar beliefs about domesticity, maternalism, and womanhood formed a core set of values that enabled WIA members to breach the color line that had long divided them. In effect, WIA was characterized by a dialectical tension that united middle-class black and white women along the lines of class-based maternalist politics even as racial differences challenged that unity.

A Model of Interracial Cooperation

The members of WIA understood that if they were to have public influence they would have to provide an example of interracial cooperation. The group's bylaws mandated that the presidents of the organization and of the board must be of different races. Each subcommittee was to be cochaired by a black and a white woman. Authentic rather than token biracial leadership

was thus ensured. WIA's sensitivity to racial politics, both symbolic and substantive, was due largely to the fact that the organization was established by a prominent African American woman, Mrs. Elna Spaulding, whose strong and visible leadership for almost eight years attracted significant numbers of black women to the group. WIA thus reflected the concerns of black women from the beginning, distinguishing the organization even among interracial groups.[15]

In the coded language of interracial relations, Mrs. Spaulding instructed the women at the first meeting: "If our purpose is to reduce violence, we should begin with ourselves by showing proper respect for the personality and dignity of each member of the group."[16] She suggested that black and white members should meet in one another's homes "not only for privacy but also so that members would have a better opportunity to become better acquainted."[17] One subcommittee reported: "Most of our meeting time is spent getting to know one another and explaining what is going on [in] both sides of Durham. We have found that we know very little about one another racially and are attempting to close that gap. We feel it would be futile to work on any extensive project together with so little understanding of one another."[18]

Committee members frequently attended churches outside their communities, and black and white women tried to speak candidly with each other. Such openness across the racial divide, however, was a new and sometimes difficult experience for many. One woman remarked after an especially frank discussion about race relations, "It may be good for the whites to be in fear— to taste what the blacks have lived with."[19] Despite the willingness of most WIA members to improve interracial communication, some women, such as Mrs. Bessie McLaurin, a black WIA member, adamantly refused to tolerate any form of racism from white women: "I don't have time to sit up here and hear no racist mess," she recalls having said. "If you are not committed and if we're not going to talk on equal terms, then let's close [WIA]."[20]

Navigating Race and Class Divisions

WIA's main purpose was to prevent violence, particularly racial violence. However, the group never precisely defined "violence," thereby enabling members to skirt potentially more divisive questions concerning both white and black violence. The answers to such questions varied, but not always in predictable ways. One African American member wondered aloud if anyone was working with the Ku Klux Klan or the white supremacist White Citizens Council. Elna Spaulding recalled that "everybody knew" about militant blacks making "threats . . . to certain parts of [the white] community."

Whites in the upper-middle-class Duke Forest section organized neighborhood watches, with "people hidden armed in their houses all night long," Spaulding claimed. Years later, a white Duke Forest resident and WIA member scoffed at the notion. The husband of another white WIA member asserted privately that "militant" black activists were threatening to blow up the black-owned North Carolina Mutual because they felt that the black business leaders were too moderate. While many such claims were based on rumors and speculation, they reflected the racial fears that gripped the city in these years.[21]

In other ways, WIA members' views on violence were quite sophisticated and reflected low-income women's influence on the organization. For example, WIA members recognized that poverty and racism fueled racial violence, and they set up subcommittees to deal with housing, welfare, employment, and education problems. Other subcommittees focused on voting, police-community relations, human (that is, race) relations, and recreation. It is no accident that the subcommittees' agendas coincided almost exactly with the demands made by UOCI and the Black Solidarity Committee. United Organizations shaped WIA's agenda at least initially by its members' presence at WIA meetings. As Mrs. Spaulding explained, "The activist tenants were there every night [at WIA meetings] and they were very helpful . . . and we all were learning as we listened to them."[22] United Organizations' impact was visible in less direct ways too, for low-income blacks had defined the direction of the freedom movement in Durham through public protests and the demands that were part of the black boycott. Thus, the middle-class elements of WIA, much like the black male elite in Durham, were drawn into a movement that had been fundamentally altered by the presence of poor black women who were already organized and mobilized.

However much the structure of the WIA subcommittees reflected the demands of United Organizations, WIA's style was decidedly different. Its members favored negotiation, mediation, and information gathering. In contrast, United Organizations employed more confrontational tactics such as public protests, boycotts, and mass meetings. Quite a few black and white women were uncomfortable with the angry outspokenness of groups such as the Black Solidarity Committee, and their discomfort enabled some black and white WIA members to forge class-based bonds. Many were "shocked, hurt and fascinated" after BSC chair Howard Clement dismissed their efforts. "Ladies, you may be part of our problem, rather than a part of our solution," he told them.[23] Another WIA member, Rose Butler Browne, a professor at Durham's historically black college, criticized BSC representatives who

were "more interested in releasing their own tensions than in teaching WIA members ways of communicating with the underprivileged." WIA agreed to advise future panels to "keep their discussion . . . low-key," but Elna Spaulding also reminded WIA members that "feelings ran high on the problems . . . and it was unrealistic to expect unbroken composure."[24] Still, Spaulding's very reference to "unbroken composure" reinscribed notions of middle-class respectability that separated WIA from UOCI and the BSC.

Not all WIA members were eager to impose middle-class modes of behavior on the poor. Julia Lucas, an African American WIA member, recalled the insensitivity of both black and white women: "I think they tried," she said, "but some of the blacks and the whites [in WIA did] not understand how the poorest of the poor acted the way they did. Cause if you don't have a dime . . . you didn't sleep that well because you were hungry and you get up and go out in the cold, you not gonna be as pleasant as that person who's got a full stomach and slept well. You're not going to act the same." Unlike some other middle-class women, Lucas felt indebted to the low-income community: "Every dime I made, I made off of those people," she said.[25]

More than style differentiated WIA from the BSC and UOCI. Unlike these groups, WIA insisted that the organization remain neutral on public issues, particularly those involving controversy. Instead of taking a position, the organization favored "adequate study of both sides of the issue" in order to determine what would be "in the best interest of the total community." Since too many advocacy groups had polarized the community, members reasoned, WIA hoped to bring people together to negotiate solutions to conflicts. Members did not see this role as passive, but rather interpreted mediation, negotiation, and fact-finding as "action." They believed that WIA could perform its chosen role better than other organizations because the group was genuinely interracial, it was more representative of "all segments of the population than any other organization," and it was "not *obligated to or aligned with* any [pre-existing] organization."[26]

The first issue that WIA took on was the black boycott. Mrs. Spaulding's insistence on maintaining neutrality was ultimately adopted by WIA, but the issue was widely debated, for many women, both black and white, felt the organization should publicly back the boycott. WIA's professed neutrality seemed both to subvert and to support the boycott. For example, WIA referred to its own mediating role as a "last resort in the prevention of violence." But boycott organizers had already used the same rhetoric, explaining that their actions were a "last resort" of the black community. On the other hand, WIA revealed its sympathy for the Black Solidarity Committee and

drew parallels between the problems of poor blacks and whites. "[The boycott] is the black community's way of calling attention to its problems and pointing out that it can wait no longer for solutions," a WIA statement asserted. "Many of these unmet needs have applied to the poor white community as well and must get our attention."[27]

United Organizations was clearly the most influential group in organizing and sustaining the boycott and in winning concessions from the white establishment. Still, WIA tried to play a mediating role by organizing several community forums, first for representatives from the Black Solidarity Committee and then for the all-white Merchants Association and Chamber of Commerce.[28] Durham's two daily newspapers were notorious for distorting black perspectives and providing largely conservative white viewpoints. WIA-sponsored public gatherings, therefore, enabled Durham residents, particularly whites, to hear the demands and frustrations of low-income blacks firsthand.[29]

Visiting Ladies: Friendship or Advocacy

Although most WIA members insist today that racial tensions were largely absent from the group, overcoming class cleavages proved difficult for many members, especially when racial differences were added to the mix.[30] During the black boycott, WIA tried to work with the BSC, but even the middle-class BSC chair, Howard Clement, was wary of the biracial group. Clement cautioned Rose Paige Wilson, the white WIA Welfare Committee cochair, that he hoped her newly formed group would "strive to do *with* rather than *for* the people it aim[ed] to serve." The poor sometimes expressed similar sentiments themselves, informing WIA that they were "not interested in having the organization do anything *for* them."[31]

Despite such warnings, WIA women often were dismayed when low-income black women responded with hostility to their overtures. Tenants slammed doors in their faces, refused to return phone calls, and failed to show up at meetings. Part of the difficulty stemmed from WIA's refusal to publicly support black residents in the public housing projects. WIA, however, insisted that the problem was due to "militants" from United Organizations who dominated the tenant councils. Even when WIA women tried to defuse tensions, they often widened the chasm that separated the poor from the more affluent. One woman reminded members, "These people have all been displaced from their homes and must learn to live at close quarters which is quite difficult"; but her comment conveniently ignored the fact that

"displacement" was really forced relocation and dismissed the anger tenants felt at being excluded from urban renewal planning.[32]

Mrs. Charlotte Sloan, a WIA member who hailed from black Durham's upper echelon, believed that the interplay of class and race relations discouraged many low-income African American women from joining WIA. They felt uneasy, Sloan claimed, joining an organization with white women whose kitchens they scrubbed and whose children they minded. One white WIA member acknowledged the racially charged attitudes of some white WIA women: "What do *they* want? After all, we've had them in our homes. They raised our children," were the unspoken sentiments of at least some, she said. But not all low-income women felt intimidated by affluent women, and some of them meant to show white women that a new day had arrived. In a striking reversal of the historic pattern of deference that marked black employee–white employer relationships, African American women from the public housing projects who were attending a luncheon at a white WIA member's home insisted that their white hostess serve them—even though the luncheon was a buffet.[33]

Class tensions both between the races and within each racial group challenged WIA unity in various ways. Segregation often brought poorer and more well-to-do black citizens into daily contact, yet a number of African American WIA members believed that many of the well-to-do black women needed to be educated almost as much as the white women regarding the needs of poor blacks. One early WIA workshop, "Techniques for Effective Interaction with the Underprivileged," featured a presentation by United Organizations representative Ann Atwater. Even after Atwater's presentation, however, some WIA members remained unconvinced about the extent of Durham's poverty. Lee Ridenour, a reporter and white WIA member, suggested that perhaps a bus tour through the housing projects might convince the skeptics. In an obvious reference to WIA's tendency to consult so-called experts, Ridenour warned that the group needed the expertise of "all the Ann Atwaters who haven't become experts in anything and are rarely listened to." WIA members and the "Mrs. Atwaters" needed to form "Dialogue Groups" or "Friendship Groups" to get to know one another, Ridenour proposed. "Otherwise," she warned, "we will be just another group of visiting ladies." By asserting that friendship "is the best 'system' of all," Ridenour helped to justify an ideology and mode of operation within WIA that both eluded systemic race and class subordination and fostered friendship as an end in itself. Thus, WIA members privatized their commitment to racial egalitarian-

ism by promoting interracial friendship among middle-class women rather than engaging in concerted struggle to provide real opportunities for low-income blacks or whites.[34]

Certainly, it was both naive and unrealistic for the members of Women-in-Action to think that interracial friendship alone could eliminate the structural barriers between the Lee Ridenours and the Ann Atwaters. Atwater was far more willing than most low-income black women in Durham to meet with middle-class white women. But some white WIA members found it almost impossible to regard women such as Atwater as their peers. One white woman who claimed that the real barrier between people was class, not race, revealed her ignorance about low-income women in her explanation of why so few of them participated in WIA: "They just didn't have any tradition [of] going to meetings. . . . They've got no time for this and besides no intellectual basis for thinking about these things." Too often, white women dismissed the outspokenness of black women like Ann Atwater or BSC secretary Charsie Hedgepath as "hostile." As one white WIA member delicately described black assertion in the late 1960s, "There were moments when it became less genteel."[35]

Not all middle-class WIA members were ignorant about the problems of the poor, however. Mrs. Julia Lucas often chided the group for proposing superficial solutions to complex problems. Reminding the WIA Civic Improvement Committee that tenants had more pressing concerns than planting flowers—like ousting the hated white Housing Authority director Carvie Oldham—she criticized their beautification plans. "Tenants don't care about shrubbery," she scoffed. Seemingly exasperated by WIA's inaction, Lucas urged members to "put ourselves on the line."[36] Although Mrs. Lucas was often a lone voice within WIA, she was not the only critic of WIA inaction. Three cochairs of the WIA Housing Subcommittee (all white women, and two of them League of Women Voters members) resigned after the organization failed to back even limited tenant demands, including tenant representation on city housing planning committees.[37]

Housing conflicts revealed some of the most difficult internal contradictions that plagued WIA. The families of WIA members Mrs. Julia Lucas (who was black) and Mrs. Blue Greenberg (who was white) had been on opposite sides of the first major public controversy over housing. Lucas's daughter, Charsie Hedgepath, worked with United Organizations in 1966 to organize the provocative pickets against Blue Greenberg's husband, Abe; some of the pickets' signs were even directed at Mrs. Greenberg.[38] Although Julia Lucas and Blue Greenberg managed to work together in WIA for several years, it

was perhaps inevitable that the two would finally lock horns in work with public housing tenants. While the exact nature of the dispute between them remains cloudy, the upshot was that WIA abandoned all future projects with tenants.[39]

Looking back some twenty-odd years later, Julia Lucas felt that it was probably easier for white women to support the black boycott than it was for them to take a stance regarding housing. According to Lucas, some black WIA members were afraid "that if they had taken a stand to go with the tenants, then maybe the white women would have withdrawn." Yet Lucas was equally critical of African American women: "We got some black women too who don't quite understand," she said. "I think [both black and white women] really were afraid to trust the tenants," Lucas asserted. In her view, neither black nor white women had made a wholehearted effort to comprehend the daily lives of those they purported to help.[40]

Despite WIA's class-based difficulties, the low-income African American women who chose to work with WIA expressed ambivalent sentiments about the organization. According to Ann Atwater, poor folks were initially reluctant to approach the WIA Clearinghouse, an information, referral, and crisis intervention service established in 1970. "They'd go everywhere else before they'd go to WIA to ask for help. But then they'd finally end up there," Atwater said. Callina Smith, cochair of the WIA Welfare Committee and a co-founder of the Durham Welfare Rights Organization, acknowledged that groups such as United Organizations might not "think of WIA as [having been] helpful." "But I do," she said. "And I think they still are. Because they opened a lot of doors. . . . Because they were in with the establishment and you couldn't have done it by yourself."[41] Pat Rogers, who became president of the Durham Tenants Steering Committee, echoed similar sentiments. Rogers was a member of the WIA Employment Committee and worked as an organizer with Operation Breakthrough and United Organizations in McDougald Terrace, where she also headed up the tenants' association. Low-income black women like herself, she recalled, "started seeking out organizations as we had been trained to do. . . . We [went to] Women-in-Action, any organization that could offer something back to our communities. Mrs. Spaulding in return was very, very open to doing whatever she could do to help us in the neighborhood."[42]

Whatever its limitations, WIA did attempt to respond to demands that were articulated largely by low-income African American women. But WIA's mode of response raises questions about the extent to which such alliances enhanced the aims of poorer women. One of WIA's most controversial fea-

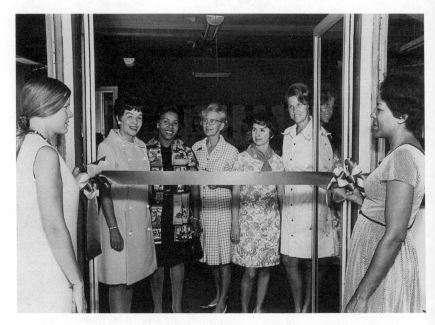

Women-in-Action adopted a policy of shared leadership between black and white women. WIA founder Elna Spaulding is pictured second from left. *(Courtesy Women-in-Action for the Prevention of Violence and Its Causes Papers, Special Collections Library, Duke University)*

tures was its decision to avoid taking public positions on some of Durham's most pressing issues. The organization's belief that it could find solutions that were "in the best interest of the total community" underscored WIA's failure to acknowledge that status differences were rooted in economic power as well as a racial caste system. More importantly, it obscured the fact that privilege and subordination are relational—that middle-class women's status is both directly and indirectly dependent upon the exploitation and subordination of low-income women.[43]

Women-in-Action was, in many respects, a product of the interracial discourse of an earlier generation that focused largely on "misunderstandings" or "miscommunication" between the races.[44] The generation that grew up in the 1950s, however, especially African Americans, insisted that real power, real material resources, and real lives were at stake, and it rejected the notion that the issues could be resolved simply through clearer communication between blacks and whites, rich and poor. On the other hand, at least some WIA members saw their mediating role as linked to more radical demands and hoped that their more moderate, respectable, even "ladylike" approach,

when backed by threats of militant actions, including violence, from United Organizations and the Black Solidarity Committee, would force white leaders to seriously address the demands of the black community.[45]

Taking a Stand on School Desegregation

If WIA's role in the boycott and its support of public housing tenants was somewhat ambiguous, its efforts on behalf of school desegregation two years later were more successful. Indeed, with groups such as ACT and United Organizations in disarray, WIA's leadership on one of the city's and the nation's most difficult racial problems was sorely needed. As other communities, both North and South, faced boycotts, pickets, and violent white retaliation over the implementation of court-ordered school desegregation plans, Durham managed to avoid overt acts of violence and obstructionism. And at least some of the credit must be given to WIA.

As we have seen, Durham mounted a campaign to resist the *Brown* decisions in the mid-1950s, admitting a handful of black students to white schools in 1959 only after African American parents filed a lawsuit against the school board. The courts upheld the legality of the city's so-called freedom of choice plan, which resulted in only minimal integration, in 1963 and again in September 1966. In October 1966, however, the U.S. Court of Appeals for the Fourth Circuit ruled that school integration plans had to provide for the desegregation of all schools. In characteristic fashion, the city school board continued to drag its feet, but several U.S. Supreme Court decisions in 1968 and 1969 made it increasingly difficult for southern districts to skirt the issue any longer. Fifteen years after *Brown*, the high court had finally declared that school desegregation had to proceed immediately.[46] In 1969, the NAACP Legal Defense and Education Fund filed suit against the Durham city and Durham County school districts as part of a larger action against almost twenty other North Carolina school systems. The Durham County schools opened with a new desegregation policy on January 1, 1970, but the city schools announced no new plan. The following month, the NAACP LDEF filed a motion calling for immediate desegregation of the Durham city schools.[47]

Women-in-Action had been wrestling with the issue of school desegregation for several years. The group castigated the local press for highlighting racial violence in the schools and urged the newspapers to cover stories of successful school integration as well as the problems.[48] One white WIA member even publicly acknowledged the link between residential and school segregation: "That we have failed to integrate our neighborhoods is the chief cause of our school integration dilemma. When we face up to this issue and

do something about it our children won't have to be bussed all over town," she said.[49]

Despite individual members' concerns, WIA proceeded in its characteristically cautious manner. At a WIA Executive Committee meeting in early 1970, the Communications Subcommittee complained that the group was not "getting involved in the community issues" and suggested that WIA take up the school desegregation problem more directly. In March, the WIA board recommended setting up summer programs and workshops to deal with the integration of city schools. But when the group tried to take a more proactive stance, school officials refused to give its representatives a copy of the city's school desegregation plan. Several members pressed WIA "to get to work as soon as possible to find ways of being helpful and effective this summer . . . so that a smooth, non-violent transition could be made in the fall."[50]

On May 28, 1970, the court ordered the city to submit a plan by June 22 for complete desegregation of all schools. WIA urged its members to attend the June 16 open meeting at which the plan would be presented to the public. The day before the meeting, members decided that a resolution from WIA merely urging support for the law was too vague and would be ineffective.[51] The following day, Women-in-Action released a statement to the press and to the board of education expressing its unequivocal support for school desegregation. In the closing words of the statement, which a member read at the public meeting, the women called for "the complete integration of the Durham City and County Schools." Women-in-Action had finally taken a stand, and it had done so on an issue of critical importance.[52]

WIA insisted that it had not deviated from its commitment to neutrality by pointing out that it did not endorse a specific plan. Few Durham residents seemed happy with the school board's desegregation design. The board revised the plan, but the NAACP was still dissatisfied and announced it would file objections. On July 24, a federal court approved the school board's revised plan.[53] Five days later, on July 29, 1970, Women-in-Action opened the Center for School Support to help implement the court-ordered school desegregation plan.[54]

Before publicly announcing its proposal for the center, WIA met with city and state officials and secured the approval of the city school board and the school superintendent as well as the Parent-Teacher Association. Blue Greenberg, who was credited with the idea for the school support center, secured the old Boone Drug Store, which had been vacated as part of Durham's urban renewal plans, for the center, and the Durham schools donated used office equipment.[55]

What had happened to make Durham officials, who had dug in their heels for years, respond so differently from officials in other North Carolina cities such as Greensboro, Charlotte, and Winston-Salem?[56] Probably the most important factor in the peaceful desegregation of Durham schools was the groundwork laid by local residents, who had carefully cultivated support from different segments of Durham's community—black and white, middle-class and low-income—representing a range of political and ideological views. And Women-in-Action's school support center was on the front lines.[57]

As the group prepared for the opening of the school support center, members pooled their decades-long experience in community and civic work to build citywide support for school integration. WIA members met with a wide range of local community and business groups. They contacted school districts where school integration had already begun in order to ask for suggestions, and they requested materials from the Department of Health, Education and Welfare for a teacher orientation workshop. WIA general meetings in June, July, and September were open to the public and featured presentations by state officials about how local communities could ease school integration.[58] WIA members approached the interim student councils at Durham and Hillside high schools (the predominantly white and historically black city high schools) and recommended the formation of Parent Teacher Student Associations to replace the older PTAs. The women urged the city's clergy to give sermons on school integration and to organize discussion groups with parents, students, and school personnel. Perhaps mindful of the disruptive and obstructionist actions of the Little Rock clergy in the 1950s, WIA suggested that Durham religious leaders hold a citywide meeting with representatives from all churches shortly before the first day of school to solidify support for a peaceful start of the new school year.[59] Even Garland Keith, a white conservative who ran for city council the following year, gave grudging approval to WIA: "In my heart I have to support you because you are for an orderly process," he said.[60] Both black and white WIA women hosted coffees and teas in their homes to which small groups of parents, students, and school personnel were invited to talk about their concerns. The group sponsored a citywide workshop with the PTA to plan open houses at all the city schools just prior to opening day.[61] Finally, WIA launched a citywide publicity campaign to mobilize support, and members sported buttons proclaiming, "Unite Our Schools."

At the opening ceremonies for the WIA school support center, Charles Steel, the mayor pro tem, cut the ribbon, lending an official imprimatur to the women's efforts. Among the twenty-five "special guests" were represen-

tatives from United Organizations, the Chamber of Commerce, the Merchants Association, the Durham Committee on Negro Affairs, the Experiment in Parallel Organization, citywide clergy associations, and even the conservative, white Citizens Committee for Law and Order.[62] The superintendent of the Durham city schools, Lew Hannen, announced to the crowd of about seventy-five people: "We have two choices: we can support [the court ruling] and make it work or tear the school system down. We're going to need all the help we can get." Hannen added, "We're going to do what we think is right—let the chips fall where they may." The following day, as Winston-Salem and Charlotte devised legal strategies to fight court-ordered desegregation in their cities, the Durham City School Board announced that "after full and careful consideration of the possible adverse consequences of an appeal, including the reassignment of pupils and teachers and disruption of school during the 1970–71 school year," it would begin immediate implementation of the desegregation order.[63]

Initially, the staff of the school support center hoped to provide referrals and serve as a sounding board for Durham residents to express their feelings about the new school plan. Although several whites had advised WIA to name a white director or staff person for the center in order to quell white fears, Women-in-Action stuck to its tradition of biracialism and insisted on hiring two paid staff members, one black and one white. In addition, the center recruited an interracial group of over one hundred volunteers from organizations such as the Harriet Tubman YWCA, the Junior League, and the League of Women of Voters to work at the center.[64]

Despite the widespread acclamation for the school support center, problems were unavoidable. After local newspapers announced that Women-in-Action and the PTA would sponsor a citywide meeting in mid-August to plan open houses for all schools prior to opening day, rumors flew and tensions soared. Part of the problem was the widespread distrust of the PTA. Many low-income whites and blacks believed that the PTA was a middle-class organization that did not represent their interests, and liberal whites harbored similar misgivings about the organization. The North Carolina Anvil, a local, white, radical newspaper, was especially pointed in its criticism, calling WIA a bunch of "middle-class ladies who wouldn't want to come too close to the messy injustices which produce violence." WIA's "silk stocking image" reinforced apprehensions about its cooperation with the PTA.[65]

But WIA efforts paid off when Durham city schools opened peacefully on September 2, 1970. In the short time the school support center had operated, staff had answered over 2,000 calls from concerned citizens and received vis-

its from hundreds of others. According to center staff, most of the calls in the first few days concerned pupil reassignment and transportation problems "from lower income groups." Yet WIA staff felt heartened that support for the center had come from "many differing opinions in the community." WIA recruited sixteen black and white women who were willing to serve as hostesses and resource persons for a Human Relations Workshop set up by the city schools for teachers shortly after the schools opened.[66] Members continued to monitor potential areas of conflict and helped avert a potentially explosive situation in which white parents were allegedly preparing for a showdown after a black boy was rumored to have dated a white girl.[67]

Some WIA members personally avoided the issue of school desegregation because their children were either grown or already enrolled in private schools. Several white women intentionally left their children in desegregated schools or sent them to formerly all-black schools where white children were now in the minority. WIA member Chris Greene, a Duke "faculty wife" whose children attended integrated schools in the early 1970s, believed that the school board had deliberately drawn the school maps to pair the middle-class children of Duke faculty with low-income black children in retaliation for the Duke faculty's alleged support of school integration. "You want it, you got it," was the message from the school board, she explained. Class, not race, she believed, was the real problem. True, the Duke faculty children had enjoyed "every advantage," she conceded, but she did not link their advantages to racially discriminatory policies that had simultaneously deprived black children of the same opportunities available to whites.[68] Still, Chris Greene did not pull her children out of public schools even when her youngest daughter was the last of three whites in a local elementary school or after her oldest daughter was transferred to the historically black Hillside High School. Few white parents who had other options elected to send their children to majority-black schools.[69]

Ultimately, however, most middle-class whites, whether inside or outside WIA, found their own ingenious ways to subvert school integration. Wealthier whites simply sent their children to private schools. Known as "seg academies" by some, private schools proliferated across the South. But for the majority of southern whites, private schools were not a viable option. Most middle-class whites (and affluent blacks) in Durham abandoned the city for county suburbs, where student populations were nearly 70 percent white and overwhelmingly middle-class. Even more devious was the "city-in/city-out" gerrymandering scheme devised by Durham officials to allow the city to expand without altering the dual city-county school system. Thus, the newer

outskirts of the city were designated "city-out," which entitled residents to city services and voting rights in city elections but enabled their children to attend county schools. In 1970, 55 percent of the students attending Durham city public schools were African American; by 1984, the figure had risen to 87 percent. But unlike segregated schools in the Jim Crow era, the two city high schools, Durham High and Hillside High, became not only entirely black but largely low-income as well.[70] In Durham, as in much of the South and the nation, school district boundaries soon became racial boundaries.[71]

While race remained an important factor in the post-desegregation era, class became a more telling factor in the decisions that both black and white parents made about their children's education, especially among the middle classes. Indeed, in the Durham school controversy, class was as crucial as race.[72] WIA's Center for School Support had helped Durham to avert the more virulent forms of racial violence that Boston and other cities experienced over school desegregation in the 1970s, but in the long run Durham's policies led to the same race and class-based divisions that characterized city schools across the nation by the 1980s. As a result, Durham blacks increasingly rejected the hollow promise of school integration. Cleveland Hammond, an African American superintendent of Durham schools, explained, "Quality education—not integration—[became] the top priority." The "victory" of school desegregation had become a bitter irony for a people who had struggled so long and sacrificed so much and were now forced to settle for so little.[73]

Women's Voluntarism and the Politics of Respectability

As the freedom movement splintered under official repression and as government indifference toward the plight of the urban poor swelled, Women-in-Action abandoned its advocacy role on behalf of school desegregation and resumed the earlier traditions of women's voluntarism familiar to most members. Only now, women's reform efforts were genuinely interracial, at least within WIA. The group resurrected its initial policy of neutrality and assiduously managed to avoid taking a position on most of the controversial issues that arose throughout the 1970s.[74] The women converted the storefront Center for School Support into a clearinghouse of information and a crisis intervention center that is still in existence. The clearinghouse staff, which was almost all volunteer, responded to a range of individual problems concerning health, employment, rent control, traffic lights, family, and consumer issues.[75] As WIA focused more and more of its energy on the clearing-

house and abandoned its mediator role, it became easier for it to insist on maintaining official neutrality.[76]

It is not surprising that WIA's most enduring effort was the clearinghouse, for the project drew on a historic tradition of women's voluntarism among both black and white women.[77] Women's voluntary and civic organizations in the 1940s and 1950s served as a link to the protest movements of the 1960s, but WIA members were also able to reassert a tradition of women's voluntarism when the more radical and militant efforts of groups such as United Organizations had been squelched.

Paradoxically, women's voluntarism served reformist as well as conservative aims. On the one hand, it galvanized a particular group of black and white middle- and upper-middle-class women to help ease racial tensions in the late 1960s. But the same tradition also enabled WIA to survive in a more conservative era when poverty programs were decimated and black protest was suppressed. Thus, WIA's politics of respectability—particularly its refusal to advocate on behalf of low-income blacks—may have helped to create an atmosphere in which whites could make some concessions to the more radical demands voiced by UOCI. Yet the politics of respectability could just as easily undermine the actions of the Black Solidarity Committee and United Organizations. The BSC member who pointedly remarked, "Ladies, you may be part of our problem, rather than part of our solution," underlined one of WIA's central contradictions—that many WIA members had a stake in the systems of racial and economic subordination that constrained the lives of so many of Durham's poor.

The black and white middle-class and elite members of WIA who sought to include low-income women from groups such as UOCI simply acknowledged poor women's organized power base, much as the BSC had been forced to do during the black boycott. WIA needed low-income black women to legitimize its actions and to learn what needed to be done. One might well ask: Had poor women not been so well-organized and so vocal, primarily through UOCI, and had they not been at the center of Durham's most pressing racial issues, would the members of WIA have been so magnanimous, so egalitarian in their efforts to reach out to their less fortunate sisters? Perhaps. But the history of black and white middle-class women's reform efforts in Durham and elsewhere suggests not. In effect, WIA's adherence to a politics of respectability hindered its ability to include low-income women. In both style and substance—ranging from its mode of operation (charging dues, using parliamentary procedures at meetings) to its insistence that WIA remain

neutral—WIA's politics of respectability meant that the organization never became an effective advocate or ally for the interests of low-income blacks. Whereas middle-class respectability arguably could be used to promote the interests of the black community in the age of Jim Crow, by the late 1960s such tactics were fundamentally conservative, especially within a biracial organization. For WIA, respectability entailed not only class-inflected but also racialized patterns of behavior. By insisting on operating within the constraints of respectability, WIA undermined an earlier tradition of respectability among black women that could, at times, transcend intraracial class divisions. During the Jim Crow era, poor and working-class black women found it possible to join the ranks of respectable women through church or community work. Yet class barriers remained; as historian Leslie Brown points out, in the capital of the black middle class respectability could never "lift them into a position of equality with the African American elite."[78]

The needs of low-income communities, both black and white, made it difficult for WIA to remain neutral without reinforcing the racial and economic status quo. One wonders, for example, what might have happened had WIA truly used its collective class-based influence to pressure authorities on behalf of United Organizations. Whether or not it realistically could have done so obscures a more pressing issue—by not taking a stance, by refusing to become advocates for the poor, the middle- and upper-middle-class members of WIA never had to confront the ways in which their own class interests were served by their policy of neutrality. Middle-class women may have sincerely believed that they could best serve the interests of the poor by remaining neutral, by playing a mediator role. But WIA's neutrality also reinforced its members' own class-based interests in the status quo—for both black and white middle-class women. Middle-class women's status and effectiveness as mothers and homemakers (and professionals, for those who had careers) often depended on the availability of services such as child care and household help that were provided by women who were overwhelmingly African American and underpaid—that is, the very constituency of United Organizations. WIA's failure to advocate structural change for low-income women in effect reinscribed class-based power relations and concealed the ways in which women's class privileges (and race privilege for white women) were often directly dependent upon the economic exploitation of low-income black women.[79]

Elite African American women were not immune from these complicated relations of inequality. Many of them also employed black domestic help, although as employers black women's position in these relationships was am-

bivalent. Some had direct ties to women domestics, sometimes in their own families, and black middle-class and elite status frequently was, and remains, less stable than that of affluent whites. But whatever indignities black elite women had suffered under Jim Crow—and these were not insignificant—the erosion of Jim Crow also potentially threatened the foundation of their class position.[80]

The limitations of WIA's politics of neutrality, ironically, are illuminated by the one instance in which they abandoned them—during the school desegregation crisis. The organization's public advocacy of school desegregation, specifically the creation of the school support center, was its greatest achievement and represented its most successful response to an immediate and widespread racial crisis. The failure of school desegregation was not due to WIA's limitations but to the class and race privileges exercised by middle-class whites and, to a lesser extent, middle-class blacks and institutionalized through the creation of a dual county-city school system. Of course, individual WIA members also exercised their race and class privileges, but at least some white WIA members were willing to participate in school integration in good faith. Moreover, WIA's school support center did help to ease the desegregation of Durham's schools without the violence and upheaval that accompanied such efforts in some cities. And this success would have been impossible without WIA's strong, unwavering, public support for school desegregation.

The Paradox of Women's Interracial Friendships

The politics of respectability lay at the heart of WIA's limitations but also accounts for its longevity. WIA's most enduring legacy was the establishment of interracial friendships, in part because white women recognized they had black counterparts in Durham whom segregation had largely prevented them from seeing. White women repeatedly expressed both surprise and delight that there was a group of African American women so educated, so articulate, so well dressed, so respectable—in other words, so like themselves. Although black and white middle-class women did not share precisely the same needs, interests, or values, there was enough class-based commonality among the majority of women in WIA to sustain the organization. Moreover, black and white women could sometimes work together even when their motives differed. Concerns over racial violence thus united black and white WIA women in an "unlikely sisterhood" shaped by different perspectives and experiences.[81]

Perhaps WIA's most striking achievement was its ability to create and sus-

tain a biracial women's organization in a period when Black Power, increased hostility and violence on the part of whites, and a conservative political backlash made interracial alliances ever more difficult to establish and maintain.[82] Was WIA, then, simply an anomaly—a biracial women's organization created by a prominent African American woman in the midst of a black economic boycott and heightened racial tensions? This simplistic assessment obscures the historic changes brought about by the struggle for racial justice that, ironically, made it possible for women in Durham to create WIA. Had it not been for the achievements of the black freedom movement of the 1950s and 1960s, no black woman in Durham, even one as prominent and "respectable" as Mrs. Elna Spaulding, could have united women in an organization in which power and leadership were shared equally between blacks and whites. At the same time, the freedom movement also rendered the politics of respectability obsolete. What may have had liberatory possibilities within the severe constraints of southern Jim Crow society served to reinforce class divisions among black women once segregation had been abolished and, even more importantly, once low-income blacks had their own organizational base separate from middle-class women.

In the end, Women-in-Action, not United Organizations, survived. Both groups struggled to address the complex web of poverty and racism that continues to plague our society. Whatever their limitations and failures, perhaps the more remarkable story is that despite such odds they succeeded at all. Still, survival does not in itself define accomplishment. However laudable their ability to sustain interracial friendships may have been, WIA members also privatized the struggle for racial and economic justice, substituting personal relationships for substantive change in the larger society.[83] Similarly, WIA's insistence on neutrality served not only to insulate the organization from the racial conflicts taking place throughout the city, especially those centered around United Organizations, but also to mask potential divisions among WIA members.[84]

Whatever racial differences may have divided black and white middle-class women, WIA provided an arena in which their shared class values could be acknowledged and cemented. But this interracial class-based alliance also reinforced class divisions among black women. Once desegregation began to erode the bonds of racial solidarity between poor and more affluent African Americans, new economic, political, and even social alliances between middle-class whites and blacks were possible. Middle-class and elite black WIA members may well have had more in common with white WIA members than they did with United Organizations women. If

segregation helped to mute class divisions among blacks, desegregation served to highlight them. And WIA, whatever its intentions, did the same.

In the 1940s, Julia Lucas had witnessed the limitations of interracial sisterhood when white Durham women prayed alongside their African American sisters in annual World Day of Prayer services but quickly retreated across the color line, where they proceeded in their "separate ways." A quarter century later, she observed a similar difficulty as black and white women reached across class boundaries while vowing to remain neutral on matters of the greatest concern to their less fortunate sisters. Women-in-Action may have successfully negotiated the racial divide, but Lucas simply and succinctly summed up the group's greatest shortcoming: "I guess the final answer is, you can't always be neutral on everything."[85] Despite the accomplishments of the African American freedom movement, black and white middle-class women were unable to transcend their separate ways when it came to their treatment of poor women. It was a legacy that haunted not only the capital of the black middle class but also the nation.

Conclusion

Following World War II, African Americans quickly discovered that their country had little intention of allowing them to claim the democratic freedoms they had just defended. In response, black women and men throughout the South launched the most vigorous campaign against racial injustice the nation had ever witnessed. As Durham blacks debated how best to carry out their struggle for freedom, more space was created for both women and youth to participate—sometimes in concert with but often separately from the traditional black male leadership. High school and college students flocked to newly revived NAACP youth chapters in working-class neighborhoods, while African American women drew on a historic tradition of black women's community work—a tradition that was strengthened by the exigencies of the wartime emergency—to transform formal and informal women's networks into vehicles of collective protest. The war spurred the formation of new groups in Durham such as local chapters of the Housewives League and the National Council of Negro Women. Their activities created the links that connected the battles of the 1940s to those of the 1960s. When the Black Solidarity Committee launched a seven-month boycott of Durham's white merchants, it seemed logical that even the male-dominated BSC Executive Committee would include a member of the Housewives League.

African American women may not have held many official leadership titles outside their own organizations, but they frequently were the majority of participants in a wide range of protest and civil rights activities in the late 1950s and the 1960s. After the *Brown* decision, black women's organizational base, especially in working-class neighborhoods, proved indispensable to NAACP legal campaigns against school segregation; their participation suggests new ways of understanding the relationship between lawsuits and community organizing. Black women were similarly critical players in local efforts to dismantle legal segregation in public facilities, expand employment opportunities, and combat the difficult problems of urban poverty.

White organized women, too, became caught up in the grip of the new

black insurgency as they struggled to respond. Following the erosion of popular front politics in the region, mainstream women's organizations braved the chill of Cold War anticommunism and a pervasive antireform atmosphere and responded to black women's insistence that they live up to their democratic principles. Some white, middle-class women's groups were spurred by black women's organizations, by the remnants of white southern radicalism, and by religious convictions to cautiously, at times, and courageously, at other times, challenge white supremacy. By the mid-1950s, African American women had prodded white women toward adopting more racially inclusive policies in organizations such as the YWCA, the League of Women Voters, and the American Association of University Women; another predominantly white group, the Women's International League for Peace and Freedom, even boasted a biracial leadership. In these ways, some black and white women forged an uneasy alliance, keeping alive a vision of racial integration in the South during the postwar years. Perhaps it is no wonder, then, that some of these liberal women's organizations joined the handful of southern whites who publicly supported the *Brown* decision. Consideration of women's activities in the 1940s and 1950s, therefore, sheds new light on postwar southern liberalism and anticommunism in the South.

When direct action protests emerged in 1960, black middle-class women in particular, and adult women generally, often seemed out of place in a movement that drew its greatest support from the sons and daughters of the African American working and lower middle classes. As a result, most adult women either remained aloof or found indirect ways to support the new youthful militancy. A number of black, middle-class women, however, provided invaluable assistance to the burgeoning racial justice struggle, while adult black churchwomen of all classes were some of the most consistent supporters of the new insurgency. And although the Durham movement adopted the philosophical and strategic tenets of nonviolent civil disobedience, some activists quietly accepted armed self-defense as a necessary complement to nonviolence, thus collapsing the artificial barrier between seemingly opposed strategies.

Once Durham blacks toppled segregation in public facilities in 1963, class divisions within the African American community—always a sore spot in the capital of the black middle class—became even more pronounced. These class tensions were frequently gendered. By the mid-1960s, largely as a result of the success of local War on Poverty campaigns, poor African American women were among the best-organized members of the black community. Because of their mass base, they were able to set the tone and the agenda of

black protest. Militant, low-income African American women, especially in United Organizations for Community Improvement, challenged not only the middle-class male leadership of the freedom movement, and middle-class black and white women reformers, but Durham's white power structure as well. Poor black women formed the foundation of the Black Solidarity Committee, a Black Power–oriented, cross-class alliance that waged an economic boycott of white merchants in 1968–69, the city's longest mass-based protest.

As advocates of a hypermasculinized Black Power ideology captured local and national headlines and sent fearful whites into a near panic, low-income black women continued to rally behind the Black Power banner. Yet the largely female United Organizations insisted on drawing distinctions between militancy (an uncompromising, mass-based confrontational politics demanding racial and economic justice), which it embraced wholeheartedly, and violence, which it mostly, though not entirely, denounced. Despite their support for avowedly Black Power projects such as the Malcolm X Liberation University, black women were not averse to working jointly with low-income whites. Women's activism reminds us that such strategies as black separatism and biracial coalition building were not mutually exclusive, again underlining the need to rethink traditional interpretations of the civil rights movement.

Looking across the color line—with a mixture of resentment and admiration—at the successful organizing campaigns in low-income black communities, poor whites, too, pressed demands on a power structure that had ignored their needs almost as consistently as it had those of their African American counterparts. Drawing on low-income women's informal neighborhood and kin networks, white organizers in Durham formed a new organization, ACT, that was modeled after United Organizations. Yet ACT found itself enmeshed in its own web of contradictions: low-income whites, reluctant to discard white supremacy, initially defined overt protest as "black" and therefore outside the range of acceptable behavior, and the largely white, middle-class, male leadership of ACT underutilized one of its most valuable indigenous resources—community women's networks. Thus, white activists missed an opportunity to build a more durable, mass-based community organization. But historical timing was every bit as critical as the limitations of organizers and neighborhood residents. Caught in the political and ideological cross fire of the late 1960s and early 1970s, both locally and nationally, white activists could scarcely have chosen a less opportune time to build an interracial movement of the poor. On the other hand, the story of ACT is not simply one of unmitigated failure. Despite the organization's in-

ability to achieve its goal of forming an interracial poor people's movement, ACT achieved some remarkable successes, and some of its most impressive efforts were interracial projects spearheaded by black and white low-income women.

Yet in the end, decisions by white power brokers—whether to shut down the recently desegregated Edgemont Elementary School or to revamp neighborhood zoning regulations, forcing the closure of the Edgemont health clinic—contributed to Edgemont's decline and closed off opportunities for biracial neighborhood alliances between low-income whites and blacks. There were no guarantees, of course, that even the most successful of these experiments could have diminished the allure of white supremacy for poor whites. But the ability of ACT and United Organizations to forge even fragile alliances offers an intriguing possibility of what might have been and moves us beyond simplistic critiques of white racism that locate its source in individual psyches rather than in institutional arrangements that primarily benefited not low-income whites but the more affluent.

As the 1960s drew to a close, middle-class black and white women sought to find a way out of the increasingly polarized racial tensions of these years by reasserting older traditions of women's voluntarism and creating a new biracial women's organization, Women-in-Action for the Prevention of Violence and Its Causes. Significantly, most of the white WIA members came from mainstream women's organizations that black women had forced to integrate in the 1950s, and many had belonged to the handful of white groups that publicly endorsed the *Brown* decision. Like the Black Solidarity Committee, WIA took its cues from a protest movement that was shaped by the organized presence of low-income African American women, and it similarly adopted the agenda formulated by United Organizations. WIA's response to low-income black women was a striking reversal of the historic class-inflected relationship between more affluent African American women reformers and their less fortunate sisters whom they sought to "uplift." The influence of poor women on WIA also challenged the noblesse oblige sensibilities of white women reformers who extended a helping hand to the destitute of both races. However, rather than deploying their class-based privileges to mitigate the conditions facing low-income, mostly black women, WIA members fostered interracial friendships among middle-class women. Ultimately unsuccessful at creating a cross-class, interracial sisterhood, WIA retreated behind a politics of respectability and neutrality, settling for an easier (though no less remarkable) class-based, interracial women's alliance. However, in the one notable instance in which it abandoned its insistence on

neutrality—over school desegregation—WIA made a difference on an issue of paramount importance. Although WIA helped ease the city through the final phases of court-ordered school desegregation, helping it to avoid the violence and racial polarization that plagued other cities, it could do little to halt white flight or the eventual resegregation of Durham schools.

By the end of the 1960s, Durham's black freedom movement found itself in disarray. But more than simply internal ideological divisions can explain the movement's demise. White power brokers, locally and nationally, had become increasingly uneasy with the growing militancy of blacks in Durham and across the state, a militancy grounded in the successful grassroots organization of low-income African American women. Emboldened by the conservative presidency of Richard Nixon, government officials launched an all-out assault on black community organizers in Durham and throughout North Carolina. Thus, United Organizations lost funding and faded away due in part to federal regulations that prevented even private foundations from supporting grassroots organizing projects that empowered low-income blacks. Indeed, Congress pointed to black community organizing in North Carolina as justification for enacting restrictive legislation such as the 1969 Tax Reform Act. And so, much as WIA had revived older traditions of women's voluntarism, low-income African American women in Durham reasserted their own traditions of black women's community work and carried on as best they could—though without a formal, organized base—trying to meet the needs of their families and neighbors.

Clearly, African American women were central to the postwar black freedom struggle in Durham and throughout the South. But it is not simply that "women were there too." By centering women's activities in our field of vision, we gain a sharper picture of how the freedom movement emerged, how it operated, and how it was sustained. At the very least, this history suggests a more complex narrative about the "civil rights movement"—the phrase itself distorts the much broader struggle blacks waged—than the one most Americans, regardless of race, have harbored.

First and foremost, women's participation forces a reconsideration of the terms and definitions of protest and leadership. The emphasis on formal and public leadership and on the more dramatic moments of the civil rights struggle—the sit-ins, the mass demonstrations, marches and pickets captured in sound bites and media blitzes—has diverted attention from the work that made such moments possible, organizing work that drew on women's networks that in turn were deeply embedded in local communities. Less dramatic perhaps than the media portrayals that have consumed the popular

imagination and most scholarship as well, black insurgency relied upon personal relationships and alliances forged in families, neighborhoods, bridge clubs, juke joints, and beauty parlors as well as in more formal institutions like black churches, civic organizations, and the NAACP. The post–World War II civil rights movement was part of the centuries-long struggle for black freedom, but it also drew upon a historic tradition of black women's community work, a tradition that was critically shaped and transformed by women's experiences during World War II.

The inclusion of women, especially poor black women, in the history of black insurgency also challenges essentialized notions of racial solidarity, focusing greater attention on the class and gender fault lines within African American protest movements. Race was not automatically the unifying force that many observers have assumed. Nor did the middle classes or black male leaders always set the agenda and direction of the movement. Rather, the "leaders" often followed the masses. An examination of the strategies and tactics utilized by less affluent women offers a clearer picture of how black communities were able to mount effective challenges to segregation and racial injustice. Mass demonstrations, economic boycotts, and even legal campaigns could not succeed without the grassroots support of black, frequently working-class, women. Even seemingly isolated and individualized acts of defiance such as Joyce Thorpe's showdown with the county sheriff were linked to broader, collective, and more formalized modes of protest.

Placing women, particularly African American women, at the center of inquiry also demands rethinking the evolution of the movement, whether we are considering the impact of Cold War politics and anticommunism on interracial democracy in the South or assessing the meaning of Black Power. Notwithstanding the virulence of white supremacy, black and white women sometimes forged fragile alliances both during the anticommunist fervor of the postwar years and in the heightened Black Power era of the late 1960s. Indeed, Black Power and racial integration, frequently defined as mutually exclusive, sometimes coexisted simultaneously even within the same organizations and individuals; so did white racism and interracial cooperation. In short, only by shifting our angle of vision to focus on women can we begin to paint a more expansive and inclusive portrait of the post–World War II African American freedom struggle—the most profound, if still unfinished, social change movement of twentieth-century America.

Epilogue

"Here is a young Black woman locked in jail, sexually assaulted . . . [and] charged with first degree murder, simply because she protected herself from being raped by a white barbarian," thundered the Reverend Ralph Abernathy. Heir to the slain Martin Luther King Jr.'s Southern Christian Leadership Conference, the nationally renowned minister exhorted the crowd gathered outside the Beaufort County Courthouse in eastern North Carolina. The 2,000 protesters he addressed represented just a handful of the hundreds of thousands who denounced the trial of Joan Little, a twenty-year-old black woman from Washington, North Carolina, who was accused of killing her white jailer after he sexually attacked her in 1974. If convicted, the young woman faced a mandatory death penalty.[1] Nearly a quarter of a century after Ersalene Williams's attempted rape by a white Durham man had aroused little notice, Joan Little's case had become a national and even international cause célèbre. In another sign of the changes that had come to North Carolina, Karen Galloway, one of the first African American women to graduate from Duke law school, successfully served as Little's cocounsel. Despite these advances, certain similarities remained between the two cases. Not only did both involve racialized sexual violence, but, behind the scenes in both cases, organized black women rallied to the defense of an impoverished black woman.

Indeed, as national civil rights leaders and feminists vied for control over Joan Little's symbolic image, local black women—often unrecognized and largely out of the limelight—set about doing what needed to be done. Just as the Durham chapter of Sojourners for Truth and Justice had rallied behind Ersalene Williams, Mrs. Christine Strudwick, a stalwart of Durham's black, working-class East End neighborhood, helped to initiate a meeting between Little's attorneys and black churchwomen at the Union Baptist Church. It was the same church where local youth had organized pickets against Durham's racially segregated Royal Ice Cream Parlor in the 1950s and 1960s. At the meeting, Strudwick, who had also helped organize the 1963 East End Elementary School boycott, joined with African American women throughout

the state to form Concerned Women for Justice and Fairness to Joan Little, becoming vice president of the group. Later changing its name to Concerned Women for Justice, the organization remained active in prison reform and became an early critic of what would later be termed the "prison industrial complex." CWJ is still in existence and has become a focal point for black community opposition to toxic waste dumping in Warren County, fifty miles north of Durham, where the campaign was joined by former Durham activists Floyd McKissick and his daughter Joycelyn. Still poor, predominantly black, and rural, Warren County faces many of the same problems it did more than half a century ago when Julia Lucas left and made her way to Durham, where she soon became part of the new black freedom movement. Now, however, a mother-daughter team—Dollie Burwell, a former civil rights activist, and her daughter, Kim—fight to ensure that the needs of the county's black citizens are addressed. Their efforts helped to elect Eva Clayton, the first black woman and one of two African Americans from North Carolina to enter Congress since Reconstruction.[2]

As these examples suggest, the spirit and determination of the postwar black freedom movement persevere. On the one hand, many of the groups that waged the struggle against racial and economic injustice—including United Organizations, the Black Solidarity Committee, ACT, and even middle-class women's organizations, among them the Durham AAUW and the YWCA (both the central Y and the Harriet Tubman branch)—have long since faded and disappeared. The racial divide and widespread economic dislocations still plague both Durham and the nation and seem more intractable than ever. Drug trafficking and gang violence tear at the fabric of once-stable working-class black neighborhoods such as Walltown, though residents charge that the media exaggerates and sensationalizes the extent of crime in their communities. And the steady growth of a mostly impoverished Latino population in the last decade has transformed Durham's biracial conflicts into multiracial battles.

Despite these problems, the legacy of the postwar freedom fighters remains, as do some of the organizations they started. Although the UDI cooperative supermarket closed its doors in 1976, its parent organization and one of United Organizations' accomplishments, United Durham, Incorporated, still exists. The achievements of the ordinary women and men who strove to break Durham's racial caste system in the three decades after World War II laid the foundation for a multiracial progressive coalition, and, while relations are far from smooth, the coalition can also boast some impressive achievements. The Durham Voter's Alliance (which recently disbanded) and

People's Alliance, predominantly white progressive/liberal organizations, frequently joined hands with the Durham Committee on the Affairs of Black People (the former Durham Committee on Negro Affairs, still referred to as the "Durham Committee"). During the 1970s, they helped to elect Elna Spaulding to the Durham County Board of Commissioners, where she served for ten years as the first woman commissioner; her husband, Asa, was the first black county commissioner. The same coalition helped Mickey Michaux become the first black legislator to represent Durham in the state House in 1972, and in the 1980s it was also instrumental in electing Durham's first black mayor. During the 1980s and 1990s, the city council saw more black faces among its members, including the election of Floyd McKissick Jr., and as the new century progresses that trend has continued. In 2004, Durham again boasts an African American mayor, and the same interracial progressive alliance recently pushed through a living wage ordinance.

In the 1990s, more than twenty years after the Bull City desegregated its public schools, prompting middle-class flight to county schools, Durham voters approved the merger of the county and city school systems. Although foes of the merger brought lawsuits, hoping to block its implementation, and Durham schools, like public schools across the country, face mounting budgetary problems and pressures to raise student test scores, the public school system in Durham promised to become more racially balanced and more economically diverse than ever before. After Durham High School desegregated, white flight led to an entirely black student population; but in the 1990s, it reorganized and is now a racially mixed magnet school for the arts. Recent trends, however, indicate a declining white population in the city and especially in the public schools. Hillside High School, the historically black school, desegregated in the 1970s, but in 2004 its student population was entirely black and Latino/Latina.

Newer organizations in the city carry on the work of the postwar freedom movement. The Institute for Southern Studies, Southerners for Economic Justice, Carolina Fair Share, and Grassroots Leadership are headquartered in Durham. (Grassroots Leadership recently relocated but remains in the South.) Each is part of the ongoing struggle for economic and racial justice in the South. Moreover, southern women have played key roles in each of these groups—Southerners for Economic Justice, founded by civil rights activist Leah Wise, was later headed by Cynthia Brown, an African American woman from North Carolina who won election to the city council in the 1990s. Temma Okun, the daughter of former Women's International League for Peace and Freedom member and longtime white activist Beth Okun, worked

with Grassroots Leadership and the Institute for Southern Studies; she headed up the Durham campaign for Harvey Gantt, the former black mayor of Charlotte, who challenged Jesse Helms for his Senate seat in the 1990s. Several years ago, a new multiracial coalition formed in Durham: Congregations, Associations, and Neighborhoods (CAN). Affiliated with the Industrial Areas Foundation, CAN has revived some of the concerns and tactics of 1960s groups such as United Organizations for Community Improvement and ACT; starting with small, winnable issues, CAN hopes to build a citywide movement. Most recently, CAN helped push through Durham's living wage ordinance and saved threatened day care and after school programs for 700 children.

Some of the major players of the postwar black freedom movement have moved on, particularly the middle-class men. Howard Fuller returned to Milwaukee and is currently in Marquette, still working with black communities and schools. He visits Durham periodically to participate in black youth development and leadership workshops at the Hayti Heritage Center. Charsie Hedgepath left Durham to join the staff of Maynard Jackson, who became Atlanta's first black mayor in 1973. Howard Clement became a Republican in 1984 and secured a seat on the city council, where he still sits, defying easy political categorization. Ben Ruffin was appointed to the Durham Housing Authority board in 1974 and became chair in 1981; currently, he is an executive at the R. J. Reynolds Tobacco Company in Winston-Salem. Before he passed on in 1991, Floyd McKissick secured a federal Housing and Urban Development loan for Soul City, a commercial and residential development in Warren County, and Evelyn became a county Republican Party official. While largely unsuccessful, Soul City boasts a housing development complete with a senior citizen section and a clinic still in operation. Others, too, have passed on, among them Julia Lucas, Louis Austin, Mary Price, Bessie McLaurin, Charlotte Sloan, Pat Rogers, and Bascie Hicks.

Although the black elite and professional classes continue to dominate the Durham Committee, that control is neither monolithic nor uncontested, and women have become more prominent. Ken Spaulding, the son of Elna and Asa Spaulding, took its helm in the 1990s, but North Carolina Central University professor and Durham Committee leader Lavonia Allison has become one of the most visible and outspoken black leaders in the city. The organization may still wield considerable electoral weight, but it cannot count on the same kind of unquestioning allegiance from the black community as it once did. During the 1990s, in a referendum on a bond issue, Callina Smith, former welfare rights activist and organizer in Durham's East End neighbor-

hood, helped to mobilize the low-income black community to defeat a bond issue that the Durham Committee had supported. More troubling for the Durham Committee is the fact that few of the candidates it endorsed in recent elections were successful.

Many former activists, like Christine Strudwick, have continued the work they began more than four decades ago. Callina Smith lent her energies to a neighborhood reclamation project, and in the 1980s a new low-income condominium, Callina Smith Place, was named in her honor. Pat Rogers became an officer of the National Tenants Organization and, despite serious health problems, took a job at the local homeless shelter in the 1990s. Beth Maxwell brought her considerable organizing skills and experience with the YWCA and WIA to the Durham Volunteers Bureau. Ann Atwater, who went on medical disability leave from the Housing Authority in the 1990s, still is called upon by low-income residents as the person to turn to when help is needed for any number of crises, and she regularly attends Durham Committee meetings, speaking out for the needs of Durham's dispossessed. In 2004, the Durham NAACP honored Ann Atwater for her years of dedicated service. Former ACT organizer Tami Hultman joined Durham-based Africa News, an organization established by Hultman's former Duke roommate, Bertie Howard, one of the founders of the Malcolm X Liberation University. Vivian McCoy, currently employed at Duke Medical Center, organized a two-day reunion/conference of Durham civil rights activists in 1995. Cora Cole-McFadden served for a number of years as the chair of the Durham Commission on Women and later became director of affirmative action for the city of Durham. Today she sits on the city council and is mayor pro tem. The list goes on.

Many of these women attribute their current work to their experiences in the 1960s protest movement and to the skills they acquired during those years. African American activists in particular embrace the tradition of passing on to the next generation a historic legacy of black self-assertion and collective protest. Perhaps it is no accident that both Christine Strudwick and Pat Rogers mentored the young attorney Karen Bethea-Shields (formerly Karen Galloway), who successfully defended Joan Little in 1975. During the 1970s, Bethea-Shields worked with Pat Rogers to develop grievance procedures for Durham tenants in disputes with landlords. Today, Bethea-Shields still represents Durham's indigent black population, especially youth in trouble.

Several years before she died, Pat Rogers reflected on her community work with Durham's poor. "I got to reach back and get some of that Howard Fuller training and help them to develop a system, [so] that if I drop dead today or tomorrow they will have . . . an organization in front of them [that] will al-

low them to continue the work that we started. . . . I can hear him [Howard Fuller] as if he's here today, reminding me, . . . always involve other people." Pat Rogers is gone, and there has been no revival of a community-based UOCI. But Rogers's spirit and determination live on in women like Karen Bethea-Shields, as the centuries-long struggle for back freedom continues.

Notes

Abbreviations

AAUW Papers	American Association of University Women Papers (Durham Chapter), Special Collections, Perkins Library, Duke University, Durham, N.C.
Boyte Papers	Boyte Family Papers, Harry C. Boyte Series, Special Collections, Perkins Library, Duke University, Durham, N.C.
CT	*Carolina Times*
DMH	*Durham Morning Herald*
DOHC	Duke University Oral History Program Collection, Special Collections, Perkins Library, Duke University, Durham, N.C.
DU	Special Collections, Perkins Library, Duke University, Durham, N.C.
Duke YWCA Papers	Young Women's Christian Association Papers (Duke Woman's College), University Archives, Perkins Library, Duke University, Durham, N.C.
Durham YWCA Papers	Young Women's Christian Association Papers (Durham central Y and Harriet Tubman branch), Special Collections, Perkins Library, Duke University, Durham, N.C.
KA Papers	Kelly Alexander Papers, Special Collections, Atkins Library, University of North Carolina, Charlotte, N.C.
LWV Papers	League of Women Voters Papers (Durham Chapter), Special Collections, Perkins Library, Duke University, Durham, N.C.
NAACP Papers	National Association for the Advancement of Colored People Papers, Manuscript Division, Library of Congress, Washington, D.C.
Natl. YWCA Papers	Young Women's Christian Association Papers (microfilm), National Board Archives, New York, N.Y.
NC Coll.	North Carolina Collection, Wilson Library, University of North Carolina, Chapel Hill, N.C.
NCCU	North Carolina Central University
NCF Papers	North Carolina Fund Papers, Southern Historical Collection, Wilson Library, University of North Carolina, Chapel Hill, N.C.
NWC	Nathan B. White Collection (audio tapes), Southern Historical Collection, Wilson Library, University of North Carolina, Chapel Hill, N.C.
SCHW Papers	Southern Conference for Human Welfare Papers, Robert W. Woodruff Library Archives, Atlanta University, Atlanta, Ga.

SHC	Southern Historical Collection, Wilson Library, University of North Carolina, Chapel Hill, N.C.
SOHC	Southern Oral History Program Collection, Southern Historical Collection, Wilson Library, University of North Carolina, Chapel Hill, N.C.
TWIU Papers	Tobacco Workers International Union Papers, Special Collections Division, Hornbake Library, University of Maryland, College Park, Md.
UPA NAACP Papers	University Publications of America, National Association for the Advancement of Colored People Papers (microfilm), Bethesda, Md.
WIA Papers	Women-in-Action for the Prevention of Violence and Its Causes Papers, Special Collections, Perkins Library, Duke University, Durham, N.C.
WILPF Papers	Women's International League for Peace and Freedom Papers (Durham–Chapel Hill Chapter), Special Collections, Perkins Library, Duke University, Durham, N.C.

Introduction

1. Boyd, *Story of Durham*, 27, 51, 58–75, 80–96, 167–73; Janiewski, *Sisterhood Denied*, 55–61.
2. Frazier, "Durham."
3. NCC was established in 1925; it grew out of a religious training school started in 1910. Boyd, *Story of Durham*, 294–95; Weare, *Black Business*, 225.
4. Crow, Escott, and Hatley, *African Americans*, 127–28; Lucas, interview; Weare, *Black Business*, 191–94.
5. Lucas, interview; Leslie Brown, "Common Spaces, Separate Lives," 304. Historian Glenda Gilmore has argued that black women in North Carolina, particularly middle-class black women, assumed the role of "diplomats" to the white community following the disfranchisement of black men at the turn of the century. In Durham, however, the pattern was different. There, a black male business elite negotiated behind the scenes with white officials. However, black business leaders occupied a precarious position as they attempted to mediate between the demands of the black masses and white power brokers. Moreover, black men's dominance did not preclude black women's community work, which has enjoyed a long legacy. *Gender and Jim Crow*, 172. For a somewhat different view that challenges Gilmore and other scholars, see Elsa Barkley Brown, "Negotiating and Transforming," 62–63.
6. Lucas, interview.
7. Quoted in Anne Braden, "Durham's ACT: A Voice of the Southern Poor," *Southern Patriot*, March 1969, 3; *Action*, 13–27 April, 27 May–15 June 1970.
8. Atwater, interview; Terkel, *Race*, 282–83; *CT*, 23 December 1967; Wallace, "How to Get Out of Hell," NCF Papers. The NCF Papers were unprocessed when I consulted them, which accounts for the inconsistencies in my citations to them.

9. Lee Ridenour to Elna Spaulding, 11 October 1968, box 1, WIA Papers.
10. Braden, "Durham's ACT"; Boyte, "History of ACT"; *Action*, 30 June–13 July 1970.
11. Davidson, *Best of Enemies*, 232–33; Ellis, "Why I Quit the Klan."
12. *CT*, 9 December 1950.
13. Raines, *My Soul Is Rested*, 241.
14. Payne, *Light of Freedom*, 266, 425. For a discussion of civil rights movement scholarship, see Steven F. Lawson, "Freedom Then, Freedom Now."
15. There are only two book-length, published treatments of women's participation in the black freedom movement, and neither is by a historian: Belinda Robnett's *How Long? How Long?* and Lynne Olson's *Freedom's Daughters*. Robnett's book utilizes the traditional civil rights periodization of 1954–65 without fully tracing the earlier roots of the movement. Both Olson and Robnett focus largely on national leaders rather than on the local level, where the movement crystallized. Although Robnett calls local women "indigenous bridge leaders," she devotes little attention to their activities, and she gives scant attention to poor women even in the Montgomery bus boycott, where their participation was critical. Important edited collections on women's participation in the black freedom struggle include Collier-Thomas and Franklin, *Sisters in the Struggle*; Ling and Monteith, *Gender in the Civil Rights Movement*; and Crawford, Rouse, and Woods, *Women in the Civil Rights Movement*. See also Barnett, "Invisible Black Women Leaders"; Feldstein, "Death of Emmett Till"; and Nasstrom, "Down to Now." Most of the material on women in the movement remains biographical. See, for example, Ransby, *Ella Baker*; Lee, *For Freedom's Sake*; Grant, *Ella Baker*; Mills, *This Little Light*; Payne, "Ella Baker"; Fleming, *Soon We Will Not Cry*; Daisy Bates, *Long Shadow*; Elaine Brown, *Taste of Power*; Angela Davis, *Angela Davis*; Clark, *Echo in My Soul* and *Ready from Within*; Moody, *Coming of Age*; Murray, *Song in a Weary Throat*; Shakur, *Assata*; Robinson, *Montgomery Bus Boycott*; Pitre, *Struggle against Jim Crow*; and Brinkley, *Rosa Parks*.

Chapter One

1. Because southern whites often insisted on addressing blacks only by their first names, courtesy titles became a source of racial contestation. Therefore, although I concur with women's historians' objection to identifying women by their marital status, I have chosen to use "Mrs." and "Miss" when blacks use these titles.
2. *CT*, 12 July 1952.
3. The outcome of the case remains uncertain. The men had every reason to believe that the courts would treat Clark leniently, for North Carolina had a history of meting out racially discriminatory sentences, especially for rape. Ibid. and *CT*, 25 November 1950.
4. Historian Elsa Barkley Brown argues that attention to lynching has obscured the history of violence against black women. Little work on this issue appears in scholarship on the civil rights movement. McGuire, "Black Womanhood, White Violence"; Elsa Barkley Brown, "Negotiating and Transforming," 52–54, 56.

5. CT, 19 July 1952. Sojourners for Truth and Justice, a left-leaning black women's organization, was established in 1951. Its founders were nationally prominent radical black women, many of whom had been associated with the Civil Rights Congress, including California newspaper editor and Progressive Party vice presidential candidate Charlotta Bass, writer Alice Childress, Eslanda Robeson, Shirley Graham DuBois, and Louise Thompson (wife of Civil Rights Congress head William Patterson). The group also included the wives of several victims of lynching and political prisoners. The organization was one of the last remnants of the black radical thrust that was squelched by anticommunist forces during the Cold War. Horne, *Communist Front*, 204–12; Weigand, *Red Feminism*, 188–89.
6. Sojourners for Truth and Justice supported a number of the high-profile civil liberties cases that arose in the South in the postwar years (a theme that will be pursued more extensively in chapter 2), including the 1947 Rosa Lee Ingram case. Like the Williams case, the Ingram case was marked by similar elements of race, sex, and violence. Shapiro, *White Violence*, 360–62; Lerner, *Black Women*, 190–93; Martin, "Rosa Lee Ingram Case."
7. CT, 14 November 1950.
8. Adam Fairclough concurs with scholars such as Harvard Sitkoff who claim that Depression-era militancy declined during the war, but he argues that investigations of local situations over time, particularly of the NAACP, have uncovered "a long and continuous history of Black organization and protest in many cities, towns and counties." My research on Durham confirms Fairclough's observations that many of the same people were active in the 1940s and the 1960s and that membership in the NAACP frequently constituted a lifetime commitment. Sitkoff, "African American Militancy," 92; Fairclough, "Civil Rights Movement," 21.
9. Richard M. Dalfiume, influenced by Charles Johnson's wartime survey of racial tensions, was one of the first historians to point to World War II as the beginning of the modern civil rights movement. Harvard Sitkoff, drawing on the earlier work of August Meier and Elliott Rudwick, has revived the debate regarding the impact of the war on black protest, claiming that the movement had its origins in the greater militancy of the Depression. However, Sitkoff neglects the role of women and focuses largely on the black press, which, while hardly monolithic, often expressed the most conservative views of the black leadership. Dalfiume, "Forgotten Years"; Charles Johnson, *To Stem This Tide*; Sitkoff, "African American Militancy" and "Racial Militancy"; Meier and Rudwick, "Nonviolent Direct Action"; Wynn, "Second World War" and *Afro-American*; Finkle, *Forum for Protest*; Washburn, *Question of Sedition*. More recent works that point to the influence of World War II on the modern protest movement include Payne, *Light of Freedom*; Dittmer, *Local People*; and Tyson, *Radio Free Dixie*.
10. Frazier, "Durham." While class is a fluid and often imprecise demarcation, its meaning takes on added complexity when discussing African Americans. Class designations do not refer simply to black income or even education levels, but often converge with "status," which can be derived from community work, church affiliations, and other factors not normally associated with class. For a

useful discussion of class and status within African American communities, see Landry, *New Black Middle Class*. For work that also includes the importance of gender, see Harley, "For the Good of Family" and "When Your Work Is Not Who You Are"; Higginbotham, *Righteous Discontent*; Shaw, *What a Woman Ought to Be*; and Leslie Brown, "Common Spaces, Separate Lives."

11. Sitkoff claims that this remained the preferred strategy within the South's bi-racial system until 1950, but in Durham there was wide disagreement within the black community regarding this approach. "African American Militancy," 79, 86–87; Weare, *Black Business*.

12. For example, in 1937, after Joe Louis's championship boxing victory, Durham blacks poured into the streets to celebrate and began throwing stones and insults at white passersby. C. C. Spaulding, one of the founders of the Mutual and a key leader among the black male business elite, quickly mounted a running board and rode through the black community beseeching residents to return to their homes. His success that evening in averting a race riot was not inconsequential in his future negotiations with white power brokers. Weare, "Charles Clinton Spaulding," 178, 188.

13. There is a wide-ranging literature on black women's community work, but most of it focuses either on the nineteenth and early twentieth centuries or on the period after the 1960s. For overviews of this literature that stress the long history of black women's community work, see Shaw, "Black Club Women" and *What a Woman Ought to Be*, and Deborah Gray White, *Too Heavy a Load*.

14. I am drawing here on Aldon Morris's notion of "movement centers," Patricia Hill Collins's articulation of black women's "safe spaces," and Sara Evans and Harry Boyte's conception of "free spaces." Morris, *Civil Rights Movement*, 40; Collins, *Black Feminist Thought*, 95–96; Evans and Boyte, *Free Spaces*, 17–18. See also Evans, "Women's History."

15. In *Abiding Courage*, historian Gretchen Lemke-Santangelo documents how black migrant women recreated communities in the California Bay Area during World War II and argues that the institutions and networks they established provided a basis for later protest activities.

16. Although most of these local organizations (with the exception of the Harriet Tubman YWCA) lack archival collections, the CT's society page carried news of black women's organizations and frequently included names of members, indicating the existence of overlapping memberships among a wide range of groups.

17. Black churchwomen and the freedom movement will be discussed in greater detail in chapter 3. Although historian Beverly Jones does not pursue the story of women's networks into the civil rights era, the dynamic she observed in "Race, Sex and Class" did carry over into World War II and the postwar years.

18. TWIU Local 194 first formed as a segregated black local in 1934 and within six months claimed nearly 3,000 members, becoming Durham's largest local. Another smaller black local, Local 208, broke off from Local 194 the same year with 800 members in the manufacturing division. Membership quickly declined, however, due largely to national officials' refusal to send an African American organizer despite repeated requests by black tobacco workers. In 1938, men occu-

pied the presidency and vice presidency of Local 194, with the remaining four offices held by women, but by 1943 men held all the leadership positions except secretary and recording secretary, or four out of six. Between 1948 and 1950, when the stemmery closed at Durham's Liggett and Meyers plant, massive lay-offs culminated in the loss of 1,800 black jobs. In addition, white workers replaced black tobacco workers who had more experience and seniority. The union survived due largely to a core group of committed unionists, including Daisy Jones, but by 1954 union membership had dropped to about 500. Haywood Williams to George Benjamin, 25 July 1948; R. J. Petree to Williams, 29 July 1948; Williams to John O'Hare, 4 June 1954, all in box 21; "Early History of Local 208," box 29, all in series 3, TWIU Papers.

19. Daisy R. Jones to Mr. Evans, 19 March 1940; Jones to Gentlemen, 15 October 1940; Jones to R. J. Petree, 21 December 1940; National TWIU president-secretary-treasurer to Jones, 26 March, 16 October 1940, all in box 21, series 3, TWIU Papers; Korstad, "Daybreak of Freedom," 136; Janiewski, *Sisterhood Denied*, 163, 165–68; Jones and Egelhoff, *Working in Tobacco*, 40–41, 35–36, 38.

20. CT, 11 December 1937, 19 September 1953; Belle Ingels, Durham YWCA visit report, 2 March 1946, reel 192, Natl. YWCA Papers.

21. "Piccolo" was a black, southern colloquial term for a jukebox, and piccolo houses were a big business in Durham up to World War II. Anderson, *Durham County*, 377.

22. Although NAACP membership lists are incomplete, there appears to have been a slight female majority in Durham's NAACP by 1960. See note below and chapters 2 and 3 for a more extensive discussion. August Meier and John H. Bracey Jr. point to the critical work of black women on the local and national levels in building NAACP branches throughout the country, work that has gone largely unexamined. "NAACP as a Reform Movement," 19–20. William Jones discovered that grassroots organizers, especially rural, poor, and working-class women, built NAACP chapters throughout North Carolina in the 1940s. Although the national office mostly ignored these grassroots supporters in the 1950s, 1960s activists drew heavily upon their networks in Durham and throughout the South. "NAACP."

23. I made this argument in my dissertation in 1996. Belinda Robnett makes a similar point in her 1997 study, but unlike my work, Robnett's book pays little attention to the mass of grassroots, local women. Kathy Nasstrom's study of Atlanta and Laurie Green's work on Memphis suggest that the experience of black women in Durham was typical of black women's experience throughout the urban South. Together, this scholarship challenges historian Glen Eskew's claim that in Birmingham and throughout the urban South men organized and led the black freedom movement. See Christina Greene, "Our Separate Ways," esp. chapter 1; Robnett, *How Long? How Long?*; Nasstrom, "Politics of Historical Memory"; Green, "Battling the Plantation Mentality"; and Eskew, *But for Birmingham* 297, 385. On the leadership debate, see also Payne, "Men Led"; Barnett, "Invisible Black Women Leaders"; Lee, *For Freedom's Sake*; and Ransby, *Ella Baker*.

24. Over the next three years, 250,000 troops were trained at Butner. One repor

estimated that Durham's population increased by about 6,000 to 66,000 during the first two years of the war. The black population remained at about a third of the total. Yancey, *Planning the Future*; James Shiffer, "When the War Came Home," *Raleigh News and Observer*, 7 May 1995.

25. Anderson, *Durham County*, 383–84; Shiffer, "When the War Came Home." North Carolina had more military training bases than any other state during World War II. Butler and Watson, *North Carolina Experience*, 388.

26. *CT*, 2 May 1942; Anderson, *Durham County*, 385.

27. Doris Terry Williams, *Old Hayti*, 2.

28. Bill Phillips, "Piedmont Country Blues," *Southern Exposure* 2, no. 1 (Spring/Summer 1974): 56, 60, quoted in Anderson, *Durham County*, 375.

29. *CT*, 17 October 1942, 19 June 1943; Anderson, *Durham County*, 377; Edwards, "All-Women's Musical Communities," 95–107.

30. Reginald Mitchiner quoted in Anderson, *Durham County*, 386.

31. *CT*, 19 September, 15 August 1942, 16, 23, 30 January, 6 February, 2 May, 12 December 1943.

32. Janiewski, *Sisterhood Denied*, 116.

33. Anderson, *Durham County*, 389; *CT*, 26, 19 December 1942, 9 January 1943.

34. *CT*, 11 April, 2 May, 20 June, 1 August, 26 September, 26 December 1942, 6 February, 2 May, 12 December 1943; Samuel, *Pledging Allegiance*, 196.

35. *CT*, 11 April, 6 June, 26 September 1942. The Double-V campaign was launched by the *Pittsburgh Courier*, a leading African American newspaper, and taken up by the black press nationwide. Finkle, *Forum for Protest*, 110–12, 127–28.

36. For a brief history of the Durham Housewives League, see *CT*, 1 August 1953, 4 September 1954, and Official Program of the 17th National Convention of the National Housewives League of America, Inc., Durham, N.C., 16–20 August 1954, Floyd B. McKissick Papers, SHC. When I first used the McKissick Papers, they were unprocessed and housed at the Hayti Heritage Center in Durham. Currently, they are part of the Southern Historical Collection. On the Jack and Jill Club, see *CT*, 18 October 1952; on the Durham chapter of the National Council of Negro Women, see "The National Council of Negro Women, 1935–1985, Fifty Years," program, 29 June 1985, Durham County Library, Main Branch, Durham, N.C. See also Waynick, Brooks, and Pitts, *North Carolina*, 64.

37. *CT*, 1 August 1953. Although the Housewives League became a national organization at a 1933 meeting of the National Negro Business League in Durham, the Durham branch of the league was started in 1943 by Jacqueline DeShazor Jackson, founder and president of DeShazor Beauty School. In 1953, the Housewives League held its first convention independent of the National Negro Business League. Official Program of the 17th National Convention of the National Housewives League, McKissick Papers, SHC; Hine, "Housewives League of Detroit," 227.

38. Black residents waged a similar campaign in Durham in 1936 in response to the firing of two blacks at a Kroger supermarket to make room for whites. Meier and Rudwick claim that these campaigns were in fact petit bourgeois efforts aimed at expanding black capitalism, not at protesting racial discrimination. Neverthe-

less, individuals often have diverse motives for participating in protest activity. "Nonviolent Direct Action," 317, 323.

39. CT, 8 August, 4 July, 12 September, 27 June 1942.

40. Ibid., 4 July 1941, 28 February 1942, 6 March 1943.

41. In 1938, black teachers in North Carolina earned 25 to 30 percent less than white teachers. Thurgood Marshall claimed that North Carolina teachers had requested the aid of the NAACP, but certain black leaders in the state undermined the salary equalization case. During the 1940s, the state began to increase black salaries to avoid litigation, and by 1945 African American teachers' salaries exceeded those of whites due to the higher qualifications of black teachers. As several historians have noted, the actions of black educators in the Jim Crow era represented neither a capitulation to white supremacy nor simply a survival strategy. Instead, they walked a precarious line, particularly those such as Shepard who worked in state-supported institutions. Their pursuit of improved schools and teachers' salaries, even within the constraints of segregation, helped to weaken the very foundations of that system. Still, in the years after World War II, their methods increasingly came under attack from other blacks. As late as 1947, even after the NAACP had begun to achieve significant legal victories, Shepard still publicly disavowed litigation. Thurgood Marshall to Carolyn Moore, 7 September 1944, part 9, series B, reel 14, UPA NAACP Papers; Anderson, Durham County, 403; CT, 4 July 1941, 6 March 1943, 28 February, 8 August, 4 July, 12, 27 September 1942; CT, 6 August 1949, clipping, box 7, William J. Kennedy Papers, SHC; Tushnet, NAACP's Legal Strategy, 58; Douglas, Reading, Writing, and Race, 18–21; Daisy Lampkin to Walter White, 27 November 1933, part 12, series A, reel 17, UPA NAACP Papers; B. Coward to Charles McLean, 19 March 1955, box C381, part 2, NAACP Papers; CT, 3 April 1948, Clippings File, NC Coll.; CT, 1 April 1950. On the balancing act that black educators in the Jim Crow South endured, see Fairclough, "Black Teachers," and Leroy Davis, Clashing of the Soul.

42. CT, 16 May 1942. The women may have been affiliated with the Southern Negro Youth Congress. At the congress's 1944 conference, female delegates outnumbered males in most states; twenty females and four males represented North Carolina. Southern Negro Youth Congress conference program, 30 November–3 December 1944, box 17, Asa T. Spaulding Papers, DU.

43. Durham's black vote is especially significant when compared with black registration elsewhere: only 38.2 percent of North Carolina's eligible black voters were registered by 1960; in Virginia, 23 percent of eligible blacks were registered (and 46.2 of the white population); and in Mississippi, only 6.2 percent of blacks were registered. Growing black electoral strength enabled the DCNA to provide a swing vote in local elections, although too often this meant endorsing the least objectionable white candidate. According to William Keech, black voting power in Durham, while decisive in winning a number of elections, was not as useful to black advancement as legal challenges and public demonstrations against segregation were. CT, 16 May 1942, 3 May 1950; Cannon, "Black Political Participation," 54; Keech, Impact of Negro Voting, 7, 30–39, 105–9; Minutes of the N.C.

NAACP Political Action Committee, 24 March 1956, box 22, folder 21, KA Papers.

44. CT, 8 July 1939, 1 August 1953, 4 September 1954, 18 October 1952; Smith, interview; Walltown Charitable Community Center, Inc., 12 March 1949, McKissick Papers, SHC.

45. In a fascinating coincidence, Robert Spicely—whose brother, Booker T. Spicely, was stationed at Camp Butner and murdered by a white Durham bus driver two years later—attended this meeting. The Southern Regional Council emerged out of the former Commission on Interracial Cooperation, although unlike the commission it finally was forced to condemn segregation in 1949. Sosna, *Silent South*, 119–20, 163.

46. CT, 21 November 1942, 3 January 1943, 8 August 1942. Perhaps in an effort to influence the proceedings, Austin published the results of a readers' "poll," which showed that most blacks supported efforts to obtain racial equality during the war. Austin's poll does not appear to have been a scientifically conducted survey, but rather a sampling of local opinion. It is unclear whether the editors simply printed responses that were in line with their own thinking.

47. Jacqueline Jones, *Labor of Love*, 237; Odum, *Rumors of Race*, 80.

48. CT, 10 October, 12 September 1942.

49. Between 1950 and 1960, domestic workers in Durham increased from 26 to 36 percent of employed black women. By 1970, the figure had dropped to 16 percent, as black women in Durham joined a nationwide shift of African American women from private household work to institutional service jobs. Black women's nonhousehold service work in Durham increased from 17 percent in 1950 to 33 percent by 1970. CT, 3 July 1943; U.S. Department of Commerce, Bureau of the Census, *Characteristics of the Population*, 1950, table 44; ibid., 1960, table 77; ibid., 1970, table 93; Odum, *Rumors of Race*, 36–37, 73–89.

50. Mebane, *Mary*, 166.

51. Broughton, "John Merrick: Pioneer and Builder," address delivered at the launching of the *John Merrick* at Wilmington, N.C., shipyard, 11 July 1943, box 82, Race Relations folder, J. Melville Broughton Papers, North Carolina Division of Archives and History, Raleigh, N.C. I am thankful to Tim Tyson for sharing this document with me. See also Tyson, "Wars for Democracy," 268–69.

52. CT, 27 February, 17 July 1943; Douglas, *Reading, Writing, and Race*, 20. To Tar Heel blacks, however, the symbolic meaning of the name selection did not simply underscore accommodationist subservience to white authority; within the black community, Merrick was widely reputed to have tipped his hat at whites while calling them sons of bitches under his breath. Clearly, the naming of the *John Merrick* carried profoundly different meanings on either side of the racial divide. For the impact of the Wilmington riot on Durham blacks and Merrick's response, as well as a sophisticated and nuanced analysis of Durham's black "accommodationists," see Leslie Brown, "Common Spaces, Separate Lives," 108–32.

53. Spaulding to Broughton, 29 July 1943, and Shepard to Broughton, 19 June 1944, both in box 82, Race Relations folder, Broughton Papers, North Carolina Divi-

sion of Archives and History; CT, 4 November 1939, 27 August 1949, 14 January 1950. It is important, however, not to make too much of such intraracial differences, especially when they were related to dealings with powerful whites. As historian Walter Weare has observed about Spaulding and Austin, "They functioned as a team, one rocking the boat, the other stabilizing it, their reciprocal actions maintaining movement without upheaval." Similarly, despite Austin's denunciations of Shepard, he also acknowledged the educator's contributions and understood the constraints under which Shepard operated. "Charles Clinton Spaulding," 180.

54. In 1938, a Durham woman brought a suit against the local bus company when a white male passenger demanded that she move farther to the rear. The Durham NAACP failed to take up her case, but when the state court decided in her favor local blacks were elated, though the judge determined only that she had not violated Jim Crow laws, not that segregation was unconstitutional. CT, 21 May, 18 June, 16 July 1938. See also Kelley, "Congested Terrain."

55. Murray, Song in a Weary Throat, 210; CT, 3, 10 April, 12 June 1943; Vann and Jones, Durham's Hayti, 8.

56. Stanley Winborne to Broughton, 17 July 1943, box 82, Race Relations folder, Broughton Papers, North Carolina Division of Archives and History; CT, 20 March 1943. The charge that northerners and "outside agitators" were responsible for racial conflict was one of the ways that white southerners deflected criticisms of segregation.

57. Historians disagree about whether spontaneous actions like Lyon's can be considered protest. See, for example, Fairclough, Race and Democracy, 83, and "Civil Rights Movement," 21; Kelley, "Congested Terrain" and "We Are Not What We Seem."

58. CT, 8, 22 August, 5 September 1942, 13 February 1943; Minutes of the USO Council meeting, Durham, N.C., 19 October, 22 June 1944, U.S. Navy Waves box, Alice Mary Baldwin Papers, University Archives, Perkins Library, Duke University, Durham, N.C.

59. Anderson, Durham County, 386; CT, 26 August 1939, 10, 4, 17 April, 15, 23 May 1943; Cannon, "Black Political Participation," 51–52. Police brutality was one of the principal complaints of African Americans throughout the country, a grievance that was aggravated during the war. Shapiro, White Violence, 339.

60. Terms such as "militant," "protest," "radical," and "conservative" are relational and encompass fluid rather than static meanings. For example, the "radical" demand in 1944 for NAACP participation in the Spicely case would be fairly moderate by the 1960s. The attempt to expand the base of the Durham NAACP and the rejection of the Spaulding-Shepard negotiating style in favor of more direct challenges to segregation, including litigation, were radical departures in the 1940s.

61. Durham Sun, 8 July 1944; Pittsburgh Courier, 22 July 1944; War Department memorandum, Subject: Racial Incident, Shooting of Negro Soldier, Durham, N.C., on 8 July 1944 at about 1940, Franklin Delano Roosevelt Library, Hyde Park, N.Y. (My thanks to Gary Mormino for sharing this document with me.) Potter, Libera-

tors, 120. Because it was operated by a private company, the Durham bus would not have come under federal jurisdiction.

62. Tim Tyson makes this point regarding gender and masculinity in "Wars for Democracy."

63. *Pittsburgh Courier*, 22 July 1944; War Department memorandum, Subject: Racial Incident, Franklin Delano Roosevelt Library, Hyde Park, N.Y.

64. On Spaulding's leadership style, see Weare, "Charles Clinton Spaulding." Sometimes in high-profile cases, citizens hired their own attorney(s) to assist the prosecution. However, it is not clear what role the NAACP hoped to play in the Spicely case.

65. *Durham Sun*, 18 September 1944; DMH, 18 September 1944; *Baltimore Afro-American*, 23 September 1944. See also copy of letter from Spaulding to Robert Spicely, undated; Spicely to Charles Houston, 20 July 1944; Spicely to Hugh Thompson, 28 July 1944; Thurgood Marshall to Thompson, 1 August 1944; C. Jerry Gates to Marshall, 11 August 1944; and Edward R. Dudley to Gates, 5 September 1944, all in part 9, series B, reel 14, UPA NAACP Papers.

66. *Durham Sun*, 10 July 1944; DMH, 10 July 1944.

67. On the Detroit race riot, see Capeci and Wilkerson, *Layered Violence*, and Marilyn S. Johnson, "Gender, Race and Rumours." For a sampling of similar incidents throughout the state, see box 82, Race Relations folder, Broughton Papers, North Carolina Division of Archives and History; part 15, series A, reels 8, 11–13, UPA NAACP Papers; Tyson, "Wars for Democracy"; Sitkoff, "Racial Militancy"; Daniel, "Going among Strangers"; Bruce Nelson, "Organized Labor"; Shapiro, *White Violence*, 301–48; Tyson, "Wars for Democracy"; and Sullivan, *Days of Hope*, 136–37, 14.

68. "Soldier Killing May Lick FDR," *Crisis* 51, no. 8 (August 1944): 249.

69. *Pittsburgh Courier*, 22 July 1944; Austin, interview (my thanks to Tim Tyson for this reference); Leta H. Galpin, Visit report, 17–18 October 1944; Isobel C. Lawson, Visit report, 12–14 December 1944, both in reel 192, Natl. YWCA Papers.

70. *Report of Conference on Race Relations*, 3, 25 (emphasis added).

71. Durham NAACP lists are incomplete, but an examination of existing membership lists, oral histories, and correspondence between local and national NAACP officials supports the contention that women were a majority of NAACP members, especially by the outbreak of direct action protest in 1960. In 1930, the Durham branch was reported "inactive," and throughout the decade individual blacks in Durham contacted the national office for assistance in reviving the branch, starting a youth chapter, or both. Except for a brief resurgence in 1933–34, when the branch attracted 500 new members, these efforts were largely futile. In 1934, Durham women constituted 60 percent of the nearly 200 members; by 1940, membership was down to only about 90 members, with women comprising only 35 percent; and by 1942, it fell even farther. John Bracey cautions that even these lists are misleading, for they often include only new members rather than membership renewals. I found both kinds of lists for Durham. Bracey, telephone conversation and personal correspondence; Report of the Durham Branch of the NAACP, 24 February 1930, 1940, and 1942, box C25, part

2, NAACP Papers; J. N. Mills to Walter White, 11 September 1933, Mills to William Pickens, 21 October 1936; "Dean" to Walter [White] and Roy [Wilkins], 8 December 1936; Charles Black to Thurgood Marshall, 24 February 1938; Daisy Lampkin to Walter [White], 27 November 1933; Miss R. M. Withers to Frederick Morrow, 20 July 1939; Durham Branch membership lists, all in Durham Branch 1919–1930s, part 12, series A, reel 18, UPA NAACP Papers; Gavins, "NAACP in North Carolina," 107; Pearson, interview.

72. CT, 13 June 1942; Edward Dudley to Thurgood Marshall, 10 September 1944, part 9, series B, reel 14, UPA NAACP Papers. Correspondence from the 1930s reveals similar antipathy between the national office and certain black leaders in Durham.

73. Marshall to Carolyn Moore, 7 September 1944, part 9, series B, reel 14, UPA NAACP Papers. On the role of Spaulding and Shepard in sabotaging the Hocutt case, see Tushnet, NAACP's Legal Strategy, 52–53; Weare, Black Business, 227–36, 245; Douglas, Reading, Writing, and Race, 18–19; and Cannon, "Black Political Participation," 24, 39–42.

74. Weare, "Charles Clinton Spaulding," 184–85, and Black Business, 236–39; Cannon, "Black Political Participation," 19; Spaulding to Walter White, 24 October 1933, part 12, series A, reel 18, UPA NAACP Papers; Spaulding, "Let's Understand Each Other," 25 June 1943, Broughton Papers, North Carolina Division of Archives and History.

75. The Durham NAACP had also threatened to oust its leaders in 1933 if the organization failed to support the Hocutt case. Statement of the Durham Branch of the NAACP on Hocutt Case, 20 March 1933, quoted in Cannon, "Black Political Participation," 43–45.

76. Robert Spicely, the brother of the slain soldier, believed that the acquittal of the bus driver helped to reactivate the Durham NAACP; the murder also motivated him to organize a Tuskegee branch of the NAACP in 1944 despite the opposition of a conservative, Washingtonian black elite. Tuskegee, like Durham, witnessed a similar leadership shake-up among local blacks, although historian Robert Norrell contends that there were significant continuities between the "'old school type of Negro'" and the "'Modern' group" that emerged during World War II. Spicely to Marshall, 13 November 1944, part 9, series B, reel 14, UPA NAACP Papers; Norrell, Reaping the Whirlwind, 31–43, 57–58.

77. In 1944, the national NAACP viewed Rencher Harris as one of three black leaders in Durham who was willing to revive the local branch by moving it beyond the sphere of the Mutual. Edward Dudley to Marshall, 10 September 1944, part 9, series B, reel 14, UPA NAACP Papers; R. A. Young to Walter White, 28 September, 9 October 1944, and Young to Ella Baker, 27 December 1944, all in box C135, part 2, NAACP Papers.

78. Arline Young also directed the youth choir at White Rock Baptist Church, probably Durham's most influential black church, and chaired the board of directors of the Harriet Tubman YWCA. However, an officer in the national YWCA office believed that Young's teaching responsibilities in Raleigh diminished the Shaw professor's "community position" as well her influence among the elite women

who dominated the Tubman Y. Belle Ingels, Convention Consultation, 2 March 1946, Natl. YWCA Papers. Ella Baker, a fellow North Carolinian and Shaw graduate, was director of branches during the extraordinary expansion of the NAACP in the South during World War II, and her contacts throughout the region proved invaluable to civil rights activists in the 1950s and 1960s. Payne, "Ella Baker"; Grant, *Ella Baker*. On Ella Baker's work with the NAACP, see Ransby, *Ella Baker*, 105–47.

79. Beth Bates argues that the Chicago branch's takeover by a more militant "new crowd" in the 1930s influenced the national office to expand its strategies and adopt a more militant, labor-oriented agenda. While she notes the role of women in this struggle, Bates does not offer an explicit gender analysis of their participation. "New Crowd."

80. In contacting Ella Baker, Young gave as personal references both the moderate Channing Tobias and "Mrs. Max Yergan," a good friend of Baker's who was a dean at Shaw and wife of radical activist Max Yergan, who later refuted his radical past. Baker to Mangum, 20 September 1944, box C141, part 2, NAACP Papers; Young to White, 28 September 1944; White to Young, 2 October 1944; Young to Baker, 1 December 1944, all in box C135, part 2, NAACP Papers. In a further effort to enlist national input and circumvent the influence of the "adverse" local leadership, the new regime hoped to place Louis Austin on the national board.

81. The Durham example challenges the notion that southern blacks showed diminished support for the Double-V campaign after 1943. Young to Baker, 27 December 1944, box C135, part 2, NAACP Papers.

82. Apparently, union duties had taken Trice out of the city. Gavins, "NAACP in North Carolina," 110; Comparative Study of NC Branches, [1946–1950], box C380; Alexander to Gloster Current, 7 October 1949; Alexander to Lucille Black, 26 September 1944, both in box C141; Alexander to Current, memo, 25 January 1962; Annual Report of Durham Branch Activities, 1946, both in box C272, all in part 2, NAACP Papers; Study of Membership Enrollment in 100 Branches with a Potential of 1,000 or More Members, 14 July 1961, box 1, folder 17, KA Papers.

83. Young, TWIU weekly reports, 1 June 1946, box 66, series 2, TWIU Papers. Although the CIO enjoyed a somewhat better record with black workers in the South than the AFL, Young may have worked with the TWIU (an AFL union) because it was already established in Durham before the CIO entered the state. Young also noted that the CIO initially had no black organizers in the areas where she was working. Michael Honey points out that the AFL employed more black organizers in its southern campaign than did the CIO, which directed its postwar Operation Dixie drive at white textile workers. Ironically, despite the conservative approach of the CIO, which insisted on keeping union organizing separate from the more radical demands of the CIO-Political Action Committee, the organization made some of its most important gains among black workers in other industries. Honey, *Southern Labor*, 214–44; Sullivan, *Days of Hope*, 208.

84. Young to R. J. Petree, 16 February 1948; Young, TWIU weekly reports, 24 November 1945, 14 September, 19 October, 2 November 1946, 4 January, 1, 29

March 1947, all in box 66, series 2, TWIU Papers; Korstad, "Daybreak of Freedom," 279; Chafe, *Civilities and Civil Rights*, 5. Young estimated that about 25 percent of the local union membership was registered to vote. In a futile gesture, she wired North Carolina's Senator Josiah Bailey on behalf of nearly 9,000 Durham voters in the AFL, the NAACP, and other organizations, asking him to vote against pending antilabor legislation. Young to Bailey, telegram, undated, and Bailey to Young, 30 May 1946, both in box 370, 1946 Labor/Management folder, Josiah Bailey Papers, DU.

85. Young, TWIU weekly report, 6 July 1946, box 66, series 2, TWIU Papers; Annual Report of Durham Branch Activities, 1946, box C272, part 2, NAACP Papers. The Durham NAACP supported Young, although she hired her own attorney and the disposition of her case remains unclear. On the dangers black women organizers faced when traveling throughout the Jim Crow South, see Ransby, *Ella Baker*, 124–29.

86. Young, TWIU weekly report, 18 May 1946; George Benjamin to R. J. Petree, 10 December 1946; Young to O'Hare, 22 February 1947; O'Hare to Young, 3 May 1947; James Gillis to TWIU, telegram, 4 May 1947; Memorandum by R. J. Petree, 23 May 1947; F. L. Fuller Jr. to O'Hare, 21 May 1947; Exhibit I—Record of Dr. R. A. Young, Former Representative of TWIU, undated, all in box 66, series 2, TWIU Papers.

87. Hurley to George Chauncey, 24 April 1946, box E21, part 2, NAACP Papers.

88. Their shock may have been somewhat exaggerated, as Shepard had allowed similar efforts in the 1920s and 1930s. Young to Walter White, 12 August 1947, box C141; Hurley to T. V. Mangum, 4 September 1947, box E43, both in part 2, NAACP Papers; Shepard to Robert Bagnall, 23 February 1923; Shepard to Juanita Jackson, 13 November 1936, both in box G147, part 1, NAACP Papers.

89. Young also dipped into her own pocket to send youth delegates to a Tuskegee conference in 1948. Not all black youth jumped aboard the new activism. In 1948, the NCC student council attempted to ban all political organizations on campus, but the college NAACP prevailed and gained control of the campus newspaper. Nathaniel Bond to Hurley, 12 May, 19 July, 2 October 1948, box E86; Bond to Hurley, 2 February 1949, box E48, all in part 2, NAACP Papers; *Campus Echo*, January 1949.

90. Anderson, *Durham County*, 403. Most adults were more cautious. For example, state NAACP leaders dropped their proposed "March on Raleigh" for civil rights legislation, opting instead for a meeting with the newly elected governor, Kerr Scott, who promised to name blacks to state boards. In Durham, a controversy had erupted in 1941 regarding the blatant inequalities between black and white schools, with the DCNA threatening legal action. CT, 4 July 1941, clipping; J. H. Wheeler to A. E. Burcham, 31 March 1947, both in box 1, Spaulding Papers, DU.

91. Blacks in Durham pursued both strategies—equalization of facilities and racial integration—simultaneously. In the years before *Brown*, litigation or the threat of litigation was a highly effective tool, helping North Carolina blacks secure increased expenditures for black public school education, graduate programs, and equal teacher salaries. Moreover, southern blacks well understood that "the dual

system of education [was] futile." Floyd McKissick, interview by Bruce Kalk. In 1951, a federal court declared that the Durham schools were unconstitutionally "unequal." Gavins, "NAACP in North Carolina," 116; Crow, Escott, and Hatley, *African Americans*, 178; Report of the Conference with the Honorable Governor W. Kerr Scott, January 1949; L. B. Michael to Lucille Black, 27 April 1949; N.C. State Conference of NAACP Branches, Minutes of the Executive Committee and Board of Directors Meeting, 28 January 1950, all in box C141, part 2, NAACP Papers; CT, 3 April 1948, Clippings File, NC Coll.; CT, 11 March 1950; Douglas, *Reading, Writing, and Race*, 21–22; CT, 2 November, 3 December 1949.

92. McKissick, interview by Jack Bass; Obituary for Floyd McKissick, CT, 4 May 1991, Clippings Files, Durham County Library, Stanford Warren Branch, Durham, N.C.

93. Annual Report of the Secretary of the North Carolina State Conference of NAACP Branches to 13th Annual Conference, 19–21 October 1956, box 22, folder 2, KA Papers.

94. In 1949–50, four out of seven state youth officers were female, although men held the two top positions. Hazel Jackson represented the NCC branch at the National Emergency Civil Rights Mobilization in Washington, D.C.; in 1953, 1954, 1956, and 1959, the NCC chapter was headed by a woman president, and thirty-six out of fifty-nine members were female. Membership lists for NCC (1947–52), though probably incomplete, reveal more males than females, thus making women's leadership of the college branch even more remarkable. In 1954, NCC student Shirley Temple James presided over the Durham intercollegiate NAACP (after serving as head of the NCC campus branch in her freshman year), and two years later she became president of the statewide NAACP youth council–college division, with all the top offices except treasurer going to women. Shirley James also became the fourth female editor of the NCC *Campus Echo* in 1955. The upsurge in female membership in the NCC NAACP was probably due to a deliberate effort to recruit women in the wake of the Korean War, when male enrollment at NCC declined. The Durham city youth chapter reported ninety girls and sixty boys by 1960. Edward Pygatt to Ruby Hurley, 10 January 1951; James to Herbert Wright, 23 November 1954, both in box E86, part 2, NAACP Papers. Another NCC female student, Guytana Horton, succeeded James as head of the state NAACP youth division before Duke student Edward Compton took over in the early 1960s. NCC Chapter of the NAACP, undated; McKissick to Irmenia Davis, 2 December 1953; Bull City Barber College Youth College, 25 April 1960; De-Shazor's NAACP Youth Council, 25 April 1960; Durham Youth Crusaders of the NAACP, Membership Lists, 11 March–23 July 1960; another list of students and their schools includes 49 girls and 38 boys, all in McKissick Papers, SHC; Letter of Credentials, 1950; NAACP and Labor, 13, series B, reel 4, UPA NAACP Papers; Annual report of the N.C. Conference of State NAACP Branches, October 1956, box 22, folder 21, KA Papers; *Campus Echo*, 27 November 1957.

95. Many of Durham's black male business elite and their wives held lifetime memberships in the NAACP, and a number of elite men chaired committees within the local branch, but twenty-nine out of forty-seven of the 1957 membership

campaign committee members were women. In a typical women's fund-raising event, Juanita Crowe of the youth advisory to the NAACP and D. L. Walker of the Social Committee of the Durham NAACP organized a "Freedom Hop" at Durham Business College in 1958. Life membership roster, Durham, N.C., 10 March 1958; Mildred Bond to McKissick, 10 March 1958; Durham NAACP meeting announcement, Asbury Temple Methodist Church, 23 February 1958; 1957 NAACP membership campaign; 1962 NAACP membership campaign; Durham Branch NAACP Freedom Hop, 6 December 1958, all in McKissick Papers, SHC. On McKissick's reorganization of local NAACP youth chapters, see McKissick to Herbert Wright, 7 March 1959, McKissick Papers, SHC.

96. A paucity of Durham NAACP membership lists from the 1940s and 1950s make exact changes within the organization difficult to analyze with precision, but in 1960 and 1961 women seemed to outnumber men by about 100 members. The most complete lists I found were from 1960, but even these seem to be missing about 200 to 300 names when compared to state records. 1960 NAACP membership campaigns, Reports from 19, 26 March, 9 April 1960; NAACP membership lists, 1961, all in McKissick Papers, SHC; NAACP membership, ca. 1950–55, box 2, Rencher Harris Papers, DU; Durham NAACP branch membership reports, 11 June, 18 July 1940, box 258, and 8 May 1942, box C25, all in part 2, NAACP Papers; *Durham City Directory*, 1940, 1942, 1950, 1955, 1960.

97. Historian Linda Gordon makes this point as well. "Visions of Welfare," 580. See the "Woman's Social Whirl" and "Society Notes" sections in CT from the 1940s and 1950s. Fire destroyed copies of the paper from 1944–49; assorted clippings from this period can be found in other archival collections.

98. In 1954, the president, vice president, corresponding secretary, and treasurer of the Durham Housewives League were all beauticians. Housewives League national convention program, 16–20 August 1954; "The Durham Business and Professional Chain and Housewives League," brochure, undated, both in McKissick Papers, SHC.

99. Miles Horton inadvertently noticed that a number of people who came to the Highlander Folk Center in Tennessee for civil rights training were black beauticians. Because beauticians often were better educated than other black women and, most importantly, were economically independent, Horton decided to run training workshops specifically for black beauticians. The postwar years saw the growth of beauty shops as visits to the beauty parlor came to be routine for both black and white women. Beauty parlors still function as key institutions in black communities, and the introduction of weaves, braids, and other intricate African American women's hairstyles has spurred the contemporary revival of this black "woman's culture." Horton, *Long Haul*, 145; Ransby, *Ella Baker*, 226; Willett, *Permanent Waves*, 18–26, 134–35, 147, 189–90.

100. Barber shops, too, were sometimes owned by women and were often patronized by poorer women. Freedom Sunday worship service program, 27 May 1962, McKissick Papers, SHC; Black Solidarity Committee meeting, Emancipation Proclamation Day program, Fisher Memorial United Methodist Church, 1 January 1969, tape 1, side 1, NWC.

101. CT, 2 April 1955; Mawhood, "African-American Beauty Parlors," 27–28.

102. Quoted in Colburn, *Racial Change*, 2.

103. Thorpe Nichols, interview. A character in the recent film *Barbershop* made a similar point about the function of barbershops in black communities.

104. CT, 24 September 1938, 18 March 1939; Giddings, *When and Where I Enter*, 187–89.

105. Charles McLean, Annual report of the N.C. State Conference of NAACP Branches, 1955, box C142, part 2, NAACP Papers; CT, 2 March 1957. Madame C. J. Walker, who died in 1919, proclaimed that all of her beauty agents must "become community leaders and political lobbyists." Quoted in Willett, *Permanent Waves*, 26. Voter registration was a major focus of the National Beauty Culturists League, and the organization played an important role in the SCLC's citizenship schools, first initiated by Septima Clark at the Highlander Folk Center before Ella Baker arranged for their transfer to the SCLC in 1959. Robnett, *How Long? How Long?*, 88–89, 93. Poet Willie Coleman noted the loss of beauty parlors as communal gathering spaces for black women when the Afro, or natural hairstyle, became fashionable among black women in the 1960s and 1970s. "Things That Used to Be."

106. CT, 6 April, 4 May 1957.

107. Dula and Simpson, *Durham and Her People*, 18. Glenn Hinson, a folklorist and anthropologist at UNC-CH, has conducted numerous interviews with Durham blacks concerning drink houses and Durham's blues tradition. Hinson, conversation; Lee, conversation. Shirley Moore notes that women blues club owners in Richmond, California, in the 1940s were frequently "information and power brokers in their communities." Moreover, blues clubs often served as organizing centers and information centers for NAACP-led desegregation efforts against white-owned businesses in the late 1940s. "Black Women and Blues Clubs." Taylor Branch describes Martin Luther King's trek to the "country 'dives'" and "juke joints" on a Saturday night in 1956, which he made to "catch large numbers of [his] fellow citizens at the only traditional Negro meeting places other than the churches" in order to deliver critical information about the Montgomery bus boycott. *Parting the Waters*, 156–57.

108. Lee, conversation; McCoy, interview by the author; Mike Nathan, "Community Organizing in Edgemont," 19, NCF report, May 1968, box 4, NCF Papers; Kelley, "We Are Not What We Seem," 111.

109. Kelley, "We Are Not What We Seem," 84. James Borchert observes that leisure pursuits in extralegal activities such as bootlegging, numbers, and speakeasies provided an important source of income that kept money within low-income black communities. *Alley Life in Washington*, 221. Durham blacks rallied to the defense of black bootleggers, who were a frequent target of Alcohol Beverage Commission squads. For one highly publicized incident in the late 1930s involving the murder of a local tobacco worker by a commission official who raided his home on the suspicion that he was running a drink house, see CT, 4 June, 16 July 1938. For a discussion of black women's role in the informal economy, see Wolcott, *Remaking Respectability*, 93–130, 195–205.

110. Kelley, "We Are Not What We Seem," 111. See also historian Tera Hunter's bril-

liant discussion of leisure activities in Atlanta's black communities in *To 'Joy My Freedom*, esp. chapters 7 and 8.

111. Gordon, "Visions of Welfare," 580; Gilkes, "Building in Many Places," 53; Robnett, *How Long? How Long?*, 17–19.

112. CT, 12 March 1955, 30 October 1954; McKissick to Mrs. J. J. Henderson, 13 March 1958, McKissick Papers, SHC.

113. Morris, *Civil Rights Movement*, 114.

114. Shepard and Spaulding passed away in 1947 and 1952, respectively. Two years after Shepard's death, the *Greensboro Record* denounced the state NAACP's determination to "fight for complete and absolute equality" and bemoaned the loss of Shepard's "practical leadership" and "steadying influence." Clipping, 25 June 1949, box C141, part 2, NAACP Papers.

Chapter Two

1. *Baltimore Afro-American*, 4 September 1948; *New York Post*, 30 August 1948; Sullivan, *Days of Hope*, 260.

2. Austin had difficulty finding lodging for the group among Durham's black elite; both Asa Spaulding and George Cox, executives at the black-owned North Carolina Mutual Life Insurance Company, refused to house the Wallace group. Ethel Hubbard, a local teacher, similarly refused, explaining that she was afraid of losing her job. *Baltimore Afro-American*, 4 September 1948; Korstad, "Daybreak of Freedom," 363–65; Sullivan, *Days of Hope*, 260–64.

3. Murray, "Open Letter to Citizens of Durham, 21 May 1954," CT, 12 June 1954. Murray also had tried unsuccessfully to desegregate UNC-CH in 1938.

4. For a discussion of this progressive alliance and southern whites in the 1940s and 1950s, see, for example, Sullivan, *Days of Hope*, Egerton, *Speak Now*, and Dunbar, *Against the Grain*.

5. The terms "radical," "liberal," and "moderate" are elusive and fluid, especially in the context of the postwar white South. When used in reference to whites, they denote various degrees of white commitment to racial equality. "Radical" generally refers to the very small group of whites who advocated a major overhaul of economic and political institutions and comprised Communists, Socialists, and even some left-leaning liberals; however, before 1954, those who advocated full racial equality, particularly integration, also were considered radical. Those who supported racial equality though not always racial integration were considered liberals or moderates. After 1954, whites who supported immediate integration were liberals, while those who advocated gradual integration were moderates, and whites opposed to integration were conservatives. I also use the term "liberal" here in its more traditional sense of commitment to individual freedom, the enhanced participation of individuals in government, and the use of political and government reforms to secure and protect individual rights. For a useful discussion of southern liberals, see Sosna, *Silent South*, vii–xi; see also Tyler, *Silk Stockings*, 5.

6. The papers for the Durham LWV, the Durham AAUW, the Durham YWCA, and

the WILPF (held privately by Charlotte Adams) were all unprocessed when I consulted them.

7. For examples of southern white women's organized response to racial inequality in Atlanta and New Orleans in the 1940s and 1950s, see Nasstrom, "Politics of Historical Memory," and Tyler, *Silk Stockings*.

8. The group was Women-in-Action for the Prevention of Violence and Its Causes, discussed in chapter 7. Susan Lynn argues that in the postwar years predominantly white women's reform groups increasingly turned their attention from class exploitation to racial discrimination. "Gender and Progressive Politics."

9. Sullivan distinguishes between the conservative approach of the CIO's Operation Dixie campaign, which sought to organize workers without challenging segregation, and the CIO-Political Action Committee, which fought for greater political power for both white and black workers. Sullivan, *Days of Hope*, 194–95, 200, 208, 220; Bartley, *New South*, 38–73.

10. Several moderate and conservative whites, including Josephus Daniels, editor of the influential *Raleigh News and Observer*, initially backed the CNC but later disassociated themselves from it. Sullivan, *Days of Hope*, 202–3, 206, 207; Reed, *Simple Decency*, 4–12; Uesugi, "Mary Price."

11. Anna Seaburg, a white woman affiliated with the Durham YWCA, and Carolyn Goldberg, a freelance journalist from Durham who wrote for the *Nation* and the *New Republic*, were on the CNC staff. Although the CNC did not focus on women's issues, the board discussed the possibility of a woman president, and the labor committee supported equal pay regardless of race or sex. Price was a member of the YWCA Public Affairs Committee, which undoubtedly facilitated cooperation between the two groups. Uesugi, "Mary Price," 281; Notes for board meeting, 28 November 1947, box 12, folder 11; Labor Committee, 3 November 1945, box 11, folder 6; Remarks of Clark Foreman, Minutes of CNC annual convention, 29 November 1947, 8–9, box 8, folder 1; Price to James Dombrowski, 28 September 1945, box 11, folder 5; Price to Tarleton Collier, 5 July 1946, box 11, folder 5; Price to Dombrowski, 9 June 1947, box 17, folder 10, all in SCHW Papers.

12. The Durham AAUW adopted the CNC's legislative agenda for discussion in 1946, supported legislation to increase the minimum wage, and worked with black women to equalize funding for black and white schools. On the AAUW efforts on behalf of white working women and Mary Cowper's creation of a nursery school in Durham for white working-class women, see Fischer, "Mary O. Cowper," 36–37. *AAUW North Carolina Division Bulletin*, May 1946, 4, and May 1947, 3, both in box B–L, AAUW Papers; Frances Jeffers, AAUW N.C. State Division Social Studies Report for 1951–52, box 10, Mary Cowper Papers, DU. See note 17 for the controversy surrounding Cowper's support of protective labor legislation. SCHW membership lists for North Carolina are scattered throughout the collection; see boxes 8, 12, 13, and 15.

13. C. C. Spaulding headed the Durham committee, but his secretary, Ethel Berry, handled all the details. Another black woman provided housing for Bethune during her visit, refusing to be reimbursed for the honor. Bethune Durham Meeting,

25 January 1946, box 8, folder 4; Berry to Price, 15, 18, 31 January 1946; Price to Berry, 20, 30 January 1946; Durham Members of the Committee for North Carolina, all in box 8, folder 4, SCHW Papers; Sullivan, *Days of Hope*, 206–7; Reed, *Simple Decency*, 100–102.

14. Durham YWCA Public Affairs Committee, "Dear Citizen of Durham," 19 April 1946, box 11, folder 6, SCHW Papers; Sullivan, *Days of Hope*, 209, 218–19.

15. Sindler, "American Negro Protest Movement," 9; Keech, *Impact of Negro Voting*, 16.

16. The NCC chapter may have had a majority female membership; one list included nine women and six men, and another list of NCC supporters of a state minimum wage bill, a key demand of the CNC, included fifty-two women and fifteen men. Price to Bethune, 9 February 1946, box 8, folder 4; Price to Tarleton Collier, 5 July 1946, box 11, folder 5; Price to Lee Sheppard, 2 February 1946, box 17, folder 1; Report of Mary Price to Annual Meeting, 1946, box 7, folder 8; C. E. Boulware to Price, 12 September 1946, box 15, folder 1; Large Contributors—Bethune Meeting, box 13, folder 5; North Carolina College for Negroes petition, box 16, folder 1, all in SCHW Papers.

17. Height, Durham YWCA visitation report, 18 February 1947; Report of Mrs. Duncan Newell's meeting with Mrs. James Cobb, 22 January 1947, all in Natl. YWCA Papers; Lynn, "Gender and Progressive Politics," 222. The Y's hysteria over the proposed labor legislation undoubtedly stemmed from the controversy in the 1920s that had nearly destroyed the organization; after Mary Cowper had persuaded the Y to back protective legislation to abolish child labor and improve working conditions for working women, male manufacturers were so outraged that they threatened to withhold funding from the Durham Y. Anne Firor Scott, "After Suffrage"; Janiewski, *Sisterhood Denied*, 83; Roydhouse, "Bridging Chasms"; Clipping, 5 May 1946, YWCA Scrapbook, 1947–50, box 13, Durham YWCA Papers; Helen Gillen to Caroline [Goldberg], 26 December [1946]; Louie Rhine to Caroline [Goldberg], 5 January [1947]; Price, CNC annual report, 1946, all in SCHW Papers.

18. Thurmond's Dixiecrats drew nearly 70,000 Tar Heel votes. "Proclamation of the Durham Youth Council of the NAACP," [8 September 1948], box E86, part 2, NAACP Papers; Korstad, *Civil Rights Unionism*, 359, 363, 366; Sullivan, *Days of Hope*, 260–64; Uesugi, "Mary Price," 308; NCC Chapter of the NAACP, Report of election of officers, May 1948, box E48, and February 1949, box E45; States' Rights Democrats ad, "Negroes to March on Raleigh—Mr. Truman Has Sown the Wind, We May Reap the Whirlwind," in *Charlotte Observer*, 20 October 1948, clipping, box C141, all in part 2, NAACP Papers. On President Truman's efforts to attract black voters in the 1948 election and his administration's civil rights record, see Dudziak, "Desegregation" and *Cold War Civil Rights*, esp. chapters 1–3.

19. Chapel Hill resident and CNC member Junius Scales's public revelation of his secret Communist Party affiliation dealt a serious blow to the SCHW and to the CNC in particular. The SCHW folded in 1948 and was succeeded by the Southern Conference Education Fund, which had formed in 1946 as a tax-exempt arm of SCHW. On the mostly unsuccessful efforts of Junius Scales and other Communists to make inroads at Durham's Erwin Mills (where the TWUA had won a

major contract in 1941), see Minchin, *What Do We Need A Union For*, 44–45. Gunnar Myrdal's *American Dilemma* portended a shift in liberalism during the postwar era. Rather than advocating biracial cooperation among working people, as the southern progressive alliance tried to do, Myrdal urged blacks to forge alliances with middle- and upper-class white liberals. America's "race problem" was separated from the struggle for industrial democracy and recast as a moral dilemma. In *Civil Rights Unionism*, Bob Korstad has shown the devastating impact this trend had on the black freedom movement in North Carolina, especially among black trade unionists. Sullivan, *Days of Hope*, 167, 241–43; Bartley, *New South*, 71; Uesugi, "Mary Price," 278, 285–87; Scales and Nickson, *Cause at Heart*; Klibaner, *Conscience*.

20. Tyson, *Radio Free Dixie*, 50–53; Badger, "Fatalism, not Gradualism."

21. Sosna, *Silent South*, 163, 166; Bartley, *New South*, 30, 57, 62–73; Sullivan, *Days of Hope*, 274. Graham lost to Willis Smith, a Duke graduate, former president of the North Carolina Bar Association and the American Bar Association, and president of the Duke University Board of Trustees. Pleasants and Burns, *Frank Porter Graham*. For a different interpretation of the Graham-Smith campaign, see Klarman, "Backlash Thesis."

22. Although Price vehemently denied being a Communist, recent discoveries in former USSR archives reveal that she did pass documents from journalist Walter Lippman's files, as well as from a friend who worked for the U.S. government, to Communist Party member Elizabeth Bentley. Korstad, *Civil Rights Unionism*, 362; Levine, *Degrees of Equality*, 65–82, 135; Seaburg to Corrine and Jewel, 11 November 1947, box 7, folder 2, SCHW Papers; Uesugi, "Mary Price," 285, 287; Alonso, "Mayhem and Moderation" and *Peace*, 168–72, 182–85; Schrecker, *Many Are the Crimes*, 379.

23. However, Asa Spaulding refused to head up a statewide Civil Rights Congress defense committee for Major Benton, a black veteran accused of raping a white woman and threatened with a lynch mob in Richmond County if he did not confess to the crime. Black women were prominent in local chapters of the left-leaning Civil Rights Congress, which played a major role in some of the most highly publicized incidents, and they were also a majority of the North Carolina delegates to the 1946 congress convention. The Fellowship of Southern Churchmen was headed by Nelle Morton, a white woman from Tennessee. Horne, *Communist Front*, 29, 31, 181, 184; Shapiro, *White Violence*, 367; Milton Kaufman to Asa Spaulding, 22 May 1946; Kaufman to Dear Delegates, 14 June 1946; Spaulding to Kaufman, telegram, n.d.; all in Civil Rights series, box 1, Asa T. Spaulding Papers, DU; Laurent Franz to CNC, 15 July 1946, box 12, folder 7, SCHW Papers.

24. The woman later testified that Bush was not the man who had approached her. Tyson, *Radio Free Dixie*, 60–61. Even a casual perusal of the *Raleigh News and Observer* from the early 1950s reveals an inordinate number of rape accusations against black men throughout the state. In one case involving the assault of a black woman by three white paratroopers in Carthage, North Carolina, in the early 1950s, the state NAACP intervened; the white men were convicted, but they received sentences of only sixteen to twenty months in prison, even though all

three admitted to raping the woman in signed confessions. CT, 20 May 1953; Kelly Alexander to Board of Directors of the N.C. State Conference of NAACP Branches, 6 February 1953, box 18, KA Papers; Young to White, 12 August 1947; V. T. Mangum to Gloster Current, 21 March 1947; Annual report of the chairman of the State Legal Committee of N.C. NAACP branches, 22 June 1949, all in box C141, part 2, NAACP Papers.

25. CT, 31 December 1949, 7 January, 25 February 1950, 15 November 1952; Horne, *Communist Front*, 200, 188–90.

26. Durham attorney C. C. Malone recalled joining the Southern Negro Youth Congress in the 1940s as a teenager, but his father forced him to quit after he began receiving notices to testify before HUAC. In the 1950s, the North Carolina State Bar produced a stack of FBI documents against Malone and refused to allow him to take the state bar exam for two years, finally relenting in 1961. Malone, interview; *Independent*, 14–27 July 1988.

27. CT, 4 February, 5, 25 March 1950; Gavins, "NAACP in North Carolina," 115, 117. Texas NAACP leader Lulu White was also red-baited. Pitre, *Struggle against Jim Crow*.

28. During the 1930s and early 1940s, the paper provided extensive coverage of the Communist Party in North Carolina and throughout the nation, defended the International Labor Defense's support of black Communist Angelo Herndon, and protested the vilification of black singer and actor Paul Robeson amidst charges of Communism. In 1951, Austin agreed to let Junius Scales, North Carolina's most well-known Communist, cover a story on the case of Mack Ingram—a black North Carolina man sentenced to two years' hard labor for "leering" at a white woman who was seventy-five feet away from him—although Scales used a pseudonym. Scales, *Cause at Heart*, 228–29; Tyson, *Radio Free Dixie*, 66; CT, 28 May 1938, 8 May 1937, 6 August 1949.

29. CT, 22 July 1950, 26 June 1948, 29 July 1950. This trend became even more evident after the NAACP ousted Communists from membership in 1950. Meier and Bracey, "NAACP as a Reform Movement," 22. See also Plummer, *Rising Wind*, chapter 5, and Dudziak, *Cold War Civil Rights*.

30. Some observers claim that the decline of the NAACP in the 1950s was also due to its decision to raise dues from one to two dollars. DCNA, Report of Education Committee, 1957, box 7, William A. Clement Papers, SHC; Biondi, *To Stand and Fight*, 67, chapters 7 and 8. For a contemporary analysis of the decline in NAACP membership nationwide, see NAACP, Draft of Annual Branches Report for 1950, box 302, and Comparative Study of North Carolina Branches, box 141, both in part 2, NAACP Papers. Another list provides a slightly higher figure for 1950. See Workshop on Branch Administration, Durham, N.C., 13 October 1962, box 23, folder 6, KA Papers.

31. Across the region, white officials waged an all-out battle against the NAACP. Between 1955 and 1958, 246 NAACP branches dissolved, with a combined membership loss of close to 50,000. Kelly Alexander to NAACP state officers, branch officials, and members, 2 February 1957, box 23, folder 1; Annual report of the N.C. Conference of State NAACP Branches, 1956, box 22, folder 21, both in KA

Papers; Tyson, *Radio Free Dixie*, 61; Morris, *Civil Rights Movement*, 30–35; Payne, *Light of Freedom*, 43; Chafe, *Civilities and Civil Rights*, 70–71, 73.

32. Following the *Brown* decision, Alexander received vicious mail from white supremacist groups in the state. States' Rights League, Patriots of North Carolina, Citizens Councils, Ku Klux Klan to Alexander, 24 October 1955; C. H. Price to [Alexander], 19 July 1955, all in box 19, folder 8, KA Papers. Charles Payne discovered a similar dynamic surrounding white violence in Mississippi. *Light of Freedom*, 40–41.

33. Hamilton quoted in Tyson, *Radio Free Dixie*, 61. Draft of annual branches report for 1950, box 302; Comparative Study of North Carolina Branches, box 141, both in part 2, NAACP Papers; Workshop on Branch Administration, Durham, N.C., 13 October 1962, box 23, KA Papers.

34. Adam Fairclough claims that during the height of McCarthyism, "survival was the name of the game," and he notes that the NAACP survived, providing a link between the civil rights struggles of the 1940s and those of the 1960s. "Civil Rights Movement," 20–21. North Carolina NAACP field representative Charles McLean assured teachers that they could receive their memberships in plain envelopes in order to avoid being detected by white authorities. Organizational memberships did not always offer protection, especially in rural areas. As late as 1962, Duplin County blacks cautioned the state NAACP not to advertise the fact that the teachers' organization had taken a life membership in the NAACP. Memorandum by McLean, ca. 1955; McLean, Annual report, 1955; Life membership roster, state of N.C., 29 January 1962, all in box C381, part 2, NAACP Papers.

35. *CT*, 14 November, 4 March 1950, 15 May 1954. Two years later, Floyd McKissick contacted every black organization and institution in the city requesting their "100% cooperation" in the NAACP membership campaign. McKissick to Dear Fellow Citizen, 11 February 1956, box 7, NAACP folder, William J. Kennedy Papers, SHC; Gavins, "NAACP in North Carolina," 114–15. On the importance of NAACP branches in North Carolina prior to the sit-in movement, see also William Jones, "NAACP."

36. *CT*, 14 August 1954, 13 September 1949, 22 June 1957; "Durham NAACP Officers for 1960," Floyd B. McKissick Papers, SHC. Ray Gavins argues that black organizations in North Carolina failed to publicly demand integration in the years before *Brown*. "NAACP in North Carolina."

37. Men's groups such as the Odd Fellows, fraternities, and Masonic lodges also joined the NAACP. But, as the head of the North Carolina NAACP acknowledged, personal contacts, which formed the basis for organizers' "house to house work," were needed to bring local folks into the NAACP, and women seemed more likely to engage in this kind of work—what Ella Baker called "spadework." Alexander to Lucille Black, 7 October 1949, box C142; McLean, Annual report, 1955, box C141, both in part 2, NAACP Papers; *CT*, 23 July 1955, 1 August 1953; Life Membership Campaign of the NAACP, 10 March 1958; Mildred Bond to Floyd McKissick, 10 March 1958, both in McKissick Papers, SHC; Life membership roster, 15 September 1960, box 23, folder 4; *The NAACP Honor*

Guard (New York: NAACP), ca. 1959, both in KA Papers; Gavins, "NAACP in North Carolina," 116; Ransby, *Ella Baker*, 106, 118.

38. Minutes of the ninth annual convention of Jack and Jill of America, Inc., NCC, Durham, N.C., 18–19 June 1954, box 69, Semans Family Papers, DU.

39. Alexander to Black, 26 September 1949, box C141, part 2, NAACP Papers; McLean, Annual report, 1955, KA Papers; CT, 11 May 1957; Alexander to NAACP state officers, branch officials, and members, 2 February 1957, box 23, folder 1; N.C. State Conference of NAACP Branches annual reports, 1955–56, box 22, folder 21; McLean, Annual reports, 1954, 1955, box 22, folder 22, all in KA Papers; Gavins, "NAACP in North Carolina," 117; Chafe, *Civilities and Civil Rights*, 70–71, 73; Bartley, *Rise of Massive Resistance*, 96–97.

40. For example, a 1957 list of NAACP youth councils and college chapters in North Carolina listed twelve female and three male advisors. Youth Council and College Chapter Officers in North Carolina, box E13, part 3, NAACP Papers; Morris, *Civil Rights Movement*, 188.

41. In 1960, only Greensboro surpassed Durham, with over 1,800 members. For North Carolina branch membership totals for 1950–60, see boxes C381, C142, and C141, part 2, NAACP Papers, and boxes 18, 19, 22, 23, KA Papers. NAACP, 1955 Membership and FFF Goals, North Carolina Branches; N.C. State Conference of NAACP Branches, State Officers and Branch Officials Meeting, Charlotte, N.C., 29 January 1955, both in McKissick Papers, SHC.

42. For two different views of southern white liberalism, neither of which devotes much attention to southern women (although Badger notes women's role in liberal politics in the 1940s), see Chappell, *Inside Agitators*, and Badger, "Fatalism, not Gradualism."

43. Gilmore, *Gender and Jim Crow*, 192–95; Boyd, *Story of Durham*, 272–73; "History of the Durham Young Women's Christian Association," typescript, ca. 1949, box 11; Minutes of the Board of Directors meeting of the Durham YWCA, 22 July 1922, box 36, both in Durham YWCA Papers; Lynn, "Gender and Progressive Politics," 221; Eleanor Copenhaver, "Durham, North Carolina," 25 August 1931; Marion Cuthbert, Report of visit to Durham, 7–8 November 1934; Annie Kate Gilbert, Visitation report, 14–15 October 1935; Mrs. James Robins to Gilbert, 9 May 1935, 20 June 1936; Isabel Lawson, Visitation report, 5–6 March 1941; Report of Cordelia Winn, January–February 1931; Winn report, 16–19 November 1933, all in reel 192, Natl. YWCA Papers. For a discussion of black women's pressure on organized white women in groups such as the YWCA, the LWV, and the WILPF, see, for example, Giddings, *When and Where I Enter*, 155–58, 166, 172–76, and Hall, *Revolt against Chivalry*, 86–89, 98.

44. Ruth Addoms to Mrs. Hazen Smith, 25 August 1945; "Inter-Club Council, 1948–1949," both in box M–P, AAUW Papers; Altrusa Club, "Report on YWCA [Public] Affairs Committee Meeting," 14 February 1946, box 2; "Altrusa Club President's Report," 3 June 1954; *Second District Altrusa News* 7, no. 1 (Spring 1954): 3; "Club Activities Report," 1942–43, box 1, all in Altrusa Club Papers, DU.

45. White Durham native Hilda Coble recalled that her boyfriend "was furious" after she participated in an interracial student program in the 1930s at Watts Street

Baptist Church, which was considered to be racially progressive among the white, mainstream churches in Durham. Coble ditched her boyfriend rather than her principles. Lucas, interview; Carr, interview; Coble, interview; CT, 7, 14 May 1955.

46. James McBride Dabbs, *Haunted by God*, quoted in Sosna, *Silent South*, 173. Sosna claims that Christian love, probably more than any other factor, accounted for southern white liberals' racial egalitarianism. On the role of religion in the civil rights movement, see Marsh, *God's Long Summer*, and Chappell, *Stone of Hope*. On the role of religion in fueling Christian segregationist sentiments, see Dailey, "Sex, Segregation and the Sacred."

47. Okun defied her southern upbringing in various ways, including her decision to marry a Jewish man. Later, she became the first white woman to take a job in the black school in Chapel Hill; when she received her first paycheck, it included a "C" for "colored"—the payroll office assumed she was black. Okun, telephone interview. For discussion of other white southern "dissenters" and their conversions from white supremacy to racial egalitarianism, see, for example, Boyle, *Desegregated Heart*, Hobson, *But Now I See*, Curry et al., *Deep in Our Hearts*, and Fosl, *Subversive Southerner*.

48. In a 1990 interview, Jones was hesitant to acknowledge the role of race in his removal from the Presbyterian church; however, most observers pointed to his racial views as the primary explanation for his expulsion. Jones, interview; U.S. War Department memorandum, "Commingling of Whites and Negroes at Chapel Hill, NC," 19 August 1944, Franklin Delano Roosevelt Library, Hyde Park, N.Y. My thanks to Gary Mormino for sharing this document with me. Charlotte Adams, interview; Egerton, *Speak Now*, 422, 556–57; Okun, telephone interview.

49. Sadie Hughley, a librarian and WILPF member, was active in a number of black women's groups in Durham. Rev. J. Neal Hughley, chaplain at NCC, had helped establish the Fellowship of Southern Churchmen in Chapel Hill, and he often preached at the Community Church. Charlotte Adams, one of the founding members of the local branch of the WILPF, also attended the Community Church. The Durham Friends, a Quaker group, also attracted an interracial group of worshipers, many of whom joined the black freedom movement. CT, 29 August 1953.

50. Durham YWCA standards study, 1937; Eleanor Copenhaver, Visit to Durham, 15–19 April 1931, both in reel 192, Natl. YWCA Papers; Minutes of the Durham YWCA Board of Directors meetings, 20 March 1934 and 19 April 1938, both in box 11, Durham YWCA Papers.

51. Leta Galpin, Durham YWCA visit report, 17–18 October 1944; Isobel Lawson, Durham YWCA visit report, 12–14 December 1944; Belle Ingels, Durham YWCA visit report, 2 March 1946, all in reel 192, Natl. YWCA Papers; Lynn, "Gender and Progressive Politics," 221.

52. Report of the Negro Leadership Conference, 23–30 June 1942; Summary of the Suggestions for the Negro Leadership Conference, 9 March 1942, both in box 37, Durham YWCA Papers; Lynn, *Progressive Women*, 148.

53. Report of the Negro Leadership Conference, 23–30 June 1942; Undated clipping, both in box 37, Durham YWCA Papers; Lynn, *Progressive Women*, 46–47; Belle Ingels, "Convention Consultation," 2 March 1946, reel 192, Natl. YWCA Papers.

54. Lynn, "Gender and Progressive Politics," 226; Ingels, "Convention Consultation."

55. Mrs. Fredrick Swamer and Lillian Hunt, Summary interviews, Minutes of the Durham, N.C., YWCA, January–March 1950, vol. 11, box 1, Durham YWCA Papers; Report on basic standards, Durham YWCA, 6 July 1951, reel 192, Natl. YWCA Papers. Susan Lynn found that religious ideals among Y women help to explain why they were more receptive to racial equality than was the YMCA. "Gender and Progressive Politics," 223.

56. Ethel Montgomery (Roanoke, Virginia, branch) to Harriet Tubman YWCA, 14 July 1950; Blanchard to Montgomery, 22 July 1950; Laura K. Fox (Patterson Ave. branch, Winston-Salem) to North Carolina branch executive directors, undated; [Blanchard] to [Fox], ca. 1956, all in box 37, Durham YWCA Papers.

57. Pauline Newton (branch chair) to Y members, 12 January 1956, box 36; 1958–59 Board of Directors Roll, box 11, both in Durham YWCA Papers; Durham YWCA visit report, 7–13 October 1953; Florence Harris to Dorothea Burton, 27 November 1953; Burton to Harris, 3 February 1954, all in reel 192, Natl. YWCA Papers.

58. By comparison, the Greensboro YWCA voted in 1950 to hold dinner meetings for all members. Despite their own hesitations, white Durham Y members permitted the local AAUW and LWV to hold interracial meetings *and* meals at Y facilities. Although segregated eating facilities had long been commonplace throughout Durham, the increased presence of black servicemen in the state led anxious whites to codify their dining habits, and Durham's city council passed an ordinance in 1940 banning integrated meals. Belle Ingels, Report of interview with Mrs. James B. Robins, June 1940, Natl. YWCA Papers; YWCA executive director to Elizabeth Bookhout (secretary of the AAUW), 28 October 1955; Minutes of the board of directors, 1955–56, vol. 14, both in box 11, Durham YWCA Papers; Burns, "North Carolina," 233; Chafe, *Civilities and Civil Rights*, 31.

59. Levine, *Degrees of Equality*, 106.

60. Quoted in ibid., 112, 65–82.

61. Ibid., 107–11.

62. Ibid., 117–20, 121–23, 125; Rupp and Taylor, *Survival in the Doldrums*, 156–58.

63. Minutes of the Durham AAUW board meeting, 7 September 1948, box M; Mrs. Hazen Smith to Mrs. Robert Humber, 10 January 1949, box M–P; Alice Mary Baldwin, "History of the North Carolina Division of the American Association of University Women, 1947–1957," unpublished typescript, 11, box B–L, all in AAUW Papers. The N.C. AAUW was also capable of racist stereotyping. One news brief, apparently in an effort at humor, reported that a member had urged her "colored cook" to attend night school but that the cook had rejected the suggestion, explaining, "I decides I know enough to last me a year, maybe more." *AAUW North Carolina Division Bulletin*, May 1946, 6, box B-L, AAUW Papers.

64. Kerber, "Unfinished Work," 349, 367–70; Branch meeting minutes, 4 January 1955; Louise Horner to AAUW members, 5 November 1955; AAUW branch president's report, 1955–56, both in box P; Durham AAUW Executive Board

meeting, 17, 24 October, 21 November 1955, 20 February 1956; AAUW branch meeting, 3 January 1956, box M, all in AAUW Papers.

65. Most southern AAUW branches did not suffer much membership loss overall as a result of integration, although a number of branches remained segregated into the 1960s despite increased pressure from local black women for inclusion. Levine claims that membership in the Durham AAUW declined from 56 to 25 women between 1955 and 1956. However, the records I consulted showed a far smaller decrease. The Durham branch lost 19 out of 107 members, but the branch also gained 5 new members, so that it had a total of 93 members for the 1955–56 year. Between 1957 and 1967, Durham membership fluctuated between 67 and 83 members, averaging abut 74 members each year and gradually attracting more black members. Not all resignations were necessarily tendered in opposition to integration. Levine, *Degrees of Equality*, 131, 204; AAUW branch president's report, 1955–56, box P; Mattie Russell, "The Durham Branch of the AAUW, 1957–1967," box B-L; Virginia Sherman to Florence Brinkley, 19 April 1961, all in AAUW Papers.

66. The Durham, Winston-Salem, Raleigh, and High Point branches of the AAUW all desegregated. Several Durham AAUW women approached the manager of Harvey's Cafeteria asking him to reconsider his policy regarding black patrons, but he refused. Durham AAUW Executive Board meeting, 20 February 1956; AAUW branch report, 1955–56; Marjorie Applewhite (AAUW, North Carolina state division) to Dorothy Post, 24 January 1956; Florence Brinkley to Mrs. Derrick Sherman, 25 April 1961, all in box P, AAUW Papers.

67. The Nashville branch successfully integrated in 1955, and Durham tried to follow its example. Nashville was far more successful than Durham, but the racial difficulties that branch women experienced across the country ultimately shaped the national AAUW's ambivalent response to the *Brown* decision and to integration generally. Levine, *Degrees of Equality*, 127–30, 135; Brinkley to Sherman, 25 April 1961, box P, AAUW Papers.

68. Chris Greene, interview; Clement, interview; CT, 4 March 1950; Minutes of the YWCA Board of Directors, September 1958, box 11, Durham YWCA Papers. Following World War II, white organized women frequently complained the city was "overorganized," and that women had numerous demands on their time—from a range of civic responsibilities to domestic duties—that made it difficult to attract and keep members.

69. This was not only a southern problem. Class and racial barriers in the LWV were evident in chapters throughout the country during the 1950s, and in San Diego a confluence of anticommunism and racism split the local AAUW. Ware, "American Women," 281–99; Levine, *Degrees of Equality*, 122–24.

70. WILPF meeting, 8 May [1952], WILPF Papers (Durham–Chapel Hill branch), DU; Okun, telephone interview.

71. The local WILPF formed in 1938 and barely survived World War II and the Red Scare. The failure of most white suffragists to support black voting rights and the close links between the WILPF and the woman suffrage movement kept many black women away from the WILPF, even though the national organiza-

tion opposed segregation and supported the Dyer antilynching bill in the 1920s. In 1928, the national WILPF created an Interracial Committee and tried to recruit middle-class, educated black women, but persistent racial exclusion in local branches marred these efforts. Still, Joyce Blackwell-Johnson contends that the organization was in the vanguard among white organized women regarding race in the early part of the twentieth century. From the late 1930s onward, moreover, black WILPF members such as Mary Church Terrell and Durham's Bessie McLaurin made racial issues a central feature of the national WILPF agenda. The organization aggressively lobbied for a federal antilynching bill, rallied behind the Scottsboro boys, and convinced local branches to abandon exclusionary practices. Blackwell-Johnson, "African American Activists," 467, 470–71.

72. It is not clear why the local WILPF failed to attract more black women, given that it had a better record on race than other liberal women's organizations. Although local WILPF branch organizer Charlotte Adams claimed the branch had always been inclusive since its was formed in 1938, black women do not appear to have joined until the 1950s, when the Chapel Hill group recruited black women from Durham. The Durham women—Sadie Hughley and Bessie McLaurin in particular—may have been affiliated with the national WILPF before joining the local branch. Adams, interview; "WILPF: A Brief History of the Chapel Hill–Durham Branch," WILPF Papers (Durham–Chapel Hill branch), DU.

73. In 1957, two black women held official leadership positions: Sadie Hughley, a librarian at the black Stanford Warren branch of the Durham County Library, was vice president of the local WILPF, and Dessa Turner, also from Durham, was legislative secretary. That same year, three African American women—Hughley, Turner, and Selena Wheeler, wife of John Wheeler, a prominent black Durham banker and head of the DCNA—were members of a four-person delegation to the annual WILPF meeting in Miami. Hughley subsequently served as treasurer and president of the local chapter and later as a national vice president, while Turner was secretary and vice president of the local chapter. Bessie McLaurin, a black teacher and activist from Durham, served on national WILPF committees and also represented the local WILPF at annual meetings. CT, 15 June 1957; McLaurin, interview.

74. On the Pearsall Plan and pupil assignment, see Chafe, Civilities and Civil Rights, 50–60, 64–65, and Douglas, Reading, Writing, and Race, 25–49.

75. Betts, letter to the editor, DMH, 13 October 1957.

76. Quotations in Blackwell-Johnson, "African American Activists," 478, 479, 468; see also Alonso, Peace, 101–5.

77. Annual report of the Durham–Chapel Hill WILPF, 1 June 1957; Statement of the Chapel Hill branch of the WILPF to the General Assembly of North Carolina, undated, both in box 1, DOHC; Adams, interview.

78. WILPF women also established an interracial cooperative play group that met weekly at the Community Church and attracted about thirty black and white preschoolers. Annual report of the Durham–Chapel Hill WILPF, 1 June 1957; WILPF Newsletter, 9 April 1959, 18 June 1959; Chapel Hill–Durham branch WILPF

membership list, ca. 1970, all in WILPF Papers (Durham–Chapel Hill branch), DU.

79. Levine, *Degrees of Equality*, 124, 131–35. According to Susan Lynn, the AAUW (in contrast to the YWCA) never made civil rights a major priority; however, Lynn's focus is on the national organizations. *Progressive Women*, 65.

80. Executive Committee of the North Carolina division of the AAUW, "Policy Statement in Regard to the Expected Supreme Court Decision on De-segregation of the Races in the Public Schools," 7 March 1954, box M, AAUW Papers.

81. Susan Levine claimed that no Durham women attended the conference, but handwritten notes on a workshop program in the Durham AAUW papers suggest otherwise. Ruth Skretting to the branch president, 4 May 1955; "The Crisis in Public Education—Where We Stand Today," workshop program, undated, both in box P; Alice Mary Baldwin, "History of the North Carolina Division of the American Association of University Women, 1947–1957," unpublished typescript, 17–18; *AAUW North Carolina Division Bulletin*, September 1955, June 1956, both in box B–L, all in AAUW Papers; Levine, *Degrees of Equality*.

82. Bartley, *Rise of Massive Resistance*, 274–75; Baldwin, "History of the North Carolina Division," 18; *AAUW North Carolina Division Bulletin*, June 1956, both in box B–L, AAUW Papers.

83. Durham AAUW board meeting, 6 September 1956, AAUW Papers.

84. Charlotte Adams, "Legislative Action," WILPF Newsletter, ca. 1957, in author's possession.

85. Burgess, *Negro Leadership*, 172. See Clippings File, NC Coll., for a sampling of North Carolina editorial responses to *Brown* and to the Pearsall Plan. While several newspapers opposed the plan, most favored it.

86. Many prominent blacks throughout the region considered Semans a sympathetic ally, and Rencher Harris, the first black city councilman in Durham, attributed his victory in 1953 to her support. Box 15, Semans Family Papers, DU; Cannon, "Black Political Participation," 81–82.

87. Semans placed the burden of blame for Durham's school desegregation fiasco on the board of education, claiming that the city council had no jurisdiction over the matter, even though the city council appointed all the school board members. Semans, interview.

88. Quoted in Young, *In the Public Interest*, 172. The eleven southern state LWVs made up only 15 percent of league membership nationwide. Six of the southern chapters included African American members—mostly from historically black colleges—comprising less than one hundred black members throughout the region.

89. Three years later, after the conservative white South had launched a campaign of massive resistance to school integration, Percy Lee, the LWV president, continued to justify the southern LWVs' refusal to back school desegregation. Ibid., 172–73.

90. *Durham LWV Bulletin*, November 1953, January 1954, 10 January 1957, box 3, Winifred Gail Soules Bradley Papers, DU. Not all southern leagues remained aloof. In Atlanta and New Orleans, league women worked actively to keep pub-

lic schools open in the face of segregationist attempts to close them and divert public funds to private schools. Their efforts did not necessarily indicate support for school desegregation, although by the 1960s this attitude was beginning to change. Bartley, *Rise of Massive Resistance*, 54–55; Nasstrom, "Politics of Historical Memory," 141–43; Tyler, *Silk Stockings*, 220, 228–29.

91. Young, *In the Public Interest*, 146. The North Carolina LWV was first organized in Greensboro in 1920, and, like the national LWV, it was an outgrowth of the woman suffrage movement, in this case the North Carolina Woman Suffrage Association. After the state LWV disbanded in 1937, a statewide organization was reorganized in 1943, and a Durham chapter was established in 1947. Coates, *By Her Own Bootstraps*, 88; *Durham LWV Bulletin*, March 1967, box 4, Bradley Papers, DU.

92. Beginning in the 1920s, the national LWV's broad support for voting rights drew it into a prolonged battle over legislative reapportionment, which it usually viewed in urban versus rural terms rather than racial terms. Both the North Carolina and the Durham LWV supported legislative reapportionment by appealing to broad principles of democracy and citizenship while ignoring the implicit racial inequities. *Durham LWV Bulletin*, June 1953, 10 January, 29 April 1957, box 3, Bradley Papers, DU; Young, *In the Public Interest*, 171–72.

93. NAACP youth chapters even sought out LWV support in the early 1960s after joining the federal Voter Education Project (see chapter 6). N.C. Conference of Youth and College NAACP Chapters, minutes of the Executive Committee meeting, 17 February 1962, McKissick Papers, SHC; Durham LWV membership list, 1966, LWV Papers (Durham chapter), DU; *Durham LWV Bulletin*, November 1964, box 4, Bradley Papers, DU; Hugh Price, "FCD: A Unique Experiment in Community Development," March 1972, 19, box 81, NCF Papers, series 1.8.

94. Braden to George [Weissman], 21 February 1959, Committee to Combat Racial Injustice Papers, State Historical Society of Wisconsin, University of Wisconsin, Madison, Wisc.; Levine, *Degrees of Equality*, 67–135; Lynn, *Progressive Women*; Arlene Kaplan Daniels, *Invisible Careers*. For a discussion of the civil rights activism of Anne Braden (and other white southern "dissenters") in the 1950s, see Fosl, *Subversive Southerner*, esp. chapters 6–8. Both black and white women filled a public void left by the South's historic reluctance to provide social and municipal services. See, for example, Anne Firor Scott, *Southern Lady*, ix–xii, and *Natural Allies*; Gilmore, "She Can't Find Her [V. O.] Key," 152; Sims, *Power of Femininity*. The term "doldrums" was coined by Rupp and Taylor in *Survival in the Doldrums*. For an early corrective to the "doldrums thesis," see Meyerowitz, *Not June Cleaver*.

95. Semans, "The Right to Excel," unpublished typescript, 1957, box 69, Semans Family Papers, DU. See also Fosl, *Subversive Southerner*, 116, 118.

96. Sosna, *Silent South*, 172; Egerton, *Speak Now*, 549. For a discussion of white southern liberalism and progressivism in North Carolina, see Chafe, *Civilities and Civil Rights* and *Never Stop Running*, 38–42, 87–92.

97. Adam Fairclough's study of the Louisiana civil rights movement makes this point. *Race and Democracy*, xiii, 136–47. See also Dunbar, *Against the Grain*, 221, 224, 258, and Kelley, *Hammer and Hoe*, 227–31.

98. Both Chafe and Egerton present this perspective, though in somewhat different versions. Chafe, *Civilities and Civil Rights*, 42–49; Egerton, *Speak Now*, 615–27.

99. Semans, interview.

100. CT, 29 August 1953; Semans, interview; Ruth Dailey, interview; Hobby, interview. Social position did not always shield prominent white women from white retaliation, as Fosl's study of Anne Braden and Pam Tyler's account of New Orleans activist Rosa Freeman Kellor reveal. Fosl, *Subversive Southerner*; Tyler, *Silk Stockings*, 206. Similarly, Virginia Durr, a white activist from Montgomery, was subjected to harassment from white supremacists in Congress despite her prominent family and political connections to the Supreme Court and Congress. Chappell, *Inside Agitators*, 54; Virginia Durr, *Outside the Magic Circle*. See also Boyle, *Desegregated Heart*.

101. DMH, 29 August 1948, quoted in Uesugi, "Mary Price," 303; Ames quoted in Hall, *Revolt against Chivalry*, 9–10. Price, who later married, conceded that marriage would most likely have prevented her from running for governor on the Progressive Party ticket, but only, she insisted, because it would have created time constraints. Indeed, women without children certainly had more time to devote to civic activism. However, in the early 1950s, white, married women were just as likely to join voluntary associations as unmarried women were, although this willingness did not necessarily translate into liberal attitudes on race.

102. There is no evidence that any of the Durham women discussed in this book were lesbians, but single women, regardless of sexual orientation, were already perceived as "deviant," especially in the postwar South. Barbara Benedict, whose impact on students will be discussed in the next chapter, and who later married, broke tradition by living off campus with another female from Duke. Apparently, her living arrangements were unconventional enough to justify an explanation in her annual report to the Duke Woman's College dean. Benedict, Report of the Associate Director of Religious Life, Duke University, 1956–57, box 6, Duke YWCA Papers.

103. Braden to George [Weissman], 21 February 1959, Committee to Combat Racial Injustice Papers, Madison, Wisc. Minnie Bruce Pratt and Mab Segrest are more recent examples of white southern lesbians who became antiracist activists. On the links between Smith's and Lumpkin's sexuality and racial politics, see Gladney, *Letters of Lillian Smith*, xvi; Hall, "Open Secrets"; Hobson, *But Now I See*, 21–22, 37, 50–51; Hale, *Making Whiteness*, 273–77; and Clayton, "Lillian Smith," 92–114. For the debilitating impact of homophobia on civil rights activist Bayard Rustin, see D'Emilio, *Lost Prophet*. Fosl suggests that elite, married white women who were activists in the South enjoyed a "shield" of male protection, although support for racial justice could easily limit or erode that protection. *Subversive Southerner*, 124.

104. Droll, Durham YWCA visit reports, 12 December 1957, 29–30 January, 2 December 1959, all in Natl. YWCA Papers.

105. Fairclough, *Race and Democracy*, xiii.

1. McCoy, interview by Chris Howard; Chris Howard, "Eyes on the Prize," 113–14; *Campus Echo* quoted in ibid., 116; CT, 25 May 1963.
2. The NAACP called on top branches in cities across the nation to show their outrage at events in Alabama by staging supportive demonstrations. The 1963 protests compelled President Kennedy to meet with 1,600 leaders between May 22 and July 19 to build support for federal civil rights legislation. CORE helped initiate protests throughout the state in Durham, Raleigh, Greensboro, High Point, Charlotte, and Winston-Salem. CT, 10, 18 May 1963; *CORE-lator*, July 1963, Civil Rights series, box 4, Spaulding Papers, DU; Chafe, *Civilities and Civil Rights*, 128–52; Meier and Rudwick, *CORE*, 171, 217; Carson, *In Struggle*, 90; Steven F. Lawson, *Running for Freedom*, 89; Chafe, *Unfinished Journey*, 214.
3. This history of black women's activism adds a critical dimension to the debates over the meaning and impact of *Brown* on both white opposition and black insurgency. See Christina Greene, "New Negro Ain't Scared."
4. Glen Eskew disputes these links in *But for Birmingham*.
5. Recent work on women in the civil rights movement suggests the need to expand traditional definitions of leadership. See, for example, Ransby, *Ella Baker*; Lee, *For Freedom's Sake*; Nasstrom, "Down to Now"; Barnett, "Invisible Black Women Leaders"; Robnett, *How Long? How Long?*; and Olson, *Freedom's Daughters*.
6. This pattern was repeated in countless towns and cities throughout North Carolina and the Upper South. Chafe, *Civilities and Civil Rights*.
7. DMH, 25 June 1957; CT, 20 July 1957. On the Royal Ice Cream sit-in, see also Naomi Kaufman, "Durham Sit-in Helped Change Racial Patterns," *Daily Independent*, 16 December 1979; Morris, *Civil Rights Movement*, 198; Foy, "Durham in Black and White," 34–38.
8. Moore's account of the sit-in paints it as a rather spontaneous event, although the students were part of a youth group that had been meeting with Moore and Floyd McKissick for some time to discuss current events and racial problems. Initially, seven youth had entered the Royal Ice Cream Parlor with Moore, but one male left before police arrived. The Hill case was related by Alma Turner at the 1994 Durham Civil Rights Reunion. Videotapes of the conference are in the James E. Shepard Library, North Carolina Central University, Durham, N.C.
9. The accuracy of this claim is difficult to assess. Since there were no arrests and therefore no court records or newspaper accounts, it rests entirely on oral histories. Nevertheless, a number of local activists have corroborated this version of events, including Floyd McKissick and student leaders John Edwards and Lacy Streeter. Chris Howard, "Eyes on the Prize," 31–32. Other challenges to racial segregation in the 1950s have been documented, including the student protest against Umstead State Park. Comments regarding closing restrooms at the Durham bus station made by John Edwards, 1994 Durham Civil Rights Reunion, James E. Shepard Library, NCCU; Floyd McKissick interview, DOHC; Morris, *Civil Rights Movement*, 198.
10. Moore had studied at NCC in the late 1940s and later transferred to Boston University in the early 1950s. There, he met fellow student Martin Luther King Jr.,

but Moore's activism branded him a "radical," and the studious King remained aloof. In 1956, Moore returned to Durham to pastor the Asbury Temple Methodist Church and made numerous attempts, most single-handed and all unsuccessful, to desegregate several public facilities in Durham. After the Greensboro sit-ins, Moore and McKissick helped to notify blacks throughout the South. Kennington, "Royal and the Elite"; CT, 20 July 1957; Campus Echo, 29 September 1956; Branch, Parting the Waters, 93; Douglas Moore, interview; N.C. NAACP, "In Action for Freedom," ca. 1957, 5, box 23, KA Papers; Durham Sun, 24 June 1957.

11. CT, 11 May 1957, 6, 13, 20, 27 April 1957; Chris Howard, "Eyes on the Prize," 26.

12. Quoted in Kennington, "Royal and the Elite," 11.

13. CT, 2 April 1952, 1, 15 June 1957. The reason behind Moore's neglect to enlist Austin remains a mystery. Austin, whose newspaper did not cover the sit-in until a month after it occurred, heard about the arrests from a radio broadcast, and Floyd McKissick was out of town the day the sit-in occurred. The paper's silence may have been designed to buy time while the black community debated how to proceed. The CT often agreed not to release news or to time the release of certain stories to coincide with other black interests or goals. Austin to John Wheeler, 30 July 1957, Floyd B. McKissick Papers, SHC.

14. Minutes of the DCNA Economic Committee, 24 July 1957; Annual report of the Economic Committee of DCNA, 12 January 1958; Proposed program of the Economic Committee of the DCNA, all in McKissick Papers, SHC. Moore's comments regarding Coletta support the contention of David Roediger and others regarding the social construction of whiteness and the fact that European immigrants frequently were considered to be nonwhite or members of minority groups. "Whiteness and Ethnicity." See also Jacobson, Whiteness; Allen, Invention of the White Race; Sacks, "Jews Become White Folks"; Douglas Moore, interview; and Hamilton and Schliep, "Royal Ice Cream Company."

15. The timing of demonstrations against Royal Ice Cream is unclear; some report six years of picketing, while other sources show that pickets emerged in the 1960s. Whether or not blacks organized an official boycott, many may have participated in an unofficial boycott. There is also contradictory evidence regarding the number of female pickets. Vivian McCoy, one of the teen pickets, remembers that the group was about evenly split among males and females. However, Bill Crumpton interviewed other participants who claim that females were in the majority. Despite these discrepancies, it is clear that Royal Ice Cream became a symbol of the daily indignities Durham blacks endured, particularly due to its location on the edge of a black working-class community. Floyd McKissick, interview by Chris Howard; Douglas Moore, interview; Kennington, "Royal and the Elite," 11; Morris, Civil Rights Movement, 198; Hamilton and Schliep, "Royal Ice Cream Company," 11; CT, 20 July 1957; Crumpton, "Royal Ice-Cream Sit-in"; McCoy, interview by the author.

16. CT, 9 March 1963; McCoy, interview by the author.

17. The project in Durham initially involved black groups and then in 1958 expanded to become an interracial endeavor. Greensboro launched an almost identical project, also under the direction of the American Friends Service Committee.

Chafe, *Civilities and Civil Rights*; Mayes Behrman, "Report to Harry S. Jones," 24 October 1958; Ray Thompson (DCNA) to Henry Catchings (American Friends Service Committee), 9 July 1956; Catchings to Thompson, 20 July 1956; N. B. White to Henry Alston (National Urban League), October 1956; Alston to White, 17, 26 October 1956; Survey of Work Done by the Economic Committee of the DCNA, 6–8 December 1956; Southeast Region Proposal: Merit Employment Survey, Durham, N.C., n.d.; Minutes of luncheon meeting of the DCNA Executive Committee, 15, 29 November, 31 December 1958; "What Makes Durham Tick," unpublished typescript, ca. 1962, all in McKissick Papers, SHC; *American Friends Service Committee Southeast Regional Office Bulletin*, Fall 1959, 2, Organizations—box 5, Asa T. Spaulding Papers, DU.

18. Just one month before the sit-in, R. Kelly Bryant, one of the first two black registrars in Durham County and an officer with the Business and Professional Chain, proposed to the DCNA that a boycott and pickets be organized against a building owner who refused to rent to black businesses despite the fact that blacks were 95 percent of the clientele in the targeted building. CT, 25 May, 13 April 1957, 6 May 1950.

19. Ibid., 29 May 1954.

20. Report of the DCNA Education Committee, 1957, box 7, William A. Clement Papers, SHC; CT, 2 April 1954.

21. Petition to the Board of Education of the public school district of Durham, N.C., 11 July 1955, box 7, William J. Kennedy Papers, SHC; CT, 16 July 1955; Foy, "Durham in Black and White," 51.

22. DMH, 30 July 1957, Clippings File, NC Coll.; Foy, "Durham in Black and White," 42, 52; DCNA Education Committee to the N.C. Advisory Committee of the U.S. Commission on Civil Rights, draft, n.d., William A. Clement Papers, box 7, SHC; CT, 16, 30 July 1955; W. A. Clement and D. Eric Moore, Statement to Board of Education, 13 April 1959; Minutes of the Durham Board of Education, 13 April 1959, both in Rencher Harris Papers, DU.

23. Chafe, *Civilities and Civil Rights*, 50–60, 64–65; Douglas, *Reading, Writing, and Race*, 25–49; Karpinos, "With All Deliberate Speed," 13, 14.

24. Chafe, *Civilities and Civil Rights*, 76.

25. As part of the Pearsall Plan, these three cities were urged to make the minimal sacrifice (by instituting token desegregation) so that segregated schools throughout the state could remain unhampered by federal intervention. Durham initially was selected for this strategy, but the idea was never pursued there. Ibid., 64–65.

26. Minutes of the DCNA Education Committee, 15 May 1957; Report of the DCNA Education Committee—1957, 12 January 1958, both in box 7, William A. Clement Papers, SHC; Douglas, *Reading, Writing, and Race*, 48, 46. James Patterson notes the importance of several grassroots organizers to NAACP lawsuits during the 1950s, although he does not specifically explore black women's unique contributions. *Brown v. Board.*

27. For example, the DCNA claimed that Mr. Hennessee "would be of invaluable service," but after he was unable to secure a single name in two weeks the DCNA

turned to neighborhood women, whom everyone agreed had "been quite successful in securing plaintiffs from the Walltown area." Minutes of the DCNA Education Committee, 15, 22, 29 May 1957, box 7, William A. Clement Papers, SHC.

28. Robnett, *How Long? How Long?*, 20–21. Anthropologist Karen Sacks refers to women who perform such organizing activities as "centerwomen." "Gender and Grassroots Leadership," 77–94. Ransby, *Ella Baker*, 114, 135–37; DCNA Subcommittee on Education to Rev. C. E. McLester and W. A. Clement, n.d., box 7, William A. Clement Papers, SHC; William Fuller to Warren Carr, 1 February 1958, Civil Rights series, box 3, Spaulding Papers, DU; Floyd McKissick, interview by Chris Howard. According to Barbara Ransby, Ella Baker understood that without simultaneous mass campaigns, NAACP legal victories "were shallow and short lived." *Ella Baker*, 139.

29. The NAACP state conference presented an achievement award to the youth branch for securing the most school reassignment requests in North Carolina. Foy, "Durham in Black and White," 65–66, 69; Karpinos, "With All Deliberate Speed," 21; *Raleigh News and Observer*, 21 August 1958, Clippings File, NC Coll.; Minutes of the DCNA Education Subcommittee, 17 April 1956; Minutes of the DCNA Finance Committee, 4 November 1958, both in box 7, William A. Clement Papers, SHC; "Elementary Requests Denied Tuesday," 25 August 1959, box 9, Harris Papers, DU; 1960 Awards, Plaques, Certificates and Citations, box 23, KA Papers.

30. Quotes from Chris Howard, "Eyes on the Prize," 27. See also J. H. Wheeler and C. E. Boulware to Asa Spaulding, 23 December 1957; *Norfolk Journal and Guide* (Carolina edition), 28 December 1957; DMH, 11 March 1958, all in Civil Rights series, box 2, news clippings, Spaulding Papers, DU; Rev. Warren Carr to Rencher Harris, 22 January 1958, box 7, Harris Papers, DU; Burgess, *Negro Leadership*, 127–32; and Keech, *Impact of Negro Voting*, 67.

31. Cannon, "Black Political Participation," 87–93, 97; Harris to F. L. Fuller, 15 July 1959; Fuller to Harris, 18 July 1955, both in box 9, Harris Papers, DU; Foy, "Durham in Black and White," 55–56, 63–64, 67–69.

32. Foy, "Durham in Black and White," 64–66; Karpinos, "With All Deliberate Speed," 17–18; "Special Meeting—Board of Education," 28 August 1959; "Elementary [School Student] Requests Denied Tuesday August 25, 1959 Who Have Asked for Hearing," both in box 9, Harris Papers, DU; Floyd McKissick, interview by Chris Howard.

33. Karpinos, "With All Deliberate Speed," 18, 21, 22, 30; Chafe, *Civilities and Civil Rights*, 76.

34. Although more boys than girls appealed the school board's August 1959 refusal to grant reassignment (except on the high school level, where girls outnumbered boys nineteen to thirteen), in future years girls often constituted the majority of reassignment requests. More black girls than black boys desegregated Durham schools in the early years. Karpinos, "With All Deliberate Speed," 23–28; Foy, "Durham in Black and White," 73. For lists of students requesting reassignment, see Minutes of the Board of Education meetings for 3 September 1957, 25, 28

August, 21 September 1959, 24 August 1960, 27, 31 July, 2 August 1961, 25, 26, 28 June, 11 July, 1, 20 August 1962, 21 January, 16 April 1963, Main Administration Building, Durham Public Schools, Durham, N.C. By 1964, the Durham school board had ceased to include the names of students requesting reassignment in school board minutes.

35. Anecdotal evidence suggests that lost athletic opportunities for boys may also explain some of the discrepancy, since white schools tended to penalize black male athletes. In an oral history project on school desegregation in North Carolina currently underway through the Southern Oral History Program that includes Durham, interviewees reported an acute sense of loss when officials failed to move athletic trophy cases from black schools into the newly desegregated, formerly white schools. It is equally likely that the tiny number of black boys accepted to Durham High School (one each in 1959 and 1960) reflected white fears even more than those of black parents. Demographic explanations are not pertinent, since the black sex ratio in Durham below age eighteen was fairly even in 1960. Lindland, "Beyond the Law," 2–3; McCoy, interview by Chris Howard; Joycelyn McKissick, interview; Joycelyn McKissick presentation, Black History Month, 1993; Cole-McFadden, interview; Audrey Mitchell and Harrison Johnson, 1994 Durham Civil Rights Reunion, James E. Shepard Library, NCCU. For a moving account of the physical and emotional torment that one black family suffered after desegregating public schools in Drew, Mississippi, see Curry, Silver Rights.

36. The widely publicized 1958 "Kissing Case" in nearby Monroe, North Carolina, in which two boys aged eight and ten were arrested and sentenced to a juvenile correctional institute for allegedly kissing three white girls, occurred less than two weeks after Robert Williams, head of the Monroe NAACP, and his wife, Mabel, petitioned the Monroe school board to transfer their sons to an all-white elementary school. The case became a national and international cause célèbre and received extensive coverage in the Carolina Times; state NAACP leaders even made a belated appeal to Durham blacks on behalf of the boys. Tyson, Radio Free Dixie, 93, 98–99, and chapters 4 and 5; CT, 20 December 1958.

37. John Edwards to Herbert Wright, 14 September 1961; Gloster Current to Floyd McKissick, 6 October 1961, both in box E12; CT clipping, box C112, all in part 3, NAACP Papers; Evelyn McKissick quotation in Lindland, "Beyond the Law," 7.

38. Two years earlier, Charlotte, North Carolina, had drawn national attention when a white mob terrorized Dorothy Counts, the lone black student who tried to enter an all-white high school. Similarly, Lucy Mae Jones recollected the hostile signs, the insults, and the ominous silence that greeted her as she stepped out of the car that first day. Charles W. Davis to W. A. Clement, 11 March 1959; Confidential—Minutes of American Friends Service Committee School Desegregation Program Committee, 14 June 1960, High Point, N.C., both in box 7, William A. Clement Papers, SHC; Douglas, Reading, Writing, and Race, 72.

39. Shaw, What a Woman Ought to Be.

40. Joycelyn McKissick presentation, Black History Month, 1993.

41. Lindland, "Beyond the Law"; CT, 18 October 1952.

42. Quoted in Lindland, "Beyond the Law," 7.
43. More severe forms of violent reprisal were directed against male activists who participated in street protests, several of whom received death threats. Ibid., 8; Statement of Andree McKissick—Durham High School, 30 May 1963, Civil Rights series, box 4, Spaulding Papers, DU.
44. Statement of Frances Marrow—Carr Junior High School; Statement of Claudia Dixon—Durham High School, both 30 May 1963, Civil Rights series, box 4, Spaulding Papers, DU; Floyd McKissick, interview by Chris Howard; Joycelyn McKissick presentation, Black History Month, 1993; Maxine Bledsoe Thorpe and Harrison Johnson, 1994 Durham Civil Rights Reunion, James E. Shepard Library, NCCU; McCoy, interview by Chris Howard.
45. Both quotations in Lindland, "Beyond the Law," 11.
46. Quoted in Gallo, "Emergence of Direct Action," 19.
47. Ibid., 18. The Asheville meeting Gallo dates as 1958 is probably a reference to the 1959 Asheville meeting. Annual report of the 16th annual conference of the N.C. State Conference of NAACP Branches, Asheville, N.C., 8–11 October 1959; Agenda of the N.C. State Conference of NAACP Branches, 30 January 1960, both in box 23, KA Papers.
48. For a discussion of the network of activists who contacted each other in the first days of the sit-in movement, see Ransby, *Ella Baker*, 238; Branch, *Parting the Waters*, 272–73; and Morris, *Civil Rights Movement*, 199–203. Although Morris claims that the sit-ins grew out of activist church networks rather than among student groups, there was considerable overlap among these networks.
49. DMH, 8, 9 February 1960; CT, 13 February 1960.
50. DMH, 8 February 1960. Since the national NAACP refused to back the direct action protests, Greensboro NAACP head George Simpkins had contacted CORE, which sent a field secretary to North Carolina. Chafe, *Civilities and Civil Rights*, 84.
51. Several individual blacks denounced the protests, but not one black organization in the state opposed the demonstrations. CT, 13, 20 February 1960; N.C. Council on Human Relations, "Special Report: The Sit-in Demonstrations; What Do They Mean? What Will the Outcome Be?," 30 April 1960, Civil Rights series, box 3, Spaulding Papers, DU; DMH, 8 February 1960.
52. CT, 20 February 1960; DMH, 17 February 1960.
53. Arrest records can be misleading, however, for police seemed more prone to arrest males, who usually received harsher sentences. For lists of student protesters, see McKissick Papers, SHC, and Petition for writ of certiorari to the Supreme Court of North Carolina, Statement, ca. January 1961, box 26, KA Papers. Written, anecdotal, and photographic evidence confirms that black women were frequently a majority of protesters, although they did not always outnumber men. Chris Howard claims that women constituted the majority of what he calls the "third level" of the Durham movement, that is, the participants in mass protest. Chris Howard, "Eyes on the Prize," 49; Thorpe Nichols, interview; Cole-McFadden, interview. On the use of photographic evidence for documenting women's participation in the freedom movement, see Black Panther Party member Kathleen Cleaver's statement in Harley, "Chronicle of a Death," 177.

54. CT, 13, 27 February, 5 March 1960; DMH, 9, 17 February 1960; Durham Sun, 17 February 1960; Sindler, "American Negro Protest Movement," 25–26; Douglas, Reading, Writing, and Race, 65.

55. Mawhood, "African-American Beauty Parlors"; CT, 5, 12, 19 March 1960; Floyd McKissick to Gloster Current, 21 May 1960, box C112, part 3, NAACP Papers.

56. Warren Carr, a white liberal, was pastor at Watts Street Baptist Church. No list of the meeting's attendees exists, but in interviews and descriptions of these meetings no women were mentioned. Sindler, "American Negro Protest Movement," 28.

57. DMH, 9, 10 February 1960; CT, 13 February 1960.

58. Twenty-two percent of whites described themselves as moderate on integration or desegregation. The poll was countywide, but the city of Durham constituted the largest population center in the county. Chris Howard, "Eyes on the Prize," 38; DMH, 31 March 1960; Sindler, "American Negro Protest Movement," 27, 71.

59. CT, 19 March 1960; DMH, 5 March 1960.

60. Edward Opton to NAACP members, 28 May 1961, McKissick Papers, SHC. As late as 1961, the Duke student government denied the campus NAACP a charter. Duke finally voted in 1962 to desegregate its undergraduate schools (the Divinity School had already desegregated), and the first African American undergraduates entered Duke in 1963.

61. Chestnutt, interview; Benedict, Annual report of the associate director of religious life, Woman's College, Duke University, May 1961, box 6, Duke YWCA Papers; Duke Chronicle, 10, 12 February, 14 March, 11 April 1960. In a Duke student referendum in the spring of 1960, 56 percent of the undergraduate West Campus (that is, male) student body and 66 percent of the graduate students and faculty supported desegregating the university.

62. Sara Evans later became a prominent feminist historian, and Charlotte Bunch emerged as an internationally recognized lesbian theorist-activist. Evans, interview; Bunch, interview. For more on student YWCAs and on the Duke YWCA, see Wilkerson, Interracial Programs, and Christina Greene, "Our Separate Ways," 62–78, 221–27. Historian Doug Rossinow links the emergence of white southern student activism in the 1950s and 1960s to shifts in secular liberalism and the rise of Christian existentialism. See Politics of Authenticity, esp. chapters 2 and 3.

63. Benedict, Annual report of the associate director of religious life, Duke YWCA Papers. Articles in the Duke Chronicle throughout the spring of 1960 confirm this view. Chestnutt, interview. On Benedict's efforts to desegregate Duke's dining facilities in the 1950s, see correspondence to President Hollis Edens, box 31, Edens Papers, University Archives, Perkins Library, Duke University, Durham, N.C., and Minutes of the Faculty Program of the Duke University Religious Council, 1956–58, box 6, Duke YWCA Papers.

64. Receipt from Southern Fidelity Mutual Insurance Co. for bond payments for Joan Harris Nelson et al., 1 July 1960; Duke Christian Action Commission, Bulletin Concerning the Protest against Racial Discrimination at the Movies in Durham 20 January 1961, both in McKissick Papers, SHC.

65. After leaving Duke, Joan Nelson Trumpauer went to Washington, D.C., where

she joined the D.C. Area Non-Violent Action Group, a SNCC affiliate at Howard University. Later, she attended Tougaloo College, a black college in Mississippi, where she met Anne Moody and became one of the most dedicated white activists in Mississippi. Thirty-five years later at a Durham civil rights reunion, a number of former NCC student activists still remembered her dedication and commitment to black freedom. Moody, *Coming of Age*, 251, 266, 272, 306–9, 339; Schultz, *Going South*, 38–40; Carson, *In Struggle*, 30, 72, 103–4; Payne, *Light of Freedom*, 286; Robert Markham, 1994 Durham Civil Rights Reunion, James E. Shepard Library, NCCU; Trumpauer to Floyd McKissick, 10 March 1961, McKissick Papers, SHC; Markham, conversation.

66. Annual report of the Duke University YMCA, 1959–60, box 6, Duke YWCA Papers; *Duke Chronicle*, 13, 16 May 1960; McLaurin, interview.

67. DMH, 8, 9 March, 20 December 1961, clippings in McKissick Papers, SHC. White harassment and violence against blacks is discussed in the next chapter. For a fictionalized account of white retaliation against economically independent blacks in the 1940s through targeting their neighbors, families, and even domestic help, see Parker, *These Same Long Bones*.

68. *Durham Sun*, 4 March 1960, clipping, Civil Rights series, box 4, Spaulding Papers, DU.

69. McKissick to Peoples, 5 March 1960, McKissick Papers, SHC; *Durham Sun*, 4 March 1960, clipping, Civil Rights series, box 4, Spaulding Papers, DU. (Several other letters of support from white southern women are collected here as well.)

70. Semans, Untitled typescript, March 1960, box 69, Semans Family Papers, DU; *Durham–Chapel Hill WILPF Newsletter*, May 1960, in author's possession.

71. Sindler, "American Negro Protest Movement," 28–35; McKissick et al. to Reverend Carr, 9 April 1960; Nelson Strawbridge (Human Relations Committee chair) to McKissick, 12 May 1960; Strawbridge to Walter Biggs (mayor pro tem), 13 May 1960; C. M. Purdy (Woolworth's manager) to Strawbridge, 16 May 1960, Strawbridge to S. H. Kress and Co., 19 July 1960, all in Civil Rights series, box 3, Spaulding Papers, DU.

72. Annual report of the N.C. Conference of NAACP Youth and College Chapters, 1 January 1961–27 January 1962; "What Makes Durham Tick," unpublished typescript, undated, both in McKissick Papers, SHC; "23 Stores in Durham Add Negro Employees in NAACP Drive," 6 May 1961, box C112, part 3, NAACP Papers.

73. Relations between the national office and Durham youth were not always so smooth; on President Kennedy's 1961 visit to Durham and the ensuing conflict over Durham NAACP plans to protest airport segregation, for example, see Herbert Wright to Dr. Morsell, 13 October 1961; Durham youth to John F. Kennedy, telegram regarding segregation at Durham Airport, 9 October 1961, both in box E12, part 3, NAACP Papers.

74. NAACP Commandos, Expenses, 19–26 July 1963, box E12, part 3, NAACP Papers. Perhaps in an effort to attract more male participation, a proposal for a 1964 summer Commando program suggested that an adult advisory board be established on a "2–1 basis, men-women." Commando program, undated, box E47, part 3, NAACP Papers.

75. In June 1963, the Commandos were forced to make a hasty retreat from Monroe, North Carolina, after militant blacks (once under the leadership of ousted NAACP president Robert Williams, who was then in exile in Cuba) rejected their nonviolent tactics. According to Joycelyn McKissick, Monroe was the most "frightening" town the Commandos visited that summer. Annual report of the N.C. Conference of NAACP Youth Chapters, 1961–62; Laplois Ashford to Mr. Wilkins, 13 June 1963, both in box E47, part 3, NAACP Papers; Joycelyn McKissick, interview; Baker, interview; McCoy, interview by Chris Howard.

76. CT, 25 May 1963. Historian Robin Kelley revealed a similar pattern in Birmingham. "Birmingham's Untouchables."

77. It is not clear from McLaurin's remarks if the church received the bomb threat that night or at another time. McLaurin, interview.

78. McCoy, interview by Chris Howard; Floyd McKissick, interview by Chris Howard; Joycelyn McKissick, interview; McLaurin, interview.

79. McCoy, interview by Chris Howard; Cole-McFadden, interview; Margaret Turner, 1994 Durham Civil Rights Reunion, James E. Shepard Library, NCCU.

80. The Fruit of Islam was the paramilitary arm of the Black Muslims. NCC football players also volunteered as personal bodyguards for Floyd McKissick. Tyson, *Radio Free Dixie*, 308; CT, 25 May 1963; Floyd McKissick, interview by Chris Howard; Bates, *Long Shadow*, 158–59, 162–63, 172, 174; Branch, *Parting the Waters*, 174, 179.

81. Perhaps hoping to dispel white fears, McKissick wrote a note of appreciation to both FBI director J. Edgar Hoover and his assistant, William Sullivan, after Sullivan gave a talk, "The Negro Faces Communism," at Shaw University and at the North Carolina Mutual Life Insurance Company. Despite FBI objections, McKissick did legal work for the Nation of Islam and even spoke at the local mosque on occasion. Black students also frequented the Muslim restaurant in town. McKissick never became a Muslim, but by the middle of the decade he publicly embraced Black Power and presided over CORE's ouster of whites from the organization. Several years later, McKissick underwent another shift and backed Richard Nixon (see chapter 6). McKissick to Sullivan, 8 April 1963, McKissick Papers, SHC; *Daily Tar Heel*, 10 April 1963, Clippings File, NC Coll.

82. Floyd McKissick to Basil Patterson, 1 May 1962, McKissick Papers, SHC; Edwards, interview; Baker, interview; Streeter, interview; McCoy, interview by Chris Howard; Joycelyn McKissick, interview; Chris Howard, "Eyes on the Prize," 83–86.

83. Joycelyn McKissick, interview; Edward Opton, Annual report of the N.C. Conference of NAACP Youth and College Chapters, 1 January 1961–27 January 1962, NAACP folder; Floyd McKissick to John Edwards, 24 January 1963; Edward Opton to Alfred Lewis, 25 September 1963; Opton to Lewis, 13 October 1963, all in McKissick Papers, SHC; Baker, interview; Edwards, interview; Floyd McKissick, interview by Chris Howard.

84. *Durham Sun*, 31 July 1962, clipping, box C112, part 3, NAACP Papers. Floyd McKissick, whose links to CORE extended back to the 1940s when he had participated in the Journey of Reconciliation—an early freedom ride—eased tensions and provided a bridge between the two civil rights organizations. However,

by 1964 Floyd McKissick had left the NAACP, and he soon became national chair of CORE.

85. C. D. Banks, Notes for Mr. Wilkins, n.d.; DMH, 31 July 1962, clipping, both in box C112, part 3, NAACP Papers; CT, 25 August 1962.

86. CT, 25 August 1962.

87. "What Makes Durham Tick," unpublished typescript, ca. 1962, McKissick Papers, SHC.

88. CT, 1 September 1962; Chris Howard, "Eyes on the Prize," 62–63.

89. CT, 1 September 1962.

90. Ibid., 20, 2 October 1962; Chris Howard, "Eyes on the Prize," 74.

91. For evidence of fragmentation and apathy among black students at NCC and within the movement, including problems within the NAACP, see Floyd McKissick to John Edwards, 24 January 1963; Edward Opton to Alfred Lewis, 25 September, 13 October 1963; Quinton Baker, "An Open Letter to the North Carolina College Community," 4 April 1963, all in McKissick Papers, SHC.

92. Walter Riley (Durham NAACP), Quinton Baker (NCC NAACP), and Isaac Reynolds (CORE) to Durham Merchants Association, 18 February 1963; Riley, Baker, and Reynolds to Dear Valuable Friend and Supporter, 30 April 1963; Baker, "An Open Letter to the North Carolina College Community," 4 April 1963, all in McKissick Papers, SHC; Chris Howard, "Eyes on the Prize," 79–82; Baker, interview.

93. Durham Sun, 24, 26 April 1963; DMH, 25 April 1963.

94. DMH, 26 April 1963; Durham Sun, 30 April 1963; CT, 18 May 1963.

95. DMH, 8, 14 May 1963; Petition of Parents and Citizens of the East End Community to the Durham Board of Education, n.d.; "To the Durham Board of Education from the East End Betterment League and 378 Parents and Citizens in the East End School Zone," 6 May 1963; DMH, 13 May 1963, clipping, all in McKissick Papers, SHC.

96. Figures on student enrollment at East End Elementary School vary from 715 to 750. DMH, 3, 8 May 1963; Smith, interview; Chris Howard, "Eyes on the Prize," 86–88; Report of the Mayor's Committee on Human Relations to Mayor Evans on the East End School Controversy; Plaintiffs' Opposition to the Defendants' "Plan for Further Desegregation of the Durham City Schools" in Warren Wheeler et al. v. Durham City Board of Education and C. C. Spaulding III et al. v. Durham City Board of Education, both in Civil Rights series, box 4, Spaulding Papers, DU.

97. Grabarek was originally from Pennsylvania. He had come to Durham as a young man during World War II, and after the war he married a local woman, became an accountant, and served on the city council from 1957 to 1961. Allan Sindler, a young Duke professor, was a participant-observer during the May demonstrations, and much of my discussion here is based on his account. Sindler, "American Negro Protest Movement," 38–53, 79, 74; Chris Howard, "Eyes on the Prize," 103–39.

98. Carr, interview.

99. Grabarek, interview.

100. Documentary evidence, particularly photos, provides an invaluable confirmation

of both the written and anecdotal evidence regarding female participation in the civil rights movement. On the May 1963 demonstrations, see, for example, photos in the CT, 25 May 1963; "Durham Freedom Rally Held to Hear New Mayor Discuss Plans for Resolving Racial Discord and Discrimination," photograph in Waynick, Brooks, and Pitts, North Carolina, 62; and "Durham NC, Civil Rights Demonstration, 1963," photograph, box 21, Robert Preston Harriss Papers, DU. Although black males are clearly visible in each of these photographs, women constitute the majority of protesters in all of the photographs cited except for one of the Carolina Times photos. My thanks to Leslie Brown for her suggestions concerning documentary evidence.

101. Baker, interview; Chris Howard, "Eyes on the Prize," 111, 113, 119; Sindler, "American Negro Protest Movement," 41. Howard Johnson's was targeted not only because of its intransigence but also because it was a national chain and was therefore susceptible to outside pressure. In addition, former North Carolina governor Luther Hodges (who was then the secretary of commerce in the Kennedy administration) owned part of the Durham building and the land where the "HoJo" was located.

102. CT, 25 May 1963; Chris Howard, "Eyes on the Prize," 116, 109–20; Phelps, interview.

103. Both quotations in Chris Howard, "Eyes on the Prize," 123.

104. McLaurin, interview; "To Honorable R. Wensell Grabarek from NAACP-CORE Negotiating Committee and Negro Citizens of Durham Community," 24 May 1963, McKissick Papers, SHC; Durham Sun, 23 May 1963, clipping, Civil Rights series, box 4, Spaulding Papers, DU.

105. Carr, interview; Grabarek, interview; Chris Howard, "Eyes on the Prize," 123, 130. Although the city failed to adopt a fair employment practices law, over forty retail stores, six banks, and the three largest insurance firms agreed to exclude race as a factor in hiring decisions, which affected about 14,000 jobs.

106. Duke University and several businesses that had federal contracts were already operating without regard to race—at least on paper. The U.S. Supreme Court decision on 20 May 1963 in Avent v. North Carolina, 373 U.S. 375, and Peterson v. Greenville, 373 U.S. 244, voided Durham's trespass law and held that mandatory state segregation laws violated the Fourteenth Amendment, thus making Durham's 1947 ordinance unconstitutional. Waynick, Brooks, and Pitts, North Carolina, 63–76; Chris Howard, "Eyes on the Prize," 109–26, 133–34; Meier and Rudwick, CORE, 217–18; Sindler, "American Negro Protest Movement," 36–55; Keech, Impact of Negro Voting, 87.

107. A similar pattern was evident among boys. Charsie Herndon Hedgepath, who was also a plaintiff in the school desegregation lawsuits, would become the only woman officer in the Black Solidarity Committee, which waged a seven-month boycott against white Durham merchants in 1968–69.

108. Andree and Joycelyn McKissick's father, Floyd, was a well-known Durham attorney, but the family lived in the working-class East End. Handwritten notes by Buris Toomer and Liticia Thompson concerning the man who kicked Marva Bullock; Floyd McKissick to Basel Patterson, 1 May 1962; McKissick to Edwards.

1 December 1962, all in McKissick Papers, SHC; Floyd McKissick, interview by Chris Howard; DMH, 17 March 1962, clipping, Civil Rights series, box 3, Spaulding Papers, DU. A similar pattern was evident among male students. The fathers of John Edwards, president of the Durham NAACP youth chapter, and NCC student leader Callis Brown were tobacco workers. Edwards's mother was an elevator operator. These findings seem to contradict Matthews and Prothro's contention that middle-class status was the most salient predictor of black student participation in the movement; however, their interviews focused on the 1961–62 protest period and centered on sit-ins and freedom rides, in which middle-class students may have predominated throughout the South. Edwards, interview; Baker, interview; McCoy, interview by the author; Matthews and Prothro, *Negroes*, 418, 429–30, 489–95.

109. Cora's mother's fear for her safety points to a debate concerning gender and violence. Scholars and movement participants suggest one reason for the greater participation of women in the movement was that black men were more frequently the victims of violence. However, Charles Payne cites numerous instances of violence against black women and points out that whites directed economic and violent reprisals not simply against individuals but also against groups by bombing family homes or firing the relatives of activists. Payne finds that religious convictions and kinship and friendship networks provide better explanations for black women's greater civil rights activism. This study concurs with Payne's findings, suggesting similarities between rural and urban women's activism. Payne, "Men Led"; Ross, *Witnessing and Testifying*; Lynn, *Progressive Women*, 138; Cole-McFadden, interview. Little work has been done on the sexual vulnerability of black women activists. For a report on the strip searches and rapes of female civil rights activists arrested in Selma, see Associated Negro Press, "Bare Sexual Abuse of Negro, White Women Arrested in Dixie Civil Rights Demonstration," cited in Deborah Gray White, *Too Heavy a Load*, 194; see also McGuire, "Black Womanhood, White Violence."

110. Gallo, "Emergence of Direct Action," 32; DeShazor's NAACP Youth Council, 25 April 1960, McKissick Papers, SHC.

111. Floyd McKissick to John Edwards, 1 December 1962, McKissick Papers, SHC; Edwards, interview. For a discussion of titled positions and black women's leadership in SNCC, see Robnett, "Women in SNCC."

112. McCoy, interview by the author; Betty Bledsoe Allen and Alma Turner, 1994 Durham Civil Rights Reunion, James E. Shepard Library, NCCU; "Members Attending Churches to Make Announcements," ca. 1960, McKissick Papers, SHC.

113. Barbara Ransby has suggested that we think of leadership, perhaps especially black women's leadership, in horizontal as well as vertical terms. It is not surprising that NAACP youth chapters exhibited some of the nonhierarchical traits usually associated with SNCC. Rev. Douglas Moore and Durham NAACP youth members attended the founding meeting of SNCC in Raleigh, and Ella Baker, adult advisor to SNCC and a staunch proponent of group-centered leadership, made several visits to NCC during the 1960s. Ransby, *Ella Baker*, 240, 421; Robnett, "Women in SNCC."

114. Minutes of the meeting of the NAACP Youth Crusaders, 24 September 1961; Program of Durham NAACP youth councils and college chapters mass meeting, St. Joseph's AME Church, Durham, N.C., 20 March 1961, both in folder NAACP Youth Activities, 1960–1961, McKissick Papers, SHC.

115. McKissick, 1994 Durham Civil Rights Reunion, James E. Shepard Library, NCCU; McCoy, interview by the author.

116. Quite a few Durham women downplayed the significance of their contributions to the movement. Kathy Nasstrom found a similar historical amnesia about black women's participation in a 1946 voter registration drive in Atlanta. "Down to Now," 117.

117. Memo to Gloster Current re: Callis Brown, ca. May 1960; Floyd McKissick to Current, 21 May 1960, both in box C112, part 3, NAACP Papers; "What Makes Durham Tick," unpublished typescript, ca. 1962, McKissick Papers, SHC.

118. Royal to youth branch of the NAACP, 10 June 1963, McKissick Papers, SHC.

119. For example, Sadie Hughley became treasurer of CORE in 1964.

120. CT, 20 April 1963; McCoy, 1994 Durham Civil Rights Reunion, James E. Shepard Library, NCCU; Smith, interview.

121. "Civil Rights Movement in Durham: A Pictorial Perspective," Program of the 1994 Durham Civil Rights Reunion; Margaret Turner, 1994 Durham Civil Rights Reunion, both at James E. Shepard Library, NCCU. NCC NAACP president Quinton Baker recalled that working-class blacks attended some protest rallies and often fed the students. Baker, interview.

122. John Wheeler was among a handful of black businessmen who had supported a political alliance between labor unions and white workers after World War II. Like his wife, he was somewhat unique among Durham's black elite in his open support of direct action, and he was one of the few black businessmen to appear on the picket line during demonstrations. Weare, *Black Business*, 261.

123. McLaurin, interview; CT, 13 February 1960, 23 May 1963; Streeter, interview; John Edwards, 1994 Durham Civil Rights Reunion, James E. Shepard Library, NCCU; McCoy, interview by Chris Howard.

124. At the 1994 Durham Civil Rights Reunion, former youth activists claimed that Louise Latham, Bessie McLaurin, and Sadie Hughley—all black, middle-class women—were among their most supportive adult allies. Willa Player, president of Bennett College in Greensboro, played a similar role, although unlike Latham she was at a private black women's college and was therefore less vulnerable to reprisals from white officials. Chafe, *Civilities and Civil Rights*, 127; McLaurin, interview; CT, 13 February 1960, 23 May 1963.

125. Smith, interview; McLaurin, interview; Joycelyn McKissick, 1994 Durham Civil Rights Reunion, James E. Shepard Library, NCCU; Chafe, *Civilities and Civil Rights*, 23.

126. Of course, men also could be role models for young women, as Floyd McKissick's influence makes clear. Vivian McCoy noted the significance of John Edwards's father, "Pratt" Edwards, a tobacco worker and Democratic Party precinct captain, who organized black teens to do voter registration prior to the reorganization of the city NAACP youth chapters in the 1950s. McCoy, interview by the author.

127. Ibid.; McCoy, interview by Chris Howard.

128. Cole-McFadden, interview; CT, 5 May 1969.

129. DMH, 3 March 1979, Clippings Files, Durham County Library, Stanford Warren Branch, Durham, N.C.

130. According to one estimate, black women constituted more than 70 percent of black church membership, attendance, or both. Cole, "Commonalities and Differences," 21. Durham women also led statewide church groups that promoted civil rights and integration. Mrs. Johnnie McLester, a Durham schoolteacher and wife of the Reverend Charles McLester, held leadership positions in the statewide Women's Baptist Home and Foreign Missionary Convention, which claimed membership in the NAACP, and her husband was a prominent supporter of the freedom movement. The Carolina Times often listed the meeting times and activities of churchwomen's groups. CT, 6 April 1957, 1 August 1953.

131. See, for example, the programs for Durham NAACP meetings in McKissick Papers, SHC, and Weare, Black Business, 191–95.

132. CT, 22 August 1942.

133. Until recently, most scholars have focused on the leadership role of male ministers while ignoring the role of black churchwomen. Morris, Civil Rights Movement, 4, 51–63. On the tradition of black churchwomen's community work and civil rights activism, see Ross, Witnessing and Testifying, and Gilkes, If It Wasn't for the Women.

134. Joycelyn McKissick, interview. See also McCoy, interview by Chris Howard.

135. Cole-McFadden, interview. Women were not necessarily more religious than men, but the organizational basis of black women's church work and the social networks that evolved from such activity spurred black women's participation in the movement. Charles Payne makes a similar point in Light of Freedom, 272–74.

136. CT, 12 January 1957. Jake inspired a bus boycott in Tallahassee, Florida, and Lucy faced down an angry mob at the University of Alabama.

137. CT, 14 November, 4 March 1950; N.C. State Conference of NAACP Branches, 1962 annual convention, box 23, KA Papers; Freedom Sunday worship service program, 27 May 1962, McKissick Papers, SHC.

138. CT, 14 November, 4 March 1950, 27 September 1952. Sometimes men simultaneously celebrated and derided women's contributions: "We especially need more women, as the woman goes, so goes the man. Yuk, yuk." CT, 13 May 1950.

139. Chafe, Civilities and Civil Rights, 125.

140. Beverly Jones presentation, Black History Month, 1993.

141. Nasstrom, "Down to Now," 115; Barnett, "Invisible Black Women Leaders," 162, 163, 176; Payne, Light of Freedom, 271–77.

142. Karpinos, "With All Deliberate Speed," 32–33; Foy, "Durham in Black and White," 79.

Chapter Four

1. During the first wave of racial unrest in the 1960s—prior to the disturbances that followed King's assassination in 1968—329 major rebellions erupted in 257

cities. Woodard, *Nation within a Nation*, 71. Thorpe's case went to the U.S. Supreme Court twice, in 1966 and in 1968, before the high court ruled in her favor. *Joyce C. Thorpe v. Housing Authority of the City of Durham*, October 1966, Supreme Court of the United States, no. 712, series 4.8, no. 4484, NCF Papers; [Bertie Howard], "Beginnings of Community Organization"; Thorpe Nichols, interview; Strange, "Politics of Protest," 5; Franklin and Moss, *From Slavery to Freedom*, 514.

2. In the spring of 1965, thirty-one black cafeteria workers (including five men and twenty-six women) in the Durham city schools formed the School Employees Benevolent Society.

3. Midgette and the other three women were later reinstated after seeking the assistance of attorney Floyd McKissick, who contacted federal and local officials. Annabelle D. Selph to Midgette, 11 June 1965; Selph to Midgett, 16 June 1965; McKissick to Max Cohen (Department of Health, Education, and Welfare), 15, 18 June 1965; McKissick to Selph, 14 June 1965; Petition of the School Employees Benevolent Society, n.d.; Petition of the School Employees Benevolent Society to the legislature of North Carolina, all in Floyd B. McKissick Papers, SHC; DMH, 1 June 1965; DMH, 26 October 1965, clipping, box 33, Wilbur Hobby Papers, DU; CT, 13 November, 11 December 1965; Peter Brandon and Nancy Park, "A Brief History of Duke Employees Local 77, AFSCME, AFL-CIO," Southern Student Organizing Committee (SSOC) pamphlet, April 1966, box 16, Boyte Papers.

4. "The Need for Partial Arbitration of Labor Disputes at Duke University," ca. 1967; Statement of Policy—Duke Employees Local 77, undated, both in box 4, Boyte Papers; Peter Brandon and Nancy Park, "A Brief History of Duke Employees Local 77, AFSCME, AFL-CIO," box 16, Boyte Papers; quotation regarding the housekeepers is from Sacks, *Caring By the Hour*, 45. African American men also participated in the labor activism at Duke, and a few, such as Oliver Harvey, founding president of Local 77, were important and influential leaders. But black women workers—primarily housekeepers, food service workers, and hospital workers—fueled much of the employee protest activity described here. In a tragic twist, King's assassination in April 1968 provided an unexpected catalyst for Local 77's campaign, and workers finally won major concessions from Duke, including union recognition, in 1972. Ludwig, "Black Women's Grievances."

5. The Durham Tenants Steering Committee was formed in 1967 after the Housing Authority agreed to meet monthly with tenants; it was comprised of two tenant representatives from each of the city's public housing projects. Although the rent strike was not as effective as organizers had hoped, the action revealed that tenants could act in unison to force some concessions from the Housing Authority. Veraline Wilson, "The Durham Rent Strike," NCF report, revised August 1968, box 8, NCF Papers; *Housing Authority of the City of Durham vs. United Organizations for Community Improvement*, Superior Court, Durham County, N.C., 12 January 1968, series 4.8, no. 4485, NCF Papers; DMH, 15 January 1968.

6. Although black activists in the 1950s and early 1960s had not totally neglected economic and housing concerns, especially in the area of employment discrimination, by the mid-1960s poor blacks, especially women, had ignited a new wave of militant activism around these issues. Floyd McKissick was representing the

striking school cafeteria workers. McKissick to Max Cohen, 15, 18 June 1965; Annabelle Selph to Lucy Henderson, 16 June 1965; McKissick to Selph, 18, 22 June 1965; Carol Silver to McKissick, memo, 7 May 1965, all in McKissick Papers, SHC; Obituary for Floyd McKissick, CT, 4 May 1991, Clippings Files, Durham County Library, Stanford Warren Branch, Durham, N.C.; Meier and Rudwick, CORE, 293, 406–8; Van Deburg, New Day in Babylon, 134–37.

7. On poor people's activism in the 1960s, including that of African American women, see, for example, Piven and Cloward, Poor People's Movements; West, National Welfare Rights Movement and "Cooperation and Conflict"; Pope, "Welfare Rights Struggle"; Naples, Grassroots Warriors; Deborah Gray White, Too Heavy a Load, 223–42; Kelley, "Birmingham's Untouchables"; Gilkes, "Building in Many Places" and "Community Work and Social Change"; Sacks, "Gender and Grassroots Leadership"; and Valk, "Mother Power."

8. Rogers, interview; Howard and Redburn, "United Organizations," 36–37; Sacks, Caring By the Hour, 209; Hugh Price, "Foundation for Community Development: A Unique Experiment in Community Development," March 1972, series 1.8, no. 887, NCF Papers.

9. Throughout chapters 4 and 6, I use the terms "low-income," "poor," and "working-class" somewhat interchangeably. Although there are some differences among these groups, the terms are fluid, especially in relation to black women whose economic and class locations shifted. Unemployment and poverty were ever-present realities even for employed blacks, since many held seasonal or temporary jobs in the tobacco industry, schools, or private households for which they frequently received poverty-level wages. Historically, the poor often combined intermittent wage work with unemployment insurance, welfare benefits, and other sources of legal and illegal income until the 1996 welfare reform legislation made these survival strategies more difficult to utilize. Pearce, "Welfare Reform."

10. The NCF was created by Governor Terry Sanford in 1963 as an independent, non-profit charitable corporation that would run for five years with private foundation grants. It became a model for the federal War on Poverty, and Sanford and NCF director George Esser helped write the Economic Opportunity Act that launched the federal assault on poverty. The NCF established programs based on a community action model that promoted grassroots mobilization of the poor "to identify their needs and become active participants in the decision-making processes of the entire community." When the federal War on Poverty was created, Operation Breakthrough reorganized as a community action agency in order to be eligible for federal poverty funds. NCF memorandum of organization, 21 September 1966; "NCF Chronology of Events, 1962–1969," undated, both in NCF Papers; [Howard], "Beginnings of Community Organization"; "Crisis and Conflict: The Story of Operation Breakthrough," and "A Case Study of the War on Poverty in Durham, North Carolina," in North Carolina Fund Process, part 3, 1, 5–13; Korstad and Leloudis, "Citizen Soldiers," 139–42. For a more detailed discussion of Operation Breakthrough and its racial and political difficulties, see Christina Greene, "Our Separate Ways," chapter 4.

11. James Cunningham, "Summary of Notes on Resident Participation in Durham, N.C. (Draft—Not for Circulation)," June 1966, McKissick Papers, SHC. Despite the state's progressive image, slightly more than half of all North Carolina families were impoverished, compared to a fifth nationally—more than in any other southern state. This figure is based on the definition of a family as two or more persons, and it uses the official poverty level of a $4,000 annual income for a family of four. In North Carolina in 1960, 552,327 families, or about half of all families, were living in poverty. Adding the "deprivation index," which included families with incomes between $4,000 and $6,000 a year, 72 percent of all families in the state were living at poverty or deprivation levels. Due to lower wages and cost of living, North Carolina used $3,000 per year as its poverty level cut-off, but 37 percent of all families were impoverished even by the lower standard. In Durham County, using the statewide index, 26 percent, or 7,000 families, had incomes below poverty; in the city, 29 percent of all families were at or below poverty. Among black families, 53 percent were impoverished, compared to 15 percent of white families. U.S. Department of Commerce, Bureau of the Cen-sus, *Characteristics of the Population*, 1960, vol. 1, tables 33, 77; Brooks, *Dimensions of Poverty*, 3–4, 6; "Durham County Summary—Costs of Poverty in Durham County," ca. 1964, series 4.8, no. 4486, NCF Papers.

12. When Operation Breakthrough was created, Floyd McKissick began pressing the organization to put more blacks and more poor people on the board. But the original board simply selected its own members, leading to a "predominantly self-perpetuating board." Martha McKay, "Standards and Procedures for Evaluation of a Community Action Agency," NCF report, 18 August 1966, 69, series 4.8, no. 4439, NCF Papers. For discussions of the War on Poverty, see Matusow, *Unraveling of America*, esp. chapters 8 and 9; Katz, *Undeserving Poor*, esp. chapter 3; Patterson, *America's Struggle against Poverty*; and Quadagno, *Color of Welfare*. For two of the few works focusing specifically on women and the War on Poverty, see Naples, *Grassroots Warriors*, and Orleck, "If It Wasn't for You."

13. Bob Korstad has described a similar process behind a seemingly "spontaneous" strike initiated by a black woman tobacco worker in Winston-Salem. *Civil Rights Unionism*, chapter 1.

14. Thorpe Nichols, interview. Like many low-income women, Thorpe downplayed her previous involvement in civil rights protest and her church activities, and she dismissed her leadership experience as president of the Youth Usher Board and the Youth Choir. There is some confusion regarding the formation of the mothers' club. According to Thorpe, the mothers' club was in existence before Operation Breakthrough organizer Joan Alston arrived in McDougald Terrace in the summer of 1965. The important point is that Operation Breakthrough built on a preexisting base, whether it was a formal club, an inactive tenants' cooperative, or an informal network of women tenants who shared similar concerns [Howard], "Beginnings of Community Organization," 11–13.

15. There is a long tradition of duplicity and dissemblance as forms of resistance within African American communities that has been documented by historians of slavery. See, for example, Aptheker, *American Negro Slave Revolts*, and Genovese

Roll, Jordan, Roll. For the use of these tactics among black women, see Hine, "Rape."

16. In another effort to draw public attention to the tenants' plight, Fuller contacted the sororities at NCC and asked them to write daily letters to the local newspaper editors. [Howard], "Beginnings of Community Organization," 14.

17. Thorpe Nichols, interview; [Howard], "Beginnings of Community Organization," 17–18.

18. The lengthy lawsuit allowed Joyce Thorpe to remain in the housing project for four more years and to complete a physician's assistant program at Duke University, making her the first woman and the first black P.A. at Duke. In the process, Thorpe successfully challenged Duke's exclusion of women from the P.A. program, and today she is known in Durham as the "Mother of P.A.s." NAACP Legal Defense Education Fund, "Low Income Housing Project Eviction Procedures to High Court for Review," press release, 21 October 1966, McKissick Papers, SHC; Morgan, conversation; Thorpe Nichols, interview.

19. Scott and historian Robin Kelley, among others, suggest that marginalized and disempowered people "rehearse" in less formal modes and settings their opposition to oppression. James C. Scott, *Domination,* 186, 199, 221–27; Kelley, "We Are Not What We Seem." See also James C. Scott, *Weapons of the Weak.* For recent scholarship that explores similar resistance tactics among African American women, see Hine, "Rape," and Hunter, *To 'Joy My Freedom* and "Domination and Resistance."

20. Historian Lawrence Goodwyn has called this process "social learning." *Breaking the Barrier: The Rise of Solidarity in Poland,* cited in Korstad, *Civil Rights Unionism,* 427. Evans and Boyte, *Free Spaces,* 17–18; see also Evans, "Women's History." I enlarge Evans and Boyte's definition to include places where people hang out and talk if that includes the kinds of conversations Thorpe reports among McDougald Terrace tenants.

21. James Scott makes this point in countering Antonio Gramsci's concept of hegemony. See *Domination,* chapter 4. The examples presented here and throughout this book counter the notion that protest originates and is led solely or even largely by middle-class people who have greater skills and access to power and resources.

22. Terkel, *Race,* 282–83; Atwater, interview; CT, 23 December 1967.

23. Atwater, interview; "Ann Atwater, Durham, N.C.," series 4.8, no. 4579, NCF Papers.

24. Rogers, interview.

25. Ibid.

26. People still call on Atwater today (and on Rogers until her death) for help in solving problems or dealing with city bureaucracies despite the serious health problems that plagued both women. Ibid.; Atwater, interview.

27. Rogers, interview; Amott, "Black Women and AFDC"; *Common Good,* November 1995; *Durham City Directory,* 1960. Historically, poor blacks, especially in the South, were excluded from receiving Aid to Families with Dependent Children benefits. Thus, one focus of the welfare rights movement in the 1960s, particu-

larly in the South, was both to inform and mobilize poor women to apply for those welfare benefits to which they were entitled and to force the government to revamp the entire welfare program. Despite the public clamor regarding "welfare dependency," 70 percent of women on welfare prior to President Clinton's 1996 welfare reform bill received benefits for less than two years. It is also important to note that not all the low-income black women who emerged as indigenous community organizers or leaders were single mothers. For example, Annie Louise Ballentine and her husband, James Nathaniel, were neighbors of Thorpe's, and both became active members of a new McDougald Parents Club and of United Organizations. Similarly, Christine Strudwick, a stalwart of the East End Betterment Society (see chapter 3), was a homemaker married to London Strudwick, a laborer at the American Tobacco Company in Durham.

28. Rogers, interview; James Cunningham to Moses Burt, 29 July 1966, McKissick Papers, SHC; Howard and Redburn, "United Organizations"; [Howard], "Beginnings of Community Organization"; Strange, "Politics of Protest."

29. By 1960, Durham's economy was tied largely to the tobacco industry, the two colleges—Duke and NCC—and increasingly to Research Triangle Park. Apart from the colleges, out-of-state businesses accounted for 80 percent of Durham's payroll in the 1960s. Over 90 percent of commercial banks had home offices outside of Durham, and a significant number of downtown retail establishments had absentee owners as well. Howard and Redburn, "United Organizations," 2–3.

30. Rubye Gattis to James McDonald, 27 April 1966, series 4.8, no. 4476, NCF Papers. Ironically, black voters had provided the margin of victory for Durham's urban renewal bond referendum. [Howard], "Beginnings of Community Organization," 16, 1; Howard and Redburn, "United Organizations," 12–13, 2–3; Bryant, interview; Smith, interview; Hayti file, Clippings Files, Durham County Library, Stanford Warren Branch, Durham, N.C. For several examples of the attack on poverty programs by local and national officials in Mississippi, New York City, Philadelphia, and Las Vegas, see Dittmer, Local People; Naples, Grassroots Warriors; and Orleck, "If It Wasn't for You."

31. Operation Breakthrough supported the creation of UOCI, partly because of its concern regarding federal scrutiny, which United Organizations could alleviate, but also because a number of low-income, black OBT board members supported the new organization. Blacks in the NCF also applied internal pressure, threatening to resign if United Organizations were not funded by the NCF, and NCF director George Esser managed to convince board members to see community organization of the poor "not as a threat but as an opportunity." Thus, in early 1967, UOCI received its first funding from the NCF. "The Foundation for Community Development," in North Carolina Fund Process, part 3, 1–4; "Community Action in North Carolina: An Overview of the North Carolina Fund Projects, 1964–1967," in ibid., part 1, 135–36; Howard and Redburn, "United Organizations," 21–26; Hugh Price, "Foundation for Community Development: A Unique Experiment in Community Development," March 1972, 1–3, series 1.8, no. 887, NCF Papers.

32. James Cunningham, "Resident Participation: The Struggle of the American Ur-

bident for Freedom and Power," report to the Ford Foundation, August 1967, quoted in "A Case Study of the War on Poverty in Durham, North Carolina," in *North Carolina Fund Process,* part 3, 18.

33. George Esser, interview by Karen Thomas; [Howard], "Beginnings of Community Organization," 6–7. Although some Operation Breakthrough people may not have known much about Fuller, two NCF employees, Morris Cohen and Jim McDonald, did. Cohen had been friends with Fuller in graduate school; McDonald met him working as a community organizer for the Milwaukee Urban League when Fuller was only fourteen. According to one report, McDonald "was anxious to see a militant in [the Operation Breakthrough] position," and both he and Cohen recommended Fuller. Howard and Redburn, "United Organizations," 5; Bamberger, "Education of Howard Fuller."

34. Fuller quoted in Wallace, "How to Get Out of Hell," and in "Citizens Express Job and Housing Needs through 18 Durham Neighborhood Councils," in *Blueprint for Opportunity: A Progress Report of the North Carolina Fund,* 2, no. 4 (October 1966), box 54, Herbert Clarence Bradshaw Papers, DU. Fuller reportedly picked up his ideas about community organizing when he was working with Cleveland CORE. He also may have been influenced by Saul Alinsky's Industrial Areas Foundation, which was active in Chicago, where Fuller also worked with the Urban League. Some of Alinsky's published work was listed in the NCF training curricula for community organizing. Strange, "Politics of Protest." On Alinsky and the Industrial Areas Foundation, see, for example, Horwit, *Call Me Rebel,* and Boyte, *Commonwealth and Community Is Possible,* 34–35, 129–34.

35. Joan Alston, who helped Thorpe set up the McDougald Terrace Mothers Club, was a twenty-year-old North Carolina native whose mother was a food server and whose father was a textile worker; according to Fuller, Alston had a keen sensitivity and understanding of tenants' problems. Thorpe Nichols, interview; Wallace, "How to Get Out Of Hell"; Bamberger, "Education of Howard Fuller"; Payne, "Ella Baker"; Ransby, *Ella Baker,* 113–18.

36. Smith, interview.

37. James Cunningham, "Summary of Notes on Resident Participation in Durham, N.C. (Draft—Not for Circulation)," June 1966, 8, McKissick Papers, SHC. Gattis had recently been hired by OBT's New Careers program to train high school graduates who could not afford college. She had also served as president of the five-council area coalition that formed the nucleus of United Organizations. New Careers was a federal poverty program that hired community people to serve as bridges between the poor and social service agencies. Ibid.; Howard and Redburn, "United Organizations," 15; Naples, *Grassroots Warriors,* 221.

38. CT, 21 May 1966.

39. Although the mid- to late 1960s saw an increased emphasis on community organizing, such work had been a critical component of the earlier civil rights movement, and it provided a foundation for later organizing work in the antipoverty movement in the South. Charles Payne believes scholars have emphasized more dramatic moments of the black freedom movement while ignoring and undervaluing the tedious organizing work, or what Ella Baker called

"spade work"—"the patient and sustained effort, the slow, respectful work, that made such moments possible." *Light of Freedom*, 264; Ransby, *Ella Baker*, 118.

40. James Cunningham, "Summary of Notes on Resident Participation in Durham, N.C. (Draft—Not for Circulation)," 12, June 1966, McKissick Papers, SHC.

41. The refusal of local officials to accept federal money as a means of avoiding federal civil rights regulations and undermining civil rights protest was not uncommon in the South. See Payne, *Light of Freedom*; Mills, *This Little Light*; and Dittmer, *Local People*, for a similar controversy surrounding Head Start in Mississippi. It is not surprising that the Durham school board rejected federal minimum wage regulations considering that it was also fighting similar demands by the School Employees Benevolent Society; the school board insisted on paying full-time school cafeteria workers, most of whom were black women, less than the salaries of teenagers who participated in federal programs. Ibid., 3–5; "Education and the War on Poverty: Durham, North Carolina," in *North Carolina Fund Process*, part 3, 33–34; Strange, "Politics of Protest," 7; James Cunningham, "Resident Participation: The Struggle of the American Urbident for Freedom and Power," report to the Ford Foundation, August 1967, quoted in "A Case Study of the War on Poverty in Durham, North Carolina," in *North Carolina Fund Process*, part 3, 160.

42. Community action programs were the community organization component of the War on Poverty program. The predominance of women in community action programs was also a national phenomenon. Rogers, interview; Cunningham to Moses Burt, 29 July 1966, McKissick Papers, SHC; [Howard], "Beginnings of Community Organization," 7; Howard and Redburn, "United Organizations," 6; Naples, *Grassroots Warriors*, 220–21.

43. *North Carolina Anvil*, 24 February 1968. Fuller's insight regarding low-income women most likely derived from his own upbringing. For the first six years of his life, which he spent in Louisiana, his grandmother raised him. When he went to live with his mother and stepfather, his stepfather's violent alcoholism led Howard to side with his mother and to seek refuge within a wider black community that functioned much like a surrogate family. Although there were also important male figures in Fuller's life, he undoubtedly witnessed firsthand the tradition of black women's community work that was prevalent not only in Durham but in black communities throughout the country. Still, many male activists had similar experiences but were unable to translate them into greater appreciation for women's abilities. Bamberger, "Education of Howard Fuller"; Howard Fuller, interview. My thanks to Jack Dougherty for sharing this material with me.

44. Among the community leaders recruited or trained by Fuller or both were Ben Ruffin, who became executive director of UOCI; Charsie Hedgepath, who headed up organizing efforts in Hayti and later became secretary of the BSC; Callina Smith and Pearlie Wright, who founded the Durham Welfare Rights Organization; Ann Atwater, who supervised UOCI neighborhood workers and headed the UOCI Housing Committee; and Pat Rogers, who headed the Durham Tenants Steering Committee. Fuller's assertions were confirmed by a team of outside evaluators, who commented that Durham's local leadership was "very

outstanding." Howard and Redburn, "United Organizations," 61–62; Ed Sylvester, Richard Dowdy, John Lewis, James Prothro, William Snider, "Evaluation of the Foundation for Community Development," unpublished report, 12, October 1969, NCF Papers.

45. Holman, a machine operator at a local warehouse, was treasurer of the United Organizations board of directors and was a well-respected leader in his own right. Oliver Harvey, who was also a member of UOCI, was widely respected, and both black and white student activists at Duke found him especially inspiring. During this period, black male tobacco workers in Durham waged their own battle against white workers and the international union, both of which suddenly backed integrated locals in an attempt to displace black leadership and undermine black seniority. Out of eighteen United Organizations neighborhood councils in 1967, twelve of the presidents were women. Later, James Potter replaced Rubye Gattis as UOCI president. Carey, "Forced Merger"; Bertie Howard, interview; Boyte, interview; Evans, interview; Pat Wallace, United Organizations interim evaluation, 9 October 1967, box 370, series 4.8, no. 4564, NCF Papers.

46. Charles Payne found a similar pattern in Mississippi; for example, in Greenwood, one woman claimed that much of black organizational life in the town "was dependent upon women." Robin Kelley describes the same kind of male participation in Birmingham that Fuller cites for North Carolina. Payne, *Light of Freedom*, 277; Kelley, "Birmingham's Untouchables"; Mike Nathan, "Community Organizing in Edgemont," 19, NCF report, May 1968, box 4, NCF Papers; "A Radish Interview with Howard Fuller," *Radish*, 28 July–10 August [1969], FCD news clippings, box 84, series 1.8, NCF Papers.

47. Rogers, Summary of the week's activities, 7–14 April 1967, series 3.5, no. 3161, NCF Papers.

48. "Review and Assessment of Operation Breakthrough," August 1967, in *North Carolina Fund Process*, part 3, 64.

49. Quoted in Howard and Redburn, "United Organizations," 9.

50. Welfare policies are addressed in chapter 6.

51. Nathan, "Community Organizing in Edgemont," 19, NCF report, May 1968, box 4, NCF Papers. Unless otherwise noted, the discussion that follows is drawn from this report.

52. Although Nathan does not comment directly on the role of personal networks in community organizing, studies of neighborhood and community organizing among low-income women reveal that personal networks often form the basis for more formal community organizations. See, for example, Sacks, "Gender and Grassroots Leadership"; Naples, "Activist Mothering"; and Collins, "Meaning of Motherhood."

53. The churchwomen's lack of participation in and enthusiasm for council meetings undoubtedly had many causes, not least of which may have been the presence of whites such as Nathan.

54. "Crisis and Conflict: The Story of Operation Breakthrough," in *North Carolina Fund Process*, part 3, 9; Wallace, "How to Get Out of Hell."

55. Strange, "Politics of Protest," 8; "Crisis and Conflict," in *North Carolina Fund*

Process, part 3, 12–13; Robert Blow to Jim [McDonald?], 9 February 1966, series 4.8, no. 4483; Edgemont Community Council, "We Are Picketing Because of the Condition of Houses Owned by Abe Greenberg," fact sheet, series 4.8, no. 4485, both in NCF Papers; Wallace, "How to Get Out of Hell."

56. Tami Hultman, "Edgemont," NCF report, August 1968; Day Piercy, "The Greenberg Housing Controversy: A Case Study in Community Organizing," NCF report, June 1968, both in NCF Papers; Redburn, "Protest and Policy," 89, 91; Ron Semone, "The Greenberg Demonstrations, 21 June 1966," series 4.8, no. 4585, NCF Papers.

57. "Crisis and Conflict," in North Carolina Fund Process, part 3, 11–16, 19–23; Wallace, "How to Get Out of Hell"; Semone, "Greenberg Demonstrations," series 4.8, no. 4585, NCF Papers.

58. Durham blacks had participated in Democratic Party functions since at least the 1950s, but aside from several African American male labor leaders most were members of the middle-class and business elite. Howard and Redburn, "United Organizations," 16–17; Strange, "Politics of Protest," 7–8.

59. William Pursell was the new Operation Breakthrough director, a Baptist minister and former Neighborhood Youth Corps director who succeeded Foust. "Crisis and Conflict," in North Carolina Fund Process, part 3, 35; Rubye Gattis and Carrie McNeil to Foust, 11 May 1966; Southside Betterment Club to Foust, 12 May 1966, both in series 4.8, no. 4469, NCF Papers. See also letters from the West End Community Club and the Better Community Council in this same series.

60. Durham Sun quoted in "Crisis and Conflict," in North Carolina Fund Process, part 3, 40.

61. James Cunningham, "Summary of Notes on Resident Participation in Durham, N.C. (Draft—Not for Circulation)," June 1966, McKissick Papers, SHC; Howard and Redburn, "United Organizations," 9; "Durham County Summary—Costs of Poverty in Durham County," ca. 1964, series 4.8, no. 4486, NCF Papers; Brooks, Dimensions of Poverty, 40; NCF 1964 Volunteers: David Entin, series 2.1.1.3, vol. 4, NCF Papers.

62. Disputes over the perpetuation of segregated housing patterns also erupted, one of which involved black opposition to a proposal by Duke University. Strange, "Politics of Protest," 9–10, 13–16; Cynthia Guberick to George Esser, Nathan Garrett, and Mike Brooks, memo, 21 October 1966, series 4.8, no. 4397; Housing Authority of the City of Durham, Memorandum on Administrative Policy and Procedure for Selection and Admission of Tenants to Low-Rent Housing and on Continued Occupancy, [11 August 1966], series 4.8, no. 4483, both in NCF Papers.

63. Howard and Redburn, "United Organizations," 28–29; Strange, "Politics of Protest," 10–13.

64. There is some confusion regarding the date of Jacobs's appearance. The CT reported that it was July 19, but other details of the meeting as reported in the same story indicate it was July 17. See also North Carolina Anvil, 21 July 1967. A photograph of Jacobs standing behind a group of seated people with an unidentified black woman looking over her shoulder at him appeared in the CT, 29 July 1967.

65. Fuller, Transcript of Statement Made before Durham City Council Meeting, 17 July 1967, series 4.8, no. 4481, NCF Papers.
66. DMH, 18 July 1967, quoted in Redburn, "Protest and Policy," 95.
67. Howard and Redburn, "United Organizations," 28–29; DMH, 18 July 1967, quoted in Strange, "Politics of Protest," 12.
68. "Crisis and Conflict," in North Carolina Fund Process, part 3, 47–48.
69. Gattis statement, undated, series 4.8, no. 4483, NCF Papers.
70. Meeting between United Organizations and Durham Housing Authority, 27 July 1967, 9, series 4.8, no. 4580, NCF Papers; Howard and Redburn, "United Organizations," 9.
71. "Crisis and Conflict," in North Carolina Fund Process, part 3, 50, 52; Howard and Redburn, "United Organizations," 28–29; Strange, "Politics of Protest," 10–13.
72. Quoted in CT, 29 July 1967.
73. Quoted in Strange, "Politics of Protest," 18. "Crisis and Conflict," in North Carolina Fund Process, part 3, 50, 55, 57–58; Strange, "Politics of Protest," 12–13; Esser, interview; "Dewitt Sullivan," 21 July 1967, series 4.8, no. 4444, NCF Papers. Similar attacks on poverty programs occurred not only in the South but in cities throughout the nation. Quadagno, Color of Welfare, 47–59.
74. Howard and Redburn, "United Organizations," 35; CT, 29 July 1967; Louis Austin to Sargent Shriver, 25 July 1967; Browne to whom it may concern, 25 July 1967; Spaulding to Esser, 25 July 1967; Mrs. Joel Smith to Shriver, 30 July 1967; Rev. Julius Corpening to Shriver, 21 July 1967, all in series 4.8, NCF Papers.
75. The DMH initially printed only excerpts of Hill's letter, distorting its message. Only after Hill protested did the paper include the letter in its entirety. "Crisis and Conflict," in North Carolina Fund Process, part 3, 56–57.
76. Grabarek and Democratic congressman Galifianakis hurried to Washington, D.C., to meet with Shriver, Vice President Humphrey, and other officials in an attempt to settle the Operation Breakthrough dispute, promising to continue their "inquiries" into OBT activities. Ibid., 60; Statement by Dan Moore, 11 August 1967, series 4.8, NCF Papers.
77. The Department of Labor, under pressure from North Carolina congressman Lawrence Fountain, a Democrat from eastern North Carolina who headed the powerful House Appropriations Sub-Committee for the Department of Labor, refused to release the report, which exonerated the NCF. According to Esser, a Department of Labor official informed him that the NCF would not receive a promised Department of Labor grant for its Manpower Development Corporation if the report were made public. It is not clear whether Esser's comments refer to the 1967 or the 1969 attacks on Fuller. (See chapter 6 for the 1969 attacks.) "Crisis and Conflict," in North Carolina Fund Process, part 3, 63; Esser and Billy Barnes, "Uphill in North Carolina," 26 May 1969, no. 4710, NCF Papers; Esser, interview; OEO Public Affairs press release, 31 August 1967; Theodore Perry (OEO) to Esser, 17 January 1968, both in series 4.8, NCF Papers; McGeorge Bundy to Gardner, 6 September 1967, 7 March 1968, series 1.8, NCF papers.
78. Gardner's original amendment had sought to prevent any OEO employee from

picketing, demonstrating, protesting, rioting, or engaging in similar group activities. Gardner amendment quoted in notes attached to Esser interview.

79. Ed Sylvester, Richard Dowdy, John Lewis, James Prothro, and William Snider, "Evaluation of the Foundation for Community Development," unpublished report, 6, October 1969, NCF Papers. Many people, especially influential whites, feared both the FCD and UOCI. The FCD in particular was subjected to harassment and investigations by state and federal officials. Ford Foundation, Mitchell Sviridoff (director of national affairs) to McGeorge Bundy, ca. 1968, NCF Papers; McKinney, "Violence of Poverty."

80. Howard and Redburn, "United Organizations," 30–35; Strange, "Politics of Protest," 27.

81. CT, 5 August 1967.

82. Howard and Redburn, "United Organizations," 33.

83. CT, 23 December 1967; "Ann Atwater, Durham, N.C.," series 4.8, no. 4579, NCF Papers.

84. Howard and Redburn, "United Organizations," 33, 35; Esser to NCF Board of Directors, 5 February 1968; Preface to United Organizations Grievance report, both in series 1.32, NCF Papers.

85. Most historians agree that the War on Poverty was never fully fought, falling victim to conservative attacks and to funding constraints made worse by the escalation of the Vietnam War. While antipoverty programs did not eliminate poverty, they did reduce some of the worst destitution. Little of the scholarship on the War on Poverty, with the notable exception of works by Nancy Naples and Annelise Orleck, provides a full analysis of the experiences of low-income black women. Thus, the poverty debate obscures the ways in which local women used poverty programs to empower themselves and their communities. My research supports Naples's findings, particularly the notion that the War on Poverty inadvertently built on a history of poor women's community work, both paid and unpaid; however, I also include informal networks and tactics that served as a foundation for more formal and overt protests.

86. James Cunningham to Moses Burt, 29 July 1966; Cunningham, Summary of Notes on Resident Participation in Durham, N.C. (Draft—Not for Circulation), June 1966, both in McKissick Papers, SHC.

87. The distinction between mobilizing and organizing is explored by Payne in *Light of Freedom*. Pat Wallace, United Organizations interim evaluation, 9 October 1967, box 370, series 4.8, no. 4564, NCF Papers.

88. The alliances that poor blacks and whites sought to establish will be discussed in the next chapter. Chapter 6 will include a fuller discussion of black women and Black Power.

89. Quoted in Howard and Redburn, "United Organizations," 63 (emphasis in original).

90. Wallace, "How to Get Out of Hell." The neighborhood organization remained deeply committed to establishing and running innovative programs for and by poor people that would alleviate poverty, including cooperatives, buying clubs, and low-income housing construction projects. Operation Breakthrough's and United Organizations' antipoverty programs and community organizing efforts

had other repercussions. As Karen Sacks notes, many of the women who became the first black clerical and technical workers at Duke had been trained in Operation Breakthrough programs, and they became a leading force in union struggles at Duke in the 1970s. Sacks, *Caring By the Hour*, 43.

Chapter Five

1. The NAACP lawsuit called for Durham public schools to reflect the citywide student population, which was 58 percent white and 42 percent black. *Action*, August–September 1970; Boyte, "History of ACT," 8–12.

2. The stereotype gained prominence after white mothers in Boston organized a virulently racist campaign against school desegregation. Formisano, *Boston Against Busing*; Lukas, *Common Ground*; Wrigley, "From Housewives to Activists." For a corrective to this white-focused story about Boston desegregation, see Theoharis, "Boston's School Desegregation."

3. The groundwork for a black-white alliance in Durham had been established in the fall of 1969; blacks and whites, working through United Organizations and the low-income white neighborhood federation ACT, respectively, joined forces to protest the local implementation of the 1965 federal Elementary and Secondary School Education Act, which was designed to provide educational support for low-income students. *Action*, ca. October 1969, 19 February 1970, August–September 1970; Boyte, "History of ACT," 8–12.

4. DMH, 25 April, 18 September 1965, clippings; Report of Formation of White Citizens Council Group Formed in Durham, North Carolina, undated; "Early History of Local 208," all in box 33, Wilbur Hobby Papers, DU. The KKK enjoyed a revival across the state after 1964, but, as David Cecelski and William Chafe note, most of those who attended KKK rallies were not members, suggesting that the Klan had far greater appeal than numbers would indicate. Nor was the Klan simply a haven for lower-class "rednecks," especially in eastern North Carolina; but it enjoyed tacit approval from white elites elsewhere, as well. Former Durham KKK member C. P. Ellis claims that white officials in Durham quietly encouraged the KKK but maintained their distance from the white supremacist group publicly. Chafe, *Civilities and Civil Rights*, 162–63; Cecelski, *Along Freedom Road*, 36–41, 183; Terkel, *Race*, 273–74.

5. For the distinction between interracial cooperation and an interracial movement, see Frost, "Community and Consciousness." See also Frost, *Interracial Movement*.

6. Hultman, interview.

7. In 1960, 552,000 North Carolina families, or just over half of all families in the state, were poor, more than in any other southern state, and 60 percent of those families were white, also more than in any other southern state. Relatively few poor whites participated in antipoverty programs, primarily because the programs were perceived to be "black." *North Carolina Fund Survey*; Brooks, *Dimensions of Poverty*, 3–4, 6; Flynt, *Dixie's Forgotten People*, 118, 109.

8. "Review and Assessment of Operation Breakthrough," August 1967, in *North Carolina Fund Process*, part 3, 70, 140.

9. Quoted in Anne Braden, "Durham's ACT: A Voice of the Southern Poor," *Southern*

Patriot, March 1969, 3. One of Operation Breakthrough's three target areas, Area B, was selected intentionally because it included a large, indigent white population. In this area, median family income for both black and white families was about the same, $2,000 for both groups, a figure well below the U.S. government's official poverty level of $4,000 for a family of four. (North Carolina set the annual poverty level at $3,000.) Median family size was also similar, with blacks having slightly larger families. Female-headed families were prominent among both groups—44 percent for blacks and 39 percent for whites. Although black unemployment was higher than among whites (24 percent and 19 percent), clearly unemployment was a serious problem for both groups. Similar income levels between poor whites and blacks, however, were largely dependent on the higher labor force participation rate of black women—70 percent of black women worked compared to 31 percent of white women. In Durham, using the statewide index, 26 percent of families had incomes below poverty. Although Durham blacks, comprising 32 percent of the population, had a median family income of $2,800 compared to $4,600 for whites, there was serious white poverty as well. For example, in census tracts 10A, 10B, and 11 (a large, poor, white area in East Durham), 25 percent of families fell below the poverty line, and another 28 percent had incomes of $3,000 to $5,000 a year. In census tract 11, 37 percent of families fell below poverty level. Statistical references to poverty indices among blacks and whites are taken from a survey of poor black and white families in Operation Breakthrough Target One and thus do not necessarily represent Durham as a whole. Black and white residents in this area were among the poorest in Durham. *North Carolina Fund Survey*; U.S. Department of Commerce, Bureau of the Census, *Characteristics of the Population*, 1960, vol. 1, tables 33, 77; *A Profile of Community Problems: Durham County*, Operation Breakthrough report, tables 1, 2, NCF Papers.

10. Quoted in Harry Boyte and Dick Landerman, "Poor Whites on the Move!," ca. 1969, box 1, Boyte Papers. Black perceptions, of course, were quite different; despite several years of organizing, low-income blacks felt they had accomplished little.

11. Ibid.; Harry Boyte and Dick Landerman, "Position Paper on White Organization," unpublished typescript, April 1968, box 1, Boyte Papers. "ACT" was not an acronym.

12. Quoted in Anne Braden, "Durham's ACT: A Voice of the Southern Poor," *Southern Patriot*, March 1969, 3.

13. Only two councils were still in existence by 1971. Boyte, "History of ACT," appendix 3.

14. This debate over service provisions also plagued the projects of the northern Students for a Democratic Society–Economic Research and Action Project (SDS-ERAP), whose organizers believed that services fostered dependency and powerlessness among the poor. Frost, *Interracial Movement*, 103–10.

15. Freeman, "White Community Organization." On efforts to organize white southern students, see Greene, "We'll Take Our Stand," and Fosl, *Subversive Southerner*, 253–55, 275–80.

16. The Boyte family had defended black activist Robert F. Williams after the local Ku Klux Klan and the FBI targeted him in the early 1960s, forcing him into exile in Cuba. On the citizenship schools, see Morris, *Civil Rights Movement*, 149–55, 236–39; Boyte, interview; and Fairclough, *Soul of America*, 206–8.

17. Boyte, interview; Landerman, interview.

18. Freeman, "White Community Organization."

19. Boyte, interview and "History of ACT."

20. Although Deborah Cook verbalized the typical "town-gown" divisions that often plague university towns, she was very appreciative of most of the Duke students who organized in low-income white communities. As she explained, "They were all street smart, so that made a difference." Cook Milan, interview.

21. Freeman, "White Community Organization," 4–9; Landerman, interview; Glenda Bunce, "Organizing Poor Whites: A Case Study of Patlock Park," NCF report, June 1968, NCF Papers.

22. Cuba Matlock and his wife, Julia, had six or seven children, and their home became a magnet for neighborhood activists. Both Cuba and, especially, Julia were active in ACT. Landerman, interview; Cook Milan, interview; Freeman, "White Community Organization," 4–5, 9; Elizabeth Tornquist, "So They'll Always Have a Place to Play: A Report on the Making of Patlock Park," *North Carolina Anvil*, 10 February 1968, 2.

23. The name "Experiment in Parallel Organization" was selected because the group paralleled black community organizing efforts. Harry Boyte and Dick Landerman, "Poor Whites on the Move!," ca. 1969, and ibid., "Position Paper on White Organization," unpublished typescript, April 1968, both in box 1, Boyte Papers.

24. Boyte, "Act Survey," appendix to "History of ACT," 3. Although none of the organizers in Durham had heard of radical community organizer Saul Alinsky at the time, ACT's organizing principles were remarkably similar to Alinsky's ideas, particularly his notion of building "power bases." Horwit, *Call Me Rebel*, 533, 534–35; Boyte, *Community is Possible*, 129–31.

25. ACT's approach was similar to that of the Southern Student Organizing Committee, which tried to bring white southern students into the freedom movement not by attacking southern racism but by emphasizing the positive elements of southern culture, or what they called "Southern Consciousness." There was some overlap between the SSOC and ACT students in Durham, and the SSOC house was often seen by neighborhood people as an ACT operation. Christina Greene, "We'll Take Our Stand"; Hultman, interview.

26. According to many on the Left, poor whites suffered from a failure to see that their "real" interests lay with those of poor blacks and other dispossessed members of society. For a recent rejection of this line of analysis, see Roediger, *Wages of Whiteness*. Nor were southern whites the only supporters of George Wallace, as Thomas Sugrue has pointed out in *Urban Crisis*.

27. Boyte and Landerman did not distinguish among working-class whites, low-income whites, and indigent whites. However, most of the people ACT targeted had incomes (either through part-time or intermittent wage labor and/or welfare) below the poverty level, although some traditional working-class families

(for example, Bascie and Doug Hicks) also joined ACT. Boyte, "History of ACT."

28. Dick Landerman, *Operation Breakthrough Newsletter* 1, no. 2 (February 1968), series 4.8, no. 414, NCF Papers; "Review and Assessment of Operation Breakthrough," August 1967, in *North Carolina Fund Process*, part 3, 139.

29. For example, 90 percent of low-income blacks compared to only 65 percent of whites reported church membership, and almost 50 percent of poor blacks compared to 35 percent of the whites attended church regularly. *North Carolina Fund Survey*, 36–37.

30. Boyte and Landerman developed their ideas partly in response to the failure of an interracial project in Few Gardens, a formerly white public housing project that had become 40 percent black by 1968 largely as a result of the impact of urban renewal. For a fuller discussion of the Few Gardens conflict, see Christina Greene, "Our Separate Ways," chapter 5; *Public Housing News* (Durham Tenant Steering Committee), October 1973, box 18, Boyte Papers; Boyte, "ACT Survey," 2; Boyte, "History of ACT," appendix 1; Elizabeth Tornquist, "Standing Up to America: Poor Whites in Durham," *New South*, Fall 1969, 43.

31. Northern Students for a Democratic Society–Economic Research and Action Project (SDS-ERAP) made a similar blunder. Because ERAP men dominated community organizing campaigns, which focused on unemployed men, the organization's women were left to initiate separate organizing drives focused on women, particularly welfare women, with far better results, particularly in Cleveland. See Sara Evans, *Personal Politics*, 126–55, 164, and Frost, *Interracial Movement*, 20, 23, 153–54, 166–68. Historian Michael Katz has also observed that analyses of poverty in the 1960s were often male-centered. *Undeserving Poor*, 37; Miller, *Democracy*, 201–3.

32. Boyte, "History of ACT," 5; Elizabeth Tornquist, "Standing Up to America: Poor Whites in Durham," *New South*, Fall 1969, 45–46.

33. Boyte, "ACT Survey," 3–4, 7.

34. Ibid., "History of ACT," 5.

35. Doug Hicks, a World War II navy veteran, came to Durham in 1946, where he took a job at the Golden Belt Mill and soon became a TWUA shop steward. Although the TWUA was a CIO union, Pat Sullivan and Tim Minchin point out that the TWUA was one of the most conservative of the CIO unions; after World War II, the TWUA pushed the CIO to abandon its earlier support for racial integration in the South. However, the Durham mills were noteworthy for employing some of the state's most important white radicals, a number of whom were from Edgemont, the same neighborhood where ACT launched its most successful interracial projects. ACT's experience suggests that neighborhoods as well as workplaces could also be sites for interracial alliances. Sullivan, *Days of Hope*; Minchin, *What Do We Need a Union For*; *Action*, ca. 1969, 13–27 April, 27 May–15 June 1970; Landerman, interview; Boyte, interview. Hicks quoted in Braden, "Durham's ACT," 3. Although Hicks portrayed her silence as evidence of racial prejudice, she may also have feared losing her job if she spoke out.

36. *Action*, 14–27 July 1970.

37. Another ACT woman organizer described her as a "wonderful woman . . . who was a very important leader, a brilliant woman." Landerman, interview; Elizabeth Tornquist, "Standing Up to America: Poor Whites in Durham," *New South*, Fall 1969, 46; Evans, interview.

38. Centerpeople (they are usually women) bring values of family, neighborhood, adulthood, and responsibility to local organizing efforts. Deeply rooted in communities and families, centerwomen often possess interpersonal skills that enable them to mediate and resolve conflicts. Bridge leaders often lack formal titles, but their community ties enable them to link ordinary citizens with more formal organizations. In Bascie's case, her husband, Doug, was the president of the ACT council that united about fifteen white neighborhood councils. Yet, according to a number of ACT people, Bascie was the one with the real presence and commitment. Sacks, "Gender and Grassroots Leadership"; Robnett, *How Long? How Long?*, l; Boyte, interview and "History of ACT."

39. Landerman, interview; Freeman, "White Community Organization," 4; *Action*, February, 25 April–9 May 1970.

40. Today, Boyte agrees that ACT never formulated a concise theory about how to build community organizations or about the importance of women in such efforts, but he notes that he had been influenced by the SCLC citizenship schools and by Dorothy Cotton. His approach, therefore, was to think about relationships, about who had relationships in the community and who were the centers of community life. These were invariably women, said Boyte. In the 1960s, Boyte was married to Sara Evans, who helped start the first women's liberation group in North Carolina, and she undoubtedly also influenced his views on women. Boyte, interview; Sara Evans Boyte, Untitled typescript, February 1969, 4, box 1, Boyte Papers; Landerman, interview.

41. Landerman, interview.

42. Sociologist Ida Susser describes how working-class women's traditional domestic responsibilities promoted a collective sensibility rooted within kin networks and neighborhoods to a much greater extent than did men's. "Working-Class Women." Anthropologist Carol Stack explored a similar phenomenon among low-income black women in the mid-1960s in *All Our Kin*.

43. Sara Evans Boyte, Untitled typescript, February 1969, 2–3, box 1, Boyte Papers.

44. Elizabeth Tornquist, "Standing Up to America: Poor Whites in Durham," *New South*, Fall 1969, 41.

45. Landerman, interview; Cook Milan, interview. In many respects, the neighborhood councils that were the foundation of ACT and United Organizations were what Harry Boyte and Sara Evans would later call "free spaces." Evans and Boyte, *Free Spaces*, 17–18. While Evans in particular collapses the rigid line dividing public and private spheres, she and Boyte differentiate public and private life while also identifying their interconnectedness. Evans, "Women's History"; Boyte, "Critic Critiqued." Scholar/activist and former SNCC member Bernice Johnson Reagon made a similar argument in "Coalition Politics."

46. Susser, "Working-Class Women." See contemporary analyses of the Durham economy by liberal city councilman and sociologist Jack Preiss and by Bob Booth

of the Durham Chamber of Commerce in *Action*, 28 July–8 August 1970, and in "A Depressed Area," *Action*, February 1970.

47. Landerman, interview.

48. Historian Sara Evans discovered that in northern SDS-ERAP groups women tended to be the best organizers: "In general women were better trained in the interpersonal skills that good organizing required—empathy, listening, warmth, and non-competitiveness in personal relationships." Women drew these skills from their social roles, not from an innate, essential female nature. *Personal Politics*, 140.

49. Hultman was part of a cadre of Duke student activists who worked on a range of issues both on and off campus. She followed in the footsteps of activists Sara Evans and Charlotte Bunch, who, in a show of feminist solidarity, insisted on sharing the Y presidency as co-presidents. Hultman's husband, Reed Kramer, was also active in the campus Y, and his roommate was white community organizer Mike Nathan, who worked in Edgemont (see chapter 4). Hultman, interview; Evans, interview.

50. ACT developed many of the same tensions around issues of gender, class, and political ideology that plagued other movement projects, such as SDS's ERAP. The similarities between ERAP and ACT were probably not coincidental. Both Harry Boyte and Sara Evans (who were married in the 1960s) had spent a year in Chicago, where Sara had close contact with many of the ERAP women, primarily through the Chicago women's liberation group. Recently, she observed that ACT was in many ways a southern ERAP, only no one recognized it at the time. When Sara and Harry returned to Durham, he formed ACT, while she started the first women's liberation group in North Carolina and one of the first in the South. Evans, interview.

51. A full discussion of feminist politics and women's liberation in the South is beyond the scope of this study, but the subject deserves broader attention, particularly the relationship between feminism and race. Certainly, feminists generated support for the ACT child care center, but, as we will see, the organization failed to fully support it. Black women such as Duke student Bertie Howard also embraced women's liberation. Howard noted that many of her "allies were white radical women"; however, Howard, like most black women, pursued feminist politics separately from white women. Hultman, interview; Bertie Howard, interview.

52. Hultman, interview; Howard, interview.

53. The ACT men acknowledged the women's grievances and agreed to hold regular staff meetings where decisions could be openly discussed. They also agreed to create an ACT board with representatives from each neighborhood council. But these gestures were too little too late, and the ACT men were powerless to affect the issue of the women's dismissal. Boyte, "History of ACT," 11, 17; Landerman, interview; Cook Milan, interview; *Action*, 13–27 October 1970. For a fuller discussion of the ACT firings, see Christina Greene, "Our Separate Ways," 278–84.

54. Boyte claims that ACT was never officially closed down but that its work simply was taken up by other groups. Landerman, interview; Boyte, interview.

55. Boyte, interview; *Action*, 19 August–1 September 1970, 26 March–26 April 1971; Boyte, "History of ACT," 16–17.
56. Some ACT leaders did recognize the potential of service provisions to foment political action in white neighborhoods. *Operation Breakthrough Newsletter* 1, no. 2 (February 1968), series 4.8, no. 414, NCF Papers. SNCC organizers faced a similar dilemma in Mississippi when trying to use food and clothing to spur voter registration and other protest actions among the poor. Lee, *For Freedom's Sake*, 62–65.
57. In a state where 60 percent of mothers with children under six years of age worked outside the home and state officials refused to license day care facilities, quality child care was extremely difficult to find, especially for low-income women. Boyte, "ACT Survey," 6; Elizabeth Tornquist, "Special Interests Hurt Child Care," *Action*, 15–28 June 1970.
58. Since the child care center was an all-white project, it is debatable whether it could have provided a base for interracial projects like the biracial Edgemont health clinic did.
59. Tami Hultman, "The Edgemont Community Center," NCF report, August 1968, box 4, NCF Papers; Leon Rooke, "Through the Streets of Edgemont: A Neighborhood in Transition," *North Carolina Anvil*, 15 April 1967, 2.
60. One-third were welfare recipients; another third claimed incomes of under $3,000 a year. Eighty percent lacked a high school diploma, and 60 percent had never finished grade school. A census report in the 1960s revealed that almost 45 percent of the houses in Edgemont were "deteriorated" or "dilapidated." Rooke, "Through the Streets of Edgemont," 2.
61. This was the experience of Willie Mae Mitchell, a mother of six children and a member of the third black family to move to Edgemont. (Mitchell also headed the UOCI Welfare Committee.) Of course, not all whites were so receptive to black newcomers.
62. Cook Milan, interview; Tami Hultman, "The Edgemont Community Center," NCF report, August 1968, box 4, NCF Papers; Rooke, "Through the Streets of Edgemont," 2. Residential segregation has a long and violent history. On white resistance to residential integration throughout the nation, see, for example, Hirsch, "Massive Resistance" and *Making the Second Ghetto*; Sugrue, "Crabgrass-Roots Politics" and *Urban Crisis*; Gerstle, "Liberal Consensus"; and Meyer, *Don't Move Next Door*. For a different view of white working-class racial attitudes, see Kenneth Durr, *Behind the Backlash*.
63. O'Hare, "Edgemont"; *Action*, October 1969.
64. *Action*, 30 June–13 July 1970; Sidney M. Gospe, "The Edgemont Community Clinic: Durham's Student-Operated Clinic Begins Its Second Decade," typescript, undated, Edgemont Clinic Papers, SHC.
65. *Action*, 30 June–13 July 1970; Mike Nathan, "Community Organizing in Edgemont," 19, NCF report, May 1968, box 4, NCF Papers; "We All," magazine clipping, ca. 1972, box A–C, Edgemont Community Center Papers, DU.
66. DMH, 22 November 1969; *CT*, 5 July 1969.
67. *Action*, 9–30 March, 30 June–13 July 1970; *Daily Tarheel*, 14 February 1973, clip-

ping, Edgemont Clinic Papers, SHC. Studies of the clinic confirm Hicks's observations about use of the clinic. In its first month of operation, 96 percent of patients were black. A year later, 56 percent of patients were black and 44 percent were white. Ten years later, the ratio was 49 percent black and 51 percent white. More women than men of both races used the clinic: 57 percent of patients were female and 43 percent were male. A 1972 study reported that more black males than white males used the clinic (222 to 149). "Edgemont Community Clinic Study," July–August 1970; Sidney M. Gospe, "The Edgemont Community Clinic: Durham's Student-Operated Clinic Begins Its Second Decade," typescript, undated; John Hughes, Duncan L. McRae, and Donald L. Madison, "Patterns of Patient Utilization in a Volunteer Medical Clinic," *North Carolina Medical Journal*, May 1972, all in Edgemont Clinic Papers, SHC.

68. Cook Milan, interview; *Action*, 15–28 June 1970; *Action*, 30 June–12 July 1970.

69. Elizabeth Tornquist, "An Analysis of Durham Politics," *Durham Voters Alliance Newsletter*, May 1973, LWV Papers (Durham chapter), DU. In another example of a women's interracial alliance unrelated to ACT, over 150 women, 30 percent of them black, in Local 179 of the International Union of Electrical, Radio and Machine Operators waged a largely successful strike against Techitrol Corporation in Durham's Research Triangle Park in 1971. A male union official testified: "The relation[s] between blacks and whites on the [picket] line are the best I've seen." *Action*, 12–25 May, 28 July–11 August 1970, 26 January–23 February, June–July 1971; *North Carolina Anvil*, 17 July 1971.

70. The Christmas House grew out of separate projects organized by white and black women, and organizers intentionally avoided the patronizing effect of most charity groups that gave presents to poor children. DMH, ca. December 1969, clipping, box 1, Boyte Papers; Boyte, "History of ACT," 13; *Action*, February 1970.

71. Internal divisions also undermined the clinic, especially class tensions between medical providers and community residents, which appear to have been more divisive than racial tensions. When the clinic reopened as the East End Health Clinic, longtime black community activists McDuffie Holman and Christine Strudwick assumed leadership positions. Sidney M. Gospe, "The Edgemont Community Clinic: Durham's Student-Operated Clinic Begins Its Second Decade," typescript, undated; DMH, 27 October 1979, 2 December 1973, clippings; David Ross Garr, "An Examination of the Edgemont Community Clinic: A Study of Growth and Frustration," 5, unpublished typescript, 1971; Frances Strychaz, "Community Health Projects: A Closer Look at Problems," *New Physician*, April 1970; Minutes of the Edgemont Clinic Staff community meeting, 12 November 1975, all in Edgemont Clinic Papers, SHC.

72. In one survey of twenty-eight white households surrounding the Edgemont Community Center, 57 percent of families with eligible children refused to send their children to the center's preschool for "racial reasons." Tami Hultman, "The Edgemont Community Center—The Edgemont Community's Evaluation of the Center," attachment to unpublished NCF report, 7 August 1968, NCF Papers. For other examples of racist motherhood politics, see the essays in the "Nationalist Motherhood" section in Jetter, Orleck, and Taylor, *Politics of Motherhood*.

73. Sandra Morgen and Sally Maggard have demonstrated that women's family and domestic responsibilities are shaped as much by relations of race and class as by gender. Morgen, "Whole Power of the City"; Maggard, "Gender Contested." See also Naples, "Activist Mothering," and Lawson and Barton, "Sex Roles."

74. By the spring of 1970, ACT had recognized the need to deal more directly with racism, but it never systematically addressed the issue. Boyte, "ACT Survey," 5.

75. The tendency to vilify poor whites, especially poor southern whites, as more racist than affluent whites has a long history. During the 1960s, this perception was widespread, especially after a white backlash found national expression in the presidential candidacy of segregationist George Wallace, former governor of Alabama. As historian Thomas Sugrue has shown, Wallace's appeal was not limited to southern whites; he had strong backing among northern whites as well. Similarly, historian William Chafe has revealed how the stereotype of the bigoted "redneck," coupled with the progressive mystique of racial "civility" in North Carolina, supported a racist status quo that kept blacks subordinate and largely benefited not low-income whites—who lacked the economic and political power to effectively oppress blacks—but more affluent whites. Sugrue, *Urban Crisis*; Chafe, *Civilities and Civil Rights*, 37–38. For another view of the white backlash that downplays white working-class racism, see Kenneth Durr, *Behind the Backlash*.

76. Several scholars have made similar observations concerning what sociologist Bob Blauner calls the "paradox of working-class racism." Racial conflict between working-class whites and blacks is seemingly more prevalent because these groups are more likely to have greater contact with each other in schools, neighborhoods, and in the workplace. By contrast, class privilege affords more affluent whites greater insulation from blacks. Yet, as Blauner notes, "this is not the whole story. . . . because white and black workers share the difficulties of making a living and a better life for their families, they sometimes acknowledge a common class position." Sociologist Charles Payne also discovered that in Mississippi some of the poorest whites, "contrary to their redneck image, were often willing to get along with Blacks." Blauner, *Black Lives, White Lives*, 122–23; Payne, *Light of Freedom*, 311.

77. Roediger and others have echoed W. E. B. Du Bois's claim that common class interests have never been wholly effective in uniting blacks and whites. Nor have poor whites simply been the dupes of more powerful whites who have foisted white supremacy upon them. Rather, working-class whites fostered their own distinctive racism based on conceptions of whiteness that were linked to gendered self-perceptions as workers and as citizens. George Lipsitz calls this phenomenon the "possessive investment in whiteness." He illustrates the material and psychological advantages for lower-class whites of identifying with dominant whites, but he also underlines the ways in which government policies institutionalized white privilege. There has been a virtual explosion of "whiteness" studies in recent years; see, for example, Roediger, *Wages of Whiteness, Colored White*, and *Abolition of Whiteness*; Lipsitz, *Possessive Investment in Whiteness*; Brattain, *Politics of Whiteness*; and Hale, *Making Whiteness*. For several critiques of this schol-

arship, see Kolchin, "Whiteness Studies," and Stein, Arnesen, et al., "Scholarly Controversy."

78. Even Deborah Cook was reluctant to engage in direct action, although she insisted that her reluctance had nothing to do with its association with the civil rights movement. Landerman, interview; Cook Milan, interview; *Action*, 26 January–23 February 1971.

79. Ellis, "Why I Quit the Klan"; Davidson, *Best of Enemies*, 232–33.

80. Although this example involves an interracial alliance between a man and a woman, it revolved around school concerns, traditionally the responsibility of women. Atwater, interview; Terkel, *Race*, 271–83; *North Carolina Anvil*, 17 July, 14 August 1971; Werner, *Change Is Gonna Come*, xiii, 28.

81. The isolation and persecution that Ellis suffered from Klansmen and from his community was so intense that he suffered a nervous breakdown. Later, he earned a high school diploma from night school, joined a union drive at Duke University, where he worked as a maintenance worker, and became business manager of the International Union of Operating Engineers. Ellis, "Why I Quit the Klan"; Terkel, *Race*, 275–80; Cook Milan, interview.

82. Chafe, *Civilities and Civil Rights*; Ackelsberg, "Communities."

Chapter Six

1. BSC Meeting, 26 January 1969, tape 7, side 2, NWC. The Montgomery bus boycott has not gone unnoticed, largely because it thrust Martin Luther King Jr. into national prominence. Even scholars who have noted the importance of economic boycotts often fail to assess women's role. For example, in Tuskegee, Alabama, and in Greenwood, Mississippi, blacks organized "secondary boycotts" of local white merchants very similar to Durham's, but women's participation in these campaigns has gone largely unanalyzed. Payne, *Light of Freedom*, 325, 328; Norrell, *Reaping the Whirlwind*, 95–109. Two recent works that examine black women in the Montgomery boycott—but without noting the tactical significance of boycotts or examining the critical role of low-income women—are Robnett, *How Long? How Long?*, 55–70, and Barnett, "Black Women's Movement Organizations."

2. Differences over mobilizing versus indigenous organizing confronted United Organizations and permeated the national movement as well, becoming a major source of contention between SCLC and SNCC, especially during the 1965 Selma to Montgomery march. Carson, *In Struggle*, 158. For the distinction between mobilizing versus organizing traditions in black protest, see Payne, "Ella Baker."

3. Boycotts were not altogether risk free; for example, nearly one hundred members of the Montgomery Improvement Association were arrested, leaders were threatened, some blacks lost their jobs, and others became targets of white violence. But boycotts were less likely to draw white retaliation than other forms of protest, largely because participants were more difficult to identify.

4. Not only in the black freedom movement but historically, women have been key players in selective buying campaigns. On the role of women in boycotts, see, for example, Orleck, *Common Sense*.

5. Although United Organizations was widely recognized as the impetus for the boycott, black organizations representing all segments of Durham's black population had met for nine weeks before forming the BSC.
6. *North Carolina Anvil*, 6 June 1968.
7. Ibid., 3 August 1968. The dominance of males in the leadership of the BSC was not uncharacteristic of mixed-sex civil rights or community organizations in Durham or elsewhere.
8. CT, 3 August 1968. BSC member R. Kelly Bryant generously shared the BSC list of eighty-eight demands with me from his personal papers.
9. Strange, "Politics of Protest," 13; Howard and Redburn, "United Organizations," 33.
10. *North Carolina Anvil*, 6 June 1968.
11. Firefighters were ordered to turn hoses on the crowd during the February Orangeburg march after demonstrators lit a coffin in effigy. However, similar demonstrations, including effigy burnings, had occurred throughout the state without incident. Apparently, Martin Luther King had just cancelled a scheduled trip to Durham the night he was killed. *North Carolina Anvil*, 24 February 1968; Davidson, *Best of Enemies*, 221, 225–26. Over a nineteen-month period between April 1968 and October 1969, at least ninety incendiary fires were reported in Durham, not including a number of smaller brush and woods fires. Redburn, "Protest and Policy," 200–201. In the past, arson had been a weapon of slave resistance perhaps more feared than any other by southern slaveholding whites.
12. *Report of the National Advisory Commission* (popularly known as the Kerner Report).
13. Beginning in late fall 1968, BSC meetings were taped by one of the participants, Nat White Sr. Much of the discussion that follows is based on these tapes. The tapes offer a rare glimpse into the class and gender dynamics within the BSC and provide a microcosm of the tensions surrounding such issues within Durham's broader black protest community. I am extremely grateful to Doris Terry Williams, executive director of the Center for the Study of Black History at NCCU, for allowing me access to the tapes in the Nathan B. White Collection at the Hayti Heritage Center in Durham. I used the original reel-to-reel tapes. Copies have since been moved to SHC, but the numbering may not correspond to the tape numbers I use here.
14. In 1970, black female income had risen to only 35 percent of the median income in Durham and was 70 percent of black male income. U.S. Department of Commerce, Bureau of the Census, *Characteristics of the Population*, 1960, vol. 1, tables 33, 77; ibid., 1970, vol. 1, tables 41, 93, 95. Evelyn Nakano Glenn has shown that while the shift from domestic work to low-level service occupations experienced by most African American women and other women of color in the 1970s and 1980s seemingly offered little advancement, most women workers preferred the change. However, their work became more "invisible," and structural hierarchies of the public workplace simply replaced personal hierarchies of the private home. "Servitude to Service Work," 18, 1.
15. One of the BSC welfare demands was that the requirement regarding male support

and male presence in the household be abolished and that North Carolina's guidelines be changed to coincide with federal requirements. Initially, two-parent families were restricted from receiving aid under federal regulations, but in the 1950s these restrictions were lifted. However, only twenty-five states adopted the new, more permissive guidelines, and North Carolina was not one of them. Piven and Cloward, *Poor People's Movements*, 266–67; West, "Cooperation and Conflict," 153; *North Carolina Anvil*, 6 July, 17 August 1968; Barbara Nelson, "Two-Channel Welfare State"; Amott, "Black Women and AFDC."

16. Quoted in James Cunningham, "Resident Participation: The Struggle of the American Urbident for Freedom and Power," report to the Ford Foundation, August 1967, cited in "A Case Study of the War on Poverty in Durham, North Carolina," in *North Carolina Fund Process*, part 3, 165.

17. The FCD was created by black activists in North Carolina seeking independence from conservative white influence in the NCF (see chapter 4). United Organizations projects included Durham Homes, Inc., which built nearly one hundred low-income homes in a development called Unity Village, and one of its most significant efforts, United Durham, Inc., a community development corporation that was locally owned and controlled by the poor. UDI-sponsored projects included a community-owned supermarket, a cannery, and a modular homes factory. United Durham, Incorporated, undated; *UDI Newsletter*, ca. 1971, no. 904; United Organizations Review, no. 891, all in series 1.8, NCF Papers; CT, 26 April 1969.

18. One of the major causes of the housing crisis was the lack of coordination between the Housing Authority and the Redevelopment Commission, with the result that slum clearance projects did not include low-income housing construction plans. Elizabeth Tornquist, "Urban Renewal in Durham," *North Carolina Anvil*, 7 September 1968, 1–2.

19. Patrick O'Connell, "Hayti," *Tobacco Road*, 3, 1, 6, October 1979, Clippings Files, Durham County Library, Stanford Warren Branch, Durham, N.C. According to Moses Burt, a local black attorney representing Joyce Thorpe (see chapter 4), the poor "despised" the black middle-class and business elite, and many held the black elite at least partially responsible for the destruction of Hayti (and still do today). This pattern of destroying black communities through "urban renewal" (frequently by constructing highway projects that literally split communities in half) was repeated throughout the country. Smith, interview; Bryant, interview; Weare, *Black Business*, 283.

20. John Wheeler and several DCNA members had failed to persuade white officials to include African Americans on the welfare board or the board of elections. Nor were they able to convince the mayor to elevate a black vice chairman to the vacant chairmanship of the Housing Authority. Ron Semone, Report of DCNA meeting, 20 February 1966, no. 4424; Dick First and Marv Zomick, DCNA meeting, 10 February 1966, no. 4401; "George and Tom Interview with Moses Burt," 26 July 1967, no. 4444, all in series 4.8, NCF Papers; James Cunningham, "Resident Participation: The Struggle of the American Urbident for Freedom and Power," report to the Ford Foundation, August 1967, quoted in "A Case Study of

the War on Poverty in Durham, North Carolina," in *North Carolina Fund Process*, part 3, 165.

21. On the National Welfare Rights Organization, see West, *National Welfare Rights Movement*; Piven and Cloward, *Poor People's Movements*; and Valk, "Mother Power." A number of important welfare rights cases were decided in the 1960s, but local officials often refused to comply with federal regulations or adopt federal programs. For example, only 60 of 100 counties in North Carolina had food stamp programs by the end of the 1960s. (Durham County was one.) The Durham Welfare Steering Committee began in 1966 as a UOCI committee and was the first welfare rights group in North Carolina. By 1968, there were five welfare rights groups statewide, and the following year there were nine groups as well as a statewide welfare rights group established when welfare rights activists successfully marched on Raleigh to prevent cutbacks in welfare grants. Charles Finch, "Welfare Rights Organizing in Durham, North Carolina," December 1972, box 19, Boyte Papers.

22. Durham's black weekly included a comprehensive listing and explanation of the eighty-eight boycott demands. See *CT*, 3 August 1968.

23. *North Carolina Anvil*, 3 August, 21 September 1968.

24. On the relationship between white southern businessmen and the civil rights movement, see Jacoway and Colburn, *Southern Businessmen and Desegregation*. Martin Luther King and civil rights activists learned from the failures of the Albany, Georgia, movement to target merchants, not politicians, a lesson that King and local activists applied successfully in Birmingham. Branch, *Parting the Waters*, 769–70.

25. *North Carolina Anvil*, 28 September 1968. A 1964 survey of employment practices in Durham had recommended a boycott and picket lines as possible solutions to racial barriers. See "What's Ahead for the Negro Job Seeker in Durham, North Carolina," July 1964, NCF report, series 4.8, no. 4401, NCF Papers; BSC to Durham Chamber of Commerce, Merchants Association, undated, box 12, WIA Papers. On the black boycott, see also Redburn, "Protest and Policy," 161–200.

26. Quoted in *CT*, 17 August 1968.

27. *CT*, 3, 24 August 1968.

28. *DMH*, 2, 3, 7, 8, 15, 16, 21, 23, 29, 31 August 1968. Quotation from 31 August issue. The two white dailies had the same owner, and the *Durham Sun* showed a similar lack of sympathy for the boycott and BSC demands. For copies of the series on "Negro Grievances," see also box 66, Herbert Clarence Bradshaw Papers, DU. For a discussion of racial attitudes among Durham whites and of white voting patterns, see Stone, "Southern City."

29. The Durham Liberal Alliance, the Durham Citizens for McCarthy, the Durham Council on Human Relations, the Durham Young Democrats, and the Duke University YMCA and YWCA were among the white-dominated groups that publicly endorsed the boycott. White students from the Southern Student Organizing Committee (a radical student group with chapters at Duke and the University of North Carolina) helped to monitor stores, where they tried to counter KKK vows to break the boycott. The *North Carolina Anvil*, a white radical weekly published in

Durham, provided supportive and detailed coverage of the boycott. Durham Liberal Alliance, "What Are You Doing," ca. August 1968; Durham Citizens for Mc-Carthy, Press release, 29 July 1968; Duke YMCA-YWCA, "Remember the Boycott?," undated, all in box 19, Milo Guthrie Papers, DU; *North Carolina Anvil*, 10, 24 August, 21 September, 5, 19, 26 October 1968.

30. CT, 8 February 1969; Durham Council on Human Relations Meeting, 25 November 1968, tape 3, NWC.

31. Parliamentary procedure was a double-edged sword: it could ensure democratic participation by preventing a few individuals from dominating meetings, or it could be used to limit participation. Nevertheless, the issue of who knew the rules and who had experience using them tended to divide along class and, at times, gender lines within the BSC. Operation Breakthrough and United Organizations offered specific instructions to poor blacks about parliamentary procedure. For examples of similar disputes regarding the use of rules for meetings, see Piven and Cloward, *Poor People's Movements*, 292, and Woodard, *Nation within a Nation*, 206.

32. BSC Meeting, 7 December 1968, tape 5, side 2, NWC. The perception that Robert's rules of order were "white" came up in another context, when one BSC member reminded the group that in meetings with the white Chamber of Commerce and Merchants Association it was important that at least one BSC representative be well-versed in the procedures in order to avoid white trickery. Harrison Johnson, BSC Meeting, 22 March 1969, tape 10, side 2, NWC.

33. BSC Meeting, 30 November 1968, tape 5, side 1, NWC.

34. Ibid., 7 December 1968, tape 5, side 2, NWC. Housewives League member Hazeline Wilson was the only woman on the BSC Executive Committee, which met daily. Walltown activist Belle Bradshaw became the second woman on the BSC Executive Committee. After the boycott, Wilson, who worked at the Mutual, ran afoul of Durham's black business elite when she headed up a union organizing drive at the black-owned insurance company. Rose Paige Wilson, interview.

35. Ibid.; BSC Meeting, 14 December 1968, tape 6, side 1, NWC; Pat Wallace, United Organizations interim evaluation, 9 October 1967, box 370, series 4.8, no. 4564, NCF Papers, quoted in Howard and Redburn, "United Organizations," 50, 52–54.

36. BSC Meeting, 7 December 1968, tape 5, side 2, NWC.

37. Ibid.; BSC Meeting, 14 December 1968, tape 6, side 1, NWC. One indication that the women had been heard could be seen at the December 15 mass meeting, which boasted an entirely female program, including several low-income women.

38. BSC Meeting, 7 December 1968, tape 5, side 2, NWC.

39. Ibid., 4 January 1969, tape 7, side 1, NWC.

40. United Organizations mass meeting, 6 July 1969, tape 12, side 2, NWC.

41. Ibid.

42. Ibid.

43. CT, 16 November, 10 December 1968; *North Carolina Anvil*, 28, 21 September 1968 Redburn, "Protest and Policy," 177–78, 167, 179–82. Redburn estimated tha

stores lost $200,000 in December alone, although he believes actual losses were higher, since this figure only represents those businesses for which the Department of Tax Research had information.

44. BSC Meeting, 7 December 1968, tape 5, side 2, NWC.

45. Ibid., 26 January 1969, tape 7, side 2, NWC.

46. Ibid.

47. Ibid.

48. Robnett explains, much as I argue in chapter 1 and throughout this book, that in times of crisis (such as World War II, the direct action protests of the 1960s, and during the neighborhood organizing campaigns of the mid- and late 1960s) when traditional, usually male leadership is under assault or is less effective, women's bridge leadership becomes more visible and critical to organizing community support for protest activity. Robnett also points to the role of spontaneity and emotion in mobilizing communities. *How Long? How Long?*, 19, 22, 34, 69, 114.

49. Elna Spaulding, interview; Christina Greene, "Women-in-Action." For an examination of middle-class black women's activism and the politics of respectability in an earlier period, see Higginbotham, *Righteous Discontent*, esp. chapter 7.

50. Elna Spaulding, interview. Women-in-Action is discussed in the next chapter. For a recent but somewhat flawed discussion of class tensions among black women, see Mack, *Parlor Ladies and Ebony Drudges*.

51. Quoted in Terkel, *Race*, 286.

52. Chana Kai Lee reminds us that scholarship on black women has frequently yielded yet another one-dimensional portrayal of the "strong, Black woman" without giving due recognition to the pain, loss, and failures that such women also endured. *For Freedom's Sake*, 180–81.

53. Two excellent early studies of black poverty that document the ways in which poor black women in the 1960s forged survival strategies out of a distinctive set of African American family and community values are Carol B. Stack's *All Our Kin* and Joyce Ladner's *Tomorrow's Tomorrow*.

54. BSC Meeting, 7 December 1968, tape 5, side 2, NWC.

55. The BSC continued to meet following the end of the boycott (which was officially a "moratorium") to monitor progress. Some in the BSC were wary of the committees, which they feared could easily become a way of stalling real change, a concern that was soon borne out. Shortly after the boycott ended, the *Carolina Times* voiced its disappointment with the achievements of the boycott in yet another attack on Durham's black leadership: "About the best that can be said since the calling off of the boycott . . . is: where do we go from here?" CT, 12 April 1969; BSC Meeting, 15 March 1969, tape 10, side 1; BSC Meeting, 22 March 1969, tape 10, side 2, both in NWC.

56. Bryant, interview; Smith, interview; Redburn, "Protest and Policy," 269, 257–80; Strange, "Politics of Protest," 28.

57. Although a liberal-labor-black alliance managed to secure control of the Durham County Democratic Party in 1968, this was also the same year that Richard Nixon launched his "Southern Strategy," leading to the resurgence of the Re-

publican Party and the decline of Democratic Party strength in the South. *North Carolina Anvil*, 25 May, 1 June, 27 July 1968. For an analysis of black-white progressive alliances in Durham in the late 1960s and early 1970s, see Elizabeth Tornquist, "An Analysis of Durham Politics," 1973, unpublished typescript, LWV Papers (Durham chapter), DU.

58. Even today, women such as Ann Atwater and Callina Smith regularly attend DCNA (renamed the Durham Committee on the Affairs of Black People) meetings to represent the interests of the poor.

59. Marable, *Race, Reform and Rebellion*, 86–113. Many of the dimensions of the Black Power movement overlapped, as Komozi Woodard has shown in *Nation within a Nation*. Howard Fuller, "The Opening of Malcolm X University," 24 October 1969, tape 13, side 1, NWC.

60. Tyson, *Radio Free Dixie*, 27–28, 191–92.

61. See, for example, the fall 1968 issue of the North Carolina Mutual Life Insurance Company employee magazine, the *Whetstone*, which featured a series of articles on Black Power, and editorials in the CT: "The Black Man's Place in America," 4 January 1969; "Green Power vs. Black Power," 1 February 1969. See also the report on comments by Pearson at the North Carolina College Conference on the Black Lawyer and the Black Law School in CT, 3 March 1969, and an interview with Howard Fuller, "Where Do We Go From Here: Howard Fuller Speaks Out," *North Carolina Anvil*, 24 February 1968, 4–6.

62. There is still too little work on women and Black Power. For a recent work that includes some discussion of women and black nationalism and notes the critical work of black women in many of the nationalist organizations as well as black women's struggle against sexism, see Woodard, *Nation within a Nation*, esp. 285. Woodard also notes that women sometimes held top leadership positions, as in the Philadelphia and Albany chapters of the Congress of African People. On women and the Black Panther Party, see, for example, Matthews, "No One Ever Asks," and Elaine Brown, *Taste of Power*.

63. By the late 1960s, Fuller was the director of training for FCD, which funded United Organizations; however, most whites cared little for these distinctions. After the events of 1967, Fuller repudiated racial integration as a primary goal for the black freedom movement, which most whites interpreted as a call to arms. Others, however, believed that without him, "Durham would be no better than Detroit." Fuller ridiculed the accusation that he was "inciting Negroes." The idea "that black people need me to incite them," he retorted, was a sign of "white people's naivete." (See chapter 4 for a discussion of 1967 and the creation of the FCD.) Fuller quotations in *North Carolina Anvil*, ca. 1969, and in *Charlotte Observer*, 25 May 1969, clippings, both in NCF Papers.

64. "An Information Sheet for Captains in UOCI Fund-Raising Drive," series 1.32, no. 447, NCF Papers; Rogers, interview.

65. Atwater quoted in Davidson, *Best of Enemies*, 233, 214, 226. The union was Local 179 of the International Union of Electrical, Radio and Machine Operators Official quoted in *Action*, June–July 1971. Recent work suggests black women were instrumental in a wide range of Black Power activities. For example, Ruth

Turner, who worked with Cleveland CORE and knew Howard Fuller when he was in Cleveland, later developed CORE's Black Power philosophy, becoming the assistant to Floyd McKissick after he assumed the national chair. Gloria Richardson was probably the most prominent (yet often ignored) black woman advocate of armed self-defense. However, both scholars and activists stress that the emphasis on black manhood in the Black Power movement of the 1960s was disastrous for black women activists. Robnett, *How Long? How Long?*, 168; Robnett, "Women in SNCC"; Harley, "Chronicle of a Death."

66. William Chafe found a similar phenomenon in Greensboro, where the most disruptive blacks were FBI informants from outside the state. *Civilities and Civil Rights*, 194–202, 264. Bertie Howard, interview; "A Radish Interview with Howard Fuller," *Radish*, 28 July–10 August [1969], FCD news clippings, box 84; *Washington Post*, 17 February 1969, clipping, series 1.8, no. 926, both in NCF Papers.

67. The Black Panther Party had created a Malcolm X Liberation School in Harlem in 1966. The opening of Malcolm X Liberation University in Durham was part of a national movement that saw the creation of independent black nationalist schools in various cities, including Youngstown, Newark, Atlanta, Washington, D.C., and East Palo Alto. Howard and Redburn, "United Organizations," 23; Bertie Howard, interview; Proposal for Malcolm X Liberation University, 5 June 1969, series 1.8, no. 842, NCF Papers; Fuller, interview; Woodard, *Nation within a Nation*, 73, 126–27; CT, 30 November 1968; George Esser and Billy Barnes, "Uphill in North Carolina," 26 May 1969, no. 4710, NCF Papers; Opening of the Malcolm X Liberation University, 24 October 1969, tape 13, NWC.

68. Black students were angry at what they perceived to be foot-dragging by Duke administrators over the formation of a promised Afro-American Studies Program, and especially by officials' refusal to allow "meaningful" student participation in shaping the program. Students were also concerned over the 15 percent dropout rate among black students after one semester at Duke, which they attributed to the hostile environment for African American students at the largely white university. Background Information on the Malcolm X Liberation University, March 1969, series 1.8, no. 903, NCF Papers.

69. A summer intern program in 1968 during which black students lived and organized in black neighborhoods strengthened the links between students and local residents. Black students also supported the mostly black nonacademic employees at Duke. When black students took over the Allen Building at Duke, they received immediate and active support from the organized black neighborhood groups in Durham. Organizers hoped these alliances between black students and the community residents would be strengthened by the Malcolm X Liberation University. Proposal for Malcolm X Liberation University, 5 June 1969; Interim Committee of Malcolm X Liberation University to the directors of FCD, 20 June 1969; Background Information on the Malcolm X Liberation University, March 1969, all in series 1.8, NCF Papers.

70. Many activists, particularly students, saw the Durham movement as part of a broader black nationalist and even internationalist Pan-African movement. During the daylong celebration of the school's opening, Stokely Carmichael, widely

credited with bringing the Black Power slogan to the attention of white America, sent greetings from Guinea, where he was working with exiled Ghanaian black nationalist leader Kwame Nkrumah. Carmichael had recently been at the historically black Saint Augustine College in Raleigh and at UNC-CH, where he reportedly urged students to "get guns." *Winston-Salem Journal*, 25 February 1968; DMH, 26 October 1969, clippings, both in NCF Papers; Opening of the Malcolm X Liberation University, 24 October 1969, tape 13, NWC.

71. Like Ann Atwater, Fannie Lou Hamer was not averse to retributive violence, although both women also endorsed the use of nonviolent tactics. Hamer had half-jokingly threatened to take a knife to Aaron Henry's throat when he suggested accepting the Democratic Party's compromise at the 1964 Democratic National Convention. Lee, *For Freedom's Sake*, 121, 131, 130.

72. Historian William Van Deburg has suggested that the most durable legacy of the Black Power movement was its cultural contributions. *New Day in Babylon*. The Betty Shabazz Preschool moved eventually into the old DeShazor Beauty School building before the building was condemned and the school closed. Other examples of Black Power activism among Durham women abound. In 1969, Karen Rux, a recent graduate of NCC, and Wanda Garrett, wife of FCD director Nathan Garrett, created Your Own Thing, a theater project that enjoyed broad community support and marked "a spirited revival of the black arts movement" in the Bull City. The project featured a teen drama group of "Ghetto Players," which Rux and Garrett saw as the backbone of the new theater, as well as daily drama classes, workshops, and nightly movies. The women hoped to showcase nationally prominent black performers as well as recruit local talent. Bertie Howard, interview; CT, 26 July 1969; *North Carolina Anvil*, 24 February 1968.

73. Students and young Black Power advocates in the city did not denounce Atwater the way the newer SNCC militants derided Hamer; however, the shift away from neighborhood organizing meant that low-income women like Atwater would play a less prominent role in the movement. Mills, *This Little Light*, 240; Payne, *Light of Freedom*, 363–90; Robnett, "Women in SNCC," 155–65.

74. James Gardner, whose 1967 attack on the NCF and Operation Breakthrough (see chapter 4) helped make him one of the first Republican congressmen from eastern North Carolina in decades and head of the North Carolina Republican Party, had his eye on the upcoming governor's race, and he launched an all-out assault on the FCD. Fuller's association with FCD and his speaking engagements at colleges and high schools across the state, some of which experienced racial protests, added fuel to the charges against the FCD. Former NCF head George Esser negotiated with OEO officials Donald Rumsfeld and Dick Cheney to effect the release of the grant to FCD, but to no avail. Although the federal grant was announced in April, it was delayed for over a year, and then only $300,000 was released directly to UDI, bypassing FCD altogether. A 1969 evaluation of FCD summed up the fiasco: "As is often the case with advocates of rapid social and economic change, FCD has a bad image with much of the establishment middle-class—black and white." However, in Durham, FCD and Garrett received significant support from black business leaders. Ed Sylvester, Richard Dowdy, John

Lewis, James Prothro, and William Snider, "Evaluation of the Foundation for Community Development," unpublished report, October 1969, NCF Papers. For a sampling of state newspaper coverage regarding the FCD controversy, see the clippings file, series 1.8, NCF Papers. See also Mitchell Sviridoff to McGeorge Bundy, Ford Foundation memo, NCF Papers; CT, 17, 24 May, 7, 21, 28 June, 26 July 1969; DMH, 3 May, 5, 8 June 1969; City council meeting, 16 June 1969, tape 11, side 2, NWC; Esser to Howard Dressner, Ford Foundation interoffice memo, 23 July 1969; Esser to Rogers Wilkins, 12 February, 1970; "United Durham, Incorporated (foreword)," undated, all in series 1.8, NCF Papers.

75. The controversies that surrounded the NCF and Howard Fuller in 1967 led to severe restrictions in federal grants for community organizing projects. It is also important to note that Democrats as well as Republicans launched attacks on local poverty programs; however, the 1969–1970 attack on Fuller and the FCD was Republican-driven. Hugh Price, "Foundation for Community Development: A Unique Experiment in Community Development," March 1972; George Esser to Mitchell Sviridoff, 5 August 1972; Summary of the Tax Reform Act of 1969; George Esser and Lucy Watkins to Ron Gualt, Ford Foundation-FCD Monitoring, interoffice memo, 3 April 1971; Nathan Garrett, Employment with FCD, 14 January 1970, all in series 1.8, NCF Papers; DMH, 27 March 1970.

76. The police shooting occurred after a Malcolm X memorial service and in the midst of a cafeteria workers' strike in Greensboro, cementing the link for most whites between Black Power, violence, and black worker actions. Cafeteria workers were also on strike at NCC and UNC-CH, while 1199 had begun an organizing drive to unionize the mostly black hospital workers at Duke Hospital. Chafe, *Civilities and Civil Rights*, 177, 181–95 (see also the more extensive notes in the hardback edition of the book, 406); Price, "Foundation for Community Development," March 1972, series 1.8, NCF Papers. On the 1199 campaign at Duke, see Sacks, *Caring by the Hour*.

77. Nathan Garrett and Howard Fuller attended the conference in Detroit in April 1969 where the "Black Manifesto" was adopted, although both men thought the tactical approach was problematic. Upon Fuller's return from Africa, he worked with the Organization of African Unity and initiated the African Liberation Day celebration. *Charlotte Observer*, 25 May 1969; Nathan Garrett, News release, 1 June 1969; *Raleigh News and Observer*, 31 May 1969; DMH, 16 August 1969; Hearings before the Permanent Subcommittee on Investigations of the Committee on Government Operations, United States Senate, *Volume 59: Riots, Civil and Criminal Disorders and Disruptions on College Campuses*, Washington, D.C., 10 July 1969, stenographic transcript; George Esser to Mike Sviridoff, 16 May 1969; James Forman, "Manifesto to the White Christian Churches and the Jewish Synagogues in the United States and All Other Racist Institutions," presentation adopted by the National Black Economic Conference in Detroit, Michigan, 26 April 1969; IFCO News release, 1 May 1969, all in series 1.8, NCF Papers; Woodard, *Nation within a Nation*, 173–75.

78. Garrett believed that the UDI struggle was part of a nationwide ideological and political battle between those who supported community-based economic devel-

opment (in projects such as UDI and FCD, the Harlem Commonwealth Council, the Bedford-Stuyvesant Restoration Corporation, the Cleveland Hough Development Corporation, and others) and the Nixon administration, which opposed making grants to poor people. In contrast, Nixon supported a kind of "black capitalism" that benefited a small number of individual entrepreneurs. Floyd McKissick's Soul City—fifty miles north of Durham in Warren County—was another kind of black economic development. It was established in 1969 as a model city of black independence, combining aspects of black nationalism, black capitalism, and older traditions of African American self-help. Manning Marable, however, accused McKissick of "forg[ing] a Booker T. Washington–type alliance with the Nixon administration to establish petty bourgeois power." Van Deburg, *New Day in Babylon*, 134–37; *CT*, 25 January, 15 February 1969; Marable, "Reaction," 138; "United Durham, Incorporated"; FCD report to the North Carolina Fund, 9 October–1 August 1969; Garrett to Dear Friend of FCD, 8 May 1970, all in series 1.8, NCF Papers. For a somewhat more positive view of Nixon's support for black businesses, see Kotlowski, "Black Power—Nixon Style."

79. *Durham Sun*, 24 April 1970; DMH, 25 April 1970.
80. Bermanzohn, "Survivors"; Atwater, interview.

Chapter Seven

1. Asa Spaulding was the nephew of C. C. Spaulding, one of the founders of the North Carolina Mutual Life Insurance Company. Weare, *Black Business*.
2. *CT*, 10 August 1968. By defining Atwater's efforts in individualist terms, Spaulding also implicitly reinforced a privatist ethos, a recurring theme that had conservative implications regarding government responsibility for the poor. "The Ann Atwater Story," *McCall's*, July 1968, 4.
3. Most of the women represented mainstream women's voluntary, government, and religious organizations, but both radical and conservative women's groups were also included. For a full list, see "Womanpower-in-Action," *McCall's*, October 1968, clipping, box 1, WIA Papers.
4. Elna Spaulding may have represented the Durham LINKS Incorporated, a black women's service organization, at the New York City meeting. *CT*, 10 August 1968.
5. DMH, 21 August 1968; Elna Spaulding to "Dear Editor," undated, clipping, box 1, WIA Papers. The newspaper notices were entered in the *Congressional Record* on 11 September 1968; copy in box 1, WIA Papers. For the statewide conference, see boxes 6 and 10, WIA Papers.
6. Despite the apparent class similarities between black and white women, many of the African American WIA women considered to be middle-class were employed, usually as teachers, and some were even small business owners. There was also a fairly substantial black elite within WIA—the wives of Durham's black business establishment, who did not work outside their homes. Lucas, interview; Report of the Employment Committee of Women-in-Action, June 1969, box 9, WIA Papers.

7. See chapter 2.

8. WIA was never able to attract poor white women except for a short time when one low-income white woman served as a board member. Impressions vary among both black and white women regarding WIA's racial composition, without consistent views expressed by either race. In the beginning, although white women seem to have been in the majority, black women constituted a significant minority; WIA subcommittee lists for 1968 (box 9, WIA Papers) indicate a fairly even racial balance and in some cases reveal that more black than white women were involved in the group. In later years, black women occasionally outnumbered white women on the board. Elna Spaulding's visibility and leadership seems to have been the most significant factor in attracting large numbers of black women. Maxwell, interview; Sloan, interview; Elna Spaulding, interview; Atwater, interview; Smith, interview; Rogers, interview.

9. There were important differences between the ways black and white women understood domesticity. Glenn, "Servitude to Service Work," 427.

10. All the women I interviewed, both black and white, expressed this sentiment. There is an enormous literature on conceptions of domesticity and maternalism among women and the role these play in women's activism. Patricia Hill Collins has coined the useful term "othermother" to describe this phenomenon among black women. For just a sampling of this work, see Weiner, "Maternalism as Paradigm"; Boris, "What About the Working"; Ladd-Taylor, "Toward Defining Maternalism"; Joan C. Williams, "Domesticity"; Michel and Koven, *Mothers of a New World*, esp. Boris, "Power of Motherhood"; Glenn, Chang, and Forcey, *Mothering*, 129–32, 147–48; Collins, "Meaning of Motherhood"; Naples, "Activist Mothering"; Blumberg, "White Mothers"; Feldstein, "Death of Emmett Till"; Valk, "Mother Power"; Jetter, Orleck, and Taylor, *Politics of Motherhood*; and Swerdlow, *Women Strike for Peace*.

11. Spaulding's reference to men's lack of "training" suggests her belief that women's nurturing tendencies are not necessarily innate. Another black WIA member also felt that mothers in particular would be inclined to join a group like WIA. Elna Spaulding, interview; Lucas, interview.

12. When a controversy arose regarding male membership, WIA voted to ban men from membership and from attending WIA meetings unless the meetings were open to the public. However, black women in particular noted that they had their husbands' support. Elna Spaulding even claimed that both she and her husband had originated the idea for WIA, and at the founding meeting Asa T. Spaulding addressed the women. Elna Spaulding, interview; Minutes of the Steering Committee, 26 May 1969; Minutes of the Executive Committee, 9 December 1970, both in box 4, WIA Papers; Chris Greene, interview.

13. A number of scholars, including Linda Gordon, Elizabeth Lasch-Quinn, Cheryl Townsend Gilkes, and others, have argued that black women did not separate community or welfare work from civil rights activity. Gordon, "Visions of Welfare"; Lasch-Quinn, *Black Neighbors*; Gilkes, "Building in Many Places."

14. On black women and the politics of respectability, see Hine, "Rape"; Elsa Barkley Brown, "What Has Happened Here"; Higginbotham, *Righteous Discontent*,

esp. chapter 5; Feldstein, "Death of Emmett Till"; Wolcott, *Remaking Respectability*; and E. Frances White, *Dark Continents*.

15. Elna Spaulding remained active and highly visible in WIA even after relinquishing the presidency. In High Point and Goldsboro, North Carolina, black and white women formed biracial groups in 1963 and organized community discussion groups to "promote understanding" between the races. Although the Women's Good Will Group of High Point was started by a black and a white woman, the steering committee had eight white women and only two black women. Waynick, Brooks, and Pitts, *North Carolina*, 267–69.

16. Agenda for Opening Meeting, undated, box 6, WIA Papers.

17. Although it might seem like a small matter for black and white women to have met in one another's homes, such a prospect had been feared by some white LWV members when that group began holding integrated meetings in the mid-1950s (see chapter 2). Estelle Himes, wife of the late sociologist and NCC professor Joseph Himes, reported a similar dilemma in Durham during the 1950s. Minutes of WIA meeting, 18 September 1968, box 3, WIA Papers; Chris Greene, interview; Himes, telephone conversation.

18. Audrey Burt, Report of the Employment Subcommittee of WIA, June 1969, box 9, WIA Papers.

19. Minutes of the WIA Human Relations Subcommittee meeting, 7 April 1969, box 9, WIA Papers.

20. McLaurin, interview.

21. WIA Civic Improvement Committee meeting, 3 June 1969, box 9, WIA Papers; Elna Spaulding, interview; Chris Greene, interview; Coble, interview; Watson, interview.

22. Elna Spaulding, interview. See box 9 in WIA Papers for a description of WIA subcommittees and their membership.

23. Quoted in Lee Ridenour, "Blessed Are the Peacemakers," DMH, 29 December 1968.

24. WIA Executive Committee meeting, 6 October 1968, box 4, WIA Papers.

25. Lucas claimed that her daughter, Charsie Hedgepath, who helped organize the initial Hayti councils that became the nucleus for UOCI and who later served as secretary of the BSC, had a great influence on her views. But Lucas's own experiences undoubtedly were just as important. She had regular contact with poor and working-class blacks in her barbershop and pool hall, which she ran herself after becoming a widow when her daughter was only three months old. Lucas, interview.

26. "Concerning the Role of the Organization," ca. 1969, box 4, WIA Papers (emphasis in original). Rose Paige Wilson, WIA secretary, believed that Elna Spaulding was the major force behind WIA neutrality, yet the organization's insistence on the study of issues, the formation of consensus, and neutrality was very similar to that of the LWV. Rose Paige Wilson, interview.

27. Statement on Selective Buying Campaign, undated, box 6; BSC to Durham Chamber of Commerce, Merchants Association, undated, box 12, both in WIA Papers; CT, 3 August 1968.

28. The three BSC representatives included Howard Clement (who was also the nephew of WIA member Josephine Clement); Ben Ruffin, director of United Organizations; and Moses Burt, president of the Durham Council on Human Relations, an unofficial body formed by concerned citizens to address race relations. (Burt was also the husband of WIA member Audrey Burt and one of the local attorneys in the Joyce Thorpe case.) Floyd Fletcher and James Hawkins of the Chamber of Commerce and T. M. Patrick, president of the Merchants Association, were on the other panel. A. J. H. Clement to Josephine Clement, 7 October 1968; Richard Arey (Durham Merchants Association) to Josephine Clement, 11 October 1968; Edward G. Lilly (president of Durham Chamber of Commerce) to J. Clement, 10 October 1969, all in box 1, WIA Papers; DMH, 23 October 1968.

29. For example, two days after WIA's founding meeting, the *Herald* ran an ad by the Durham County Citizens Council, a white supremacist group, entitled "Black Power Demands and Communist Demands" that "proved" that the civil rights movement was linked to the Communist Party since both advocated the abolition of discriminatory laws and all Jim Crow ordinances as well as equal opportunity in employment, wages, hours, and working conditions for both white and black workers. DMH, 9 September 1968. WIA members were upset that their own efforts frequently received little press attention. Minutes of WIA Steering Committee meeting, 29 April 1969, box 4, WIA Papers.

30. Several white women did acknowledge that there were tensions between black and white women but argued that these tensions were not usually expressed overtly. Watson, interview; Chris Greene, interview; Rose Paige Wilson, interview.

31. Clement to Wilson, 21 October 1968, box 1; Minutes of WIA board meeting, 17 December 1974, box 3, both in WIA Papers.

32. Minutes of Civic Improvement Committee, 4 March, 4 April, 6 May, 3 June 1969. See also annual reports of the Civic Improvement Committee, 1968–69, 1970, 1971, 1972, all in box 9, WIA Papers.

33. Several white women reported that they had employed black women as household workers or had grown up with black domestic "help." Sloan's view conveniently overlooked the black elite who also employed black domestic help. Sloan, interview; Coble, interview; Watson, interview; Chris Greene, interview; Rose Paige Wilson, interview. For a look at the relationships between southern white women employers and black household workers, see Tucker, *Telling Memories*; for black women employers and black servants, see Mack, *Parlor Ladies and Ebony Drudges*.

34. Ridenour to Elna Spaulding, 11 October 1968, box 1, WIA Papers. Ridenour also displayed her ignorance of Atwater's extensive knowledge concerning Housing Authority regulations and federal law; Atwater's expertise was well known and respected among both low-income and middle-class blacks and was publicly acknowledged by BSC chair Howard Clement.

35. Minutes of WIA meeting, 18 September 1968, box 3, WIA Papers; Atwater, interview; Elna Spaulding, interview; Rose Paige Wilson, interview; Sloan, interview; Watson, interview; Chris Greene, interview.

36. Another problem with the WIA beautification project was that in the Fayetteville Street housing project there was almost no play space for the 600 children, and they subsequently trampled WIA's shrubbery. Minutes of the special meeting of the WIA board, executive and advisory committees, 17 May 1971, WIA Papers; Lucas, interview.

37. The two LWV members were Annie Laurie O'Neal and Harriet Quin, both of whom brought their expertise to the WIA Housing Subcommittee. The LWV interest in affordable housing, especially for low-income blacks, was due to pressure from United Organizations, which prompted the league to drop its support for urban renewal in 1967 and to refocus its efforts on the housing crisis in Durham. Annie Laurie O'Neal, "Homes for the Disadvantaged: Public Housing and Its Alternatives," ca. 1969; *Durham LWV Bulletin*, April, September, June 1967, September, November 1969; "Local Contenting Responsibilities Durham LWV 1965–66," all in LWV Papers (Durham chapter), DU; Quin to Elna Spaulding, undated; Willa Johnson to Spaulding, 11 April 1969, both in box 9, WIA Papers; "Recommendations from the Housing Subcommittee of WIAPVC," n.d.; Annual Report of the Subcommittee—Housing, 11 January 1971, both in box 4, WIA Papers.

38. See chapter 4 for a discussion of the Greenberg housing dispute.

39. Greenberg and Lucas even managed to work on the same committee until their dispute over the tenant issue in 1974–75. Minutes of WIA board meeting, 26 November, 17 December 1974, 25 February 1975; Report of the Resource Committee, 19 September 1974; Mannie Geer, "WIA Board Meeting—New Project Report," 22 October 1974; Mannie Geer, "A Rebuttal to the Minutes [of] December 17, 1974"; Blue Greenberg to the members of the board of Women-In-Action, undated, all in box 3, WIA Papers; Sloan, interview; Watson, interview; Rose Paige Wilson, interview.

40. Lucas, interview. Despite WIA inaction on issues of central concern to poor blacks, some WIA members often tried to publicly back the poor. For example, Bessie McLaurin was cochair of Citizens for UOCI, which provided fundraising assistance. CT, 10 May 1969.

41. Atwater, interview; Smith, interview.

42. Rogers, interview.

43. For an insightful analysis of the relationship between privilege and exploitation among middle-class and low-income women, see Glenn, "Servitude to Service Work"; see also Elsa Barkley Brown, "What Has Happened Here."

44. See Chris Howard, "Eyes on the Prize," for an excellent discussion of the politics of racial discourse in Durham in the 1960s.

45. Herbert Haines makes a similar argument concerning the relationship between moderate and militant blacks. *Black Radicals*.

46. In the 1968 Virginia case *Green v. New Kent County School Board*, the Supreme Court overturned "freedom of choice" plans that allowed only for token desegregation. According to Davison Douglas, the case unleashed a flurry of school litigation cases throughout the South. The 1969 Mississippi case *Alexander v. Holmes County Board of Education* marked the first time the federal government, under the Nixon

administration, intruded to delay school desegregation; the Supreme Court ruled that the "all deliberate speed" standard of the *Brown* decision was no longer permissible and that school boards must immediately terminate all dual system school districts and operate only "unitary" school systems. Douglas, *Reading, Writing, and Race*, 130, 163–64; Goldfield, *Black, White and Southern*, 257.

47. Presumably, the city school board was preparing its own desegregation procedures to be implemented in 1970–71 even before the motion was filed. David McKnight, "Desegregation: Durham City School Case History," DMH, 18 September 1970.

48. *Women-in-Action Communications Committee Newsletter* 2 (8 December 1969), box 6, WIA Papers.

49. Doris McAdams, untitled article, *WIA Newsletter* 5 (2 March 1970), box 6, WIA Papers.

50. Minutes of WIA Executive Committee meeting, 16 February 1970, box 4; Minutes of WIA Board of Directors meeting, 17 March 1970, box 3; Minutes of WIA Advisory Committee meeting, 18 May 1970, box 4, all in WIA Papers.

51. Minutes of Advisory Committee meeting, 15 June 1970, box 4, WIA Papers.

52. Many WIA members belonged to other women's groups that had backed school desegregation since the *Brown* decision (see chapter 2). By the 1960s, however, groups like the AAUW, the LWV, and the YWCA appeared mild, even timid, in the context of a more vigorous and militant black protest movement. Nevertheless, the AAUW's 1965 call for "forthright integration" was significant, particularly in the face of the local school board's intransigence. Minutes of WIA Executive Committee meeting, 16 June 1970, box 4, WIA Papers; "Durham Branch of the AAUW, 1957–1967," box B–L, AAUW Papers.

53. The revised school board plan paired predominantly white and black schools and included busing 2,000 of about 12,000 students. The judge accepted this plan but mandated that two more schools be paired, for a total of six out of thirty-four schools, and he threw out the provision that seniors be permitted to graduate from their old high schools. David McKnight, "Desegregation: Durham City School Case History," DMH, 18 September 1970.

54. At a WIA meeting the day before the June 16 public meeting, WIA had come up with the idea for the school support center. At the same meeting, Bessie McLaurin drew attention to a related problem—the dismissal of black teachers and students without cause and with no redress—but WIA failed to deal head-on with the issue. Minutes of WIA Advisory Committee meeting, 15 June 1970, box 4, WIA Papers.

55. "Women's Group Plans School Support Center," *Durham Sun*, 25 July 1970; DMH, 30 July 1970, both in Clippings File, WIA Papers; Minutes of WIA Steering Committee meeting, 30 June 1970, box 7, WIA Papers.

56. By 1971, Greensboro was one of only five school districts in the state still not in compliance with federal guidelines. Charlotte's school desegregation battle ended with the landmark 1971 *Swann v. Charlotte-Mecklenburg Board of Education* Supreme Court decision known as the "busing case." Like Durham women, women in Greensboro and Charlotte played a prominent role in preparing their

communities for school desegregation. Ironically, by the early 1970s, blacks in North Carolina began to split over the issue of school desegregation, with some shifting their emphasis to quality education rather than integrated schools. Mosnier, "Inc. Fund South"; Chafe, *Civilities and Civil Rights*, 220–34; Douglas, *Reading, Writing, and Race*, 182, 205. For one black community's organized opposition to court-ordered desegregation in North Carolina, see Cecelski, *Along Freedom Road*. On the Swann case, see also Gaillard, *Dream Long Deferred*, and Schwartz, *Swann's Way*.

57. WIA was not altogether unique. Southern women entered the school desegregation controversy on both sides of the issue. Before the mid- to late 1960s, black opposition to school desegregation was fairly muted, while whites were always divided, though not always equally. When southern white women in cities such as Little Rock, Charlottesville, New Orleans, and Atlanta organized against massive white resistance, they often did so not to desegregate public schools but to keep public schools open in the face of segregationists' threats to close them in the years after *Brown*. There was a certain irony in WIA's school desegregation work. The accomplishments of the black freedom movement made possible the creation of WIA, while Durham's refusal to desegregate its schools until 1970 meant that a biracial women's group was able to offer its support, an option that would have been unlikely earlier. On women's efforts to desegregate schools in several southern cities, see Murphy, *Breaking the Silence*; Gates, "Power from the Pedestal"; Jacoway, "Down From the Pedestal"; Daniel, *Lost Revolutions*, 282–83; Lewis, "Emergency Mothers"; Tyler, *Silk Stockings*, 225–29, 297; and Nasstrom, "Politics of Historical Memory," 138–209.

58. Agenda of WIA general meeting, 8 June 1970, 13 July 1970, 14 September 1970, box 3, WIA Papers.

59. On the role of disruptive or silent clergy in Little Rock, see Daniel, *Lost Revolutions*, 267–69. Minutes of WIA Steering Committee, 9 July 1970; Women-in-Action Church Support Committee to members of the Durham Ministerial Association, 20 July 1970, both in box 7, WIA Papers. For a critical view of the Parent Teacher Student Association, see *Action*, 13–27 October 1970.

60. Fact Sheet on Center for School Support, [1970], box 7, WIA Papers.

61. William Self (superintendent, Charlotte-Mecklenburg schools) to Eula Miller, 26 June 1970; W. J. House (superintendent, Greensboro schools) to Miller, 8 July 1970; Dean Pruette (superintendent, High Point schools) to Miller, 26 June 1970; Minutes of WIA Steering Committee meeting, 30 June 1970; DMH, 2 August 1970, Clippings File, all in box 7, WIA Papers; *North Carolina Anvil*, 22, 29 August 1970, Clippings File, box 10, WIA Papers.

62. Program, Women-in-Action for the Prevention of Violence and Its Causes Formal Opening [of the] Center for School Support, 29 July 1970, box 7, WIA Papers.

63. DMH, 18 September 1970. The NAACP announced it would not appeal the final ruling.

64. Minutes of WIA Steering Committee meeting, 9 July 1970; Resolution adopted by Women-in-Action, 14 September 1970, box 7; Untitled newspaper clippings,

24, 28 July 1970; "Women in Action Lead Move to Ease Integration Tensions," DMH, 18 September 1970; *Durham Sun*, 20 September 1970, all in Clippings File, box 7, WIA Papers.

65. Several groups were convinced that the mid-August meeting was "an undercover attempt" to bring former PTA members together so that they could maintain control under the new integration plan. Though the *North Carolina Anvil* criticized the WIA, the paper did try to quell rumors and encouraged parents to attend the open house. DMH, 20 August 1970; *North Carolina Anvil*, 29 August 1970, both in Clippings File, box 7, WIA Papers.

66. In an ironic twist, one of the school officials involved with the workshop was Annabelle Selph, the former supervisor of the Durham school lunch program who had dismissed four black women cafeteria workers in 1965 after they had formed the School Employees Benevolent Society (see chapter 4). Elna Spaulding to Selph, 1 September 1970, box 1, WIA Papers.

67. Fact sheet on Center for School Support, [1970]; DMH, 2 August 1970, both in box 7, WIA Papers; Elna Spaulding, interview; Wayne Hurder, "School Desegregation Smooth in Durham," *Raleigh News and Observer*, 20 September 1970.

68. Chris Greene, interview.

69. A number of other white WIA women such as Hilda Coble, Beth Maxwell, and Eula Miller also sent their children to desegregated schools. Carl and Anne Braden, southern white activists in Louisville, sent their children to majority-black schools in the late 1950s and were treated as pariahs by most other whites. I do not mean to make heroines out of white women for sending their children to integrated schools. At the same time, other white WIA women expressed relief that their children were already grown and that they could avoid these decisions. Coble, interview; Maxwell, interview; Watson, interview; Rose Paige Wilson, interview; Fosl, *Subversive Southerner*, 215.

70. The *Raleigh News and Observer* reported a slightly higher figure, saying that 58 percent of Durham city school students were black, as were 50 percent of the teachers. 20 September 1970, clipping box 7, WIA Papers. The resegregation of public schools was a national pattern. In the first three years after the *Swann* decision, the number of private schools in Memphis more than doubled, from forty to eighty-five. In Atlanta, the "city too busy to hate," black students were 80 percent of the public school population by 1973. That same year, the Supreme Court extended busing orders outside the South in the *Keyes v. Denver* decision. As David Goldfield points out, busing plans for metropolitan areas were implemented only in consolidated city-county districts like Charlotte-Mecklenburg and Louisville-Jefferson. Dual school systems not only perpetuated racial segregation but strained local budgets as well, especially in rural areas. In Robeson County, an impoverished rural area in eastern North Carolina, five school districts—one largely white, one predominantly Native American, two largely African American, and only one integrated—cost the county $175,000 in superintendent salaries alone in 1985. *Black, White and Southern*, 260–61.

71. North Carolina and Tennessee enacted legislation prohibiting the use of state vehicles to achieve racial balance in schools. Alabama, Georgia, Louisiana, and

South Carolina followed the example of "liberal" New York and adopted laws forbidding student placements on the basis of race, creed, color, national origin, or to increase or decrease attendance at any school. In the South, Reubin Askew, governor of Florida, stood alone in publicly endorsing busing as a necessary measure to desegregate schools. Foy, "Durham in Black and White," epilogue; Livesay, "Domination and Legitimation"; Bartley, New South, 417–19; Goldfield, Black, White and Southern, 261. For examples outside the South, see Theoharis and Woodard, Freedom North.

72. Scholars have not always ignored class factors in the school desegregation controversy, particularly in discussions of busing. For works that examine the disproportionate busing of low-income whites to achieve school desegregation, see, for example, Douglas, Reading, Writing, and Race; Lukas, Common Ground; and Formisano, Boston Against Busing.

73. The 1974 Detroit case, Milliken v. Bradley, sounded the death knell for multidistrict desegregation plans when the U.S. Supreme Court ruled that metropolitan plans linking urban and suburban school districts to achieve school desegregation were punitive to white suburban districts and threatened local choice and governance. Thus, school districts that encompassed both urban and suburban areas, as in Charlotte, found it far easier to desegregate than urban districts that became increasingly low-income and minority, as in Durham. Douglas, Reading, Writing, and Race, 247, 254; Hammond quotation in Goldfield, Black, White and Southern, 264, 262. For a scathing indictment of the resegregation of public schools, see Kozol, Savage Inequalities. For an incisive reassessment of Brown, especially of its failure to eliminate white supremacy or to address questions of power, privilege, and exploitation, see Gaines et al., "Round Table," particularly the contributions of Kevin Gaines, Adam Fairclough, Charles Payne, and Lani Guinier.

74. WIA managed to sidestep many of the contentious issues in the emerging women's movements. Although WIA never considered itself a feminist organization, it did support some of the same issues that feminist organizations championed. The WIA Clearinghouse provided abortion referrals, and WIA sponsored a student intern at the newly formed Durham Rape Crisis Center in 1973–74. A number of WIA members, both black and white, worked with various segments of the women's movement throughout the 1970s and 1980s. For a fuller discussion of WIA and the women's movements of the 1970s, see Christina Greene, "Our Separate Ways," 379–88.

75. Women-in-Action Clearinghouse, [1977]; "Nature of Calls Received at the Women-in-Action Clearinghouse and How They Are Handled," April 1972; Mannie T. Geer, Annual report of the WRAL—Calls for Action, 13 January 1975, all in box 7, WIA Papers.

76. As has been the case historically with women's voluntary efforts, government and private agencies in the city soon offered many of the services initially provided by the clearinghouse. The United Way set up an information and referral service and a volunteer bureau headed by Beth Maxwell, a former WIA member, that seemed to compete directly with the clearinghouse. However, govern-

ment cutbacks in the 1980s made the clearinghouse services, however small or redundant, increasingly important. Anne Firor Scott, *Natural Allies*, 2; Maxwell, interview.

77. Women's historians have documented that women's voluntary associations, particularly for women of color, always had broader political implications and that black, middle-class women's philanthropic work was crucial to the survival of the most vulnerable in the black community. See, for example, Hine, "Philanthropic Work of Black Women," and Hewitt, "Politicizing Domesticity." See also essays by Sara Evans, Darlene Clark Hine, Deborah Gray White, Marion W. Roydhouse, and Mary E. Frederickson in Hewitt and Lebsock, *Visible Women*, and Meyerowitz, *Not June Cleaver*.

78. Leslie Brown, "Common Spaces, Separate Lives," 224. I am using the term "politics of respectability" somewhat differently from the way most historians do. Closely linked to racial uplift ideology, it generally denotes black women's efforts during the Jim Crow era to instill African Americans with bourgeois notions of female comportment and domesticity, sometimes as a precondition for proving to whites that blacks were deserving of citizenship rights and sometimes as a refutation of negative stereotypes regarding black female sexuality. I use it to denote similar modes of bourgeois behavior that stressed middle-class values and, above all, a commitment to civility, persuasion, and neutrality as opposed to militant, confrontational politics. Higginbotham argues that female respectability had both conservative and emancipatory implications for black women in the Jim Crow South. Kevin Gaines contends that black uplift ideology and respectability promoted conservative gender and class politics. Higginbotham, *Righteous Discontent*, 203–4, 222, 227–28; Gaines, *Uplifting the Race*. See also Ransby, *Ella Baker*, 42–45, 49–53, 225–26. Victoria Wolcott argues that a masculinist and more militant politics replaced earlier traditions of female bourgeois respectability in interwar black Detroit; however, as this study suggests, black female respectability was quite prevalent in the South even during the civil rights era, suggesting the existence of regional differences. Wolcott, *Remaking Respectability*. On the separation of employment from respectability for black women, see also Harley, "When Your Work Is Not Who You Are," and Shaw, *What a Woman Ought to Be*.

79. Interviews with white women reinforced this point. While many were willing to acknowledge the class-based exploitation of low-income women, they were far less willing to concede their own complicity in such relations of power.

80. For example, the success of the North Carolina Mutual and other black businesses in Durham was dependent upon working-class blacks who frequently had few other choices but to serve the black bourgeoisie and patronize its businesses. Of course, urban renewal and the destruction of Hayti was far more deleterious to black businesses in Durham than desegregation. For an insightful discussion regarding the impact of desegregation on the North Carolina Mutual, see Weare, *Black Business*, 280–87.

81. Higginbotham notes that black and white women reformers often came together from different motives. *Righteous Discontent*, 89–90.

82. Anne Braden, a white southerner and longtime civil rights and social justice activist in the South, claimed that the media's attention to a white backlash came precisely at a time when polls indicated a greater abhorrence of racial discrimination on the part of whites than ever before. Anne Braden, Keynote address, Second Southern Conference on Women's History, 7 June 1991, UNC-CH, in Duke/UNC-CH Center for Research on Women, *Branches Newsletter*, Fall 1991.

83. For a different view that stresses the political implications of women's interracial friendships, see Lugones and Spelman, "Theory for You."

84. On the role of conflict within women's organizations, see, for example, essays by Allison Tom, Carol Mueller, and Suzanne Staggenborg in Ferree and Martin, *Feminist Organizations*. Although WIA did not consider itself to be a feminist organization, the clearinghouse did offer a number of services promoted by feminists.

85. Lucas, interview.

Epilogue

1. *New York Daily Challenge*, 16 April 1975; conversation with Karen (Galloway) Bethea-Shields, 5 August 2004.

2. After a five-week trial, Little was acquitted by a jury of six blacks and six whites. Although a number of black women who supported Joan Little received media attention, among them congresswoman Shirley Chisholm and radical activist Angela Davis, most of the media headlines were captured by men, and CWJ received almost no media coverage. Glusman, "Moment of Possibility," 59–66; Kaplan, *Crazy for Democracy*, 47–71, 103–24; McNeil, "Joanne Is You."

Bibliography

Archives

Atlanta, Ga.
 Robert W. Woodruff Library Archives, Atlanta University
 Southern Conference for Human Welfare Papers
Bethesda, Md.
 University Publications of America
 National Association for the Advancement of Colored People Papers
 (microfilm)
Chapel Hill, N.C.
 North Carolina Collection, Wilson Library, University of North Carolina
 Clippings File
 Southern Historical Collection, Wilson Library, University of North Carolina
 William A. Clement Papers
 Edgemont Clinic Papers
 William J. Kennedy Papers
 Floyd B. McKissick Papers
 North Carolina Fund Papers
 Southern Oral History Program Collection
 Nathan B. White Collection (audio tapes)
Charlotte, N.C.
 Special Collections, Atkins Library, University of North Carolina
 Kelly Alexander Papers
College Park, Md.
 Special Collections Division, Hornbake Library, University of Maryland
 Tobacco Workers International Union Papers
Durham, N.C.
 Durham County Library, Main Branch
 Durham County Library, Stanford Warren Branch
 Clippings File
 Durham Public Schools, Main Administration Building
 Minutes of the Board of Education
 James E. Shepard Library, North Carolina Central University
 Durham Civil Rights Reunion, 8–9 April 1994 (videocassettes)
 Special Collections, Perkins Library, Duke University
 Altrusa Club Papers

American Association of University Women Papers (Durham chapter)
Josiah Bailey Papers
Boyte Family Papers, Harry C. Boyte Series
Winifred Gail Soules Bradley Papers
Herbert Clarence Bradshaw Papers
Mary Cowper Papers
Duke University Oral History Program Collection
Edgemont Community Center Papers
Milo Guthrie Papers
Rencher Harris Papers
Robert Preston Harriss Papers
Wilbur Hobby Papers
Chris Howard Papers
League of Women Voters Papers (Durham chapter)
Perkins Pamphlet Collection
Semans Family Papers
Asa T. Spaulding Papers
Women-in-Action for the Prevention of Violence and Its Causes Papers
Women's International League for Peace and Freedom Papers
 (Durham–Chapel Hill branch)
Young Women's Christian Association Papers (Durham central Y and Harriet
 Tubman branch)
University Archives, Perkins Library, Duke University
Alice Mary Baldwin Papers
A. Hollis Edens Papers
Young Women's Christian Association Papers (Duke Woman's College)
Madison, Wisc.
State Historical Society of Wisconsin, University of Wisconsin
Carl and Anne Braden Papers
Committee to Combat Racial Injustice Papers
New York, N.Y.
National Board Archives
Young Women's Christian Association Papers (microfilm)
Raleigh, N.C.
North Carolina Division of Archives and History
J. Melville Broughton Papers
Washington, D.C.
Manuscript Division, Library of Congress
National Association for the Advancement of Colored People Papers

Periodicals

Action (ACT newsletter, Durham)
Baltimore Afro-American
Branches Newsletter (Duke/UNC-CH Center for Research on Women)

Campus Echo (North Carolina College, Durham)
Carolina Times (Durham)
Charlotte Observer
Common Good (Newsletter of Southerners for Economic Justice, Durham)
Crisis (NAACP)
Daily Independent (Kannapolis, N.C.)
Daily Tarheel (UNC-CH)
Duke Chronicle
Durham Morning Herald
Durham Sun
Independent (Durham)
McCall's
New York Daily Challenge
New York Post
North Carolina Anvil (Durham)
Pittsburgh Courier
Raleigh News and Observer
Southern Patriot (Southern Conference Education Fund, New Orleans)
Washington Post
Winston-Salem Journal

Oral Histories

Interviews and more informal conversations took place in Durham, North Carolina, and tapes and transcripts of interviews are held by the author, unless otherwise noted.

Charlotte Adams, interview, 23 June 1998, Chapel Hill, N.C.
Ann Atwater, interview, 12 January 1993
Louis Ernest Austin, interview notes, ca. 1957, box 49, folder 11, Carl and Anne
 Braden Papers
Quinton Baker, interview by Chris Howard, 5 February 1983, notes, Chris Howard
 Papers
Karen (Galloway) Bethea-Shields, conversation, 5 August 2004
Harry C. Boyte, telephone interview notes, 27 July 1995, Minneapolis, Minn.
John Bracey, personal correspondence, 28 April 1999
————, telephone conversation, 14 May 1999
R. Kelly Bryant, interview, 25 February 1993
Charlotte Bunch, interview, 14 June 1989, Washington, D.C.
Warren Carr, interview by anonymous, 31 January 1978, Winston-Salem, N.C., tran-
 script, Duke University Oral History Program Collection
Mr. Chestnutt, interview by "White Male from Duke," undated, transcript, Duke
 University Oral History Program Collection
Josephine Clement, interview, 13 July, 3 August 1989, transcript by Kathryn
 Nasstrom, Southern Oral History Program Collection
Hilda Coble, interview, 2 November 1992

Cora Cole-McFadden, interview, 30 March 1993

Deborah Cook Milan, interview, 18 June 1999

Ruth Dailey, interview by Chris Howard, 8 October 1982, tape recording, Chris Howard Papers

John Edwards, interview by Chris Howard, 26 October 1982, 23 February 1983, notes, Chris Howard Papers

George Esser, interview by Karen Thomas, 3 October 1995, transcript, Southern Oral History Program Collection

Sara Evans, interview, 22 March 1994, Chapel Hill, N.C.

Howard Fuller, interview by Jack Dougherty, 28 December 1975, Milwaukee, Wisc., edited transcript, in author's possession

Wense Grabarek, interview by Chris Howard, 25 February 1983, notes, Chris Howard Papers

Chris Greene, interview, 6 March 1993

Estelle Himes, telephone conversation notes, 20 April 1996, Greensboro, N.C.

Glenn Hinson, telephone conversation, 3 March 1994, Creedmoor, N.C.

Wilbur Hobby, interview by Jack Bass and Walter DeVries, 18 December 1973, transcript, Southern Oral History Program Collection

Bertie Howard, interview, 7 September 1994

Tami Hultman, interview, 21 July 1999

Charles Jones, interview by John Egerton, 21 July 1990, transcript, Southern Oral History Program Collection

Dick Landerman, interview, 14 July 1995

Jim Lee, conversation, 8 March 1994

Julia Lucas, interview, 10 November 1992

C. C. Malone, interview notes, Duke University Oral History Program Collection

Robert Markham, telephone conversation notes, 20 April 1996

Beth Maxwell, interview, 18 May 1993

Vivian McCoy, interview by Chris Howard, 1 April 1983, notes, Chris Howard Papers

———, interview, 14 June 1994

Floyd McKissick, interview by anonymous, 12 October 1978, notes, Duke University Oral History Program Collection

———, interview by Jack Bass, 6 December 1973, transcript, Southern Oral History Program Collection

———, interview by Chris Howard, 30 November 1982, notes, Chris Howard Papers

———, interview by Bruce Kalk, 31 May 1989, transcript, Southern Oral History Program Collection

Joycelyn McKissick, interview by Chris Howard, 15 March 1983, notes, Chris Howard Papers

Bessie McLaurin, interview by anonymous, 20 April 1973, tape recording, Duke University Oral History Program Collection

Douglas Moore, interview by anonymous, 28 January 1978, transcript, Duke University Oral History Program Collection

Perri Morgan, conversation, December 1993

Beth Okun, telephone interview notes, 19 June 1995

Conrad Pearson, interview by Walter Weare, 18 April 1979, transcript, Southern Oral
 History Program Collection
Jake Phelps, interview by Chris Howard, 1, 4, 11 November 1982, notes, Chris
 Howard Papers
Pat Rogers, interview, 23 April 1993
Mary Duke Biddle Trent Semans, interview by Chris Howard, 10 October 1982, tape
 recording, Chris Howard Papers
Charlotte Sloan, interview, 8 March 1993
Callina Smith, interview, 14 January 1993
Elna Spaulding, interview, 2 November 1992
Lacy Streeter, telephone interview by Chris Howard, 6 March 1983, notes, Chris
 Howard Papers
Joyce Thorpe Nichols, interview, 9 December 1993
Ruth Watson, interview, 15 January 1993
Hazeline Wilson, interview, 15 July 1993
Rose Paige Wilson, interview, 18 January 1993

Directories, Pamphlets, and Reports

Brooks, Michael P. *The Dimensions of Poverty in North Carolina.* Durham: North Caro-
 lina Fund, 1964.
Durham City Directory. Durham, 1950, 1960.
Jones, Beverly, and Claudia Egelhoff, eds. *Working in Tobacco: An Oral History of
 Durham's Tobacco Factory Workers.* Durham: North Carolina Central University, 1988.
North Carolina Fund Process Analysis Final Report, part 1, part 3. Durham: North Carolina
 Fund, 1968. North Carolina Collection.
*North Carolina Fund Survey of Low-Income Families in North Carolina—Characteristics of In-
 dividuals in Areas Served by the Community Action Program of the City of Durham.* Report
 N. 3F. Durham: North Carolina Fund, August 1967. North Carolina Collection.
O'Hare, Thomas. "Edgemont and the Edgemont Community Center." 1971. Perkins
 Pamphlet Collection.
Report of Conference on Race Relations, North Carolina College for Negroes, Durham,
 N.C., 10–12 July 1944. North Carolina Room, Durham County Library, Main
 Branch.
Report of the National Advisory Commission on Civil Disorders. Washington, D.C.: U.S.
 Government Printing Office, 1968.
U.S. Department of Commerce, Bureau of the Census. *Characteristics of the Population,*
 vol. 2, part 33, North Carolina. Washington, D.C.: U.S. Government Printing
 Office, 1950.
————. *Characteristics of the Population,* part 35, North Carolina. Washington, D.C.:
 U.S. Government Printing Office, 1960.
————. *Characteristics of the Population,* part 35, North Carolina. Washington, D.C.:
 U.S. Government Printing Office, 1970.
Vann, Andre D., and Beverly Washington Jones. *Durham's Hayti.* Charleston, S.C.:
 Arcadia / Tempus, 1999.

Williams, Doris Terry. *Old Hayti: A People's History*. Oxford, N.C.: Pen and Press United, 1994.

Yancey, Henry. *Planning the Future—Durham, North Carolina: A Report for the City Council and Citizens*. April 1943. Special Collections, Perkins Library, Duke University.

Books

Allen, Theodore W. *The Invention of the White Race*. 2 vols. New York: Verso, 1994–97.

Alonso, Harriet Hyman. *Peace as a Women's Issue: A History of the U.S. Movement for World Peace and Women's Rights*. Syracuse: Syracuse University Press, 1993.

Anderson, Jean Bradley. *Durham County*. Durham: Duke University Press, 1990.

Aptheker, Herbert. *American Negro Slave Revolts*. New York: International Publishers, 1943.

Bartley, Numan V. *The New South, 1945–1980*. Baton Rouge: Louisiana State University Press, 1995.

————. *The Rise of Massive Resistance: Race and Politics in the South during the 1950's*. Baton Rouge: Louisiana State University Press, 1969.

Bates, Daisy. *The Long Shadow of Little Rock: A Memoir*. New York: David McKay, 1962. Reprint, Fayetteville: University of Arkansas Press, 1986.

Biondi, Martha. *To Stand and Fight: The Struggle for Civil Rights in Postwar New York City*. Cambridge, Mass.: Harvard University Press, 2003.

Blauner, Bob. *Black Lives, White Lives: Three Decades of Race Relations in America*. Berkeley and Los Angeles: University of California Press, 1989.

Borchert, James. *Alley Life in Washington: Family, Community, Religion, and Folklife in the City, 1850–1970*. Urbana: University of Illinois Press, 1980.

Boyd, William Kenneth. *The Story of Durham: City of the New South*. Durham: Duke University Press, 1925.

Boyle, Sara Patton. *The Desegregated Heart: A Virginian's Stand in Times of Transition*. New York: Morrow, 1962.

Boyte, Harry C. *Commonwealth: A Return to Citizen Politics*. New York: Free Press, 1989.

————. *Community Is Possible: Repairing America's Roots*. New York: Harper and Row, 1984.

Branch, Taylor. *Parting the Waters: America in the King Years, 1954–1963*. New York: Simon and Schuster, 1988.

Brattain, Michelle. *The Politics of Whiteness: Race, Workers, and Culture in the Modern South*. Princeton: Princeton University Press, 2001.

Brinkley, Douglas. *Rosa Parks*. New York: Viking, 2000.

Brown, Elaine. *A Taste of Power: A Black Woman's Story*. New York: Pantheon, 1992.

Burgess, M. Elaine. *Negro Leadership in a Southern Community*. Chapel Hill: University of North Carolina Press, 1960.

Butler, Lindley S., and Alan D. Watson, eds. *The North Carolina Experience: An Interpretive and Documentary History*. Chapel Hill: University of North Carolina Press, 1984.

Capeci, Dominic J., and Martha Wilkerson. *Layered Violence: The Detroit Rioters of 1943*. Jackson: University Press of Mississippi, 1991.

Carson, Clayborne. *In Struggle: SNCC and the Black Awakening of the 1960s.* Cambridge, Mass.: Harvard University Press, 1981.

Cecelski, David. *Along Freedom Road: Hyde County, North Carolina, and the Fate of Black Schools in the South.* Chapel Hill: University of North Carolina Press, 1994.

Cecelski, David, and Timothy B. Tyson, eds. *Democracy Betrayed: The Wilmington Race Riot of 1898 and Its Legacy.* Chapel Hill: University of North Carolina Press, 1998.

Chafe, William H. *Civilities and Civil Rights: Greensboro, North Carolina, and the Black Struggle for Freedom.* New York: Oxford University Press, 1980.

———. *Never Stop Running: Allard Lowenstein and the Struggle to Save American Liberalism.* New York: Basic Books, 1993.

———. *The Unfinished Journey: America since World War II.* Fourth edition. New York: Oxford University Press, 1999.

Chappell, David L. *Inside Agitators: White Southerners in the Civil Rights Movement.* Baltimore: Johns Hopkins University Press, 1994.

———. *A Stone of Hope: Prophetic Religion and the Death of Jim Crow.* Chapel Hill: University of North Carolina Press, 2004.

Clark, Septima. *Echo in My Soul.* New York: E. P. Dutton, 1962.

———. *Ready from Within: The Story of Septima Clark.* With Cynthia S. Brown. Navarro, Calif.: Wild Trees Press, 1986.

Coates, Albert. *By Her Own Bootstraps: A Saga of Women in North Carolina.* Chapel Hill, 1975.

Colburn, David R. *Racial Change and Community Crisis: St. Augustine, Florida, 1877–1980.* New York: Columbia University Press, 1985. Reprint, Gainesville: University Press of Florida, 1991.

Collier-Thomas, Bettye, and V. P. Franklin, eds. *Sisters in the Struggle: African American Women in the Civil Rights–Black Power Movement.* New York: New York University Press, 2001.

Collins, Patricia Hill. *Black Feminist Thought: Knowledge, Consciousness and the Politics of Empowerment.* New York: Routledge, 1991.

Crawford, Vicki, Jacqueline Rouse, and Barbara Woods, eds. *Women in the Civil Rights Movement: Trailblazers and Torchbearers, 1941–1965.* Volume 16 of *Black Women in United States History,* edited by Darlene Clark Hine. Brooklyn: Carlson, 1990.

Crow, Jeffrey J., Paul D. Escott, and Flora J. Hatley. *A History of African Americans in North Carolina.* Raleigh: Division of Archives and History, 1992.

Curry, Constance. *Silver Rights.* San Diego: Harcourt Brace, 1995.

Curry, Constance, Joan C. Browning, Dorothy Dawson Burlage, Penny Patch, Theresa Del Pozzo, Sue Thrasher, Elaine DeLott Baker, Emmie Schrader Adams, and Casey Hayden. *Deep in Our Hearts: Nine White Women in the Freedom Movement.* Athens: University of Georgia Press, 2000.

Daniel, Pete. *Lost Revolutions: The South in the 1950s.* Chapel Hill: University of North Carolina Press, 2000.

Daniels, Arlene Kaplan. *Invisible Careers: Women Civic Leaders from the Volunteer World.* Chicago: University of Chicago Press, 1988.

Davidson, Osha Gray. *The Best of Enemies: Race and Redemption in the New South.* New York: Scribner, 1996.

Davis, Angela. *Angela Davis: An Autobiography*. New York: Random House, 1974.

Davis, Leroy. *A Clashing of the Soul: John Hope and the Dilemma of African American Leadership and Black Higher Education in the Early Twentieth Century*. Athens: University of Georgia Press, 1998.

D'Emilio, John. *Lost Prophet: The Life and Times of Bayard Rustin*. New York: Free Press, 2003.

Dittmer, John. *Local People: The Struggle for Civil Rights in Mississippi*. Urbana: University of Illinois Press, 1994.

Douglas, Davison M. *Reading, Writing, and Race: The Desegregation of the Charlotte Schools*. Chapel Hill: University of North Carolina Press, 1995.

Dudziak, Mary. *Cold War Civil Rights: Race and the Image of American Democracy*. Princeton: Princeton University Press, 2000.

Dula, W. C., and A. C. Simpson. *Durham and Her People*. Durham: Citizens Press, 1951.

Dunbar, Anthony. *Against the Grain: Southern Radicals and Prophets, 1929–1959*. Charlottesville: University Press of Virginia, 1981.

Durr, Kenneth D. *Behind the Backlash: White Working-Class Politics in Baltimore, 1940–1980*. Chapel Hill: University of North Carolina Press, 2003.

Durr, Virginia. *Outside the Magic Circle: The Autobiography of Virginia Foster Durr*. Edited by Hollinger Barnard. Tuscaloosa: University of Alabama Press, 1985.

Egerton, John. *Speak Now against the Day: The Generation before the Civil Rights Movement in the South*. New York: Alfred A. Knopf, 1994.

Eskew, Glen. *But for Birmingham: The Local and National Movements in the Civil Rights Struggle*. Chapel Hill: University of North Carolina Press, 1997.

Evans, Sara. *Personal Politics: The Roots of Women's Liberation in the Civil Rights Movement and the New Left*. New York: Random House, 1979; Vintage Books, 1980.

Evans, Sara, and Harry Boyte. *Free Spaces: The Sources of Democratic Change in America*. New York: Harper and Row, 1986.

Fairclough, Adam. *Race and Democracy: The Civil Rights Struggle in Louisiana, 1915–1972*. Athens: University of Georgia Press, 1995.

———. *To Redeem the Soul of America: The Southern Christian Leadership Conference and Martin Luther King, Jr.* Athens: University of Georgia Press, 1987.

Ferree, Myra Marx, and Patricia Yancey Martin, eds. *Feminist Organizations: Harvest of the New Women's Movement*. Philadelphia: Temple University Press, 1995.

Finkle, Lee. *Forum for Protest: The Black Press during World War II*. Rutherford, N.J.: Fairleigh Dickinson University Press, 1975.

Fleming, Cynthia Griggs. *Soon We Will Not Cry: The Liberation of Ruby Doris Smith Robinson*. Lanham, Md.: Rowman and Littlefield, 1998.

Flynt, J. Wayne. *Dixie's Forgotten People: The South's Poor Whites*. Bloomington: Indiana University Press, 1979.

Formisano, Ronald P. *Boston Against Busing: Race, Class, and Ethnicity in the 1960s and 1970s*. Chapel Hill: University of North Carolina Press, 1991.

Fosl, Catherine. *Subversive Southerner: Anne Braden and the Struggle for Racial Justice in the Cold War South*. New York: Palgrave Macmillan, 2002.

Franklin, John Hope, and Alfred A. Moss Jr. *From Slavery to Freedom: A History of African Americans*. Seventh edition. New York: McGraw-Hill, 1994.

Frost, Jennifer. "An Interracial Movement of the Poor": Community Organizing and the New Left in the 1960s. New York: New York University Press, 2001.

Gaillard, Faye. The Dream Long Deferred. Chapel Hill: University of North Carolina Press, 1986.

Gaines, Kevin. Uplifting the Race: Black Leadership, Politics, and Culture in the Twentieth Century. Chapel Hill: University of North Carolina Press, 1996.

Genovese, Eugene. Roll, Jordan, Roll: The World the Slaves Made. New York: Pantheon, 1974.

Giddings, Paula. When and Where I Enter: The Impact of Black Women on Race and Sex in America. New York: William Morrow, 1984.

Gilkes, Cheryl Townsend. If It Wasn't for the Women: Black Women's Experience and Womanist Culture in Church and Community. Maryknoll, N.Y.: Orbis Books, 2001.

Gilmore, Glenda. Gender and Jim Crow: Women and the Politics of White Supremacy in North Carolina, 1896–1920. Chapel Hill: University of North Carolina Press, 1996.

Gladney, Margaret Rose, ed. How Am I to Be Heard: Letters of Lillian Smith. Chapel Hill: University of North Carolina Press, 1993.

Glenn, Evelyn Nakano, Grace Chang, and Linda Rennie Forcey. Mothering: Ideology, Experience, and Agency. New York: Routledge, 1994.

Goldfield, David R. Black, White and Southern: Race Relations and Southern Culture, 1940 to the Present. Baton Rouge: Louisiana State University Press, 1990.

Grant, Joanne. Ella Baker: Freedom Bound. New York: John Wiley and Sons, 1998.

Haines, Herbert. Black Radicals and the Civil Rights Movement. Knoxville: University of Tennessee Press, 1988.

Hale, Grace Elizabeth. Making Whiteness: The Culture of Segregation in the South, 1890–1940. New York: Pantheon, 1998.

Hall, Jacquelyn Dowd. Revolt against Chivalry: Jesse Daniel Ames and the Women's Campaign against Lynching. New York: Columbia University Press, 1979.

Hewitt, Nancy A., and Suzanne Lebsock, eds. Visible Women: New Essays on American Activism. Urbana: University of Illinois Press, 1993.

Higginbotham, Evelyn Brooks. Righteous Discontent: The Women's Movement in the Black Baptist Church, 1880–1920. Cambridge, Mass.: Harvard University Press, 1993.

Hirsch, Arnold. Making the Second Ghetto: Race and Housing in Chicago, 1940–1960. Cambridge: Cambridge University Press, 1983.

Hobson, Fred. But Now I See: The White Southern Racial Conversion Narrative. Baton Rouge: Louisiana State University Press, 1999.

Honey, Michael K. Southern Labor and Black Civil Rights: Organizing Memphis Workers. Urbana: University of Illinois Press, 1993.

Horne, Gerald. Communist Front? The Civil Rights Congress, 1946–1956. Rutherford, N.J.: Fairleigh Dickinson University Press, 1988.

Horton, Miles. The Long Haul: An Autobiography. With Judith and Herbert Kohl. New York: Teachers College Press, 1998.

Horwit, Stanford D. Let Them Call Me Rebel: Saul Alinsky—His Life and Legacy. New York: Alfred A. Knopf, 1989.

Hunter, Tera W. To 'Joy My Freedom: Southern Black Women's Lives and Labors after the Civil War. Cambridge, Mass.: Harvard University Press, 1997.

Jacobson, Matthew Frye. *Whiteness of a Different Color: European Immigrants and the Alchemy of Race.* Cambridge, Mass.: Harvard University Press, 1998.

Jacoway, Elizabeth, and David Colburn, eds. *Southern Businessmen and Desegregation.* Baton Rouge: Louisiana State University Press, 1982.

Janiewski, Delores. *Sisterhood Denied: Race, Gender, and Class in a New South Community.* Philadelphia: Temple University Press, 1985.

Jetter, Alexis, Annelise Orleck, and Diana Taylor, eds. *The Politics of Motherhood: Activist Voices from Left to Right.* Hanover, N.H.: University Press of New England, 1997.

Johnson, Charles. *To Stem This Tide: A Survey of Racial Tension Areas in the United States.* Boston: Pilgrim Press, 1943.

Jones, Jacqueline. *Labor of Love, Labor of Sorrow: Black Women, Work and the Family from Slavery to the Present.* New York: Random House, 1985.

Kaplan, Temma. *Crazy for Democracy: Women in Grassroots Movements.* New York: Routledge, 1997.

Katz, Michael B. *The Undeserving Poor: From the War on Poverty to the War on Welfare.* New York: Pantheon, 1989.

Keech, William R. *The Impact of Negro Voting: The Role of the Vote in the Quest for Equality.* Chicago: Rand McNally, 1968.

Kelley, Robin D. G. *Hammer and Hoe: Alabama Communists during the Great Depression.* Chapel Hill: University of North Carolina Press, 1990.

———. *Race Rebels: Culture, Politics, and the Black Working Class.* New York: Free Press, 1994.

Klibaner, Irwin. *Conscience of a Troubled South: The Southern Conference Education Fund, 1946–1966.* Brooklyn: Carlson, 1989.

Korstad, Robert. *Civil Rights Unionism: Tobacco Workers and the Struggle for Democracy in the Mid-Twentieth-Century South.* Chapel Hill: University of North Carolina Press, 2003.

Kozol, Jonathan. *Savage Inequalities: Children in America's Schools.* New York: Harper Perennial, 1992.

Ladner, Joyce. *Tomorrow's Tomorrow: The Black Woman.* New York: Doubleday, 1971; Anchor Books, 1972.

Landry, Bart. *The New Black Middle Class.* Berkeley and Los Angeles: University of California Press, 1987.

Lasch-Quinn, Elizabeth. *Black Neighbors: Race and the Limits of Reform in the American Settlement House Movement, 1890–1945.* Chapel Hill: University of North Carolina Press, 1993.

Lawson, Steven F. *Running for Freedom: Civil Rights and Black Politics in America since 1941.* Second edition. New York: McGraw Hill, 1991.

Lee, Chana Kai. *For Freedom's Sake: The Life of Fannie Lou Hamer.* Urbana: University of Illinois Press, 1999.

Lemke-Santangelo, Gretchen. *Abiding Courage: African American Migrant Women and the East Bay Community.* Chapel Hill: University of North Carolina Press, 1996.

Lerner, Gerda, ed. *Black Women in White America: A Documentary History.* New York: Vintage, 1972.

Levine, Susan. *Degrees of Equality: The American Association of University Women and the Challenge of Twentieth-Century Feminism.* Philadelphia: Temple University Press, 1995.

Ling, Peter J., and Sharon Monteith, eds. *Gender in the Civil Rights Movement.* New York: Garland, 1999.

Lipsitz, George. *The Possessive Investment in Whiteness.* Philadelphia: Temple University Press, 1998.

Lukas, J. Anthony. *Common Ground: A Turbulent Decade in the Lives of Three American Families.* New York: Alfred A. Knopf, 1985.

Lynn, Susan. *Progressive Women in Conservative Times: Racial Justice, Peace and Feminism, 1945 to the 1960s.* New Brunswick: Rutgers University Press, 1992.

Mack, Kibibi Voloria. *Parlor Ladies and Ebony Drudges: African American Women, Class and Work in a South Carolina Community.* Knoxville: University of Tennessee Press, 1999.

Marable, Manning. *Race, Reform and Rebellion: The Second Reconstruction in Black America, 1945–1990.* Second edition. Jackson: University Press of Mississippi, 1991.

Marsh, Charles. *God's Long Summer: Stories of Faith and Civil Rights.* Princeton: Princeton University Press, 1997.

Matthews, Donald R., and James W. Prothro. *Negroes and the New Southern Politics.* New York: Harcourt, Brace and World, 1966.

Matusow, Allen J. *The Unraveling of America: A History of Liberalism in America in the 1960s.* New York: Harper and Row, 1984.

Mebane, Mary. *Mary.* New York: Fawcett Junior, 1981.

Meier, August, and Elliott Rudwick. *CORE: A Study in the Civil Rights Movement, 1942–1968.* Urbana: University of Illinois Press, 1975.

Meyer, Stephen Grant. *As Long as They Don't Move Next Door: Segregation and Racial Conflict in American Neighborhoods.* Lanham, Md.: Rowman and Littlefield, 2000.

Meyerowitz, Joanne, ed. *Not June Cleaver: Women and Gender in Postwar America, 1945–1960.* Philadelphia: Temple University Press, 1994.

Michel, Sonya, and Seth Koven, eds. *Mothers of a New World: Maternalist Politics and the Origins of Welfare States.* New York: Routledge, 1993.

Miller, James. *Democracy Is in the Streets: From Port Huron to the Siege of Chicago.* New York: Simon and Schuster, 1987.

Mills, Kay. *This Little Light of Mine: The Life of Fannie Lou Hamer.* New York: Penguin, Plume, 1993.

Minchin, Timothy. *What Do We Need a Union For? The Textile Workers Union of America in the South, 1945–1955.* Chapel Hill: University of North Carolina Press, 1997.

Moody, Anne. *Coming of Age in Mississippi.* New York: Dell, 1968.

Morris, Aldon D. *The Origins of the Civil Rights Movement: Black Communities Organizing for Change.* New York: Free Press, 1984.

Murphy, Sara Alderman. *Breaking the Silence: Little Rock's Emergency Committee to Open Our Schools, 1958–1963.* Fayetteville: University of Arkansas Press, 1997.

Murray, Pauli. *Song in a Weary Throat: An American Pilgrimage.* New York: Harper and Row, 1987.

Naples, Nancy. *Grassroots Warriors: Activist Mothering, Community Work, and the War on Poverty.* New York: Routledge, 1998.

Norrell, Robert J. *Reaping the Whirlwind: The Civil Rights Movement in Tuskegee*. New York: Alfred A. Knopf, 1985; Vintage, 1986.

Odum, Howard. *Race and Rumors of Race: The American South in the Early Forties*. Chapel Hill: University of North Carolina Press, 1943. Reprint, Baltimore: Johns Hopkins University Press, 1977.

Olson, Lynne. *Freedom's Daughters: The Unsung Heroines of the Civil Rights Movement from 1830 to 1970*. New York: Scribner, 2001.

Orleck, Annelise. *Common Sense and a Little Fire: Women and Working-Class Politics in the United States, 1900–1945*. Chapel Hill: University of North Carolina Press, 1995.

Parker, Gwendolyn M. *These Same Long Bones*. Boston: Houghton Mifflin, 1994.

Patterson, James T. *America's Struggle against Poverty, 1900–1994*. Cambridge, Mass.: Harvard University Press, 1994.

————. *Brown v. Board of Education: A Civil Rights Milestone and Its Troubled Legacy*. New York: Oxford University Press, 2001.

Payne, Charles M. *I've Got the Light of Freedom: The Organizing Tradition and the Mississippi Freedom Struggle*. Berkeley and Los Angeles: University of California Press, 1995.

Pitre, Merline. *In Struggle against Jim Crow: Lulu B. White and the NAACP, 1900–1957*. College Station: Texas A&M University Press, 1999.

Piven, Frances Fox, and Richard A. Cloward. *Poor People's Movements: Why They Succeed, How They Fail*. New York: Pantheon, 1977.

Pleasants, Julian M., and August M. Burns III. *Frank Porter Graham and the 1950 Senate Race in North Carolina*. Chapel Hill: University of North Carolina Press, 1990.

Plummer, Brenda Gayle. *Rising Wind: Black Americans and U.S. Foreign Affairs, 1935–1960*. Chapel Hill: University of North Carolina Press, 1996.

Potter, Lou. *Liberators: Fighting on Two Fronts in World War II*. With William Miles and Nina Rosenblum. New York: Harcourt Brace Jovanovich, 1992.

Quadagno, Jill. *The Color of Welfare: How Racism Undermined the War on Poverty*. New York: Oxford University Press, 1995.

Raines, Howell, ed. *My Soul Is Rested: Movement Days in the Deep South Remembered*. New York: G. P. Putnam Sons, 1977.

Ransby, Barbara. *Ella Baker and the Black Freedom Movement: A Radical, Democratic Vision*. Chapel Hill: University of North Carolina Press, 2003.

Reed, Linda. *Simple Decency and Common Sense: The Southern Conference Movement, 1938–1963*. Bloomington: Indiana University Press, 1991.

Robinson, Jo Ann Gibson. *The Montgomery Bus Boycott and the Women Who Started It*. Edited by David J. Garrow. Knoxville: University of Tennessee Press, 1987.

Robnett, Belinda. *How Long? How Long? African-American Women in the Struggle for Civil Rights*. New York: Oxford University Press, 1997.

Roediger, David R. *Colored White: Transcending the Racial Past*. Berkeley and Los Angeles: University of California Press, 2002.

————. *Towards the Abolition of Whiteness: Essays on Race, Politics and Working Class History*. London: Verso, 1994.

————. *The Wages of Whiteness: Race and the Making of the American Working Class*. London: Verso, 1991.

Ross, Rosetta E. *Witnessing and Testifying: Black Women, Religion and Civil Rights*. Minneapolis: Fortress Press, 2003.

Rossinow, Doug. *The Politics of Authenticity: Liberalism, Christianity and the New Left in America*. New York: Columbia University Press, 1998.

Rupp, Leila J., and Verta Taylor. *Survival in the Doldrums: The American Women's Rights Movement, 1945 to the 1960s*. New York: Oxford University Press, 1987.

Sacks, Karen. *Caring by the Hour: Women, Work, and Organizing at Duke Medical Center*. Urbana: University of Illinois Press, 1988.

Samuel, Lawrence R. *Pledging Allegiance: American Identity and the Bond Drive of World War II*. Washington, D.C.: Smithsonian Institution Press, 1997.

Scales, Junius Irving, and Richard Nickson. *Cause at Heart: A Former Communist Remembers*. Athens: University of Georgia Press, 1987.

Schrecker, Ellen. *Many Are the Crimes: McCarthyism in America*. Boston: Little, Brown, 1998.

Schultz, Debra L. *Going South: Jewish Women in the Civil Rights Movement*. New York: New York University Press, 2001.

Schwartz, Bernard. *Swann's Way*. New York: Oxford University Press, 1986.

Scott, Anne Firor. *Natural Allies: Women's Associations in American History*. Urbana: University of Illinois Press, 1991.

———. *The Southern Lady: From Pedestal to Politics, 1830–1930*. Chicago: University of Chicago Press, 1970.

Scott, James C. *Domination and the Arts of Resistance*. New Haven: Yale University Press, 1990.

———. *Weapons of the Weak: Everyday Forms of Peasant Resistance*. New Haven: Yale University Press, 1985.

Shakur, Assata. *Assata: An Autobiography*. Westport, Conn.: L. Hill, 1987.

Shapiro, Herbert. *White Violence and Black Response: From Reconstruction to Montgomery*. Amherst: University of Massachusetts Press, 1988.

Shaw, Stephanie J. *What a Woman Ought to Be and to Do: Black Professional Women during the Jim Crow Era*. Chicago: University of Chicago Press, 1996.

Sims, Anastatia. *The Power of Femininity in the New South: Women's Organizations and Politics in North Carolina, 1880–1930*. Columbia: University of South Carolina Press, 1997.

Sosna, Morton. *In Search of the Silent South: Southern Liberals and the Race Issue*. New York: Columbia University Press, 1977.

Stack, Carol. *All Our Kin: Strategies for Survival in a Black Community*. New York: Harper and Row, 1974.

Sugrue, Thomas J. *The Origins of the Urban Crisis: Race and Inequality in Postwar Detroit*. Princeton: Princeton University Press, 1996.

Sullivan, Patricia. *Days of Hope: Race and Democracy in the New Deal Era*. Chapel Hill: University of North Carolina Press, 1996.

Swerdlow, Amy. *Women Strike for Peace: Traditional Motherhood and Radical Politics in the 1960s*. Chicago: University of Chicago Press, 1993.

Terkel, Studs. *Race: How Blacks and Whites Think and Feel about the American Obsession*. New York: New Press, 1992.

Theoharis, Jeanne F., and Komozi Woodard, eds. *Freedom North: Black Freedom Struggles outside the South, 1940–1980*. New York: Palgrave Macmillan, 2003.

Tucker, Susan. *Telling Memories among Southern Women: Domestic Workers and Their Em-*

ployers in the Segregated South. Baton Rouge: Louisiana State University Press, 1988.

Tushnet, Mark V. *The NAACP's Legal Strategy against Segregated Education, 1925–1950*. Chapel Hill: University of North Carolina Press, 1987.

Tyler, Pamela. *Silk Stockings and Ballot Boxes: Women and Politics in New Orleans, 1930–1963*. Athens: University of Georgia Press, 1996.

Tyson, Timothy B. *Radio Free Dixie: Robert F. Williams and the Roots of Black Power*. Chapel Hill: University of North Carolina Press, 1999.

Van Deburg, William L. *New Day in Babylon: The Black Power Movement and American Culture, 1965–1975*. Chicago: University of Chicago Press, 1992.

Washburn, Patrick. *A Question of Sedition: The Federal Government's Investigation of the Black Press during World War II*. New York: Oxford University Press, 1986.

Waynick, Capus, John C. Brooks, and Elise W. Pitts, eds. *North Carolina and the Negro*. Raleigh: North Carolina Mayor's Coordinating Committee, 1964.

Weare, Walter. *Black Business in the New South: A Social History of the North Carolina Mutual Life Insurance Company*. Urbana: University of Illinois Press, 1973.

Weigand, Kate. *Red Feminism: American Communism and the Making of Women's Liberation*. Baltimore: Johns Hopkins University Press, 2001.

Werner, Craig. *A Change Is Gonna Come: Music, Race and the Soul of America*. New York: Penguin, Plume, 1998.

West, Guida. *The National Welfare Rights Movement: The Social Protest of Poor Women*. New York: Praeger, 1981.

White, Deborah Gray. *Too Heavy a Load: Black Women in Defense of Themselves, 1894–1994*. New York: W. W. Norton, 1999.

White, E. Frances. *Dark Continents of Our Bodies: Black Feminism and Politics of Respectability*. Philadelphia: Temple University Press, 2001.

Wilkerson, Yolanda B. *Interracial Programs of Student YWCA's*. New York: Woman's Press, 1948.

Willett, Julie A. *Permanent Waves: The Making of the American Beauty Shop*. New York: New York University Press, 2000.

Wolcott, Victoria. *Remaking Respectability: African American Women in Interwar Detroit*. Chapel Hill: University of North Carolina Press, 2001.

Woodard, Komozi. *A Nation within a Nation: Amiri Baraka (LeRoi Jones) and Black Power Politics*. Chapel Hill: University of North Carolina Press, 1999.

Wynn, Neil. *The Afro-American and the Second World War*. Revised edition. New York: Holmes and Meier, 1993.

Young, Louise. *In the Public Interest: The League of Women Voters, 1920–1970*. Westport, Conn.: Greenwood, 1989.

Articles

Ackelsberg, Martha A. "Communities, Resistance, and Women's Activism: Some Implications for a Democratic Polity." In *Women and the Politics of Empowerment*, edited by Ann Bookman and Sandra Morgen, 297–313. Philadelphia: Temple University Press, 1988.

Alonso, Harriet. "Mayhem and Moderation: Women Peace Activists during the Mc-Carthy Era." In *Not June Cleaver: Women and Gender in Postwar America, 1945–1960*, edited by Joanne Meyerowitz, 128–42. Philadelphia: Temple University Press, 1994.

Amott, Teresa L. "Black Women and AFDC: Making Entitlement Out of Necessity." In *Women, the State and Welfare*, edited by Linda Gordon, 280–98. Madison: University of Wisconsin Press, 1990.

Badger, Tony. "Fatalism, not Gradualism: The Crisis of Southern Liberalism, 1945–65." In *The Making of Martin Luther King and the Civil Rights Movement*, edited by Brian Ward and Tony Badger, 67–95. New York: New York University Press, 1996.

Bamberger, Tom. "The Education of Howard Fuller." *Milwaukee Magazine* 13, no. 7 (July 1988): 39–49, 57–62.

Barnett, Bernice McNair. "Black Women's Collectivist Movement Organizations: Their Struggle during the 'Doldrums.'" In *Feminist Organizations: Harvest of the Women's Movement*, edited by Myra Marx Ferree and Patricia Yancey Martin, 199–219. Philadelphia: Temple University Press, 1995.

———. "Invisible Southern Black Women Leaders in the Civil Rights Movement: The Triple Constraints of Gender, Race, and Class." *Gender and Society* 7, no. 2 (June 1993): 162–81.

Bates, Beth Tompkins. "A New Crowd Challenges the Agenda of the Old Guard in the NAACP, 1933–1941." *American Historical Review* 102, no. 2 (April 1997): 340–77.

Blackwell-Johnson, Joyce. "African American Activists in the Women's International League for Peace and Freedom, 1920s–1950s." *Peace and Change* 23, no. 4 (October 1998): 466–82.

Blumberg, Rhoda Lois. "White Mothers as Civil Rights Activists: The Interweave of Family and Movement Roles." In *Women and Social Protest*, edited by Guida West and Rhoda Lois Blumberg, 166–79. New York: Oxford University Press, 1990.

Boris, Eileen. "The Power of Motherhood: Black and White Activist Women Redefine the 'Political.'" In *Mothers of a New World: Maternalist Politics and the Origins of Welfare States*, edited by Sonya Michel and Seth Koven, 213–45. New York: Routledge, 1993.

———. "What About the Working of the Working Mother?" *Journal of Women's History* 5, no. 2 (Fall 1993): 104–13.

Boyte, Harry. "The Critic Critiqued: An Interview with Harry Boyte." In *From the Ground Up: Essays on Grassroots and Workplace Democracy by C. George Benello*, edited by Len Krimerman, Frank Lindenfield, Carol Korty, and Julian Benello, 209–13. Boston: South End Press, 1992.

Brown, Elsa Barkley. "Negotiating and Transforming the Public Sphere: African American Political Life in the Transition from Slavery to Freedom." In *Jumpin' Jim Crow: Southern Politics from Civil War to Civil Rights*, edited by Jane Dailey, Glenda Gilmore, and Bryant Simon, 28–66. Princeton: Princeton University Press, 2000.

———. "'What Has Happened Here': The Politics of Difference in Women's History." *Feminist Studies* 18, no. 2 (Summer 1992): 295–312.

Clayton, Bruce. "Lillian Smith: Cassandra in Dixie." *Georgia Historical Quarterly* 78 (Spring 1994): 92–114.

Cole, Johnnetta. Introduction, "Commonalities and Differences." In *All American Women: Lines That Divide, Ties That Bind*, edited by Johnnetta Cole. New York: Free Press, 1986.

Coleman, Willie. "Among the Things That Used to Be." In *Home Girls: A Black Feminist Anthology*, edited by Barbara Smith, 221–22. New York: Kitchen Table—Women of Color Press, 1983.

Collins, Patricia Hill. "The Meaning of Motherhood in Black Culture." *Sage: A Scholarly Journal on Black Women* 4 (Fall 1987): 3–10.

Dailey, Jane. "Sex, Segregation, and the Sacred after Brown." *Journal of American History* 91, no. 1 (June 2004): 119–44.

Dalfiume, Richard. "The Forgotten Years of the Negro Revolution." *Journal of American History* 55 (1968): 90–106.

Daniel, Pete. "Going among Strangers: Southern Reactions to World War II." *Journal of American History* 77, no. 3 (December 1990): 886–911.

Dudziak, Mary L. "Desegregation as a Cold War Imperative." *Stanford Law Review* 41, no. 61 (November 1988): 61–120.

Edwards, J. Michele. "All-Women's Musical Communities: Fostering Creativity and Leadership." In *Bridges of Power: Women's Multicultural Alliances*, edited by Lisa Albrecht and Rose M. Brewer, 95–107. Philadelphia: New Society, 1990.

Ellis, C. P. "Studs Terkel Interviews C. P. Ellis: 'Why I Quit the Klan.'" *Southern Exposure* 8, no. 2 (Summer 1980): 47–53.

Evans, Sara. "Women's History and Political Theory: Toward a Feminist Approach to Public Life." In *Visible Women: New Essays on American Activism*, edited by Nancy A. Hewitt and Suzanne Lebsock, 119–39. Urbana: University of Illinois Press, 1993.

Fairclough, Adam. "'Being in the Field of Education and Also Being a Negro . . . Seems . . . Tragic': Black Teachers in the Jim Crow South." *Journal of American History* 87, no. 1 (June 2000): 65–91.

———. "The Civil Rights Movement in Louisiana, 1939–1945." In *The Making of Martin Luther King and the Civil Rights Movement*, edited by Brian Ward and Tony Badger, 15–28. New York: New York University Press, 1996.

Feldstein, Ruth. "'I Wanted the Whole World to See': Race, Gender, and Constructions of Motherhood in the Death of Emmett Till." In *Not June Cleaver: Women and Gender in Postwar America, 1945–1960*, edited by Joanne Meyerowitz, 263–303. Philadelphia: Temple University Press, 1994.

Frazier, E. Franklin. "Durham, Capital of the Black Middle Class." In *The New Negro: An Interpretation*, edited by Alain Locke, 333–40. 1925. Reprint, New York: Johnson, 1968.

Gaines, Kevin, Clayborne Carson, Mary L. Dudziak, Adam Fairclough, Scott Kurashige, Daryl Michael Scott, Charles M. Payne, and Lani Guinier. "Round Table: *Brown v. Board of Education*, Fifty Years After." *Journal of American History* 90, no. 1 (June 2004): 19–118.

Gates, Lorraine. "Power from the Pedestal: The Women's Emergency Committee and the Little Rock School Crisis." *Arkansas Historical Quarterly* 55 (Spring 1996): 26–57.

Gavins, Raymond. "The NAACP in North Carolina in the Age of Segregation." In

New Directions in Civil Rights Studies, edited by Armstead L. Robinson and Patricia Sullivan, 105–25. Charlottesville: University of Virginia Press, 1991.

Gerstle, Gary. "Race and the Myth of the Liberal Consensus." *Journal of American History* 82, no. 2 (September 1995): 579–86.

Gilkes, Cheryl Townsend. "Building in Many Places: Multiple Commitments and Ideologies in Black Women's Community Work." In *Women and the Politics of Empowerment*, edited by Ann Bookman and Sandra Morgen, 53–76. Philadelphia: Temple University Press, 1988.

———. "'If It Wasn't for the Women . . .': African American Women, Community Work and Social Change." In *Women of Color in U.S. Society*, edited by Maxine Baca Zinn and Bonnie Thornton Dill, 229–46. Philadelphia: Temple University Press, 1994.

Gilmore, Glenda. "But She Can't Find Her [V. O.] Key." *Feminist Studies* 25, no. 1 (Spring 1999): 133–53.

Glenn, Evelyn Nakano. "From Servitude to Service Work: Continuities in the Racial Division of Paid Reproductive Labor." *Signs* 18, no. 1 (1992). Reprinted in *Unequal Sisters: A Multicultural Reader in U.S. Women's History*, edited by Vicki L. Ruiz and Ellen Carol DuBois, 405–35. Second edition. New York: Routledge, 1994.

Gordon, Linda. "Black and White Visions of Welfare: Women's Welfare Activism, 1890–1945." *Journal of American History* 78 (September 1991): 559–90.

Greene, Christina. "'In the Best Interest of the Total Community'? Women-in-Action and the Politics of Race and Class in a Southern Community, 1968–1972." *Frontiers* 16, no. 2/3 (1996): 190–217.

———. "'. . . The New Negro Ain't Scared No More!': Black Women's Activism in North Carolina and the Meaning of *Brown*." In *From the Grass-Roots to the Supreme Court: Brown v. Board of Education and American Democracy*, edited by Peter Lau. Durham: Duke University Press, 2004.

———. "'We'll Take Our Stand': Race, Class and Gender in the Southern Student Organizing Committee, 1964–1969." In *Hidden Histories of Women in the New South*, edited by Virginia Bernhard, Betty Brandon, Elizabeth Fox-Genovese, Theda Perdue, and Elizabeth H. Turner, 173–203. Columbia: University of Missouri Press, 1994.

Hall, Jacquelyn Dowd. "Open Secrets: Memory, Imagination and the Refashioning of Southern Identity." *American Quarterly* 50 (March 1998): 109–24.

Harley, Sharon. "Chronicle of a Death Foretold: Gloria Richardson, the Cambridge Movement and the Radical Black Activist Tradition." In *Sisters in the Struggle: African American Women in the Civil Rights–Black Power Movement*, edited by Bettye Collier-Thomas and V. P. Franklin, 174–96. New York: New York University Press, 2001.

———. "For the Good of Family and Race: Gender, Work and Domestic Roles in the Black Community, 1880–1930." *Signs* 15, no. 2 (Winter 1990): 336–49.

———. "When Your Work Is Not Who You Are: The Development of a Working-Class Consciousness among Afro-American Women." In *Gender, Class, Race and Reform in the Progressive Era*, edited by Noralee Frankel and Nancy S. Dye, 42–55. Lexington: University Press of Kentucky, 1991.

Hewitt, Nancy. "Politicizing Domesticity: Anglo, Black, and Latin Women in

Tampa's Progressive Movements." In *Gender, Class, Race and Reform in the Progressive Era*, edited by Noralee Frankel and Nacy S. Dye, 24–41. Lexington: University Press of Kentucky, 1991.

Hine, Darlene Clark. "The Housewives League of Detroit: Black Women and Economic Nationalism." In *Visible Women: New Essays on American Activism*, edited by Nancy A. Hewitt and Suzanne Lebsock, 223–45. Urbana: University of Illinois Press, 1993.

———. "Rape and the Inner Lives of Black Women in the Middle West: Preliminary Thoughts on the Culture of Dissemblance." *Signs* 14, no. 4 (Summer 1989): 912–20.

———. "'We Specialize in the Wholly Impossible': The Philanthropic Work of Black Women." In *Lady Bountiful Revisited: Women, Philanthropy and Power*, edited by Kathleen D. McCarthy, 70–93. New Brunswick: Rutgers University Press, 1990.

Hirsch, Arnold. "Massive Resistance in the Urban North: Trumbull Park, Chicago, 1953–1966." *Journal of American History* 82, no. 2 (September 1995): 522–50.

Hunter, Tera. "Domination and Resistance: The Politics of Wage Household Labor in New South Atlanta." *Labor History* 34 (Spring–Summer 1993): 205–20.

Jacoway, Elizabeth. "Down from the Pedestal: Gender and Regional Culture in a Ladylike Assault on the Southern Way of Life." *Arkansas Historical Quarterly* 56, no. 3 (Autumn 1997): 345–52.

Johnson, Marilyn S. "Gender, Race and Rumours: Re-examining the 1943 Race Riots." *Gender and History* 10, no. 2 (August 1998): 252–77.

Jones, Beverly. "Race, Sex and Class: Black Female Tobacco Workers in Durham North Carolina, 1920–1940, and the Development of Female Consciousness." *Feminist Studies* 10, no. 3 (Fall 1984): 441–51.

Kelley, Robin D. G. "Birmingham's Untouchables: The Black Poor in the Age of Civil Rights." In *Race Rebels: Culture, Politics, and the Black Working Class*, 77–100. New York: Free Press, 1994.

———. "Congested Terrain: Resistance on Public Transportation." In *Race Rebels: Culture, Politics, and the Black Working Class*, 55–75. New York: Free Press, 1994.

———. "'We Are Not What We Seem': Rethinking Black Working-Class Opposition in the Jim Crow South." *Journal of American History* 80 (June 1993): 75–112.

Kerber, Linda K. "'Why Should Girls Be Learn'd and Wise?': The Unfinished Work of Alice Mary Baldwin." In *Visible Women: New Essays on American Activism*, edited by Nancy A. Hewitt and Suzanne Lebsock, 349–80. Urbana: University of Illinois Press, 1993.

Klarman, Michael J. "How *Brown* Changed Race Relations: The Backlash Thesis." *Journal of American History* 81, no. 1 (June 1994): 81–118.

Kolchin, Peter. "Whiteness Studies: The New History of Race in America." *Journal of American History* 89, no. 1 (June 2002): 154–73.

Korstad, Robert, and James Leloudis. "Citizen Soldiers: The North Carolina Soldiers and the South's War on Poverty." In *The New Deal and Beyond: Social Welfare in the South since 1930*, edited by Elna C. Green, 138–62. Athens: University of Georgia Press, 2003.

Korstad, Robert, and Nelson Lichtenstein. "Opportunities Found and Lost: Labor,

Radicals, and the Early Civil Rights Movement." *Journal of American History* 75, no. 3 (December 1988): 786–811.

Kotlowski, Dean. "Black Power—Nixon Style: The Nixon Administration and Minority Business Enterprise." *Business History Review* 72, no. 3 (Autumn 1998): 409–55.

Ladd-Taylor, Molly. "Toward Defining Maternalism in U.S. History." *Journal of Women's History* 5, no. 2 (Fall 1993): 96–98.

Lawson, Ronald, and Stephen Barton. "Sex Roles in Social Movements: A Case Study of the Tenant Movement in New York City." *Signs* 6, no. 2 (1981): 230–47.

Lawson, Steven F. "Freedom Then, Freedom Now: The Historiography of the Civil Rights Movement." *American Historical Review* 96 (April 1991): 456–71.

Lewis, Andrew B. "Emergency Mothers: Basement Schools and Preservation of Public Education in Charlottesville." In *The Moderates' Dilemma: Massive Resistance to School Desegregation in Virginia*, edited by Matthew D. Lassiter and Andrew B. Lewis, 72–103. Charlottesville: University Press of Virginia, 1998.

Ludwig, Erik. "Closing in on the 'Plantation': Coalition Building and the Role of Black Women's Grievances in Duke University Labor Disputes." *Feminist Studies* 25, no. 1 (Spring 1999): 79–94.

Lugones, Maria, and Elizabeth Spelman. "Have We Got a Theory for You! Feminist Theory, Cultural Imperialism and the Demand for 'The Woman's Voice.'" *Women's Studies International Forum* 6, no. 6 (1983): 573–81.

Lynn, Susan. "Gender and Post World War II Progressive Politics: A Bridge to Social Activism of the 1960s." *Gender and History* 4, no. 2 (Summer 1992): 215–39.

Maggard, Sally Ward. "Gender Contested: Women's Participation in the Brookside Coal Strike." In *Women and Social Protest*, edited by Guida West and Rhoda Blumberg, 75–98. New York: Oxford University Press, 1990.

Marable, Manning. "Reaction: Thoughts on the Political Economy of the South since the Civil Rights Movement." In *From the Grassroots: Essays toward Afro-American Liberation*, 137–52. Boston: South End Press, 1980.

Martin, Charles H. "Race, Gender and Southern Justice: The Rosa Lee Ingram Case." *American Journal of Legal History* 29, no. 3 (1985): 251–68.

Matthews, Tracye. "'No One Ever Asks What a Man's Role in the Revolution Is': Gender and the Politics of the Black Panther Party, 1969–1971." In *The Black Panther Party Reconsidered*, edited by Charles E. Jones, 267–304. Baltimore: Black Classic Press, 1998.

McNeil, Genna Rae. "Joanne Is You, Joanne Is Me: A Consideration of African American Women and the 'Free Joan Little' Movement, 1974–1975." In *Sisters in the Struggle: African American Women in the Civil Rights–Black Power Movement*, edited by Bettye Collier-Thomas and V. P. Franklin, 259–79. New York: New York University Press, 2001.

Meier, August, and John H. Bracey Jr. "The NAACP as a Reform Movement, 1909–1965: 'To Reach the Conscience of America.'" *Journal of Southern History* 59, no. 1 (February 1993): 3–30.

Meier, August, and Elliott Rudwick. "Origins of Nonviolent Direct Action." In *Along the Color Line: Explorations in the Black Experience*, edited by August Meier and Elliott Rudwick, 307–404. Urbana: University of Illinois Press, 1976.

Morgen, Sandra. "'It's the Whole Power of the City against Us!': The Development of Political Consciousness in a Women's Health Coalition." In *Women and the Politics of Empowerment*, edited by Ann Bookman and Sandra Morgen, 97–115. Philadelphia: Temple University Press, 1988.

Naples, Nancy. "Activist Mothering: Cross-Generational Continuity in the Community Work of Women from Low-Income Neighborhoods." *Gender and Society* 6, no. 3 (September 1992): 441–63.

———. "'Just What Needed to Be Done': The Political Practice of Women Community Workers in Low-Income Neighborhoods." *Gender and Society* 5, no. 4 (December 1991): 478–94.

Nasstrom, Kathryn L. "Down to Now: Memory, Narrative, and Women's Leadership in the Civil Rights Movement in Atlanta, Georgia." *Gender and History* 11, no. 1 (April 1999): 113–44.

Nelson, Barbara J. "The Origins of the Two-Channel Welfare State: Workmen's Compensation and Mother's Aid." In *Women, the State and Welfare*, edited by Linda Gordon, 123–51. Madison: University of Wisconsin Press, 1990.

Nelson, Bruce. "Organized Labor and the Struggle for Black Equality in Mobile during World War II." *Journal of American History* 80, no. 3 (December 1993): 952–88.

Orleck, Annelise. "'If It Wasn't for You, I'd Have Shoes for My Children': The Political Education of Las Vegas Welfare Mothers." In *The Politics of Motherhood: Activist Voices from Left to Right*, edited by Alexis Jetter, Annelise Orleck, and Diana Taylor, 102–18. Hanover, N.H.: University Press of New England, 1997.

Payne, Charles M. "Ella Baker and Models of Social Change." *Signs* 14, no. 4 (Summer 1989): 885–99.

———. "Men Led, but Women Organized: Movement Participation of Women in the Mississippi Delta." In *Women in the Civil Rights Movement: Trailblazers and Torchbearers, 1941–1965*, edited by Vicki Crawford, Jacqueline Rouse, and Barbara Woods, 1–11. Brooklyn: Carlson, 1990.

Pearce, Diana. "Welfare Reform Now That We Know It: Enforcing Women's Poverty and Preventing Self-Sufficiency." In *Women at the Margins: Neglect, Punishment and Resistance*, edited by Josefina Figueira-McDonough and Rosemary Sarri, 125–71. New York: Haworth, 2002.

Pope, Jackie. "Women in the Welfare Rights Struggle: The Brooklyn Welfare Rights Council." In *Women and Social Protest*, edited by Rhoda Blumberg and Guida West, 57–74. New York: Oxford University Press, 1980.

Reagon, Bernice Johnson. "Coalition Politics: Turning the Century." In *Home Girls: A Black Feminist Anthology*, edited by Barbara Smith, 356–68. New York: Kitchen Table—Women of Color Press, 1983.

Robnett, Belinda. "Women in the Student Non-Violent Coordinating Committee: Ideology, Organizational Structure, and Leadership." In *Gender in the Civil Rights Movement*, edited by Peter Ling and Sharon Monteith, 131–68. New York: Garland, 1999.

Roediger, David. "Whiteness and Ethnicity in the History of 'White Ethnics' in the United States." In *Towards the Abolition of Whiteness: Essays on Race, Politics and Working Class History*, 181–98. London: Verso, 1994.

Roydhouse, Marion W. "Bridging Chasms: Community and the Southern YWCA." In *Visible Women: New Essays on American Activism*, edited by Nancy A. Hewitt and Suzanne Lebsock, 270–95. Urbana: University of Illinois Press, 1993.

Sacks, Karen Brodkin. "Gender and Grassroots Leadership." In *Women and the Politics of Empowerment*, edited by Ann Bookman and Sandra Morgen, 77–94. Philadelphia: Temple University Press, 1986.

———. "How Did Jews Become White Folks?" In *Race*, edited by Steven Gregory and Roger Sanjek, 78–102. New Brunswick: Rutgers University Press, 1994.

Scott, Anne Firor. "After Suffrage: Southern Women in the 1920s." In *Making the Invisible Woman Visible*, 222–42. Urbana: University of Illinois Press, 1984.

Shaw, Stephanie J. "Black Club Women and the Creation of the National Association of Colored Women." *Journal of Women's History* 3, no. 2 (Fall 1991): 10–25.

Sitkoff, Harvard. "African American Militancy in the World War II South: Another Perspective." In *Remaking Dixie: The Impact of World War II on the American South*, edited by Neil R. McMillen, 70–92. Jackson: University Press of Mississippi, 1997.

———. "Racial Militancy and Interracial Violence in the Second World War." *Journal of American History* 58, no. 3 (1971): 661–81.

Stein, Judith, Eric Arnesen, James R. Barrett, David Brody, Barbara J. Fields, Eric Foner, Victoria C. Hattam, and Adolf Reed Jr. "Scholarly Controversy: Whiteness and the Historians' Imagination." *International Labor and Working Class History* 60 (Fall 2001): 1–92.

Sugrue, Thomas J. "Crabgrass-Roots Politics: Race, Rights, and the Reaction against Liberalism in the Urban North, 1940–1954." *Journal of American History* 82, no. 2 (September 1995): 551–78.

Susser, Ida. "Working-Class Women, Social Protest, and Changing Ideologies." In *Women and the Politics of Empowerment*, edited by Ann Bookman and Sandra Morgen, 257–71. Philadelphia: Temple University Press, 1988.

Theoharis, Jeanne. "'I'd Rather Go to School in the South': How Boston's School Desegregation Complicates the Civil Rights Paradigm." In *Freedom North: Black Freedom Struggles outside the South, 1940–1980*, edited by Jeanne F. Theoharis and Komozi Woodard, 125–52. New York: Palgrave Macmillan, 2003.

Tyson, Timothy B. "Wars for Democracy: African American Militancy and Interracial Violence in North Carolina during World War II." In *Democracy Betrayed: The Wilmington Race Riot of 1898 and Its Legacy*, edited by David Cecelski and Timothy B. Tyson, 253–75. Chapel Hill: University of North Carolina Press, 1994.

Uesugi, Sayoko. "Gender, Race, and the Cold War: Mary Price and the Progressive Party in North Carolina, 1945–1948." *North Carolina Historical Review* 77, no. 3 (July 2000): 269–311.

Valk, Anne. "'Mother Power': The Movement for Welfare Rights in Washington, D.C., 1966–1972." *Journal of Women's History* 11, no. 4 (Winter 2000): 34–58.

Ware, Susan. "American Women in the 1950s: Nonpartisan Politics and Women's Politicization." In *Women, Politics and Change*, edited by Louise A. Tilly and Patricia Gurrin, 281–99. New York: Russell Sage Foundation, 1990.

Weare, Walter. "Charles Clinton Spaulding: Middle-Class Leadership in the Age of

Segregation." In *Black Leaders of the Twentieth Century*, edited by John Hope Franklin and August Meier, 167–90. Urbana: University of Illinois Press, 1982.

Weiner, Lynn Y. "Maternalism as Paradigm." *Journal of Women's History* 5, no. 2 (Fall 1993): 96–98.

West, Guida. "Cooperation and Conflict among Women in the Welfare Rights Movement." In *Bridges of Power: Women's Multicultural Alliances*, edited by Lisa Albrecht and Rose M. Brewer, 149–71. Philadelphia: New Society, 1990.

Williams, Joan C. "Domesticity as the Dangerous Supplement of Liberalism." *Journal of Women's History* 2, no. 3 (Winter 1991): 69–88.

Wrigley, Julia. "From Housewives to Activists: Women and the Division of Political Labor in the Boston Antibusing Movement." In *No Middle Ground: Women and Radical Protest*, edited by Kathleen M. Blee, 251–87. New York: New York University Press, 1998.

Wynn, Neil. "The Impact of the Second World War on the American Negro." *Journal of Contemporary History* 6 (1971): 42–53.

Unpublished Works

Bermanzohn, Sally Avery. "Survivors of the 1979 Greensboro Massacre: A Study of the Long Term Impact of Protest Movements on the Political Socialization of Radical Activists." Ph.D. diss., City University of New York, 1994.

Boyte, Harry C. "The History of ACT." [Ca. 1971]. Unpublished typescript, box 1, Boyte Family Papers.

Brown, Leslie. "Common Spaces, Separate Lives: Gender and Racial Conflict in the 'Capital of the Black Middle Class.'" Ph.D. diss., Duke University, 1997.

Burns, Augustus M., III. "North Carolina and the Negro Dilemma, 1930–1950." Ph.D. diss., University of North Carolina at Chapel Hill, 1969.

Cannon, Robert. "The Organization and Growth of Black Political Participation in Durham, North Carolina, 1933–1958." Ph.D. diss., University of North Carolina at Chapel Hill, 1975.

Carey, Jean. "The Forced Merger of Local 208 and Local 176 of the Tobacco Workers International Union at the Liggett and Meyers Tobacco Company in Durham, North Carolina." Unpublished typescript, 1971. Perkins Library, Duke University.

Crumpton, William. "The Royal Ice-Cream Sit-in." Paper presented at the Helen G. Edmonds Conference, "Making a Way Out of No Way: Black Women in the New South," North Carolina Central University, Durham, N.C., 19 March 1994.

Fischer, Kirsten. "'Delighted to Be in on the Fight': Mary O. Cowper, Labor Reform and the North Carolina League of Women Voters." Master's thesis, Duke University, 1989.

Foy, Marjorie Anne Elvin. "Durham in Black and White: School Desegregation in Durham, North Carolina, 1954–1963." Master's thesis, University of North Carolina at Greensboro, 1991.

Freeman, Phyllis. "White Community Organization in Durham from 1966 to the Present." Typescript, NCF report, July 1968. North Carolina Fund Papers.

Frost, Jennifer. "Community and Consciousness: Women's Welfare Rights Organiz-

ing in Cleveland, 1964–1966." Paper presented at the Berkshire Conference on Women's History, Rutgers University, June 1990.

Gallo, Elyse. "The Emergence of Direct Action: The Early Civil Rights Movement in Durham, North Carolina." Unpublished typescript, 1978. Chris Howard Papers.

Glusman, Melynn. "Moment of Possibility: The Joan Little Movement." Honors thesis, Duke University, 1994.

Green, Laurie B. "Battling the Plantation Mentality: Consciousness, Culture and the Politics of Race, Class and Gender in Memphis, 1940–1968." Ph.D. diss., University of Chicago, 1999.

Greene, Christina. "'Our Separate Ways': Women and the Black Freedom Movement in Durham, North Carolina, 1940s–1970s." Ph.D. diss., Duke University, 1996.

Hamilton, Robin, and Kim Schliep. "The Rocky Road of the Royal Ice Cream Company." Unpublished typescript, Duke University, 1994. In author's possession.

[Howard, Bertie]. "The Beginnings of Community Organization in Durham." NCF report (revised draft), August 1968. Box 9, North Carolina Fund Papers.

Howard, Bertie, and Francis Steven Redburn. "United Organizations for Community Improvement: Black Political Power in Durham." NCF Report, August 1968. North Carolina Fund Papers.

Howard, Chris. "'Keep Your Eyes on the Prize': The Black Struggle for Civic Equality in Durham, North Carolina, 1954–1963." Honors thesis, Duke University, 1983.

Jones, Beverly. Speech delivered at the Black History Month celebration, North Carolina Central University, Durham, N.C., 10 February 1993.

Jones, William. "The NAACP, the Cold War and the Making of the Civil Rights Movement in North Carolina, 1943–1954." Master's thesis, University of North Carolina at Chapel Hill, 1996.

Karpinos, Ralph. "'With All Deliberate Speed': The Brown vs. Board of Education Decisions, North Carolina and the Durham City Schools, 1954–1963." Unpublished typescript, 1972. Chris Howard Papers.

Kennington, Laurie. "The Royal and the Elite." Unpublished typescript, Yale University, 1997. In author's possession.

Korstad, Robert. "Daybreak of Freedom: Tobacco Workers and the CIO in Winston-Salem, North Carolina, 1943–1950." Ph.D. diss., University of North Carolina at Chapel Hill, 1987.

Lindland, Kerri. "Beyond the Law: The Personal Impact of Desegregation in Durham, North Carolina, 1959–1965." Unpublished typescript, Duke University, 1993. In author's possession.

Livesay, Michael J. "Domination and Legitimation in a Southern School District: The Reproduction of Racism in Black-White Relations." Ph.D. diss., University of North Carolina at Chapel Hill, 1985.

Mawhood, Rhonda. "Tales to Curl Your Hair: African-American Beauty Parlors in Jim Crow Durham." Unpublished typescript, Duke University, 1993. In author's possession.

McGuire, Danielle. "'It Was Like All of Us Had Been Raped': Black Womanhood, White Violence and the Civil Rights Movement." Unpublished typescript, Rutgers University, 2002. In author's possession.

McKinney, Charles. "Fighting the 'Violence' of Poverty: The Creation of the Foundation for Community Development." Master's thesis, Duke University, 1992.

McKissick, Joycelyn. Speech delivered at the Black History Month celebration, North Carolina Central University, Durham, N.C., 10 February 1993.

Moore, Shirley Ann. "'Her Husband Didn't Have a Word to Say': Black Women and Blues Clubs in Richmond, California, during World War II." Paper presented at the Organization of American Historians annual meeting, Anaheim, California, April 1993. In author's possession.

Mosnier, Joseph. "The 'Inc. Fund South': Julius Chambers and the NAACP Legal Defense Fund's Litigation Campaign, 1964–1975." Paper presented at the Organization of American Historians annual meeting, Washington, D.C., 1 April 1995.

Nasstrom, Kathryn. "Women, the Civil Rights Movement, and the Politics of Historical Memory in Atlanta, 1946–1973." Ph.D. diss., University of North Carolina at Chapel Hill, 1993.

Redburn, Francis Steven. "Protest and Policy in Durham, North Carolina." Ph.D. diss., University of North Carolina at Chapel Hill, 1971.

Sindler, Allan. "Youth and the American Negro Protest Movement: A Local Case Study of Durham, North Carolina." Paper presented at the Sixth World Congress, International Political Science Association, Geneva, Switzerland, 21–25 September 1964. Typescript, North Carolina Room, Durham County Library, Main Branch.

Stone, Ted. "A Southern City and County in the Years of Political Change: Durham, North Carolina, 1955–1974." Master's thesis, North Carolina Central University, 1977.

Strange, John. "The Politics of Protest: The Case of Durham." Paper presented at the Southern Political Science Association meeting, Gatlinburg, Tenn., 7–9 November 1968. North Carolina Fund Papers.

Wallace, Patricia. "How to Get Out of Hell by Raising It: The Case of Durham." North Carolina Fund, 24 May 1967. Box 369, series 4.8, North Carolina Fund Papers.

Index

Page numbers in italics refer to illustrations.

Black Economic Development Conference, 191, 305 (n. 77)

"Black Manifesto," 191, 305 (n. 77)

Black men: businesses owned by, 1, 9, 13–14, 172, 232 (n. 5); and rape of black women by white men, 8; murder of black soldier, 8, 18–21, 32, 46–47, 66; in unions, 11, 122, 276 (n. 4), 283 (n. 45); as elected officials, 14, 226, 227, 228; lynching of, 40, 42, 233 (n. 4), 234 (n. 5); rape allegations against, 40, 251 (nn. 23–24); wrongful murder charges against and execution of, 41; employment of, 69; and neighborhood organizing, 122

Black Muslims, 84, 85, 184, 270 (nn. 80–81)

Black Panthers, 186, 191, 303 (n. 67)

Black Power: and BSC, 3, 167; and interracial cooperation, 5, 141, 175, 216, 224; and UOCI, 141; masculinist politics of, 165, 184–85, 221, 303 (n. 65); Fuller on, 175; elements of, 184; and women, 184–90, 221, 302 (n. 62), 302–3 (n. 65), 304 (n. 72); white fears of, 186, 191–92, 199–200; and Malcolm X Liberation University, 186–88, 188, 221; cultural contributions of, 304 (n. 72). See also Black Solidarity Committee

Blacks: in middle class, 1–2, 9, 99–100, 171–72, 175–79, 195–96, 274 (n. 122), 298 (n. 19); poverty of, 2, 105–9, 111, 114, 115, 123, 170, 277 (n. 9), 288 (n. 9), 293 (n. 60); health care for, 3, 153–58, 189, 294 (nn. 67, 71); as elected officials, 14, 226, 227, 228, 229; and race mixing, 16, 17; employment discrimination against, 69, 81–82, 86, 88, 91, 93, 173; population of, in Durham, 237 (n. 24); unemployment of, 288 (n. 9); church membership of poor blacks, 290 (n. 29). See also Black men; Black women; Desegregation; Durham movement (1957–63); Neighborhood organizing; Segregation; Voter registration; Voting rights

Black Solidarity Committee (BSC): and boycott of white businesses, 3, 31, 165–70, 173–75, 179–81, 189, 201–2, 219, 272 (n. 107), 300–301 (n. 43); women's

leadership in, 3, 31, 176, 272 (n. 107), 282 (n. 44), 300 (n. 34); and poor women's concerns, 165, 166, 169–71, 175–79, 181–82, 189, 213, 221, 222; and class tension, 165, 166, 175–82; male leadership of, 167, 170, 175–79, 297 (n. 7); and UOCI, 167, 176, 177, 180–81; establishment of, 167, 297 (n. 5); and Human Relations Commission, 173; and welfare rights, 173; meetings of, and parliamentary procedure, 175–79, 300 (nn. 31–32); and class exploitation within black community, 178; and Black Pride Days, 179; and aftermath of boycott, 183–84, 301 (n. 55); and WIA, 200–201, 202, 213, 222; taping of meetings of, 297 (n. 13)

Blackwell-Johnson, Joyce, 258 (n. 71)

Black women: in unions, 2, 10–11, 235–36 (n. 18); in WIA, 3, 195–217, 306 (n. 6), 307 (n. 8); rape of, 7–8, 40, 192, 225, 233 (n. 3), 251–52 (n. 24); during World War II, 8–15, 31–32, 219; employment of, 13, 14, 15–16, 69, 81, 88, 239 (n. 49), 288 (n. 9), 297 (n. 14); businesses owned by, 13, 27–30; as domestic workers, 15–16, 214–15, 239 (n. 49), 309 (n. 33); and infrastructure in black community, 27, 30–31; and militancy, 32, 185–86, 195, 221, 304 (n. 71); and school desegregation, 71–75, 95–96, 161, 207–12, 215; and black freedom movement (1957–63), 77, 83–84, 87, 91–104, 220, 267 (n. 53), 271–72 (n. 100), 273 (n. 109), 275 (n. 138); and nonviolence, 83–84, 185–86, 221; leadership style of, 96–104, 121–23, 223–24; as mentors to young activists, 99–102, 229, 274 (n. 124); poverty of, 105–9, 111, 114, 115, 123, 169–71, 181–82, 277 (n. 9); and neighborhood organizing, 105–37, 189–93, 220–21; resistance strategies of, 113–16; and welfare benefits, 114, 116, 123, 170, 173, 174, 277 (n. 9), 279–80 (n. 27), 297–98 (n. 15), 299 (n. 21); and BSC, 165, 166, 169–71, 175–79; and boycotts, 165–71, 179–81, 296 (n. 1); social location of poor black women, 181–82; stereotype of "strong, Black woman,"

296 (n. 1); Tallahassee bus boycott, 275. *See also* Busing

Bush, Godwin, 40, 251 (n. 24)

Businesses: black ownership of, 1, 9, 13–14, 27–30, 172, 232 (n. 5); black women's support of black businesses, 13–14; and Merit Employment Project, 69; employment discrimination by white businesses, 69, 81–82, 86, 91, 93, 173, 237 (n. 38); black patronage of white businesses, 69, 173; out-of-state businesses in Durham, 280 (n. 29); impact of urban renewal on black businesses, 315 (n. 80). *See also* Boycotts of white businesses; Employment

Busing, 313–14 (nn. 70–71)

Cafeteria workers, 106, 117, 276 (n. 2), 276–77 (n. 6), 282 (n. 41), 305 (n. 76), 313 (n. 66)

California, 235 (n. 15), 247 (n. 107), 257 (n. 69)

Calloway, Cab, 29

Camp Butner, 11–12, 15, 18, 19, 236–37 (n. 24)

Campus Echo, 63

Carey, Gordon, 76–77

Carmichael, Stokely, 184, 303–4 (n. 70)

Carolina Fair Share, 227–28

Carolina Israelite, 78

Carolina Times: Austin as editor of, 8, 17, 172; on unions, 11; on Double-V campaign, 13; on legal action to equalize schools, 14; "Walltown Notes" column in, 15; on social equality, 16, 17; and Spicely murder case, 21; society pages of, 26, 235 (n. 16); on rape of black women, 40; on anticommunism, 41; on Korean War, 42; on NAACP membership, 43; on black leadership, 67, 171, 301 (n. 55); and school desegregation, 73–74, 88; and sit-in movement, 77, 263 (n. 13); on violence against black demonstrators, 83; on black women, 102, 135, 275 (n. 138); on Grabarek, 134; Vivian Edmunds as publisher of, 172; on boycott of white businesses, 174, 301 (n. 55); on Fuller, 192; on Atwater, 195; on "Kissing Case," 266 (n. 36)

Carr, Rev. Warren, 78, 268 (n. 56)

Carr, Watts, Jr., 94, 95

Carr Junior High School, 75

Cecelski, David, 287 (n. 4)

Center for School Support (WIA), 208–12, 215, 311 (n. 54)

"Centerpeople," 148, 291 (n. 38)

Central Leaf, 23

Chafe, William, 102, 163, 287 (n. 4), 295 (n. 75), 303 (n. 66)

Chamber of Commerce (Durham), 167, 174, 180, 202, 210, 300 (n. 32)

Chaney, James, 168

Chapel Hill, N.C., 46, 55

Charlotte, N.C.: CNC in, 38; and Pearsall Plan, 55; school desegregation in, 71, 209, 210, 266 (n. 38), 311–12 (n. 56), 313 (n. 70), 314 (n. 73); sit-in movement in, 76; CORE-sponsored demonstrations in, 87, 262 (n. 2); Black Panthers in, 186

Charlottesville, S.C., 312 (n. 57)

Cheney, Dick, 304 (n. 74)

Cherry, Robert Gregg, 40

Chicago branch of National Association for the Advancement of Colored People, 243 (n. 79)

Chicago Urban League, 119, 281 (n. 34)

Child care: and mothers' employment, 13, 293 (n. 58); for McDougald Terrace, 105; and ACT, 153, 292 (n. 51), 293 (n. 58); Betty Shabazz Preschool, 189, 304 (n. 72); WILPF's cooperative play group, 258 (n. 78); Edgemont Community Center's preschool program, 294 (n. 72)

Child labor, 250 (n. 17)

Childress, Alice, 234 (n. 5)

Chisholm, Shirley, 316 (n. 2)

Christmas House, 158, 294 (n. 70)

Church membership, 275 (nn. 130, 135), 290 (n. 29)

Church Women United, 45

Citizens Committee for Law and Order, 210

Citizens Councils. *See* White Citizens Councils

Citizens for UOCI, 310 (n. 40)

Civil liberties violations, 40–41

Civil Rights Act (1964), 64, 103

Civil Rights Congress, 36, 40, 41, 234 (n. 5), 251 (n. 23)

Civil rights movement. *See* Durham movement (1957–63); King, Martin Luther, Jr.

Clark, Septima, 247 (n. 105)

Clark, Thomas Wilbert, 7, 233 (n. 3)

Class: black middle class, 1–2, 9, 99–100, 171–72, 175–79, 195–96, 274 (n. 122), 298 (n. 19); and black freedom movement (1957–63), 99–100; racism of poor whites, 140, 141, 148, 159, 163–64, 221, 222, 295 (nn. 75–77); working-class racism, 159, 295 (n. 76); and BSC, 165, 166, 169–71, 175–82; and UOCI, 171; class tensions in black community, 171–72; class exploitation in black community, 178; social location of poor black women, 181–82; and WIA, 199–207, 214–15; and education of children, 211–12; and status among blacks, 234–35 (n. 10); as predictor of black student participation in black freedom movement, 273 (n. 108). *See also* Poor whites; Poverty

Clayton, Eva, 226

Clearinghouse (WIA), 212–13, 314 (n. 74), 314–15 (n. 76), 316 (n. 84)

Clement, Howard, 165, 180, 181, 200, 202, 228, 309 (n. 28)

Clement, Josephine, 48, 51, 309 (n. 28)

Cleveland, 290 (n. 31)

Clinton, Bill, 280 (n. 27)

Clyburn, Mary, 66, 67, 68

Coble, Hilda, 254–55 (n. 45), 313 (n. 69)

Coca-Cola Bottling Company, 173

Cohen, Morris, 281 (n. 31)

Cold War, 35, 36, 42, 60, 61, 220, 224. *See also* Anticommunism

Coleman, Willie, 247 (n. 105)

Cole-McFadden, Cora, 84, 96, 97, 100–102, 229

Coletta, Louis, 66–69, 263 (n. 14)

Coley, Nell, 100

College chapters of National Association for the Advancement of Colored People. *See* National Association for the Advancement of Colored People youth and college chapters

Colleges and universities. *See* Duke University; North Carolina College; Shaw University; University of North Carolina at Chapel Hill

Collins, Patricia Hill, 235 (n. 14), 307 (n. 10)

Colored Travelers Aid Society, 12

Commission on Interracial Cooperation, 239 (n. 45)

Committee for North Carolina (CNC), 36–40, 37, 249 (nn. 10–13), 250 (nn. 16, 19)

Communist Party, 41, 250 (n. 19), 251 (n. 22), 252 (nn. 28–29), 309 (n. 29). *See also* Anticommunism

Community action programs, 121, 282 (n. 42). *See also* War on Poverty

Community Church, 46, 255 (n. 49), 258 (n. 78)

Community organizing. *See* Neighborhood organizing

Compton, Edward, 245 (n. 94)

Concerned Women for Justice (CWJ), 192, 226, 316 (n. 2)

Congregations, Associations, and Neighborhoods (CAN), 228

Congress of Industrial Organizations (CIO), 2, 11, 23, 24, 38, 39, 243 (n. 83), 249 (n. 9), 290 (n. 35). *See also* American Federation of Labor–Congress of Industrial Organizations

Congress of Industrial Organizations–Political Action Committee, 36, 243 (n. 83), 249 (n. 9)

Congress of Racial Equality (CORE): and NAACP, 65, 82, 85–88, 90, 91, 97, 267 (n. 50); and Durham black freedom movement, 76, 85–88, 90, 91; and direct action strategy, 82, 119; and McKissick, 108, 270 (n. 81), 270–71 (n. 84), 303 (n. 65); and Fuller, 119, 281 (n. 34), 303 (n. 65); at Duke University, 143; ouster of whites from, 175, 270 (n. 81); in Greensboro, 262 (n. 2), 267 (n. 50); and Black Power, 303 (n. 65)

Cook, Betty, 149

Cook, Deborah: on Landerman, 144; and ACT, 144, 150, 154, 159; and OBT, 144, 159; capability of, 149; on lack of male participation in neighborhood councils,

on nonviolence, 83; and Malcolm X, 85; and black freedom movement (1957–63), 85–87, 93, 96–99, 101–2; arrest and imprisonment of, for "stand-in" at Howard Johnson's, 86–87; and toxic waste, 226; home of, 272 (n. 108)

McLaurin, Bessie: and literacy classes during World War II, 12; and WILPF, 52, 53, 258 (nn. 71–72), 311 (n. 54); and nonviolence, 83; and bomb threat, 83, 270 (n. 77); and CORE, 86; and DIC, 94; as "observer" at demonstrations, 99; and WIA, 199; death of, 228; as mentor to young activists, 274 (n. 124); and Citizens for UOCI, 310 (n. 40)

McLaurin, Mother, 103

McLawhorn, Bruce, 41

McLean, Charles, 44, 253 (n. 34)

McLester, Rev. Charles, 275 (n. 130)

McLester, Johnnie, 101, 275 (n. 130)

Mebane, Mary, 16

Meier, August, 234 (n. 9), 236 (n. 22), 237 (n. 38)

Memphis, Tenn., 236 (n. 23), 313 (n. 70)

Merchants Association, 134, 135, 167, 179, 180, 183, 202, 210, 300 (n. 32)

Merit Employment Project, 69

Merrick, John, 16, 17, 239 (n. 52)

Merry Wives, 26

Methodist church, 68, 263 (n. 10)

Methodist Student Union, 79

Michaux, Mickey, 227

Michaux, Mickey, Sr., 114

Middle class. See Class

Midgette, Plassie, 106, 276 (n. 3)

Migrants, 235 (n. 15)

Militancy, 32, 185–86, 195, 221, 223, 304 (n. 71)

Military training bases, 11–12, 15, 18, 19, 236–37 (nn. 24–25)

Miller, Eula, 313 (n. 69)

Milliken v. Bradley, 314 (n. 73)

Minchin, Tim, 290 (n. 35)

Minimum wage, 38, 121, 227, 228, 249 (n. 12), 250 (n. 16), 282 (n. 41)

Ministerial Alliance, 71, 77

Ministers Association, 79

Minnie Hester's Place, 29

Miscegenation, 73

Mississippi: black freedom movement in, 65, 80, 143; voter registration of blacks in, 238 (n. 43); white violence in, 253 (n. 32); and Head Start, 282 (n. 41); black organizational life in, 283 (n. 46); SNCC in, 293 (n. 56); boycott of white businesses in, 296 (n. 1); school desegregation in, 310–11 (n. 46)

Mitchell, Audrey, 84

Mitchell, Willie Mae, 293 (n. 61)

Model Laundry, 173

Model Mothers Club, 26

Moderate: definition of, 248 (n. 5)

Monroe, N.C., 266 (n. 36), 270 (n. 75)

Montgomery, Ala., 261 (n. 100)

Montgomery bus boycott, 246 (n. 107), 296 (n. 1)

Montgomery Improvement Association, 296 (n. 3)

Moody, Anne, 269 (n. 65)

Moore, Dan, 133

Moore, Rev. Douglas, 28, 65–68, 68, 76–77, 262 (n. 8), 262–63 (n. 10), 263 (n. 13), 273 (n. 113)

Moore, Shirley, 247 (n. 107)

Morehouse College, 26

Morris, Aldon, 235 (n. 14), 267 (n. 48)

Morton, Nelle, 251 (n. 23)

Mosely, Rev. A. D., 90

Motherhood and womanhood, 57, 80–81, 158–59, 197–98, 307 (nn. 10–11)

Mothers' clubs, 26, 74, 105, 111, 117, 196, 278 (n. 14), 281 (n. 35)

Movie theater desegregation, 75–76, 80, 99

Mt. Gilead Baptist Church, 120

Murder: of black soldier, 19, 20–21, 22, 32, 46–47, 66, 239 (n. 45), 242 (n. 76); wrongful charges against black men for, 41; of civil rights activists, 140, 168, 190, 191; of tobacco worker by Alcohol Beverage Commission official, 247 (n. 109)

Murray, Pauli, 34–35

Murrow, Edward R., 54

Music, 12, 161, 188, 247 (n. 107)

Myrdal, Gunnar, 251 (n. 19)

Naples, Nancy, 286 (n. 85)

Nashville, 257 (n. 67)

Oldham, Carvie, 131, 178, 204. *See also* Housing Authority (Durham)

Olson, Lynne, 233 (n. 15)

O'Neal, Annie Laurie, 310 (n. 37)

Operation Breakthrough (OBT): organizers for, 3, 112, 114–16, 119–21, 123–24, 136, 159, 281 (n. 33); establishment of, 109–10; and Thorpe case, 112; and UOCI, 117, 118, 280 (n. 31); federal funds for, 118, 153, 277 (n. 10); and housing protests, 125–27; white officials' attack on, 126–28, 132, 133, 304 (n. 74); and voter registration, 127, 172; significance of, 136, 171, 286–87 (n. 90); and poor whites, 141, 142, 143–44, 288 (n. 9); and ACT, 152, 153; and McKissick, 278 (n. 12); preexisting base for, 278 (n. 14); and parliamentary procedure, 300 (n. 31)

Operation Dixie, 39, 243 (n. 83), 249 (n. 9)

Orangeburg, S.C., 168, 190, 297 (n. 11)

Organization of African Unity, 305 (n. 77)

Organizations. *See* Black women's organizations; National Association for the Advancement of Colored People; Women's organizations (mainstream); *and other specific organizations*

Orient Street Council, 149

Orleck, Annelise, 286 (n. 85)

"Othermother," 307 (n. 10)

Parchman Penitentiary, 80

Parent-Teacher Association (PTA), 2, 70, 101, 114, 139, 208, 209, 210, 313 (n. 65)

Parent Teacher Student Associations, 209

Parks, Rosa, 102

Patlock Park, 144

Patrick, T. M., 309 (n. 28)

Patterson, James, 264 (n. 26)

Patterson, William, 234 (n. 5)

Pattie, Nan, 80

Payne, Charles, 273 (n. 109), 281 (n. 39), 283 (n. 46), 295 (n. 76)

Peachtree Verbane Council, 122

Pearsall, Thomas, 55

Pearsall Plan, 52, 53, 55, 71, 264 (n. 25)

Pearson, Conrad, 34, 66, 184

Pearsontown Needle Craft Club, 26

Peoples, Jerry Ann, 80

Peoples, Mrs. Leroy, 37

People's Alliance, 227

Peterson v. Greenville, 272 (n. 106)

Physicians' assistants, 279 (n. 18)

Pittsburgh Courier, 237 (n. 35)

Player, Willa, 274 (n. 124)

Police: and civil rights demonstrations, 63, 64, 86, 90–93, 92, 168, 191, 267 (n. 53); brutality of, 64, 84, 90–91, 168, 191, 240 (n. 59); and sit-in movement, 76–77; and eviction of tenants from public housing, 105, 109, 112–13, 116, 117, 224; black policemen, 183

Politics of respectability, 212–15, 222, 315 (n. 78)

Poor whites: and Edgemont health clinic, 3, 153–58, 189, 222, 294 (nn. 67, 71); and Edgemont School closing, 139–40; and biracial coalitions and white supremacy, 140, 141, 148, 159, 163–64, 221; and interracial cooperation versus interracial movement, 140–41; and OBT, 141, 142, 143–44, 288 (n. 9); and EPO, 142, 143, 145, 149, 152, 153, 210, 289 (n. 23); modeling of white organizing on black efforts, 142–43; initial efforts in organizing, 143–44; as George Wallace supporters, 145, 289 (n. 26), 295 (n. 75); theory of organizing, 145–46, 291 (n. 40); masculinist bias and women's networks, 146–50; leadership style of women, 147–52; and gender roles, 149; day-to-day organizing and ACT's gender tensions, 150–53; and Christmas House, 158, 294 (n. 70); limits of interracial cooperation among, 158–60; and "whiteness," 159, 295 (n. 77); stereotypes of, 163, 295 (n. 75); statistics on, 278 (n. 11), 287 (n. 7), 288 (n. 9), 293 (n. 60); church membership of, 290 (n. 29); and Edgemont Community Center's preschool program, 294 (n. 72); in WIA, 307 (n. 8). *See also* ACT; Neighborhood organizing

Potter, James, 188, 283 (n. 45)

Poverty: of blacks, 2, 105–9, 111, 114, 115, 123, 170, 277 (n. 9), 293 (n. 60); housing in low-income neighborhoods, 3, 114, 118, 125, 128–29, 293 (n. 60); War on